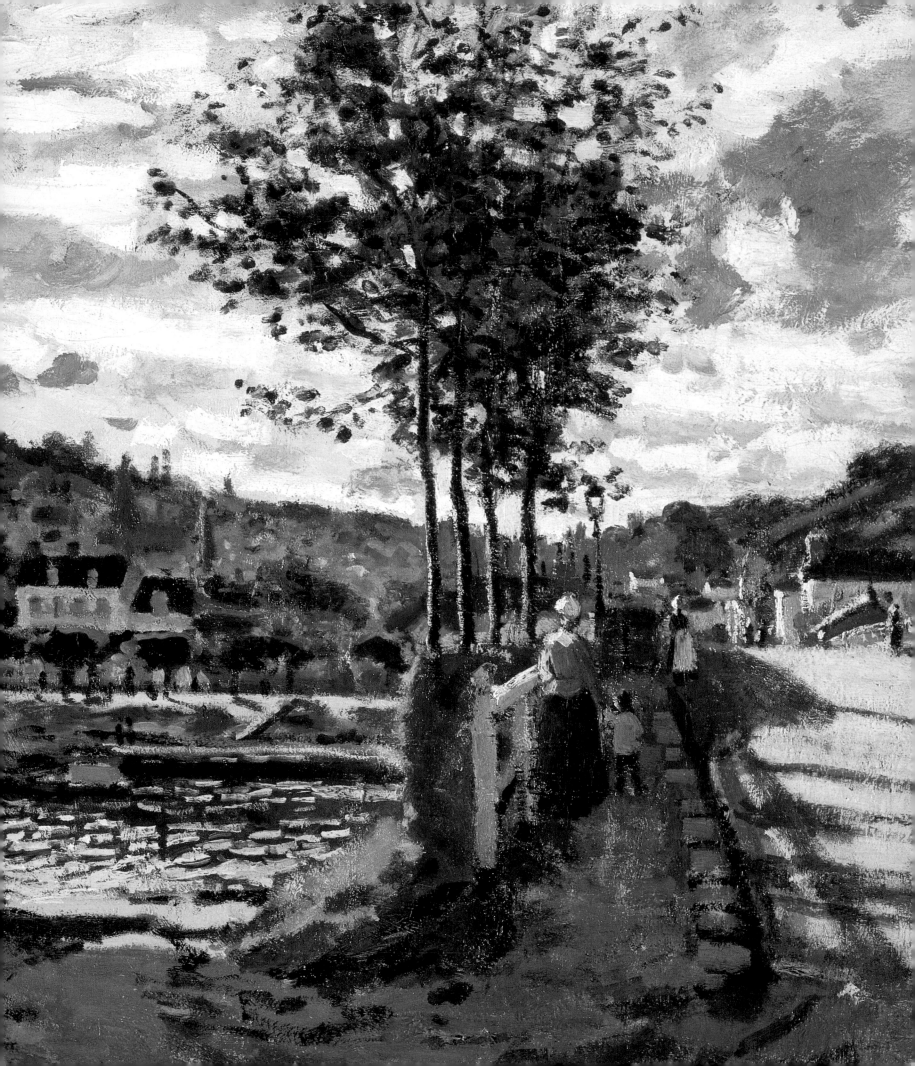

The Rise of Landscape Painting in France

COROT TO MONET

KERMIT S. CHAMPA

with contributions by FRONIA E. WISSMAN

and DEBORAH JOHNSON

with an introduction by RICHARD R. BRETTELL

THE CURRIER GALLERY OF ART • MANCHESTER, NEW HAMPSHIRE

Distributed by Harry N. Abrams, Inc., New York

The Rise of Landscape Painting in France
COROT TO MONET

THE CURRIER GALLERY OF ART
Manchester, New Hampshire
January 29 through April 28, 1991

IBM GALLERY OF SCIENCE AND ART
New York, New York
July 30 through September 28, 1991

DALLAS MUSEUM OF ART
Dallas, Texas
November 10, 1991, through January 5, 1992

HIGH MUSEUM OF ART
Atlanta, Georgia
January 28 through March 29, 1992

This exhibition has been organized by The Currier Gallery of Art and is made possible by a grant from the IBM Corporation. Additional funding was provided by the National Endowment for the Arts. Funding for the exhibition in Manchester was provided in part by The Henley Group, Inc., and Wheelabrator Technologies Inc.

Published January 1991.
Second edition November 1991.
Library of Congress Catalog Card Number: 90-85454
ISBN 0-929710-06-1 (Currier: pbk.)
ISBN 0-8109-3757-3 (Abrams)

PUBLISHED BY:
The Currier Gallery of Art
192 Orange Street
Manchester, New Hampshire 03104

COVER:
Charles-François Daubigny, *Fields in the Month of June*, 1874. Detail. Cat. 57.

FRONTISPIECE:
Claude Monet, *The Seine at Bougival*, 1869. Detail. Cat. 95.

Contents

Lenders to the Exhibition

Albright-Knox Art Gallery
The Art Institute of Chicago
The Art Museum, Princeton University
The Baltimore Museum of Art
The Brooklyn Museum
The Chrysler Museum
Cincinnati Art Museum
Sterling and Francine Clark Art Institute
The Cleveland Museum of Art
The Corcoran Gallery of Art
The Currier Gallery of Art
Dallas Museum of Art
Ruth and Bruce Dayton
The Des Moines Art Center
The Dixon Gallery and Gardens
The Fine Arts Museums of San Francisco
Thomas Marc Futter
The J. Paul Getty Museum
High Museum of Art
IBM Corporation
Indiana University Art Museum
Herbert F. Johnson Museum of Art,
 Cornell University
Joslyn Art Museum
Kimbell Art Museum
The Los Angeles County Museum of Art
Malden Public Library
Memorial Art Gallery, University of Rochester
Memphis Brooks Museum of Art
The Metropolitan Museum of Art
The Montréal Museum of Fine Arts
Mount Holyoke College Art Museum
Musée du Louvre
Musée national du château de Compiègne
Museu de Arte de São Paulo
Museum of Fine Arts, Boston
The Museum of Fine Arts, Houston

Museum of Fine Arts, Springfield
National Gallery of Art
National Gallery of Canada/Musée des
 Beaux-Arts du Canada
The National Museum of Western Art
The Nelson-Atkins Museum of Art
New Orleans Museum of Art
Ordrupgaard Collection
The Paine Art Center and Arboretum
Philadelphia Museum of Art
Portland Art Museum, Oregon Art Institute
The Saint Louis Art Museum
San Diego Museum of Art
Smith College Museum of Art
The Snite Museum of Art, University of
 Notre Dame
The Taft Museum
The Toledo Museum of Art
Tweed Museum of Art, University of
 Minnesota-Duluth
The University of Michigan Museum of Art
Virginia Museum of Fine Arts
Wadsworth Atheneum
The Walters Art Gallery
Washington University Gallery of Art
The Wellesley College Museum
Worcester Art Museum
Anonymous lenders

Foreword

In 1949, in honor of The Currier Gallery of Art's twentieth anniversary, director Gordon Smith presented an exhibition entitled *Monet and the Beginnings of Impressionism*. The renowned scholar of French painting John Rewald wrote the foreword to the modest catalogue. The show included fifty-one paintings by many of the artists in the present exhibition. The Currier's own early painting by Monet, which Smith had recently purchased, was featured, and soon after, Smith purchased the Currier's Corot and Constable works from the show. *The Rise of Landscape Painting* was first conceived as a re-creation of Smith's 1949 show to celebrate the Currier's sixtieth anniversary.

Professor Kermit Swiler Champa of Brown University, author of *Studies in Early Impressionism,* was appointed the guest curator of the new exhibition. He quickly focused the show on the French Barbizon school. While many exhibitions of French Impressionism had been seen recently in America, the artists of the Barbizon school have not been the subject of a major exhibition since *Barbizon Revisited* of 1962, organized by Professor Robert L. Herbert of Yale University and presented at San Francisco, Toledo, Cleveland, and Boston. Herbert's show had been the first comprehensive look at the Barbizon painters since 1889, and the catalogue was so definitive that it discouraged new scholarship in the field for twenty years.

A number of leading American scholars in the field helped to shape the current project and assisted us in developing the present exhibition and accompanying catalogue. Herbert agreed that it was time to reexamine the Barbizon painters and steered us to his recent student, Fronia

E. Wissman, who had written her dissertation on Corot's Salon paintings. Another of Herbert's former graduate students, Paul Hayes Tucker, professor at the University of Massachusetts, Boston, and author of *Monet at Argenteuil,* was a consultant on the project until his work on *Monet in the '90s* absorbed all of his time. T. J. Clark, author of three ground-breaking books on mid-nineteenth-century French painting, directed us to his student, Jeremy Strick, who is completing a dissertation on the relationship of the art market to the rise of landscape painting in the Barbizon school. Strick, associate curator of twentieth-century art at the National Gallery in Washington, D.C., and Tucker helped Champa to focus the rise-of-landscape theme of the show. Tucker also read some of the manuscripts and made insightful comments. Alexandra R. Murphy, the Millet expert, formerly associated with the Museum of Fine Arts, Boston, and the Sterling and Francine Clark Art Institute, Williamstown, and a former student of Champa's, agreed to become a consultant to the project. Through Champa, another former student, Deborah Johnson, assistant professor of art history at Providence College and former curator of prints and drawings at the Museum of Art, Rhode Island School of Design, became a consultant.

For this exhibition, the first reexamination of the Barbizon painters in almost thirty years, we have sought to explore the context in which these artists worked and to examine how and why landscape painting rose to center stage in France by 1870, after having been considered a minor art form as late as 1830. It has not been our goal to reveal or highlight minor masters,

new names, or works by women artists, but rather to provide a new look at masterpieces by the great artists who prepared the way for the Impressionist movement. Significant works of art have been brought together from museums throughout this country and abroad for this long-overdue examination of the leading artists of the Barbizon school.

A special goal of the exhibition is to help revive Jean-Baptiste-Camille Corot's reputation in America. Corot was one of the most popular painters in the United States at the turn of the century and one of the most highly regarded painters in nineteenth-century Europe before his influence waned. The moment is right to look at Corot anew – viewers today can appreciate the sentiment and poetry of Corot's major Salon paintings, just as a previous Modernist generation admired the freshness and directness of his sketches.

In the last decade there have been indications of a rekindling of interest in the Barbizon school, as scholars have begun to reexamine these painters. Recently a small number of tightly focused theme exhibitions have been organized in Europe and America, several Barbizon-school exhibitions have traveled in Japan, and the auction houses have begun holding specialized sales. Thorough catalogues have accompanied monographic exhibitions – for example, Alexandra R. Murphy's *Jean-François Millet*, written for the 1984 show held at the Museum of Fine Arts in Boston. Yet compared to the extensive scholarly treatment of the Realists (particularly Manet and Courbet), the Barbizon painters are only beginning to be studied in depth. This catalogue is the first American look at the Barbizon school from a post-Modernist – perhaps even post-post-Modernist – point of view and the first to incorporate new research.

Although far from definitive, this catalogue offers the reader a better understanding of the nineteenth-century decades in which these great artists worked. Professor Kermit Champa shares his new insight into the musical climate of the time; Fronia Wissman reexamines the relation of these avant-garde artists to the official Paris Salon; Richard R. Brettell presents the critical and theoretical background that provided a context for the rise of landscape painting; and Deborah Johnson traces in new ways the combined influence of the Japanese print and photography on painting. In addition, Champa's insightful entries on the individual artists sort out the role of the painters and their work in the art-historical and musical context of mid-nineteenth-century life.

Happily, other studies will soon complement this catalogue. To cite just two, the late Nicholas Green's study of landscape painting and culture in early-nineteenth-century France will appear this year, and The Metropolitan Museum of Art's exhibition on the origins of Impressionism in France will be held in New York and Paris in 1993–94. It seems certain, therefore, that the advancement of knowledge and the public appreciation of the French Barbizon school that begin with this catalogue will continue.

Acknowledgments

EVEN MORE THAN MOST such projects, this exhibition was a collaborative effort. Because the Currier Gallery staff is small, a guest curator and temporary staff and consultants were needed. Kermit Champa, guest curator, willingly brought in scholars with differing points of view, devoted enormous amounts of time over three years, provided whatever was needed promptly yet thoughtfully, put up with all the unavoidable aggravation involved in a major loan exhibition and catalogue – from patiently waiting for slides to being stranded at airports – and maintained throughout the project the highest academic and professional standards. From original concept to the last wall label, this project reflects Champa's innovative art-historical thinking as well as his brilliance as a teacher.

Alexandra Murphy acted as a consultant throughout the project. Her personal recollections and vast records of paintings in America and abroad made her invaluable to us in locating pictures. Her knowledge of the literature and her connoisseurship of objects led us to consult her regularly on questions of authenticity, quality, and condition (areas where far more research is needed and where Murphy has already made a considerable contribution), while her talent for conveying information to a museum public made her the ideal consultant on the video and public lectures presented during the exhibition in Manchester. Because Murphy or Champa, or both, had seen almost every painting borrowed, the need for extensive curatorial travel was reduced.

Fronia Wissman's records of Corot's paintings in America assisted us enormously. We thank her for her essay, her editorial wisdom and assistance, and her timely and professional contributions throughout the project. We are grateful to Deborah Johnson for her thoughtful comments as a consultant to the project and for her catalogue essay. We deeply appreciate the expertise contributed at various stages of the project by scholars Peter Galassi, Steven A. Nash, Grace Sieberling, Gabriel Weisberg, and Kern Holoman; as well as the contributions of Robert M. Doty, former director of the Currier, and trustee John H. Morison and his wife Olga Morison, who helped obtain the loan of the Renoir painting from Brazil.

Others not on the Currier staff made extraordinary contributions: Joseph and Melissa Gilbert, Anne Gibson, Linda Brissette, and Kathleen Griffin of Gilbert Associates, Providence, Rhode Island, demonstrated great patience as well as creative ability in the elegant graphic design and production of the catalogue, poster, and brochure; Linda Landis of Concord, New Hampshire, brilliantly edited the catalogue text and guided the catalogue through production; Clementine Brown served as an expert and energetic consultant on national publicity; Mattie Kelley, consulting registrar, made all the complex domestic and international shipping arrangements; John Zelenik of the Freer Gallery, Washington, D.C., created the innovative exhibition design; facilities managers Martina Corwin and Mary Shutts assured smooth operations in Manchester.

The staff and volunteers of the Currier Gallery deserve a standing ovation. In fact, Kimon

S. Zachos, president of the Currier board of trustees, believes that the real story of this exhibition is how a museum as small as the Currier was able to mount an exhibition of international importance. The reason is, surely, the devoted and remarkable staff. The project administrator was Susan L. Leidy, who is unsurpassed in her organizational skills, her ability to accomplish huge amounts of work in a short time, her experience and knowledge of diverse roles, and her sense of humor. Leidy carried the weight of the exhibition for three years. She was ably assisted by Dawn Goforth and Kristen Levesque. Curator Michael K. Komanecky lent his talent, experience, and art-historical knowledge to the exhibition installation in Manchester, the design of the catalogue, and diverse other curatorial aspects of the project. Nancy B. Tieken, director of education, created the superb educational components, including the video, labels, and brochure text, assisted by Barbara Pitsch. Amanda Preston, former director of development, and her successor Johanna Gurland obtained funding for the project. Catherine Wright supervised an extensive public relations campaign. Kathy S. Jean, business manager, assisted by Sherry Collins, bookkeeper, administered a budget equal to the normal annual operating budget of the Currier, and Jean also supervised planning of the special museum shop, chaired by volunteer Pauline Bergevin. Virginia H. Eshoo planned group tours and provided invaluable advice on logistics. Librarian Maria K. Graubart supervised research by volunteers and located needed references. Julie A. Solz devoted enormous time and energy to the obtaining of photographic materials. The curatorial department – including Timothy A. Johnson, registrar-preparator; Inez McDermott, associate curator; and Joli Foucher, curatorial assistant – worked long hours to ensure the success of the exhibition. Other staff members who made important contributions include Gale Butler-Christiansen, Donald McMahon, and Alan Grimard, assisted by Ronald Sklutas and Steven Lis. The staff was supported by over a hundred volunteers who contributed time to the project, led by Guild of Volunteers chairwoman Trisha Dastin.

The generosity of the lenders makes exhibitions such as this one possible, and on behalf of the Currier Gallery, the IBM Gallery of Science and Art, the Dallas Museum of Art, and the High Museum, Atlanta, I extend our appreciation to the many museum directors, curators, and boards who put collegiality and public accessibility to art foremost and maintained the tradition of lending to serious exhibitions. We particularly thank: Douglas G. Schultz (Albright-Knox Art Gallery); Douglas W. Druick and Martha Wolff (The Art Institute of Chicago); Allen Rosenbaum (The Art Museum, Princeton University); Sona Johnston (The Baltimore Museum of Art); Sarah Faunce (The Brooklyn Museum); Robert H. Frankel and Jefferson C. Harrison (The Chrysler Museum); Millard F. Rogers, Jr. (Cincinnati Art Museum); David S. Brooke and Steven Kern (Sterling and Francine Clark Art Institute); Evan H. Turner and Ann T. Lurie (The Cleveland Museum of Art); Christina Orr-Cahall, Franklin Kelly, and William B. Bodine, Jr. (The Corcoran Gallery of Art); Ruth and Bruce Dayton; Julia Brown Turrell (Des Moines Art Center); J. Patrice Marandel (The Detroit Institute of Arts); John E. Buchanan, Jr., and Nannette Maciejunes (The Dixon Gallery and Gardens); Harry S. Parker, III, and Lynn Federle Orr (The Fine Arts Museums of San Francisco); Thomas Marc Futter; George R. Goldner (The J. Paul Getty Museum); Adelheid M. Gealt (Indiana University Art Museum); Thomas W. Leavitt, Nancy E. Allyn, and Nancy Harm (Herbert F. Johnson Museum of Art, Cornell University); Graham W. J. Beal and Marsha Gallagher (Joslyn Art Museum); William B. Jordan (Kimbell Art Museum); Philip Conisbee (Los Angeles County Museum of Art); Dina G. Malgeri (Malden Public Library); Bernard Barryte (Memorial Art Gallery, University of Rochester); William P. Heidrich and Patricia P. Bladon (Memphis Brooks Museum of Art); Laurence B. Kanter (Robert Lehman Collection, The Metropolitan Museum of Art); Pierre Théberge, Frederik Duparc, and Louise

D'Argencourt (The Montreal Museum of Fine Arts); Teri J. Edelstein (Mount Holyoke College Art Museum); Jean-Marie Moulin and Françoise Maison (Musée national du château de Compiègne); P. M. Bardi and Fabio Magalhães (Museu de Arte de São Paulo); Charles Moffet (National Gallery of Art); Shirley L. Thomson and Katherine Laing (National Gallery of Canada); Tetsuo Misumi, Saburoh Hasegawa, and Koji Yukiyama (The National Museum of Western Art); Marc F. Wilson (The Nelson-Atkins Museum of Art); E. John Bullard (New Orleans Museum of Art); Mikael Wivel (The Ordrupgaard Collection); Bev Harrington (The Paine Art Center and Arboretum); Gerald D. Bolas (Portland Art Museum); James D. Burke and Michael E. Shapiro (The Saint Louis Art Museum); Steven L. Brezzo and Nora Desloge (San Diego Museum of Art); Edward Nygren, Linda Muehlig, and Michael Goodison (Smith College Museum of Art); Dean A. Porter and Stephen B. Spiro (The Snite Museum of Art, University of Notre Dame); David Torbet Johnson (The Taft Museum); David W. Steadman (The Toledo Museum of Art); Martin DeWitt (Tweed Museum of Art); William Hennesey (The University of Michigan Museum of Art); Paul N. Perrot and Pinkney Near (Virginia Museum of Fine Arts); Patrick McCaughey and Jean Cadogan (Wadsworth Atheneum); William R. Johnston and Beverly Balger (The Walters Art Gallery); Joseph D. Ketner (Washington University Gallery of Art); Susan M. Taylor (Wellesley College Museum); James A. Welu (Worcester Art Museum).

We are indebted to those colleagues who made an extraordinary effort in helping us locate works beyond those in their own collections or in offering new research to us. Especially generous with their time and expertise were: Doris Birmingham (New England College); Janet M. Brooke (Art Gallery of Ontario); Charles Buckley (former director of the Currier Gallery); Brandt Dayton (New York); Richard Feigen (New York); William Hutton (The Toledo Museum of Art); Ruth Meyer (The Taft Museum); James Mundy (Milwaukee Art Museum); Steven A. Nash (formerly of the Dallas Museum of Art, now with The Fine Arts Museums of San Francisco); William O'Reilly (New York); Joseph J. Rishel (Philadelphia Museum of Art); Franklin W. Robinson and Ann Slimmon (Rhode Island School of Design Museum); Pierre Rosenberg (Musée du Louvre); George T. M. Shackelford (The Museum of Fine Arts, Houston); Lisa Simpson (Knoxville Museum of Art); Hollister Sturges (Museum of Fine Arts, Springfield); Peter C. Sutton and Eric M. Zafran (Museum of Fine Arts, Boston); Gary Tinterow (The Metropolitan Museum of Art); Robert Vose (Boston); Roger Ward (The Nelson-Atkins Museum of Art); Wheelock Whitney (New York).

The three other venues offered extensive cooperation. In Dallas, director Richard R. Brettell, former curator of European paintings at the Art Institute of Chicago and a scholar in the field himself, was an early supporter of the exhibition and kindly contributed the catalogue introduction. Susan Barnes, senior curator, and Anna McFarland, exhibitions coordinator, were especially helpful. In Atlanta, Gudmund Vigtel, director, Paula Hancock, curator of research, and Frances Francis, registrar, were particularly effective.

The IBM Corporation is the model national corporate sponsor. We were privileged to work with IBM, both in New York and in Manchester. We are grateful to Richard P. Berglund, director of cultural programs, for funding and for his sensitive and professional attitude toward exhibitions; and to Cynthia J. Goodman and later Robert M. Murdock, program directors of the IBM Gallery of Science and Art. Murdock supervised the production of the handsome poster and brochure, and hosted the exhibition in New York City. Also helpful to us in New York were Dolores Gostkowski and Mary Ryan. Locally, James H. Keegan, Leonard C. Sullivan, and David E. Herlihy were enthusiastic and helpful. We express our sincere appreciation for IBM's generous financial support and enlightened partnership.

We also acknowledge a generous grant from

the National Endowment for the Arts, a federal agency. Such grants are characteristic of the role of the Arts Endowment over the last twenty-five years in making major American museum exhibitions possible. The New Hampshire Council for the Humanities granted funds for related educational programs; we thank Charles Bickford, director. The New England corporate sponsor is The Henley Group, Inc., Paul Montrone, president, and we are grateful for strong support of the New England showing of the exhibition.

MARILYN FRIEDMAN HOFFMAN
Director, The Currier Gallery of Art
August 1990

Guest Curator's Acknowledgments

IN ADDITION TO THE Director's acknowledgments, I would like to express my gratitude to those who have been helpful in matters relative to the catalogue text. For reading at an early point the main catalogue essay and commenting on it, I would like to thank, in particular, Professor Norman Bryson (University of Rochester); Professor David Carrier (Carnegie Mellon University); Professor Michael Driskel (Southern Methodist University); Professor Michael Fried (Johns Hopkins University); Professor Robert L. Herbert (Yale University); Professor Robert Scholes (Brown University); and Professor Barbara Stafford (University of Chicago).

Students in various classes at Brown University – both graduate and undergraduate – read the catalogue text in various forms as part of classroom exercises. Many refinements of argument resulted from their readings as well as from an intensive critical analysis of the text undertaken by Professor Joanna Ziegler and members of her senior concentrators' seminar (History of Art) at the College of the Holy Cross in the fall of 1989. I cannot credit Professor Ziegler's attention to the text with any but the most unqualified superlatives, and that attention has endured over three years!

In the final year of text preparation, Judith Tolnick operated as my primary research and text coordinator. Her assistance was as professionally invaluable as it was tireless. Anything resembling accuracy or consistency in the final text is largely attributable to her. In addition, during the summer of 1990, I had a Brown undergraduate research assistant, David

Dintenfass, who, besides offering enthusiastic encouragement, did very responsible biographical research. Finally, I must thank Janice Prifty, secretary of the program of the History of Art and Architecture at Brown University, for efficiently handling the logistical problems of long-distance communication with Manchester.

Susan Leidy, coordinator of the exhibition, remained my constant, understanding, and efficient contact at the Currier. Without her, the complex enterprise of exhibition *and* catalogue could never have achieved the high degree of coherence they finally came to possess. Linda Landis was an exemplary project editor. She contributed, besides her extensive expertise, exceptional patience with, and sensitivity to, a wide range of manuscript materials. To Michael Komanecky, curator of the Currier Gallery, I offer my best wishes for installation of the exhibition, and to Marilyn Friedman Hoffman, the Currier's director, my sincerest thanks for engineering the whole enterprise with such confidence from the start.

KERMIT SWILER CHAMPA
Brown University
August 1990

Introduction

RICHARD R. BRETTELL

PIERRE-HENRI DE VALENCIENNES was fifty years old in 1800 when he published his ground-breaking book on landscape painting, *Elémens de perspective pratique*. Like other French painters of the eighteenth and early nineteenth centuries, the young Valenciennes had cut his teeth in Italy, learning the lessons of Italian art. Yet, unlike most of his contemporaries in France, he followed the lead of his countrymen Claude Lorrain and Nicolas Poussin to learn equally from the Italian landscape as from her art. On his return to France, he found that landscape painting, the art form to which he had become addicted and which was to become the triumphant mode of nineteenth-century art, was viewed unfavorably by critics and important collectors and that the lessons he had learned from the landscape were not of interest to his countrymen. Joseph Vernet, the only major French landscape painter of the eighteenth century, was thought even by his contemporaries to have been an important painter working in a minor genre, and the young Valenciennes wanted to be an important painter working in an important genre. Clearly, he had his work cut out for him!

Unlike most painters, Valenciennes realized that he had to do more than to paint beautiful and moving landscapes if he wanted to change the mind-set of his contemporaries, and, perhaps for that reason, he decided to write a monumental book. The book he wrote was created for a learned eighteenth-century audience; even today, it is read only by academic specialists in eighteenth- and early-nineteenth-century art. Yet, it probably contributed more than any land-scape painting – even any single artistic career – in creating a receptive climate for landscape painting in France. Although Valenciennes would probably have detested most of the major landscapes by Corot, Rousseau, Boudin, Monet, Pissarro, Gauguin, and Cézanne that were to transform modern art, he did more than anyone to ensure that they were made.

It is a truism to say that landscape painting was among the minor genres of European art at the beginning of the nineteenth century. In spite of the fact that the two greatest British painters and the one greatest German painter of the first half of the century were landscape painters (John Constable, J. M. W. Turner, and Caspar David Friedrich), there was not one landscape painter of that stature in France, and all European artistic theory favored figure painting, both historical and allegorical, over landscape. Even portraiture, the "bread-and-butter" painting of Europe, had a higher status than landscape painting! The texts and treatises on various forms of figural art published from the sixteenth through the eighteenth century would fill volumes. Those on landscape painting would fill a single, slim volume.

Valenciennes took on this monolithic estab-lishment with a vengeance. The full title of his book, *Elémens de perspective pratique, à l'usage des artistes, suivis de réflexions et conseils à un élève sur la peinture, et particulièrement sur le genre du paysage [Elements of practical perspec-tive for use by artists, followed by reflections and advice to a student on painting, particularly the genre of landscape]*, was a sort of deception, making the book appear to be a treatise on per-

spective rather than an investigation of landscape painting per se. In nearly seven hundred pages, Valenciennes created an aesthetic, intellectual, and moral argument for the primacy of landscape over figure painting, with a particular emphasis on what he called "historical landscape," a type of painting that he contrasted with various kinds of realist landscape painting, which he called "landscape portraits." For Valenciennes, a historical landscape was to a landscape portrait what a history painting was to a human portrait. Of course, Valenciennes's logic was not quite so simplistic as this summary suggests. Indeed, the patient study of nature, in all its complexity, was as vital a component in the preparation of a historical landscape as was the reading of texts or the study of history.

Valenciennes theorized that the historical and moral emanations from landscape paintings gave them significance beyond mere appearances. Yet, with the advantage of hindsight, modern readers of Valenciennes's text can interpret his entire argument as a strategy – unconsciously applied, most likely – to lure what must have been defensive, early-nineteenth-century readers into a logical trap: that, no matter how elevated its "subject," a historical landscape had to be based on a profound study of real nature. Valenciennes won his battle for landscape painting by taking the Academy of Fine Arts, the central authority for art in France, on its own grounds. His efforts were so relentlessly consistent, indeed magisterial, that he defused what might have been a battle and allowed the Academy a way of letting landscape painting into its hallowed portals.

Any student of nineteenth-century painting would know that Valenciennes's victory was relatively complete by mid-century. By 1817, a prize for landscape painting had been established in the Academy. By the mid-1820s, the number of landscape treatises in French had increased dramatically, although *Théorie du paysage*, the ecstatic book of 1818 by Valenciennes's student, J. B. Deperthes,[1] became the only rival publication on landscape worthy of comparison with the text of 1800. Yet, most importantly, by the

middle of the century, landscape painting had become increasingly dominant in France. Artists, working with brushes and canvas rather than words, planted and harvested the field tilled by Valenciennes, who was, in many more ways than were recognized in his own century, the fountainhead.

What may have been the largest and most important figure painting of the 1850s, Gustave Courbet's *The Studio – A Real Allegory Representing Seven Years of My Artistic Life*, now hanging in the Musée d'Orsay, Paris, had as its central subject a landscape painter. Courbet represented himself surrounded by models, friends, and patrons, but, rather than to take their overwhelming figural presence into account, Courbet himself paints a landscape of his native Jura. Indeed, his brush seems poised to place a painted mark on an isolated dwelling or hut situated in the landscape painting on the easel. The contrast between the huge figure painting itself and the landscape painting within the painting could scarcely be greater, and one cannot imagine that this painting could have even been conceived at any earlier point in the history of western art.

The history of landscape painting in nineteenth-century France is so well known as hardly to bear repeating. Valenciennes and the painters of classical or historical landscape dominated the first three decades of the century, being supplanted by the so-called generation of 1830, artists who sought in their native France the charms that their teachers had found principally in Italy and who injected both patriotism and realism into landscape painting. Camille Corot and Théodore Rousseau were the most influential artists of this group, and their careers came increasingly to be associated with the landscape around the Forest of Fontainebleau, southeast of Paris. Indeed, the name "Barbizon School," by which they and their colleagues came to be known, raised to prominence a tiny village on the border of the Forest of Fontainebleau that was scarcely known in the first half of the nineteenth century. Corot and Rousseau had, by 1850, joined the aging Ingres and Delacroix as the principal painters of France, and

Corot became the most important teacher of landscape painters in the history of that art.

Two French artists emerged at the beginning of the 1860s to give added vitality to the landscape movement, Charles-François Daubigny and Eugène Boudin, each of whom, although lesser talents than Corot and Rousseau, acted as artistic bridges between the older artists and the even younger landscape painters who were to become known as Impressionists. From the moment in the mid-1860s when Monet, Pissarro, Renoir, and Sisley began to make landscape paintings seriously until the late landscapes of Cézanne and Monet, each of whom defined a central path in twentieth-century art, the history of French landscape has become canonical. Books, exhibition catalogues, dissertations, and articles on Impressionist and post-Impressionist landscape painting have almost dominated art-historical literature of the twentieth century.

Even this superficial two-paragraph history of nineteenth-century landscape painting tells us that today we know a good deal more about the second half of the nineteenth century than about the first, and that the two decades of transition, the 1820s and the 1860s, are critical to our understanding of the unified history of landscape painting in France during the nineteenth century. The fact that a complete history of French landscape painting in the nineteenth century has never been written is surprising, almost shocking, given the importance it has played in the larger history of western easel painting. And it is equally shocking to recognize the extent to which museum exhibitions of the past generation have neglected French landscape painting before the Impressionists, in spite of its evident popular appeal. There has not been a single truly important exhibition of early- or mid-nineteenth-century French landscape painting at a major American museum since Robert L. Herbert introduced *Barbizon Revisited* in 1962. And, if that is not bad enough, there has not been an internationally significant exhibition devoted to the careers of Valenciennes, Corot, Rousseau, Boudin, or Daubigny in the past generation!

The published literature is scarcely more encouraging. Indeed, the vast bibliography devoted to the Barbizon school was written largely in the nineteenth century! Important dissertations on the works of Corot and Courbet, for instance, have been produced or published only during the last decade, and that research has not been incorporated into the larger history of French landscape. Only Kermit S. Champa's seminal book, *Studies in Early Impressionism* of 1973, succeeded in treating landscape painting of the 1860s with the depth of scholarship, the critical acumen, and the seriousness it deserves. Hence, the connections between Corot and Monet have been made in print, but never in a serious exhibition in which pictures confront each other without a barrage of words.

This exhibition is, for that reason, a landmark. Many of the paintings in it have been exhibited before and are therefore familiar to students of modern painting, but they have never been assembled *as* French landscapes in an exhibition that straddles two different phases of French landscape history: the Realist landscape tradition of the mid-century and the Impressionist tradition of the latter part of the nineteenth century. The thesis of the exhibition — that Impressionist landscape painting developed logically from a well-established tradition — might therefore seem more radical than it is simply because it has never been clearly demonstrated in exhibition form.

There can be little doubt that the central figure of nineteenth-century French landscape painting was Jean-Baptiste-Camille Corot. Born in Paris four years before Valenciennes published his great text, Corot lived nearly eighty years and taught two generations of French landscape painters in the summer months during which hundreds of artists left the capital and combed the French landscape for motifs. Corot was so venerated during his lifetime and for almost two generations afterwards that his reputation was destined to stumble. An immensely prolific artist, his paintings were summarily catalogued shortly after his death by his student, Alfred Robaut, and his print production by the greatest

scholar of prints in France, Loys Delteil. His immense oeuvre of drawings as well as his experiments with the photographic medium of cliché-verre have been written about but never adequately catalogued, and even the existing catalogue of paintings is so out-of-date that it is no longer useful for a current-day scholar.

A central problem with Corot's reputation in the mid- and later twentieth century relates to forgeries, copies, and poorly preserved examples of his work. Virtually everyone in the art world knows "the Corot joke" – that Corot painted three thousand paintings, of which six thousand are in America. Yet, the victim of the joke has become Corot himself rather than the gullible early American collectors of nineteenth-century French landscape! The sheer quantity both of his work and of forgeries or poorly attributed paintings is numbing, and neither books nor exhibitions have culled a sensible canonical group from the mass of small, soft-focus, late paintings that dominate the twentieth-century image of Corot's oeuvre. For that reason, it is with amazement that one reads the "short list" of fourteen great nineteenth-century painters who form the basis for twentieth-century art, drawn up in 1929 by Alfred Barr, the founding director of the Museum of Modern Art, only to discover that Corot's name is on the list, while Monet's is omitted![2]

Corot, like his greatest pupil Pissarro, has often been thought of as a teacher as well as an artist. Thus, he fills a comfortable niche as a "precursor" of later, more consistent, and, hence, more important artists. In this view, only his tough, early oil studies of the 1820s are great works of art, worthy of comparison with Constable's landscapes, while his later works are uncomfortable elisions of France and Italy, of the "academic" and the modern – acceptable, ultimately, to neither camp. Now, however, there is no longer any necessity for this dichotomous view of nineteenth-century art, and Corot's oeuvre can be reassessed as an integral part of the total history of nineteenth-century landscape.

There is little doubt that Corot was the only great painter active in the first half of the nineteenth century who combined the theories and methods of Valenciennes and his students with an intensive analysis of the French landscape itself. His works, whether "memories" of Italy done after his last trip to that country in 1843 or carefully structured landscapes representing the forests, villages, paths, bridges, and small cities of France, balance observation and construction as carefully as the later landscapes of Cézanne or Seurat. And it must be remembered that these two post-Impressionist landscape painters learned the lessons of Corot from Pissarro.

When one reads the books, articles, and reviews about landscape painting published in France between Valenciennes's text of 1800 and the Salon des Refusés of 1863, several critical ideas emerge. The first, and most superficially obvious, is that the proper subject of the modern artist is not art, but nature. This idea was most clearly expressed in the dichotomy reported by the painter-critic Frédéric Henriet between the traditional and craft-oriented idea of "savoir faire" (to know how to make) and the modern and experimental idea of "savoir voir" (to know how to see).[3] For Henriet (whose source was reputedly Daubigny), indeed for every great nineteenth-century landscape painter, the proper work of the artist was considered to be an optical exercise and the purpose of representing nature was to teach the artist – and, by extension, the viewer – how to see. This very notion – that sight, the most "natural" of faculties, has to be learned and that artists who work at representing the physical world in all its complexity come to know both it and themselves better – is opposed at its core to the idea of the artist learning to make works of art by copying other works of art and by following "recipes" for making art from other artists.

A good deal of the intellectual impetus for the idea of "savoir voir" came from the physical sciences; not coincidentally, major advances in biology, the theory of perception, and the physics of light and the related introduction of photography were being made throughout the same period. Yet, it would be wrong to assume

that the artists were simply responding to advances in the sciences. Indeed, for many landscape painters, exactly the opposite was true. While most writers about the modern world in the nineteenth century considered science to be an analytical discipline, a discipline that divides the unity of nature into its constituent parts and then considers each part in isolation, art was thought to be a synthetic or unifying discipline. In simplest form, science conquered by dividing, while art asserted the unifying principles of knowledge, society, and morality over any single aspect of the visual world. The discussion (or better, the debate) about the relationship between art and science filled pages of nineteenth-century art criticism, particularly writing about landscape. For most nineteenth-century writers about painting, the idea of landscape itself was unifying. In what other genre of painted representation could geology, natural history, and human history be addressed simultaneously?

If unity was the goal of the landscape painter and nature his subject, there was little agreement about just what constituted either "unity" or "nature." For some, unity was to be found in nature; for others, it had to be applied. For some, nature was the entire visual world, inclusive of man and his physical residue; for others, nature was everything opposed to modern urban man. Indeed, the central concepts of landscape in the nineteenth century were debated by artists, critics, and writers rather than simply being accepted as the basis for art. And, perhaps because of the elasticity of the concepts underlying their art, landscape painting was highly experimental.

For most writers about landscape painting and, seemingly, for the painters themselves, the most crucial moments for the landscape painter were those isolated moments when he was alone "in front of nature," striving to represent a particular scene. Far from being relaxing times away from the pressures of the city, these intense periods of painting were most often described as difficult, tension-filled, and emotionally exhausting. The basic reason for this "difficulty" has to do both with the ultimate elusiveness of nature and with the physical and psychological problems involved in its representation. The continuous changes of light, the annoying interruptions by local peasants, the shifts of mood in the painter himself, or the failure of a pictorial decision in front of the maddeningly evasive "model," nature – all of these problems are cited repeatedly in the literature on landscape painting throughout the nineteenth century.

If Valenciennes's landscape painter was visualized as a kind of ideal human being who was (a) intellectually equipped with detailed knowledge of history, literature, and languages, (b) physically strong enough to travel exhaustively, and (c) morally grounded in the great guiding principles of western civilization, his rather more modest nineteenth-century successors struggled again and again to live up to his ideal. For C. J. F. Lecarpentier, writing in 1817, "the entire life of the landscape [painter] must be continuous study."[4] And this very fact was caused, for Lecarpentier, by the landscape painter's lack of method. Indeed, Lecarpentier's landscape painter "ought to renounce the principles of all the schools of art and wait patiently until he himself arrives at a path that will lead toward the study and imitation of nature."[5] Even the rather cheery Deperthes tells his reader in 1818 that "one must form a clear idea of the obstacles that one will encounter in the act of imitating nature."[6]

These notions litter the pages about landscape painting written in the first two decades of the century, but they become even more common in the mid- and later nineteenth century. For Henriet, "painting after nature will not work without an extreme tension of the painter's faculties. It is a sort of hand-to-hand combat in which the vivacity of the eye and the rapidity of movement decide the success."[7] Words emphasizing the struggle, difficulty, tension, exhaustion, and the like are as common in writing about the act of painting from nature as are more predictable words describing a relaxed, calm, restful, or natural experience.

But this very difficulty, this struggle of the landscape painter to define himself with respect both to nature and to his art, was offset by remarkable rewards. Landscape, unlike art, was considered to be a limitless and inexhaustible source for the artist. Its motifs would never "dry up," and nature is also not dependent on changes in artistic fashion. Indeed, historians of landscape painting from Valenciennes through Thomas Couture to Georges Lanoë, whose two-volume history of French landscape painting was published in 1905, stressed the continuity of landscape painting in all phases of its history. They saw landscape painting as underlying and, in an odd way, unifying the entire history of modern painting. If altarpieces with religious subjects were the raison d'être of Gothic and early Renaissance art, modern painting, particularly for the great moralist Victor de Laprade, was undergirded by landscape.

The present exhibition, *The Rise of Landscape Painting in France*, is dominated by paintings of the mid-century and has, therefore, an odd sub-title, *Corot to Monet*, given the century-long history of landscape painting in France. Indeed, the 1820s and early 1830s, the period dominated by the young students of Valenciennes and his entourage, might be a better candidate for this subtitle. Yet, in many senses, the exhibition recognizes by this very subtitle how little the general public understands the prehistory of Impressionism in French landscape painting. How many books on the most famous artistic movement of the nineteenth century contain quotations from Deperthes about the temporal structure of nature and about the landscape painter's main goal: to create through art what Deperthes himself called "une impression durable"?[8] How many of us who read about the Impressionists' pictorial attack on concepts of local color know that, as early as Valenciennes himself, the variability of local color in light was clearly recognized and that, in a little read book by the painter-writer Jean Pierre Thénot, the same "theory" of color that Seurat borrowed from "science" and applied to "art" was accurately summarized for the use of landscape painters in 1841![9]

As we wander through the galleries in Manchester, Atlanta, Dallas, or New York, or study the illustrations in this book, all of us will be given a chance to look at a carefully selected group of paintings by the great French landscape painters of the mid-nineteenth century. Two foreigners, John Constable and Johan Barthold Jongkind, have been allowed honorary French citizenship, and appropriately so. From the first exhibition of Constable in France at the Salon of 1824, his work took on mythical proportions for landscape painters, particularly for the young Impressionists who were first exposed to it in 1870–71 while exiled in London from war-torn France. And the Dutchman Jongkind spent much of his working life in France, particularly in the critical decade of the 1860s; he can be considered a French painter in the same way that the Spaniard Picasso "became" French by the mid-1920s.

When we examine paintings by Corot and Rousseau in the company of works by their friends and contemporaries – Jacque, Diaz, and Troyon – we see works that were almost canonical at the time of the founding of the great American museums in Boston, New York, Chicago, and Minneapolis. Fortunately, the exhibition recognizes that the work of these artists whose reputations were secure by 1850 was still viable in the 1860s when Daubigny and Jongkind burst onto the scene just in time to anticipate the brilliant entrances of Monet, Pissarro, and Sisley. Indeed, *Corot to Monet* reverses the trend seen in exhibitions such as *A Day in the Country: Impressionism and the French Landscape* or the relatively recent monographic exhibitions devoted to Monet, Pissarro, and Renoir. Whereas the work of the young painters of the 1860s appears to exist in isolation in these earlier exhibitions, here it is shown to spring from a great tradition.

This exhibition clearly demonstrates that the young Impressionists were able to paint as brilliantly as they did because almost three generations of landscape painters preceded them, creating collectively a tradition of landscape that

is without doubt the strongest and most important in the history of art. As we look appreciatively at the paintings in the exhibition, we must remember that the artists who made them were the vanguard of a major tradition with solid roots in the academic theorizing of Valenciennes and his students. They sought to do more than to create art about art, but in their isolated bouts of painting in the face of nature, they searched for an art that bordered on the existential. If any movement in the history of western art asked questions about the nature of art more sweepingly than French landscape painters of the nineteenth century, I cannot think of it. Had Clement Greenberg, the greatest American modernist critic of the twentieth century, read Valenciennes, Deperthes, or Henriet, he would have found his match.

NOTES

1. Jean Baptist Deperthes, *Théorie du paysage* (Paris: Lenormant, 1818).

2. Alfred H. Barr, Jr., First Loan Exhibition, 1929 (New York: The Museum of Modern Art), 11.

3. Frédéric Henriet, *Les campagnes d'un paysagiste* (Paris: H. Laurens, 1891), 69ff.

4. C. J. F. Lecarpentier, *Essai sur le paysage* (Paris: Treuttel et Wurtz, 1817), 26.

5. Ibid., 30.

6. Deperthes, *Théorie du paysage*, 19.

7. Henriet, *Les campagnes d'un paysagiste*, 70–71.

8. Deperthes, *Théorie du paysage*, 22.

9. Jean Pierre Thénot, *Les règles du paysage* (Paris, 1841), 3.

The Rise of Landscape Painting in France

KERMIT S. CHAMPA

Under the Republic and the First Empire, music rose to a height, which, in the place of poor depressed literature, made it one of the glories of the times.
— Charles Baudelaire, *Richard Wagner and Tannhäuser in Paris*, 1861

I also heard the voices of the trees ... this whole world of flora lived as deaf-mutes whose signs I divined and whose passions I uncovered. I wanted to talk with them and to be able to tell myself, by this other language – painting – that I had put my finger on the secret of their majesty.
— Théodore Rousseau, quoted in Robert Herbert, *Barbizon Revisited*

Ah! The sun, it is the lyre of Orpheus, it makes everything move, everything feel, everything attract. It renders the stones eloquent.
— Théodore Rousseau, quoted in Robert Herbert, *Barbizon Revisited*

No other musical subject has ever exhibited so vast an array of intellectual ramifications as has the music of Beethoven in France.
— Leo Schrade, *Beethoven in France*

He [Richard Wagner] is at the moment the truest representative of modernity.
— Charles Baudelaire, *Richard Wagner and Tannhäuser in Paris*, 1861

The historian gives me a reason, but he invents it; and criticism itself, of which we hear so much, is only the art of guessing, the art of choosing from among several lies, the lie that is most like truth.
— J.-J. Rousseau, *Emile*, 1762

John Constable, *Dedham Lock and Mill*, 1820. Detail. Cat. 7.

INTRODUCTION

IN UNDERTAKING to mount an exhibition devoted to the rise of landscape painting in France roughly between the years 1824 and 1870, certain obvious conditions have been considered. The bringing together of major paintings participating in the "rise" has not been attempted for well over twenty-five years – not since the epochal *Barbizon Revisited* exhibition developed by Professor Robert Herbert for the Museum of Fine Arts in Boston in 1962.[1] Some form of restaging of that event is self-evidently overdue. Relatively few of today's museum visitors have any memory of that exhibition to treasure, and those who do probably find that the memory has progressively and unavoidably faded. Unfortunately, Herbert's attempt to bring French landscape from the first half of the nineteenth century back into view did not spawn other exhibitions as it ideally should have. When the landscape accomplishment of this period has reappeared with any force of numbers, the occasion has tended to be in exhibitions of a generically "revisionist" sort – particularly those devoted to rather amorphous trends like "Realism" or to politically defined historical periods like the Second Empire or the July Monarchy.[2] As an integrated and to a large degree internally conversant corpus of work, French landscape painting in its early- and mid-nineteenth-century form has in recent years all but vanished from organized public view. This is a situation which the present exhibition seeks to rectify.

Yet simply to return a body of work to view is

hardly a sufficient excuse for the physical risks of moving paintings long distances and exposing them in their already frail condition to various forms of non-routine handling. The paintings must be made to be seen anew, rather than simply again. They must be chosen and exhibited so as to disclose extended forms of visual and ideological meaning – meaning which arguably remains concealed when the paintings just "stay home" in the permanent museum or private collections of which they are normally a part. In a responsibly conceived loan exhibition, the opportunity to "see again" is combined with a critical and historical effort either wholly to reinterpret or at least to expand on established interpretation. Educationally speaking, the practical, which is to say "what is brought together for display," complements and is complemented by the hermeneutical – the latter figuring both in what is brought together to be looked at and in how the grouping is seen to yield some particularly enlightening form of visual and intellectual discourse. Conceived in this way, the loan exhibition and its exhibition catalogue are of a piece. Presentation, analysis, and verification can be made to function organically in a manner wholly unlike what happens visually and intellectually in a book about paintings or in the galleries of any museum's permanent collection. Ideally, a loan exhibition is a unique visual and intellectual opportunity to interrogate an important corpus of objects in the presence of those objects. Scholarly methods are not, in such a situation, just up against other scholarly methods. Rather, methods confront what they are presumably devised to account for. Paintings, when they are there in force to deliver their own messages, powerfully resist having critical irrelevancies attributed to them. A large part of that ability to resist is lost when a painting or a group of paintings gives up its stubborn physical and visual character to appear as illustrations in a book. There is no contest in terms of the power of the image and the power of its interpretation in a book. The interpretation always wins, since print always favors language. In an exhibition the contest is a good

deal more equal, and potentially much more informative.

The present exhibition employs a very different strategy from that of *Barbizon Revisited,* which stressed the aspects of historical development that were presumed to be demonstrable stylistically and sociopolitically across the course of fifty years of French landscape painting. The cumulative aesthetic effect of working *from* nature and the linking of this practice to the advancing pressures for liberal political reform gave *Barbizon Revisited* – both as an exhibition and a catalogue – a distinctly evolutionary prospect. In fact, an evolution-revolution ideology was clearly in force. Today the notion of inevitable forward progress, inflexibly conceived, seems inadequate to explain the complex, sometimes forward, sometimes backward, often halting movement of landscape imaging that appears in the work of the three key founding figures of early- and mid-nineteenth-century French landscape painting: Camille Corot, Théodore Rousseau, and Jean-François Millet. It is very difficult to see their work "advancing" – changing, perhaps, but not necessarily moving cumulatively toward a point where the Impressionism of Claude Monet and Camille Pissarro becomes an evident next step, and a largely predetermined one at that.

For *The Rise of Landscape Painting in France,* some different interpretive models are being tested, and the fact that they are different and are being tested has evidently influenced the selection of works brought together for the exhibition. Rather than stretching to include in some quasi-democratic way a broad range of work stylistically or iconographically related to that of the broadly recognized *great* figures, those great figures have their work represented in quantity; the guiding assumption is that in painting as in anything else the clearest statements issue from the surest and most confident practice. In many basic ways, the grouping here responds to what had already been set out as canonical achievement by the earliest historians of nineteenth-century (or "modern") art – those historians writing in French, German, or

English around the turn of the century.[3] The work of the great figures is framed here by what in terms of conventional interpretation encouraged it into being (John Constable's painting of the early 1820s) and by what in comparably conventional interpretation issued from it (Monet's and Pissarro's paintings of 1867–70). Eugène Isabey and Paul Huet are examined on the early side for whatever their work reflects of or conveys from Constable. On the other side chronologically, Charles-François Daubigny, Johan Barthold Jongkind, and Eugène Boudin are represented by a sufficient sample of work to show whatever sorts of alternative emphases their efforts contain. Gustave Courbet appears as a landscapist with a considerable number of examples – a number necessary to display the irritating power of his highly idiosyncratic manner of landscape imaging, which of course had its roots in large-scale figure painting. Not much will be in evidence to reinforce the notion of something accomplished or definable as "Barbizon painting." The fact that Rousseau and Millet chose to live there (at or in the Forest of Fontainebleau near Barbizon) is as well known as the fact that Corot did not. A discussion of "Barbizon painting" would necessarily issue from a sampling of work related in a derivative way either to Millet or Rousseau, or both, whether that work occurred in and around the town of Barbizon or not. Much Dutch and American painting would necessarily be included, since "Barbizon painting" properly considered had as much of its life in the countryside of Holland and New England as in the Forest of Fontainebleau itself. Barbizon was certainly the mecca of a style, but it was not in any sense the continuous locale for the practice of this style.

By aiming the present exhibition away from Barbizon as a locale and in the direction of the most ambitious operations of French landscape painting, such as appear in the works of the most consistently intelligent (from a pictorial point of view) of the artists involved, some quite interesting *and* quite radical factors both of ideology and achievement begin to emerge.

The subject matter of what is displayed seems more focused on the meaning and the activity of landscape painting itself rather than on any consistently evolving form of the imitation of nature, either generic or particular. It is the complex enterprise of discovering and sorting a new language of feeling (or more properly "sentiment") that one is made to witness. A panorama of gropings for whatever are the pictorial equivalents of (or replacements for) words and sentences unfolds – not sequentially but in terms of oppositions both within the work of individual artists and across the work of artists attentive in some manner to one another's efforts. The fact that no consensus of style or imagery develops in the collective work of Corot, Rousseau, and Millet bespeaks the intensity of a profound search, but for what? Or reaction against what? An armature for the "free discourse of the sentiments," intelligibly structured but not bound by material clarity of statement: perhaps this is as useful a working definition of what was being pursued as can be offered. However, the definition requires some extensive elaboration in order to be more than conjecture.

To undertake to be a landscape painter in early- or mid-nineteenth-century France required a commitment to something other than certain recognition and concomitant financial reward. The low status accorded to the practice of landscape painting in the all-monitoring academic establishment has been discussed so extensively elsewhere as to require no elaboration here.[4] But what needs to be emphasized is the fact that to paint landscape was the clearest declaration of a desire for freedom (in one or another form) that an artist working prior to 1860 in France could possibly make. Only in an academically disrespected genre was there the promise of a broad and open field of language space for an artist to explore. Recent historical precedents for ambitious landscape-painting practices while extant were not elaborate, at least in France.

More important than prior painting was a powerful encouragement (virtually an ideology

itself) in the eighteenth-century social philosopher J.-J. Rousseau's *Emile* of the notion that operating in and with nature (read "landscape") guaranteed access to the experience of true knowledge and feeling — access cut off to those existing in the urban-commercial world of established opinion and fixed meaning. For J.-J. Rousseau, understanding formed within nature was, by definition of origin, uniquely reliable, true, and integrative of the intellectual and emotional life of the individual. Although involved only briefly in painting or drawing from nature, J.-J. Rousseau framed the positive conditions for such an enterprise with resounding eloquence. His message was not lost on Corot, Millet, and Théodore Rousseau. Even though their world was radically transformed from that of France in 1760, certain conditions of urban-academic bondage had in fact intensified, largely because of shifting patterns of work and of the distribution of wealth that were already in the 1820s immutably fixing bourgeois patterns of behavior and belief with relentlessly increasing force. Although the forms of conservatism were different, the latitude for radically effective accomplishment (originality) on any but the most material level had narrowed considerably from 1750 to 1828. For this reason J.-J. Rousseau's solutions progressively increased in their practical attractiveness. Although artists, generally speaking, rejected the seductive potential of anarchistic tendencies of any organized sort (or the kind of deconstructive or "primitivist" tendencies that were of such major aesthetic importance toward the end of the nineteenth century), J.-J. Rousseau's last frontier of the village and the forest represented over a considerable historical period an available refuge for intelligently creative free action, but action of an aesthetically self-serving rather than politically revolutionary sort. The fact that the "natural village and forest" became increasingly harder to locate as the century developed is not a stress factor in the "rise" period of French landscape painting. It obviously becomes such for Monet, Vincent van Gogh, Paul Cézanne, and especially Paul Gauguin in the 1880s.

Locating the context for freedom of any sort is only a first step in painting or in any other activity. Locations either specifically or in type do not provide in and of themselves exemplary models of anything. They are neutral ambiences rather than true resources, until they are by some creative fashioning made to convert. They are potential without direction. In this they are rather like the pre-1828 genre of landscape painting in France. There is plenty of room in which to operate, but the content of the operation, if it is to be an aesthetically important one, remains to be settled. Nothing is binding or dictated aesthetically in those Rousseauian locales, the village or the forest. Without some at least potentially intelligible manner of coding (aesthetic or other), both are either too materially simplistic or too complex psychologically (in the Burkean sense) to give articulate signals. The mundane and the sublime simply mingle amorphously.

What then, besides some form of relief or freedom from overbearing urban and academic conventions, did the practice of landscape painting coupled with residence in "nature" have to offer? What were available modern French models of significant expressive achievement which could be seen to have reaped the benefits of living in nature — beyond those of J.-J. Rousseau and later Chateaubriand? Or did the models have to be French at all? In terms of painting per se, the most forceful demonstrations were those of the Englishman Constable (and to a lesser degree those of Richard Parkes Bonington and the English watercolor tradition generally).

The impact of Constable's work in Paris between 1824 (when it first appeared at the official Salon) and 1830 has been much studied.[5] The responses of the major young figure painters Théodore Géricault and Eugène Delacroix are well documented, and the extended critical assumption has tended to be that the effect evident in Géricault and Delacroix of Constable's technical example, coupled with the appearance of so much new French landscape work just after 1830, forms a package called "Constable's influence." The problem with this assumption is

Constable: Cat. 6–10

that French landscape work, when it appears with any frequency, doesn't look very much like Constable's, either in what it images or in its technical manner of imaging. Very little of Constable's descriptively innovative technique – his handling of light as reproduced by a palette that moves rapidly between large-scale light and dark contrasts and through innumerable steps in values in reds, greens, and grays that climax frequently on the upper end of the value scale in pure or nearly pure white – appears in the early 1830s work of Rousseau or Corot. Similarly there is, at least in their largest and most ambitious landscape pictures, little echo of the improvisatory and often "rough and ready" look of Constable's constructive paint mark, which always seems more a discovery of the moment than a technical certainty known in advance. If and when something suggestive of Constable appears, as it certainly does, for example, in Rousseau's large *Descent of the Cattle* (fig. 1), the suggestion seems filtered through the non-landscape but Constable-informed exemplar of Delacroix's post-1825 work.[6]

For a variety of reasons, many of which can only be suggested here, Constable's example was in large part a negative one for French landscape painting in the 1830s. The apparent materialism that informed (or seemed to inform) Constable's vision had too much of science about it to allow any degree or form of sentiment. Seen from the vantage point of important French landscape work of the 1830s, it is clear that Constable's painting looked too materially complete in its determined accounting of natural appearance to have any expressive space or time left for natural sentiment. Or to put the matter differently, Constable seems to have seen nature without feeling anything beyond the sensation of seeing. More a scientist (which is to say a disinterested observer) than an artist in French eyes during the 1830s, Constable's example required secondary processing by an artist like Delacroix to make it aesthetically approachable. Constable could be admired for painting landscape on a comparatively large scale in a fresh and unconventional way, but at the same time his work

Fig. 1 Théodore Rousseau, *Descent of the Cattle*, 1835. Oil on canvas, 102 × 65⅜ inches (258.8 × 166 cm). Musée de Picardie, Amiens.

had to be recognized as a problematic example of what landscape painting without a "poetic" intelligence behind it, guiding it, might become. In its transcriptive brilliance, Constable's landscape expression could be comprehended technically but not as a language form or replacement for such, or at least not in France in 1830.

Corot's justly celebrated outdoor oil sketches from the late 1820s (in Italy) and early 1830s (in France) suggest precisely the degree to which Constable's example could be let to operate by a gifted but cautious French landscape

Corot: Cat. 11–14

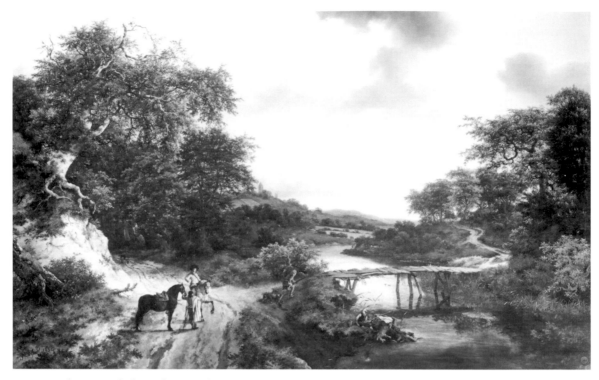

Fig. 2 Jacob van Ruisdael, *Landscape with a Footbridge*,
1652. Oil on canvas, 38¾×62⅝ inches (98.4×159.1 cm).
The Frick Collection, New York.

painter. These sketches or notes from nature demonstrate a breadth of technical means and a sensitivity to uniform lightness that sets them apart from the similarly informal works of Corot's immediate predecessors in France – Pierre-Henri de Valenciennes and Jean-Victor Bertin, for example. However, their lightness is carefully adjusted in value toward prevailing tonalities centering in beiges and light greens or blues, so that the disruptive sculptural impetus of Constable's whites never appears. Even in the most incidental seeming of Corot's sketches, the fusing of light and color toward relatively even values and often very close hues suggests that mediating "poetic values" are in force in a comprehensive way – Corot is seeing as he is comfortable seeing, or as it feels to him most poetically gratifying or productive to see. Yet, in his at least graded response to Constable, there is some confirmation of the latter's effect – albeit an inconclusive one.

Isabey: Cat. 70

Huet: Cat. 69

Isabey (along with Huet) is by far the most receptive of French landscape painters around

1830 to Constable's example, in the sense that he quite literally celebrates the "lights" and turns them very nearly into a mannerism of style in his painting, while salvaging their pictorial integrity in the best of his Normandy lithographs in the "Voyages pittoresque" mode. Whatever Rousseau accesses in Constable, in addition to what he sees in Delacroix, comes ultimately from Isabey; and it is of only momentary (and of limited) importance to the general character of his landscape imaging in the 1830s – at least as limited as it is in Corot's large-scale, so-called classical landscapes intended for the Salons.

Rousseau:
Cat. 102

The perceived absence of poetry in Constable, as suggested above, as well as the simple fact that he was English, made his landscape work much less influential in France than one might assume it ought to have been, but to say this is to misunderstand what the "poetic" meant in artistic matters for the ambitious "young France" intellectuals and aesthetes of the 1830s – the so-called romantics: Victor Hugo, Théophile

Gautier, Hector Berlioz, Eugène Delacroix, et al. The rampant distrust of eighteenth-century rationalism and the premium placed on unrestrained poetic sentiment as an intellectual locus of "truth" was extremely high. For the "young France" movement, the idiosyncratic and personalized rationalism – even the at times conscious unreason of J.-J. Rousseau – became the prime historical model for how knowledge might be acquired and at the same time be felt. If one assumes that landscape painters like Corot and Rousseau were ideologically attached, even loosely, to "young France" notions, some of the force behind their rejection of Constable becomes understandable. Similarly, their gravitation in the direction of late-seventeenth-century Dutch exemplars (in the case of Rousseau) or in the direction of mid-seventeenth-century French "classical" ones (in the case of Corot) can be seen to reflect a desire to get hold of some notion of viable landscape "painting" as opposed to the simple materialistic imaging of landscape appearance.

There seems to have been in the 1830s a concentrated effort to establish what a modern "poetic" landscape painting might or ought to look like. The issue here is definitely not one of naturalism per se but rather of poetic imaging, based in nature (but not bound by it) visually and existentially. What was the poetic language space that landscape painting (as opposed to the material description of landscape) could be made to inhabit – one thing or many things? What was the process to consist of whereby visual inspiration occasioned by the appearance of a section of nature might be structured pictorially to deliver particular sentiments to the viewer through a landscape painting devised from that natural stimulus? And was it even conceivable that such a communication or discourse – inspiration conveying inspiration via landscape imaging – could transpire at all? Could non-anthropomorphic subject matter yield anthropocentric feeling of an even roughly determinable sort? For Rousseau, the answer seems to have been "yes" to all of this when he looked at Jacob van Ruisdael (fig. 2) or Meindert Hobbema. For Corot, the same was true when he looked at Claude Lorrain (fig. 3). It appears to have been "no," when either looked at Constable.

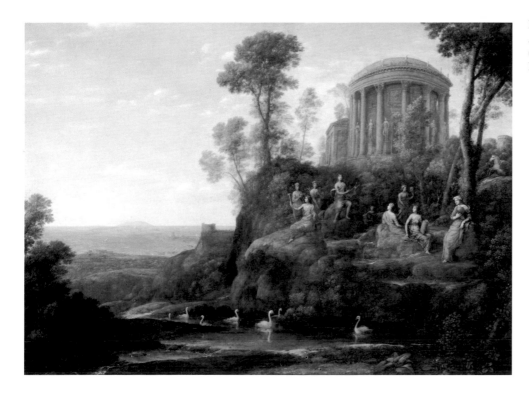

Fig. 3 Claude Lorrain, *Apollo and the Muses on Mount Helicon*, c. 1650. Oil on canvas, 39¼ × 53¾ inches (99.7 × 136.5 cm). Museum of Fine Arts, Boston, Picture Fund.

Certain motific combinations, certain emphases in terms of light, color, and texture seemed to "speak" in Ruisdael and Claude in particular, even though they speak with very different accents and through very different grammars.

What made it possible for "poetry" to be seen in Ruisdael and Claude was the fact that the means of the poetry was analogous to the means of "written" poetry. It was the poetry of conventional language. In spite of their quasi-radical commitment to landscape painting in the 1830s, both Rousseau and Corot remained faithful to a language model for painting. They subscribed, as completely as Sir Joshua Reynolds or any French neoclassical theorist, to the notion of *ut pictura poesis*.[7] This meant that whatever "poetry" of a sort might have been there to feel in Constable's work would have to have been felt outside the structures of writing-modeled pictorial language. And for the moment, this was impossible. Direct experience, working without memory and without gestures toward preestablished norms of verbal-visual reflection, could not be recognized as poetic material. For as long as the language model held, French landscape painting – which is to say Corot's and Rousseau's – would mimic poetry rather than produce it in an original way, a way particular to the medium of painting. What both artists shared with the ideology of the "young France" movement was a deep-seated belief that sensation, however exciting and liberating, was indirect and amorphous. Sensation required, for its aesthetic encoding, the processing by intellect and passion. It required translation – usually into words, sometimes into word-emulating images (like landscape paintings) – in order to be felt and in order to inspire.

For as long as landscape painting looked for its language space within the language space of written poetry (or the written word in *any* form), "working from nature" would obviously have its limitations. Only certain things would in a sense be capable of, or worthy of, being seen. Only those feelings available already in poetic written form would be productively visible. Was there not then something gratuitously redun-

dant about working from or within particular nature, since only what had already proven itself poetic in speech could be considered pictorially? How much of a freedom-seeking leap into the truly new and unknown was really being taken? Until nature was looked to for sentiment beyond written language, landscape painting in France (as elsewhere) was doomed to remain in large part illustration. The impulse to believe in the possibility of, the potential value of, and the desirability of non-verbal significations of feeling, based like verbal significations in experience, yet unlike them in being only loosely fixed (hence *not* nameable or precisely decodable), was slow in coming to French landscape painting, and it is at least arguable that this impulse never absolutely engaged either Corot or Rousseau, even though their work after the mid-1840s shows definite signs of the consideration of non-verbal poetic models.

For reasons which will be described at a later point in this essay, Corot and Rousseau seem at least to have entertained provisionally an ambition to organize feeling (or sentiment) via landscape imaging in such a way as to permit relatively free sensation rather than just word-fixed poetry to guide them. They appear to have done so because other experiences, namely musical ones, encouraged tentative probings in search of a truly free expressive space for painting, particularly nature-based painting – the sort of painting to which both were firmly committed. Increasingly, as the decades of the 1830s, '40s, and '50s unfolded, the *feeling of seeing* and the open-ended communicative potential of that feeling fascinated them. To paint from *that* feeling, without abandoning totally feelings presealed in poetic language, became the mature pictorial enterprise of both artists. The feeling of seeing would be left free to operate wherever and whenever word-based feeling reached its communicative outer limits.

The enthusiasm for music – particularly Beethoven's music – shown by the "young France" circle between 1830 and 1848, powerfully reinforced the pursuit of a non-figurative, non-word-emulative type of painting from nature.[8] The embrace of Beethoven's music by that circle developed first around the concert programs of the newly founded (1828) Société Concerts du Conservatoire.[9] The conductor-founder of those programs, François-Antoine Habeneck, undertook to establish the symphonic output of Beethoven as the centerpiece of a repertory which included the systematic scheduling of Haydn's and Mozart's work as well. What was new about the Conservatoire programs was their featuring of Beethoven. Haydn and Mozart were already established masters in French musical circles and had been so for nearly twenty years. Beethoven's work, however, was rarely performed in Paris, and no tradition of knowing it or understanding it even began to take root prior to Habeneck's programs.

It is possible, therefore, to argue, as Professor Leo Schrade did so eloquently and convincingly in his classic 1942 study, *Beethoven in France*, that Beethoven's music appeared to the French as something virtually new in 1828.[10] The important critical controversy surrounding his work – it by no means took hold immediately – dates from this point. And from the beginning, his music *was* controversial since it upset the established taste in French musical circles for Italian-based music. As Schrade has demonstrated, Mozart and Haydn, although Austrian, were understood in France as working in the Italian manner, largely because of the emphasis their work gave to melody.[11] The "beautiful singing" mode of the Italians which had begun in the mid-eighteenth century in the work of Pergolesi (and in France with the then Italianate composer J.-J. Rousseau!) seemed to the French to have continued triumphantly right through Mozart and Haydn and to have furnished France with a taste for the "best" that music could produce. What it was better than was mid-

eighteenth-century French music, particularly Rameau's. The critical battles of the 1750s (in musical circles) had seen Rameau's insistence on the basing of music in complex theory stressing harmony and counterpoint lose favor in the face of Italian song-based practices.[12] By 1828 the Italian taste was so firmly established in France that it was no longer considered a foreign import. French music and French musical taste were at one with seventy years of experience in the Italian manner, which because of its venerability was the "only" manner in which music could be imagined to operate appropriately.

Haydn and Mozart had seemed to confirm, in spite of or perhaps because of their Austro-German citizenship, the international, virtually "classic" life of the Italian style. Schrade has traced very clearly the manner in which certain of the harmonic and contrapuntal complexities resident in their work "bothered" the French at first but were ultimately assimilated as idiosyncratic bits of necessarily tolerable Germanic heaviness which only slightly obscured the ideal clarity of the Italian song model.[13] The musically dramatic character of Haydn's and Mozart's "heaviness" was not examined in any detail by the French, largely, one supposes, because they didn't want to hear it or to hear about it. To have heard it would have been to acknowledge that the Italian song model had been severely modified by German symphonic practice to the extent that in certain Haydn and Mozart works it could hardly be said to be in force at all!

When Beethoven's music began to be heard routinely after 1828, it became clear that the dramatic element and the harmonic elaborateness in the mature symphonic practice of Haydn and Mozart were something more than minor Germanic aberrations of Italian practice. Suddenly it was that aberrant part of Mozart and Haydn that Beethoven's music was almost totally about. The dramatic in Mozart and Haydn was foregrounded by Beethoven's understanding of it, and as a result the notion that Mozart and Haydn "just sang" in German became harder and harder for conservative

French critics to sustain, although many continued to try desperately to do so even into the 1840s and 1850s.[14]

Berlioz, the musical savant of the "young France" group, provided the critical language necessary to account positively for what Beethoven had accomplished in his symphonic work. He called it "poetry," which was the highest praise any creative effort could be granted in France in 1830.[15] But what Berlioz was talking about was obviously a novel kind of poetry, since, by prevailing definitions, music was not inherently built of the same stuff as poetry – namely, words and verbal images. Such apparent contradictions aside, Berlioz was arguing that Beethoven had uniquely sensed in the dramatic musical *techniques* of Haydn and Mozart a route of access to the essential expressive relationships between music and nature. Nature was an issue here because the French devotion to Italian practice, from J.-J. Rousseau forward, had been grounded at least in part in an ideology that argued for melody and song as the primal bond between nature and music. Music was most natural – most like nature – when it let nature pour through it in song, performed ideally by the most "natural" instrument, the human voice.

Berlioz saw things differently because he heard things differently, and he managed in his writings on Beethoven to get his "young France" friends to hear Beethoven *his* way.[16] In Beethoven's symphonic work (and in his instrumental chamber music), Berlioz saw music in both the specific and abstract sense become very large, *as large as nature itself.* Music became a world adjacent to the ordinary world rather than derivative from it or in any sense an "imitation." A "wholly other" yet perceptible domain of space, of images in space and time, and of figured existence lay in the dramatic technique of symphonic music – a technique which could move back and forth between the ordinary world of song and speech and the symphonic world of music, as it did in Weber's operas, or simply stay sublimely located in its symphonic selfhood, as it tended to do in

Beethoven's work. Dramatic music was *an alternative nature,* and was seen as being so. It had the potential to address certain sentiments through its own operations (its dramatic technique) more clearly and forcefully than could any properly imitative art form. It could quite literally begin to communicate where sense-translating words failed – at the outer edges of the highest form of classical poetry – and proceed to the unveiling of such things as "infinity" or the "cosmos." These could only be heard. They were unavailable to written language. As Berlioz described it, symphonic music became the quintessential domain for exploring and experiencing romantic obsessions with the rationally unintelligible and the immaterial that dominated "young France" ideology in all forms. From this elevated position, it was a comparatively short step for Wagner to take in the late 1840s and 1850s to assert the ideal complicity of poetry and music (with music as tour guide of all nature and poetry) in the *Gesamtkunstwerk* of the future. There text would be restricted to myth form and music would be allowed to generate and organize all the particulars of sentiment as well as the entire context for sentiment.

As has often been noted, Beethoven's Symphony Number 6 (the *Pastoral*) increasingly served as the prime exemplar of the metaworld of symphonic music, of its form of language space and its potential for emotionally intelligible discourse. Here, from the romantic point of view at least, Berlioz had the first and last word. He concludes his definitive discussion of the *Pastoral* Symphony as follows:

Ancient poems, however beautiful and admired they may be, pale into insignificance when compared with this marvel of modern music. But this poem of Beethoven – these long phrases so richly colored – these living pictures – these perfumes – that light – that eloquent silence – those vast horizons – these enchanted nooks secreted in the woods – those golden harvests – those rose colored clouds like wandering flocks on the surface of the sky – that immense plain seeming to slumber under the rays of the midday sun.

Man is absent, and nature alone reveals itself to admiration, and this profound repose of every living thing. This happy life of all at rest. The little brook running rippling towards the river. The river itself, parent of waters, flowing down to the great sea in majestic silence.

Then man intervenes; he of the fields, robust and god fearing. His joyous diversion is interrupted by the storm and we have his terror and his hymn of gratitude.

Veil your faces, you poor, great ancient poets – poor immortals. Your conventional diction with all its harmonious purity can never do battle with the art of sounds. You are glorious, but vanquished.

You never know what we call melody, harmony; the association of different tone qualities; instrumental coloring; modulations; the learned conflict of discordant sounds, first engaging in combat only to then embrace; our musical surprises; and those strange accents setting in vibration the most unexplored depths of the human soul. The stammerings of the childlike art you called music could give you no idea of this. You alone were the great melodists and harmonists – the masters of rhythm and expression for the celebrated spirits of your time.

But these words have in all your tongues a meaning quite different from what is now their due. The art of sounds, correctly so called and independent of all else, was born yesterday. It is hardly of age with its adolescence. It is all powerful; it is the Pythian Apollo of the moderns. We are indebted to it for a whole world of feelings and sensations from which you were shut out entirely.

Yes, great and adored poets, you are conquered: You are glorious but vanquished.[17]

What is most remarkable in Berlioz's appreciation of the *Pastoral* Symphony is the fact that he speaks of its effect as one moving from the evocation of landscape sensation in the listener to an affirmation of a musical speech capable of exposing a heretofore indescribable and even unimaginable world. That world exists only in music itself. Access to this world in Berlioz's view has the capacity to inspire as no other access can. Suggestive at first of imitative natural description, music's technical-dramatic language ultimately subverts imitation by forcing attention to the medium of musical language itself. From deceptive imitation – imitation that issues from the listener's mind – Berlioz suggests an unavoidable process (through hearing) of the subversion of imitation and the ascendance of what cannot be verbally or visually experienced. For the "young France" group what Berlioz discovered in Beethoven was a perfect example of the creatively meaningful retreat from normal experience. The potential for an "art for art's sake" ideology (with music *as* art) was also there in Berlioz's discovery, with the value of music's sentimental release seen to be triumphing over all the values of materially fixed discourse. Dramatic music was at least potentially seen as a way out of language or word-image-based communication rather than an extension of it. The expressive self-sufficiency of a technique that is not a language in any normal sense of the term easily follows as a conceivable notion from Berlioz's fully developed critical position vis-à-vis Beethoven.

Charles Baudelaire, the most consistently intelligent cultural critic of the 1850s and early 1860s (as well as the period's most original poet), indirectly took Berlioz's view of dramatic music to task, one suspects, to try to salvage some significant expressive room for creative practices other than strictly musical ones – traditionally important practices like painting and writing! In order to demonstrate that certain descriptive and discursive minimums continued to remain operative in symphonic music of the most abstractly dramatic sort (the strictly instrumental sections of Wagner's operas), Baudelaire compared three written impressions of the first-act prelude to the opera *Lohengrin*. The three "impressions" were presumably written without reference to one another: the first, Wagner's own; the second, Baudelaire's; and the third, Franz Liszt's.[18] What Baudelaire deduced from comparing the three impressions was that in spite of major differences in the verbal imagery used to "write down" or name what was perceived and understood, basic ideas of space, soli-

tude, immensity, light, and movement were relatively constant. He concluded, therefore, "that true music evokes analogous ideas in different brains."[19] He continues, saying that "what would be truly surprising would be to find that sound could *not* suggest color, that colors could not evoke the idea of melody, and that sound and colors were unsuitable for the translation of ideas, seeing that things have always found their expression through a system of reciprocal analogy ever since the day when God uttered the world like a complex and indivisible statement."[20]

What all this meant for Baudelaire's evaluation of Wagner's music (for which he admits having been prepared by Weber and Beethoven) was a sense that Wagner "possesses the art of translating, by means of the subtlest shades, all that is excessive, immense, and ambitious in spiritual and natural man."[21] Then further on in his essay, Baudelaire notes: "By forcing our memory and our power of meditation to so consistent an exercise, if in no other way, Wagner snatches the action of music from vague emotionalism, and adds to its charms some of the pleasures of the mind. . . . In the blandest or in the most strident accents it [Wagner's music] expresses all the deepest-hidden secrets of the human heart. . . . Whatever subject he may be treating, the result is a superlative solemnity of accent. By means of this passion a strange super-human quality is added to everything; by means of this passion he understands everything and makes everything understandable."[22] Earlier, Baudelaire noted that Wagner "never tired of repeating that dramatic music ought to speak the sentiment, to match the sentiment with the same precision as the word, but obviously in a different way, by which I mean that it ought to express the vague and indefinite part of sentiment which the word by its very positiveness, is incapable of rendering. . . ."[23]

Having found Wagner as an opera composer clearly dependent (in some way) on a coordinated word and sensation form of communication,[24] Baudelaire uses the opportunity afforded by his essay to pull music back from Berlioz's

otherworldly self-sufficiency and into the world of quasi-conventional description and evocation – back, in other words, into a world of quasi-fixed languages and quasi-communicative verbal discourse. Music is made to seem once again a natural complement to the type of discourse operative in language. Then Baudelaire, with his famous notion of "correspondences" (or parallel, if not absolutely identical, feelings evoked by stimuli to different senses), offered painting, via its featuring of color, a related discursive role.[25] All the arts, as he saw them, evoked and cross-evoked ideas. And all the arts behaved linguistically in some consistently intelligible, referential fashion. Having grown up witnessing the generation of the 1830s giving up all claims to the utility or sufficiency of any but musical or music-emulative language, Baudelaire used his Wagner essay to reassert a claim of different but conversant and equal status for all the major creative tongues – in other words, all the traditional media.

Much in the behavior of French painting between 1828 and 1870 can be clarified with reference to the complex reception of the powerful new "poetic" paradigm of music in France during those years. Whether wanting it to be so or not, more or less everyone of any intellectual status in France in this period had to grant that dramatic music was, however it was defined, the "art form of this century," assuming the century to have re-begun in 1830.

LANDSCAPE PAINTING AND ITS PARADIGMS

It is difficult for the critic or historian of painting to grant that at certain times and places other forms of art have so controlled sensibility that pictorial efforts have floundered, even those of incontrovertibly major talents. Corot and Rousseau *were* major talents – *the* major new talents in French painting of the 1830s and 1840s – but their work operated without any consistent notion of what-it was about or where it was going. It did not develop in any proper

sense of the term. It simply persisted, while music, particularly Beethoven's, held center stage in the high cultural arena. What is important to keep in mind here is that the musical "power" of the period was *real*. It resided in Beethoven and in the persistence of his presence in the repertory of the Conservatoire concerts. The acknowledged literary giants of the period – Hugo, Balzac, Stendhal – celebrated Beethoven's art in a vast range of works. How, one asks, could painters have remained unaffected?

Professor Andrew Kagan has recently surveyed, from the perspective of early-nineteenth-century aesthetic theory, the progressive ascendance of a musical (rather than a literary) paradigm for painting.[26] But more important in its effect was the *de facto* emergence of *Beethovenisme*. Beethoven's music and its complex reception is phenomenologically omnipresent in France between 1830 and 1860; it is not, therefore, a theoretical issue of music's power that painters (like writers) had to confront but a practical one.

At the risk of a certain degree of overstatement, it is tempting (perhaps even necessary) to posit that the practitioner of any art form in France between 1830 and 1860 had to take into account the accomplishment of dramatic music in general and of Beethoven's music in particular in order to survive aesthetically. This was a difficult task for writers, as can be seen by the complex and cleverly defensive revisionist strategy operative in Baudelaire's essay on Wagner. For painters, the issue was not simply one of intellectual (or theoretical) difficulty but of practical difficulty as well. Painting, landscape painting in particular, had from the sixteenth century onward maintained both in theory and practice a loose discursive parallel with contemporary music, but music prior to 1800 had remained a rather weak complement to a secure, historically elaborated, and massively accomplished tradition of painting. Literature had been painting's most reliably self-aggrandizing aesthetic cross-reference. The *intellectually* enhancing gestures – those which explained and elaborated painting – were those that celebrated written poetry and written drama. Only painting's soft, acknowledged sensuous side – the least "elevated" domain of its expressive address – was discussed routinely in parallel with the sensuous functionings of music.

In the early 1830s, painters saw the ground cut out from under the historically "imperative" balance of their discourse with writing and music. Music had suddenly become so powerful as to threaten the absorption of writing. Where was painting in all this? As we have seen, Corot's and Rousseau's work of the early 1830s balanced a comparatively radical commitment to the painting of landscape subjects with a conservative (J.-J. Rousseauian) reliance on nature as a domain offering up literary sentiment. Constable's painting appears to have been rejected by Corot and Rousseau because it threw material description in the face of literary sentiment. One wonders what might have happened differently in the post-1830 development of French landscape painting had Constable's achievement appeared in Salons of the early or mid-1830s rather than in the mid-1820s. How would it have looked against the backdrop of Beethoven rather than against the backdrop of J.-J. Rousseau? Certainly Constable's entrance into French painting culture was poorly timed. His work would have been seen differently had it come at a later time when "technique" and "intellectual" (read "quasi-scientific") processes could be seen as capable of producing nature and poetry of a totally revolutionary sort – not inferior in their conveyance of sentiment, but in fact overwhelmingly superior to any prior form of aesthetic display.

Because French landscape painters had been unable, or simply unwilling, to react to Constable in the mid-1820s, they were doomed to grope in the shadows of dramatic music for a considerable period of time. Corot and Rousseau possessed no techniques radical enough to converse in any articulate fashion with Beethoven's. Had they managed to absorb Constable, they would have been equipped (at least potentially) for a radical aesthetic response, but they had

not. The fault was not totally theirs. Beethoven's music was held in the repertory of the Conservatoire long enough to defeat initial critical responses that emphasized its over-intellectual, technical stress and its lack of respect for melody (read "poetry"). Constable's work was not kept in sight long enough for its technical surprise to wear off and its dramatic new form of visual sentiment to be understood.

Corot: Cat. 17

Rousseau: Cat. 103

Corot and Rousseau seem to have been destined by discords of historical timing to retrace a pictorial road back to Constable between 1820 and 1848. This process of retracing involved the exploration of a whole range of softer seventeenth-century French and Dutch alternatives – none of which ultimately served as an access to the power of dramatic music in an effectively modern way. Additionally, both artists needed the help of something utterly new, conceptually and technically, to focus their search – even if only a largely abrasive and indigestible example. They would glimpse this in Courbet's landscape painting after 1848. But the moment is not yet at hand to discuss Courbet. Other conditions must be established first.

To begin with, how can it be proven that Corot and Rousseau felt the power of dramatic music? Neither wrote very much and relatively little of what they wrote is ideologically fixed on anything but generalities regarding the near sacredness of keeping landscape painting bonded to the experience of nature.[27] But putting aside this documentary problem, it is clearly assumed in the writings of the first important historians of nineteenth-century French painting that, as of the 1890s at any rate, everything that happened after 1830 was massively music-informed. Reading the "histories" of Meier-Graefe, Muther, or Mauclair convinces one very quickly that, despite differences in interpretive emphasis, the issue of music (positively or negatively conceived) was the dominant one – the one that "milieued" everything, the one that either grew or wilted in its controlling effect as the century proceeded.[28] It

was unnecessary for the early historians to seek proof of music's comprehensive, all-pervasive aesthetic force. They felt it because in the 1890s it was still very much there to feel. With Wagner dead only recently, the ashes of his musical-dramatic hyper-achievement still smoldered at Bayreuth and their heat continued to spread relentlessly in the direction of Paris.

Today, however, we want more proof of melomania's effect in the painting of the middle third of the century in Paris. In fact such proof is not at all difficult to find, particularly if one looks for it around the figures of Corot and Rousseau (and later Daubigny). Both Corot and Rousseau (and Millet) had primary biographers who were in each instance friends of long standing, Alfred Robaut and Alfred Sensier.[29] One can reasonably assume that the perspective of emphasis given to the "interests" of each artist by his primary biographer is correct in character if not in detail. Important for interpretive purposes here is the fact that both biographers writing in the late 1860s and early 1870s emphasize the importance of music to their respective subjects. They do so in a variety of ways, sometimes rhetorically, sometimes in narrative based on observation.

Beginning with Robaut and his biography of Corot (completed by Moreau-Nélaton), one finds the biographer pointing to an 1859 review of Corot's paintings shown at the Salon of that year; the author, Zacharie Astruc, laments Corot's lack of recognition and suggests that those who don't find Corot great are the same people (philistines obviously!) who find Weber abstract and Beethoven's choral symphony diffuse.[30] Robaut then suggests,

Mozart, Weber, Beethoven: here are the names joyously approaching that of Corot. These are the men who speak in music the same language as this painter. Every Sunday when he was in Paris he went to the Conservatoire or the Pasdeloup [concerts] and, as he listened, he experienced a joy which resulted in bravos! His being expanded, his eye became bright and a communicable beatitude overtook him. Afterward, the favorite themes were sung from memory accompanied by his enlightened commentaries. *He analyzed a symphony as a picture.* He ele-

vated that which could give to a single motif very diverse effects, giving a face to the imitation of nature, an immutable appearance, yet capable of transforming itself completely by a smile of the sun or a breath of wind. He contented himself with Beethoven or Mozart, Gluck or Haydn; but he was always careful to make sure that the appropriate eulogy came from his mouth. In fact Corot also knew the secret of multiple variations; and under his magician's wand, an identical landscape transformed perhaps by brilliant colors, a lightness, or an obscure fog of melancholy.[31] [Italics added.]

Instances of Corot's musical tastes and activities abound in Robaut's text. Some seem almost insignificant, like the description of the artist being so moved by Daubigny's desire to hear Beethoven's Symphony in C minor that he gave Daubigny one of his treasured subscription tickets and then spent the time of the performance "listening" to it by himself in his studio from memory![32] Others are more than simple curiosities, like Corot's leaving money in his will for a performance of the adagio movement of the Symphony in D minor at his funeral.[33] In the weeks before his death, Corot gave his biographer his Conservatoire and Pasdeloup tickets from a special treasure box on his desk, but dispensed them only one by one – his hope, perhaps his highest final hope, being that he would be well enough to use them himself.[34]

In the posthumous eulogies to Corot published at the end of Robaut's text, musical analogies appear in abundance and from every direction. Their appearance is no surprise, since one can imagine from Robaut's biography that to have known Corot was to have known both an artist and a melomane whose love of music was a deep reservoir of feeling that spilled routinely into his painting.

With Rousseau, the "portrait of the artist as melomane" is related, but somewhat different. However, his biographer, Sensier, is as concerned as is Robaut with giving a clear account of the importance of music to the artist. Lacking Corot's independent financial security, Rousseau could not afford subscriptions to the great concert series in Paris, but he knew and loved his music in spite of this, or at least so one is led to believe by Sensier. To begin with, one sees Rousseau resorting to musical analogies in his letters almost as a matter of routine. He seems scarcely able to discuss his beloved nature without such analogies. Describing a walk he took, Rousseau wrote to Sensier (whom he had met in 1846): "I returned home completely fatigued. It seemed to me as though one of the symphonies of Beethoven or of Weber had taken complete possession of me."[35] This sort of analogy would lead Sensier at one point to conclude his report to Millet of a conversation with the artist as follows: "Rousseau, I said to him, had within him the breath of the great Weber, he knew how to make sing the spirits of the air and the divinities of the forest."[36] At another point in Sensier's biography, accents in Rousseau's works are described as follows: "These accents are for painting as the melody is to the harmonic base."[37]

During the last weeks of his life in 1867 – a period documented on a day-to-day basis by Sensier – Rousseau requested that Sensier's wife (a good amateur pianist) play for him regularly. As Sensier reports, Rousseau wanted to hear music all the time and commented constantly on its "natural influence, on its rapport with painting."[38] Rousseau, like Corot, literally died into the bosom of music, after having lived in its perpetually inspiring shadow.

While it is not particularly difficult to document the melomania of Corot and Rousseau from what are virtually primary sources, it is something of a challenge to interpret the phenomenon. Initially, it is obvious that music supplanted written poetic description as a mirror for what both painters felt themselves to be doing. What this meant in practice, one suspects, is that expression passed increasingly into technique, not abruptly and not in a systematic sequence, but inevitably. Constable's problematic effect is still recalled by Rousseau in the 1840s. The former's "rough and brittle" harmonies of green still hung as unpleasant memories. Sensier saw

Rousseau:
Cat. 104

Rousseau involved by various means in smoothing out these harmonies.[39] What this suggests is extremely important. Rousseau was seen working to counter one manner of technical emphasis with another – setting his smoothness against Constable's roughness. The issue is no longer one of poetry per se, but rather of expressive construction and emphasis natural to the painting medium.

Corot: Cat. 16, 19–21, 23, 24

The late 1840s and 1850s are a period in which the landscape imaging of both Corot and Rousseau achieves whatever degree of distinction, confidence, and range it will ever have. This is the period when Corot can be seen to "finish" his sketches from nature – with a visual and chromatic complexity and subtlety that make them more than studies. Although Corot never emphasized value contrast, a considerable amount of hue variation develops in many of his sketches, giving them a completely different character from that found in comparable work from the early 1830s. At La Rochelle in 1851 he executes an entire monumental landscape painting (not a sketch) with constant reference to the motif in stable natural light (fig. 4). Then in the mid-1850s the works by which he is best known begin to appear: those consisting of superim-

Fig. 4 Jean-Baptiste-Camille Corot, *Harbor of La Rochelle*, 1851. Oil on canvas, 19⅞ × 28¼ inches (50.5 × 71.8 cm). Yale University Art Gallery, Bequest of Stephen Carlton Clark, B.A. 1903.

posed veils of trees, water, wet atmosphere, and small strips of land with everything made to move or to hold still in response to idyllic figures or groups of figures strategically positioned. It is these works by Corot that contain most overtly his creative modeling of landscape painting on musical expression. In them he develops and deploys a visual language based – like dramatic music's audible language – on rhythms, harmonies, contrasts of accent, graphic-coloristic counterpoint, and ultimately on cadence. Corot's imaging of landscape finds its language space located at some midpoint between topographical description and strictly pictorial techniques of order and emphasis derived from (or modeled on) dramatic music. Narration is totally absent both in fact and in principle.

Corot: Cat. 23, 26, 29, 31–34, 36, 38

What ultimately replaces narrative in Corot's manner of landscape imaging is "touch," which is to say the intricately variable woven trail of his brush over the various parts of a painting, acting either with or against the figures to determine the pace of the viewing eye.[40] "Touch" for Corot is the ultimate (which is to say, final) imaging maneuver; it consolidates feeling that began in drawing and proceeded through tone and motivic order. That which is most focusing of sentiment in Corot's best-known and most autographic work is "touch." It is the aspect of technique foregrounded as "touch" with which he is most comfortable. In all of his recorded comments on how a painting ought to develop, "touch" is featured as the "last touch," the orchestration, so to speak, of the pictorial effort.[41] And, indeed, "touch" is a technical property exclusive to painting; its emphasis is ultimately what makes Corot a modern painter. However, the active presence of touch develops in response to (and is controlled by) an increasingly passive mode of landscape imaging. This passiveness is also controlled by the descriptively elusive non-painting model of music. Here is where the submissiveness and the gentility of Corot's art resides – in the roughness of back-grounding of all nature-based sensation.

Rousseau's work of the 1850s does not, superficially at least, seem to have an enormous amount

Rousseau: Cat. 105

in common with Corot's. The kinds of motifs that Rousseau images are totally different from Corot's; his palette is thoroughly distinctive, and free "touch" is a virtually non-existent feature in his work. Yet for Rousseau, too, the fundamental issues of landscape painting are bound up in the resolution of the dialectical models of music's nature and vision's nature. Like Corot, he expresses, in oil sketches and small-scaled works, a comparatively open visual response to specifics of natural appearance. Like Corot, he celebrates coloristic variety and the incidental offerings of visually perceived space. However, when he moves to a large- or even medium-sized format to produce a self-evidently "important" work, the emphasis shifts completely away from the visually incidental and toward the expressively fixed.

Clear divisions of both surface and space characterize virtually all of Rousseau's most ambitiously conceived works of the 1850s. Corot's interpenetrating veils of shape and atmosphere are nowhere to be seen, and in their place are seemingly measured certainties – definite trees, definite rocks, definite cloud forms, and a definite landscape plane (the latter sometimes populated by animals, or even figures, either alone or in small numbers). Rousseau's composing or viewing options are severely limited. He is either imaging the landscape as it is visible from the forest, framed by the forest's trees, or from the landscape plane, structured by rocks, trees, or water. An archetypal (almost mythical) severity of aspect marks Rousseau's manner of imaging; consonant with this is his self-removal (in terms of visible "free" painter's touch) from his finished work.

When speaking of Rousseau in the 1850s, it is irresponsible to ignore the fact that, as an artist, he was not nearly so communicative with and reactive to Corot as he was to the non-landscape painter Millet. Conversely, it is irresponsible to view Millet's nominally figural, peasant paintings as being non-conversant with Rousseau's landscapes. Before his move to Rousseau's domain, Barbizon, Millet had been a comparatively ordinary, although talented, painter of portraits and quasi-eighteenth-century

érotiques. His shift of aesthetic strategy in the direction of the peasant (or peasants) in situ was a radical one – not as radical perhaps as would have been a shift to straight landscape painting, but radical nonetheless. What, one wonders, drew Millet to Barbizon and to Rousseau? And what, ultimately, was there of importance in Millet's presence to the development of Rousseau's landscapes of the 1850s?

Traditionally (in terms of criticism and scholarship), Millet has been set slightly apart from not only Corot but also Rousseau because of his "classical literacy." While the point has never been developed in any depth, Millet has been viewed as a reader and his associates as some other species. Here we have referred to that other species as "melomane" – something which Millet was perhaps less likely to have been, since his provincial Norman childhood had been limited artistically (in a potentially problematic way) by his father's occupation as a choirmaster.[42] The excitements of literature would come later. Even though Millet kept certain of his father's original manuscripts (musical ones) in his possession throughout his life, there is no evidence to indicate that music per se was anything much more than a provincial memory for Millet to subvert in order to exercise his own creativity.[43] Neither Rousseau nor Corot had music in the family, but Millet did, so he was clearly not prone to being "liberated" or inspired by it to the same degree. He needed the "headier" stuff of classical poetry, having grown up with music as a probably rather oppressive constant. Corot and Rousseau, on the other hand, grew up in the Parisian world of custom tailoring and drapery-making. Each of their mothers had a fine eye for colors and materials which most likely encouraged their aesthetic efforts at first, but limited the originality of those efforts. Ultimately both needed the complex stuff of music to get loose from what they had been accustomed to knowing as tasteful. The somewhat confusing relationship between Rousseau and Millet at Barbizon must be considered aesthetically and ideologically in terms of inherently conflicting paradigms – a musical one for Rousseau, a literary one for Millet.

Only by considering this conflict is it possible to gauge how important each artist was to the other and why.

It may be useful to consider as a working interpretive notion that Rousseau and Millet instead of functioning as two independent artists at Barbizon became, in fact, two faces of a single artist – one face turned toward landscape, the other toward the figure that existed naturally in that landscape. Considered thusly, the seeming anonymity of Rousseau's rocks and trees can be seen to transmute (at least in part) into analogues of Millet's peasant figures and, conversely, much of the frozen movement of Millet's peasants seems to partake of the sculptural fixedness of Rousseau's rocks and trees. In the work of both artists in the 1850s, there is a strong sense of drama far more portentous in its feeling than what can actually be seen happening among its nameable components. Rocks, trees, working or praying peasants become "voicings" manipulated for dramatic effect by position and counterposition, by rhythmical or arrhythmical visual connections, by color and light. Ultimately, the voicings resolve into something like a musical cadence which at a perceptually fixed point collects and concludes what has been deployed fragmentarily. The effect of all this has something related to narrative about it, but the internal components are not specific enough to make the narrative truly comprehensive. Yes, there is a degree, or rather there are varying degrees, of "being toldness" operative, but there is a far stronger opposing sense of the unspeakable. One can give a title to the motif – landscape or figurative – of a given picture, but that title identifies only the subject matter and not the character of the pictorial drama that the painting (rather than the subject) enacts.

Against the subject is a far stronger antinarrative force. In the broadest terms the antinarrative force can be characterized as musical, if by musical one specifies certain things. The solo horn, the quartet of horns, or the solo clarinet in Weber's overture to *Der Freischütz* (his best-known work in France) can be said to constitute characters which in some way form into a subject. However, against the sensation

of instruments (and motifs) becoming characters is the *more* persistent sensation of sounds that remain sounds. Rousseau, a staunch Weberite, certainly understood the manner in which the retention of sound (and the defending of it against verbal-material exactness of reading) constituted dramatic music's most powerfully evocative technique. A pictorial version of this technique determines the imaging mode of both Rousseau and Millet in the 1850s. It is a mode which manages like dramatic music to offer up clear statements (or ideas in Baudelaire's sense) of precise yet ultimately indescribable sentiments – the tragic, the pathetic, the devout, the gentle, the heroic, the infinite, the intimate, the claustrophobic, and the vast. The cumulatively forceful nineteenth-century myth of music as the precise language of the sentiments is clearly in force in Rousseau's and Millet's work. The functioning of this myth is as frontal in its appearance in their work as it is passive and constituted in an overall atmosphere in Corot's. The issue of difference resides, in the final analysis, between a pictorial musicality developed incrementally (through separate voicings) in Rousseau and Millet, and one conceived more symphonically as a seamless whole characterized more generally in Corot. In either instance the pictorial language space is musically modeled, but the discourse within that space begins from different points and proceeds to different visual conclusions.

Considering the above, it is not surprising that the art of the Japanese woodblock print would become very nearly an obsessive fascination of Rousseau's and Millet's in the 1860s.[44] Its voicings (or its visual sounds) were even clearer and more distinct than their own, and even more musical in both graphic and coloristic idiosyncrasy. A nature-based art, although superficially different from theirs, it was actually identical to theirs on its deepest linguistic levels, and they could not fail to recognize the similarities and to celebrate them in terms of collecting, if not in direct pictorial emulation. Only minor indications of a Japanese graphic web, proceeding decoratively, appear in Rousseau's paintings of the mid-1860s, and only superficial gestures

Rousseau:
Cat. 106, 107

Millet:
Cat. 80, 81

Millet:
Cat. 83, 89

40

Fig. 5 Claude Monet, *Corner of the Studio*, 1861.
Oil on canvas, 71⅝ × 50 inches (182 × 127 cm). Musée
d'Orsay, Paris.

toward Japanese-inspired graphic and coloristic imaging simplifications and viewpoints appear in Millet's late landscapes – most of which were done, interestingly enough, after Rousseau's death – at a time when Millet had to be both himself *and* his no longer present "other half." For Rousseau and Millet, the recognition of the qualities particular to Japanese art confirmed their own pictorial operations rather than modified them. The case would be different with the great landscape newcomer of the next generation, Claude Monet, who would quite literally begin from Japan and not because of sentiments grounded in the experience of nature but rather because of a primal excitement experienced in shaped and painted color. In an early painting of the corner of his studio from 1861 (fig. 5), Monet would oppose an 1850s-type landscape in the upper-right-hand corner with a boldly patterned and brightly colored oriental carpet on the floor. Outlandishly florid wallpaper connects the wall to the floor, and in front of it is

Monet's paint box and palette, loaded with pure color and white straight from the tube. A clearer statement of what his art was destined to be about, and what it was to supersede expressively, could hardly be imagined.

COURBET AND THE ANTI-MUSICAL

Coupled with the landscape accomplishment of Corot, Rousseau, and Millet after 1848 was that of a very different artist – and in most respects a stronger artist – Gustave Courbet. Somewhat younger than the others, Courbet had formulated his own aesthetic agenda under conditions in no way parallel to those of c. 1830. Like Millet (and unlike Corot and Rousseau), Courbet was not a Parisian by birth. He came from the provinces (near the Swiss border). He did not have to move to the country as a gesture of defiance toward urban cultural, economic, and political beliefs or feelings. He had only to return there periodically. While not from peasant stock any more than Millet was, Courbet had no complex inherited urban-bourgeois identity to reject. His ideological task simply consisted of refusing to acquire any. And he seems to have sensed at a very early point, aesthetically at least, that the cultural craze for dramatic music increasingly represented what was at root an urban phenomenon, based on the same impulses for spiritual respite from bourgeois materialism that led urban-born painters into the country to commune pictorially with "nature." For Courbet, concert music was no solution because the desires it answered he took caution not to feel. Similarly, "nature" was entirely natural to him, or at least so he believed. Landscape was something he knew because he had grown up next to it, learning to know it with his eyes, his feet, and his hands, virtually from birth. It was no song or poem for him – it was a physical fact of substance and of appearance tightly bonded to him by his own continuous personal experiences.[45]

The inherently value-free, experiential basis of Courbet's sense of nature affected his painting in comprehensive ways. His pictorial

approach was, as he conceived it, factual and resolutely non- or anti-sentimental. He looked curiously and attentively but with a vision and touch-based physical passion that fed old, often fulfilled, appetites rather than ones which stimulated rarified new feelings. Courbet could and did relate everything in nature to himself, and as he put this relating into practice in his paintings, virtually every manner of emphasis he employed served to contradict those developed by other so-called naturalist painters like Corot, Rousseau, and Millet. Courbet's art deserves the term Realist, which he accepted for it. It is not about nature, because, as we have seen, for the painters of the generation of 1830, nature had come to be (or to be about) music. Courbet's nature is his own. It is his experience of what he knows. It is in principle, at least, ruthlessly positive and populist as *a* reality. It is a version, admittedly Courbet's private version, of "everyman's" reality. It is therefore (rhetorically at least) *really* real. Whether it is "natural" is beside the point; it has no need to be so.

Nature in Courbet's art is held to be something like simple facts or groups of simple facts – essentially material ones. These facts are at once visible, touchable, and therefore comprehensible on the basis of memories of similar, previously experienced facts. His art, whether centering on the human figure or on landscape, speaks to this particular notion of reality. Courbet, rather like early photographers – and they, as he, were developing their practice in the late 1840s and early 1850s – assumed a static form of reality, one which was in essence always the same reality varying only in terms of physical and temporal detail. It was there to be seen, photographed, or painted, and if none of this happened, it was *still* there.

The relationship of Courbet's painting to the photograph is a complex one. On the one hand, it is difficult if not impossible to imagine the former developing without the mechanical demonstration of the latter.[46] Yet photography did not cause Courbet's Realism; rather, it confirmed the material base of that structure of belief. The photograph registered neutrally an image that in some fairly complete form pre- and post-existed it, thereby demonstrating (or at least asserting) a certain material continuance of visible matter. In addition, the photograph was informative, which is to say communicative, in direct proportion to the material richness of prior visual experience it was able to summon in the viewer to facilitate the decoding of its black-and-white image. Photographs relied on the belief that things seen in them were more or less like things already seen. A pyramid or an oasis of palm trees was believable in photographed aspect and in detail because the former behaved (or was conceivable as behaving) like a building and the latter like a group of trees in an ordinary field. Primary recognitions of similarities (comparisons, in other words) between the already known and the newly offered are basic to the ability to read a photograph. And, of course, the viewer's belief in the *real* reliability of such similarities is required in order for the photograph to operate at all. This belief is an inherently fixed (or, in nineteenth-century terms, positive) one, and it is as active in Courbet's painting as it is in photography.

Courbet seems consciously to choose *not* to evoke the "look" of painting or to open his images to sentiment.[47] His works are emotionally closed doors which seem to offer only appearance. That appearance is at once momentary and dead. The particular moment of a Courbet has happened; it is over as soon as it is painted. The imaging comes and goes before it has been interrogated by feeling and sorted for ideas. But nothing is unsorted either; no ambiguities except "real" ones intrude. What Courbet manages by proceeding the way he does – besides annihilating both narrative structure and musicality – is to call an unexpectedly high degree of attention to his act of choice both in terms of what to paint and how to paint. The operation of his imaging virtually becomes his subject. Into what seems an ego-denying activity of description, Courbet implants an ego-asserting activity of aggressive and technically personalized pictorial construction – one that bonds the senses of vision and touch into a

Courbet: Cat. 40, 41, 43, 44

42

patchwork of weighty paint marks that slip back and forth in the forces of their address to one or another sense. This touch (wholly unlike Corot's rhythmical weave) moves between the only partly connected deposits of the brush, the palette knife, and the sponge. *Its* activity and *its* material life replace the deadness, or at least the pastness, of the depicted image as Courbet's "real" content. Painting is the materially live event, and technique is what there is to be seen and responded to after the comparatively simple activity of subject recognition has happened.

Of what does Courbet's technique consist in order to mean what it means? How is it like and unlike Constable's, which it all but obliterates as a pictorial issue (positive or negative) in French landscape painting? To say that it comes from some of the strongest of seventeenth-century Spanish sources – Ribera and Zurbarán – is not to say anything very original art historically. To say that it does so in a subversive way is perhaps a bit more so. By being foregrounded, Spanish-based technique no longer remains in Courbet Spanish-based technique. It doesn't dramatize, and it doesn't describe in a Spanish way, whether one is speaking of the weighty movement of touch or the matrix of light working in and out of deep shadow. Courbet wields Spanish touch and shadow as though he had invented it, and, in fact, he *had* reinvented it by making it stand alone as expression and construction, rather than being an expression or construction of any subject other than itself. Ultimately Courbet's paint construction is what he feels with; it is what enacts in the painted object the passion of touched seeing, and it is very obtrusive in an expressively unique way. Except in his seascapes, color or even tone have relatively little to contribute to this enactment. Nominal descriptive distinctions are made with color, but expression lies elsewhere.

Constable's touch was, as we have seen, inflected rather differently. It *meant* something else. It followed light into color. It probed visually, but *as touch* it never projected touch, and it certainly never theatricalized seeing as touching and vice versa in any form remotely analogous

to Courbet's. Constable had his eye, but not his "real" physical self embedded in his touch. It is in this way that he seemed intellectual, scientific, and detached – which, for a painter, he was!

To find anything remotely comparable to Courbet's self-objectification in his painted construction, one has to look momentarily away from developments in French landscape painting and to consider instead the late (post-1848) work of Eugène Delacroix. Without undertaking to treat this in detail, it is necessary at least to point out the considerable number of medium-sized paintings Delacroix produced for sale by private dealers, many of whom already handled works by Corot, Rousseau, and Millet.[48] The kinds of paintings Delacroix produced for the gallery market were, for the most part, far less complexly literary in their subject matter than was the norm for his Salon work. Lion hunts, tiger hunts, iconographically uncomplicated pictures of wandering Arab horsemen (fig. 6) – these works showed Delacroix acting as a comparatively "pure" or non-literary painter. The viewer is given little to think about, but a good deal to look at – intricate tapestries of color, a

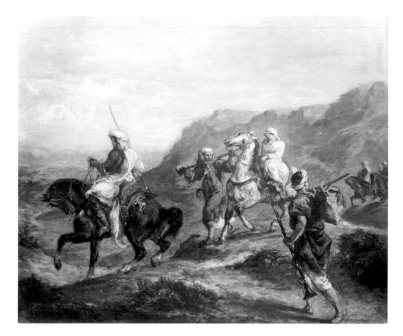

Fig. 6 Eugène Delacroix, *Arabes en voyage*, 1855. Oil on canvas, 21¼×25½ inches (53.8×64.7 cm). Museum of Art, Rhode Island School of Design, Museum Appropriation.

kind of color that moves rapidly up and down the chromatic scale carried by continuously animated graphic rhythms and an extraordinarily rich (materially) surface construction of paint. Rather like Courbet's work, these paintings by Delacroix ingest their enormous historical painting culture – a culture consisting of Rubens, Veronese, Titian, and, increasingly, Rembrandt. The often precisely quotative art-historical character of Delacroix's official art, with its perfect calibration of traditionally licensed technical effects carefully bonded to the requirements of dramatic narration, is no longer in evidence in his gallery-market works, as technique per se begins to appear the source for generating strictly personal expressive impulses that derive from the artist's most private emotions. As with Courbet, Delacroix's expression becomes increasingly identified with his technique. It is self-impassioned as is Courbet's, and through the 1850s the works of one master come to facilitate the eventual acceptance and understanding of the "technique as bearer of content" of the other.

What is most interesting in all this is the increasing momentum of the phenomenon of freestanding pictorial technique. This phenomenon becomes virtually the rule of the most important French painting of the mid- and late-1850s. That it is musically emulative in Corot, "reality" emulative in Courbet, and residually exotic in Delacroix makes very little difference. Ideological similarities of expressive and constructive practice increasingly outweigh differences in the nominal subject origins of such practices. In the emerging consensus of aesthetic opinion regarding the self-sufficiency of technique, the musical model for painting metamorphoses from one of recognized emulation to one of essence. Musicality has become intrinsic to significant pictorial practice to the degree that its ideological functioning need no longer even be recognized verbally. In spite of the fact that he painted Berlioz's portrait, Courbet would never have granted that his works, particularly his landscapes, were informed by concert music, but they were nonetheless – at least in the terms advanced and developed in the present

discussion.[49] On the other hand, Delacroix's melomania can be thoroughly documented from entries in his journal over as long (or even longer) a period of time as Corot's.

Perhaps it could be said that the seemingly exceptional situation with Courbet is, in fact, what proves the power of musicality in mid-century French painting – particularly in landscape painting. But to say this requires a rather controversial way of arguing. Anti-musical musicality as an operative ideology would have to be advanced as at least a critical and psychological possibility to explain Courbet's seemingly unintentional participation in the bourgeois cultural myth of music's expressive preeminence. Were Courbet repressing (and at the same time inadvertently disclosing) his ideological identification with music-mania, one might expect to find some evidence of complex displacement or sublimation in his activities. Such can indeed be found quite clearly in Courbet's elaborate self-promoting behavior in the year 1855. This is the year of the first of the great Parisian Universal Expositions. The exposition included among its many sections one devoted to the fine arts. Courbet was offered the opportunity of showing a considerable number of his paintings in that section; however, failing to be allowed to show everything he deemed important, he had constructed a private pavilion – the Realist Pavilion – in which to display only his own work – a radical publicity maneuver, to say the very least. In addition he undertook to use his newest monumental painting to focus in a single image his artistic "doctrine" and his achievement overall. That painting he called *The Studio – A Real Allegory Representing Seven Years of My Artistic Life* (fig. 7). It was the centerpiece for the display of a broad sampling of major paintings Courbet had accomplished to date.[50]

Because *The Studio* is so large, critics and historians tend to downplay the actual fact of its origin as an "occasional piece," something done for a particular moment. If one accepts this notion and considers it along with the promotional strategy of the Realist Pavilion, it seems probable that Courbet was not only setting up

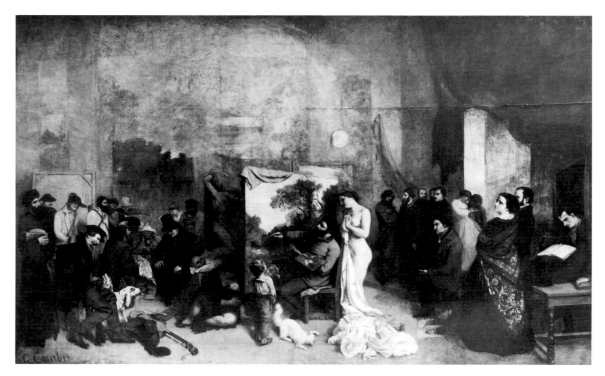

Fig. 7 Gustave Courbet, *The Studio – A Real Allegory Representing Seven Years of My Artistic Life*, 1855. Oil on canvas, 142 × 235 inches (361 × 598 cm). Musée d'Orsay, Paris.

his work to compete with an official painting display, but that he was doing so in a way that was intended to make the whole of his work available as a coherent repertory. In actuality, Courbet produced a detailed retrospective of himself, and in *The Studio* he offered, visually at least, his own interpretive catalogue to supplant a comparatively clumsily written handout – a sort of program note. There are similarities to a performance in all this, and the performance, one could argue, is not simply a fine arts one directed by the aesthetically competitive conditions of the Universal Exposition per se.

In several ways the Realist Pavilion can be seen to emulate a concert series featuring an established repertory. Like the Conservatoire's ongoing Beethoven cycle, Berlioz's orchestral-music tours in Germany and England, and Wagner's performances in London and Paris, Courbet's Realist Pavilion demanded total spectator attention to a connected body of work for an extended period of time. By having his work

"performing" alone, Courbet seems to have been establishing a role for himself in the repertory of contemporary painting that was absolutely distinct and self-contained, rather than one simply at some degree of variance with official norms. *The Studio* was set up in the pavilion to direct the "performance" or – perhaps more accurately – to conduct it. Here one might even propose that Courbet is permitting an identity of some sort to appear operative between the painter's brush, the composer's pen, and the conductor's baton. The tradition of the "composer conducting" is at least part of what *The Studio* is about, and it is in an illustrious modern tradition that includes, besides Berlioz and Wagner, Beethoven himself, Weber, Liszt, Mendelssohn, and Schumann. All the great masters of nineteenth-century music forced their way into repertory by performing their own work (or by having it performed) in concentrated and relatively exclusive series. Courbet was in many respects just following

their example.

The "concerted" aspect of *The Studio* is in fact quite remarkable. It is of course difficult to be certain of its original hanging in the Realist Pavilion, but one can assume on the basis of the painting's sheer size that it operated as a pictured extension of a space already filled with Courbet's paintings. As a representation of the artist's studio, the space of the picture is the fictive place of origin of all the work that surrounded the spectators in the Pavilion. Being fictive and being limited by its surface and its edges – neither of which Courbet violates illusionistically – the painting also becomes a kind of proscenium stage, where a performance of some sort is being enacted. The performance is self-evidently *not* a dramatic narrative or a play, since none of the figures move in any sort of "real" or "acting" way. Everything is still. The only truly significant activity within the painting is Courbet's painting of the landscape mounted on his easel and Baudelaire's reading at the right side. Not only is there no movement, but there is virtually no depicted sound. Except for the presumed whisper of Courbet's brush on the canvas – a kind of intelligent analogue to the nervous scratching of the dog's (or is it a cat's?) paws on the studio floor – there is only the soft puffing of tobacco.[51] The musical instruments on the left side of the painting are not even being held, and there is no depicted conversation at all.

What kind of performance is this? It seems above all (and appropriately for painting) a concert of silence with Courbet in the position of conductor and composer,[52] surrounded by his figural repertory of "real" motifs in the groups of figures left and right, and in terms of the nude (a model dressing or undressing, it is unclear) next to him. Who is watching or listening? Only the model, who has slipped from her traditional role as subject into one of witness, and the small boy – as simple an allegory of innocent, if ambiguous, spectatorship as Courbet could possibly have conceived.[53] What is ultimately most curious in all this is what Courbet is choosing to have himself compose and conduct –

namely, a landscape painting, which, like a piece of music, is being composed *and* performed indoors even though it is ostensibly about nature in its "real" appearance. If *The Studio* is truly an allegory, of what is it allegorical? Is it perhaps too glib to suggest that it is about defining painting (rather than architecture) as silent music? It *does* seem to be at least partly about that; however, what it seems more about is the complexity of the strategy of pictorial making, Realist or otherwise. A theatricalized tour de force of painting's enterprise, where memory and technique and genius combine into an expression-laden paint construction – this seems more completely to account for *The Studio*'s appearance.

The central position of landscape painting (whether generic or specific makes little difference) in *The Studio* signals something of the radical status Courbet granted to the practice of the freely natural image, as opposed to the traditional figurative one. Landscape practice stands almost as a signboard of modernity in the foreground of *The Studio*. It echoes through the faint images on the rear walls, making the entirety of the picture space alive with reverberations of the cadence of landscape "making." Courbet pictures himself *producing* nature in *The Studio*, making painting like music in what it "really" does, rather than in what it emulates music's having done. Courbet is effectively setting landscape painting in music's position as a source of nature rather than an imitation of it or an outgrowth of it. This positioning of landscape painting is where Courbet's sublimation of the repressed musical model operates. In addition to everything else, then, *The Studio* as a whole enacts Courbet's sublimation of a force (music) which he cannot accept ideologically but which nonetheless is called upon to define allegorically his highest sense of the mission of pictorial artistry. Courbet presents landscape painting as having risen to the challenge of music by theatrically signaling a parity. This is rather like Berlioz's epochal assertion that dramatic music had achieved and perhaps even eclipsed the expressive level of poetry!

The rise of landscape painting in France is

Courbet: Cat. 39

announced as an accomplished fact in *The Studio*. It is announced by being staged as though it had occurred, which to a certain degree it had, but never with the rhetorical authority Courbet introduced. By repertorializing his own landscape work (along with his figural work), Courbet effectively repertorialized landscape painting generally. Whether he intended consciously to do so or not is beside the point; he did! From *The Studio* forward, French landscape painting existed eventfully. Prior to *The Studio*, it had existed only in terms of gradually increasing frequency and notoriety. It was Courbet who insisted on landscape painting's fecund existence, just as Habeneck had insisted on the consolidated accomplishment of dramatic music via his institution of Beethoven as repertory in the Conservatoire concerts. Courbet's announcement regarding landscape painting in *The Studio* meant that the enterprise of landscape painting was no longer a purely speculative one. The issues in landscape painting no longer involved the establishing of an appropriate expressive space but habitation of that space. The space had been marked out, and it largely existed in the cross-calibrations of experience and technique. How to experience landscape and with what technically to image it? These were the new practical questions which the generation of landscape painters emerging in the wake of *The Studio* undertook to answer. At first the answers would not be particularly confident or conclusive. Daubigny, Boudin, and Jongkind probably all visited the Realist Pavilion and saw *The Studio*; certainly they all knew Courbet, and Daubigny worked closely at various times with Corot as well. As a group, these painters effectively made the first concentrated efforts to increase both the scope and the intensity of landscape imaging by working out-of-doors, not simply to sketch but, insofar as possible, to finish paintings.

A good deal has been written about the importance of the movement of the practice of French landscape painting into the out-of-doors, but most of what has been seen as happening as a result of this practice has been, for want of a better term, empirical.[54] The execution of paintings with constant reference to the motif being pictured is usually said to have produced a higher degree of accuracy in the translation of the optical impression into the painted construction. But to conceive of the situation this way seems to involve a misunderstanding of what was at stake in the work of the younger generation of landscape painters.

In a sense this group was free to do *anything* in landscape – to practice it in whatever way might consolidate and extend its power. The surest route to the widest range of suggestions for landscape imaging obviously lay in the infinite variability of observable nature. Recognizing the major landscape achievements of the prior generation (and those of Corot and Courbet in particular), the younger painters felt both the confidence and the obligation to "stretch." Stretching in search of consolidating power is what the new work – that of the late 1850s and 1860s – is about. It is not about representational accuracy. British Pre-Raphaelite work might properly be said to be about accuracy, but not French landscape painting after the middle of the century.

A desire to keep the imaging process persistently fresh seems better to describe the collective impulse of younger French landscape painters to work out-of-doors. In fact, it is a new quality of freshness and visual spontaneity that marks all of the best work of Jongkind, Daubigny, and Boudin. With the repertorial dignity of landscape an established condition, the new impulses were (for the first time in the history of French landscape painting) geared toward the notion of developing further, or at least differently, an already dignified practice. It would be extremely difficult to prove that French landscape artists had any truly developmental ambitions prior to this point – definitional conditions, modeling conditions, yes, but not properly defined notions of progress.

Pre-1855 French landscape practice is involved above all with the *formation* of an imaging language. Post-1855 practice features exploration and conjecture, sometimes advancing, some-

times attacking norms only recently established. Working with continuous visual access to a particular natural motif, the paint construction seems progressively to loosen and become more varied. The color (both in terms of hue and value range) becomes less predictable and more driven by the excitement of discovery. Different kinds of landscape motifs increasingly demand different graphings – different balances of emphasis on touch, and on the blocking and massing of increasingly bright color. Color becomes daylight-informed rather than painting-informed, and it becomes so in more and more extreme ways.

There were certainly precedents in the work of Corot, Courbet, and Rousseau for certain daylight models for painted color, but, generally speaking, one model eventually became the chosen norm in the work of each artist. All of this changes after 1855. Non-normative and changeable daylight is painted, and it is painted differently *by* each individual artist and *within* the personal oeuvre of each. Jongkind, in particular, explores an almost uncontrollably wide range of nature-based exercises of color and touch. Daubigny tends more to refine his construction within a comparatively narrow range of exercises, while Boudin alternates between elaborately woven, somewhat stormy tonalities and vigorously pure color-accented ones, developed with a very patchy, at times almost random, touch.

Jongkind: Cat. 76–78

Daubigny: Cat. 52, 54, 56–58

Boudin: Cat. 3, 4

The art of the Japanese woodblock print appears to inform Jongkind's and Boudin's work from a comparatively early point. Not that direct structural quotations appear with any regularity, but there does appear to be a developing confidence in the quick, schematic effect within the paint and color construction of both painters that suggests a real appreciation of Japanese visual informalities and exaggerations. Japanese viewpoints are not in effect, but certain Japanese emphases in shaping and in schematic coloring definitely are or at least can be at certain times and in certain works. The Japanese "taste" in Jongkind's and Boudin's work is distinct from that which would appear only a few years later in Millet's and Rousseau's. As has already been suggested, the Japanese effect in the work of the latter two existed in terms of certain recognized parallels of graphic emphasis. For Boudin, in particular, the taste is far more evident in terms of color.

The rather unfortunate and potentially misleading term "pre-Impressionism" has often been used to describe the collective pictorial activity of Jongkind, Boudin, and Daubigny.[55] The term is only useful in the narrowest chronological sense. Theirs is an ultimately circumscribed, although exploratory, practice. Their manners of imaging are productively self-serving and complete in themselves, and more to the point, not one of the three modifies his rather freewheeling and idiosyncratic methods in any way which might suggest that he found himself either fixed or superseded at any historical point. Yet collectively, the three artists, all of whom came to know the young Monet and Pissarro, seem to have understood instinctively that something different, rather than necessarily successive, was happening in the imaging of the younger painters. Certain established technical interests might appear reflected in the newer work, but the connections were ultimately thin and destined to be short-lived. The new work did not advance the older – it changed it.

Monet: Cat. 91–94

Pissarro: Cat. 97

Monet and Pissarro certainly perceived Boudin, Jongkind, and Daubigny as predecessors (father figures).[56] The established work of the earlier generation and its internal practices were something to lean on, while the younger painters learned how to begin landscape painting afresh after experiencing a variety of new aesthetic challenges in the early 1860s. Edouard Manet's art, while not landscape in most instances, was pictorially far more novel in its imaging and in its paint construction than anything managed individually or collectively by Boudin, Jongkind, and Daubigny. And, joined to this, there was the emergence of a changed, almost hysterical form of radical melomania centering exclusively on the music of Wagner.

The painting practice of the artists emerging in the 1860s came to life breathing an abso-

Fig. 8 Edouard Manet, *Le déjeuner sur l'herbe (Luncheon on the Grass)*, 1863. Oil on canvas, 82 × 104 inches (208 × 264 cm). Musée d'Orsay, Paris.

lutely electrified aesthetic air. In what was historically an unprecedented way, radical artistic activity in the early 1860s managed to become the focus of a broadly based public and critical scandal. "Culture" was perceived as being attacked by radical art with a force that could not be ignored and which caused, besides confusion, very real aesthetic pain. Novelty was not the issue. Novelty was really nothing new, but what was new was the sheer sensuous potency of Wagner's music and Manet's painting. The orgiastic aural free-for-all of *Tannhäuser* with its rapid alternation of dramatic focus on the sexual and the spiritual was too loud not to be heard, but if heard, too intoxicating to be considered appropriately aesthetic. At the predestined-to-be-scandalous Salon des Refusés of 1863, Manet's *Déjeuner sur l'herbe* (*Luncheon on the Grass*; fig. 8) managed to provoke an almost equal degree of aesthetic confusion to that occasioned by the Opéra's mounting of *Tannhäuser* just two years before.[57]

This essay is not the time or place to resolve the question of the degree of intentional or accidental aesthetic provocation in the art of Wagner and Manet, but the fact that their behavior was perceived as provocative does have a major bearing on the way ambitious landscape painters reacted or felt themselves compelled to react. Brilliant, confusing, and contradictory aesthetic signals were the radical norm of the early 1860s, for whatever reasons. Public and critical alarm drove aesthetic interest levels to unprecedented heights around the leaders of what was perceived to be cultural anarchy. From being moderately risky, radical artistic activity now found itself enormously powerful, if in part only antagonistically so. But that was enough. All of the monuments of romantic rhetoric, all of the anti-normativeness of Courbet, suddenly became pale gestures by comparison to the wild, nearly unintelligible cultural provocations of the early 1860s.

Because we undertake nowadays to attribute

a high degree of critical and creative intelligence to processes of cultural subversion, we are inclined to look inside (so to speak) *Tannhäuser* and the *Déjeuner sur l'herbe* for comparable patterns of intelligent deviousness – patterns which would (in retrospect at least) appear to have guaranteed their scandalous effect and the unforeseen power of that effect. Certainly neither work "crowned" anything, and both works annihilated a great deal in order to get some expressive breathing space for themselves. And yet, the composer of *Tannhäuser* had to have "loved" Beethoven almost immeasurably in order to distort his precedent so wildly, just as the painter of the *Déjeuner sur l'herbe* had to have "loved" Courbet. A form of "loving by destroying" in Wagner's work amounted in fact to the emphasizing of Beethoven's immanently coloristic orchestral techniques and the suppression of the symphonic architecture that had dramatically led *and* contained them. The result was, superficially at least, a brilliant chaos of exciting noise, stilled or animated rhythmically in response to quasi-descriptive (poetic) structures, rather than comprehensibly musical ones. In ways extreme even by Berlioz's standards, aural techniques were made to stand precariously loose from compositional (structurally formal) anchors. The result of this was to inhibit the listener's recognition of traditional musical continuities, exposing instead unfamiliar musical sounds and combinations of sounds.

Manet's strategy with Courbet's respected precedent was much the same. In two paintings done around the same time (1862–63), *Déjeuner sur l'herbe* and the *Old Musician* (fig. 9), Manet took Courbet's (theatrically autobiographical) *Studio* apart and reassembled it differently in two paintings. Courbet's allegory was already intricate and ambiguous. Manet made it impenetrable but technically (in terms of color and paint structure) attractive – sensuously, even luxuriously so. The eye was enabled to proceed uninhibitedly while the mind was made to stumble over the character of Manet's subjects – their "idea" and their meaning with reference to the technique of their presentation. His *Old*

Fig. 9 Edouard Manet, *The Old Musician*, 1862. Oil on canvas, 73¾ × 97¾ inches (187.4 × 248.3 cm). National Gallery of Art, Washington, D.C., Chester Dale Collection, 1962.

Musician sits in Courbet's own *Studio* position, but he stares at the spectator, seeming to ask what to do with his material (the figures around him). Manet's nude model in the *Déjeuner* sees (and challenges) the spectator of the painting at the moment the spectator sees her.[58] Her looking out *and* her reason for being where she is – undressed, sitting with two dressed men (who are doing nothing) in a landscape – are irrevocably disconnected whether considered in terms of reality or of allegory. As contemporary viewers were somewhat slow to see, her puzzling existence is art historically referenced through a combination of quotations from Giorgione (the *Concert champêtre*) and Raphael (a river god grouping engraved by Marcantonio Raimondi). But reference is not explanation, and, even made aware of references, the viewer has about as much access to her as a knowledge of Beethoven provides for understanding Wagner. The point here is that quotations and references don't account for the sensuous effects, and the fact that they fail to do so (even as they are recognized) is what, in both Wagner and Manet, delivers sensuously manipulated techniques so powerfully – or, from the contemporary audi-

ence's viewpoint, so scandalously.

The Wagner-Manet example provided unprecedentedly high standards of spectator excitation (or consternation) – standards with which every contemporary artist, in whatever medium, had to contend. There were really only two viable options: either the audience (critics included) could be comforted by the reinstatement of past aesthetic gentilities or the assault could be continued and even spread to different fronts. The rather surprising fact is that the latter option was acted upon most resolutely and effectively by landscape painters, in particular by Monet. He systematically absorbed and critiqued Manet as completely as Manet had Courbet. He progressively emptied out Manet's excitingly confusing imagery,[59] substituting landscape motifs in its place. Intensely arbitrary coloristic complexity became his main excitational weapon. Shadowing Monet from a respectful distance, Pissarro moved more cautiously with his palette, working instead to devise boldly equivocal ways of opposing surface (two-dimensional) and spatial signals in his landscape imaging. By the end of the 1860s, however, both painters were making very "loud" landscape constructions that effectively contained in their forthright exposition of pure technical emphases the basis for landscape painting's triumph as *the* liveliest aesthetic activity in France in the 1870s. With landscape painting's coming of age a decade before their own work developed its focus, both Pissarro and Monet were able to proceed with what they did, certain of being taken seriously almost from the start. Landscape painting was by then an established modern practice with a substantial degree of its expressive range already demonstrated and with its language space dedicated to the evocative deployment of strictly technical devices. What Monet and Pissarro did was to make the "evocative" transmute into the "provoking" in their sentimentally unresolved (or at least open-ended) manners of imaging.

They worked out-of-doors to find motifs which best supported their search for emphatic effects, but they didn't paint what they saw so much as they used what they saw to paint as

they wanted. As they painted, what they saw themselves painting was informed as much by Japanese prints, Delacroix's palette, Manet's lusciously colored touch, and Courbet's plastic turbulence as it was by the visible nature that stood before them. In the foregrounding of paint structures simultaneously driven by prior artistry *and* experience of the moment, before the motif, both painters certainly kept clear in their minds the high contemporary standards of sensuous intensity which they had felt personally in the art of Manet, Courbet, Delacroix, and Japan and which they had witnessed second-hand in the near-mystical responses of their friends, Renoir, Bazille, Cézanne, and Fantin-Latour, to the music of Wagner.[60]

Theirs was to be the "new painting," not replacing the old in landscape practice, but opposing it with a new power and a new nerve. Vincent van Gogh, visiting Paris in the mid-1880s, probably understood better than anyone else the multiple rather than successive achievements of recent French painting. Certainly Pissarro's and Monet's work spoke to him most directly, but it did so to the accompaniment of Millet's, Rousseau's, Manet's, Courbet's, and Delacroix's. He ultimately knew that he was witnessing a mountain range, accessible from many different points and in many different ways. Each route would expose alternative sentiments, and he loved them all. Wanting all the sentiment he could get for his own art, he tried valiantly to follow every road at once, and in *his* best work he succeeded.

Mechelen, 1988 and 1989

Monet:
Cat. 95, 96

Pissarro:
Cat. 98, 99

NOTES

1. Robert L. Herbert, *Barbizon Revisited* (Boston: Museum of Fine Arts, 1962).

2. Gabriel P. Weisberg, *The Realist Tradition: French Painting and Drawing 1830–1900* (Cleveland: Cleveland Museum of Art, 1981).

3. See *Methodological Notes* for contextual discussion of major writers.

4. See Herbert, *Barbizon*; John Rewald, *The History of Impressionism* (New York: The Museum of Modern Art, 1946); Kermit S. Champa, *Studies in Early Impressionism* (New Haven: Yale University Press, 1973); Joseph C. Sloane, *French Painting Between the Past and the Present: Artists, Critics and Traditions from 1848 to 1870* (Princeton: Princeton University Press, 1951); Albert Boime, *The Academy and French Painting in the Nineteenth Century* (London: Oxford University Press, 1971); T. J. Clark, *The Absolute Bourgeois* (London: Thames and Hudson, 1973); Linda Nochlin, *Realism* (Harmondsworth, England: Penguin Press, 1971).

5. The first intelligently elaborated discussion of Constable's influence appears in Richard Muther, *The History of Modern Painting* (London, 1895), vol. 2, 378–80.

6. Herbert, *Barbizon*, 175.

7. See Rensselaer W. Lee, *Ut Pictura Poesis* (New York: W. W. Norton, 1967).

8. Leo Schrade, *Beethoven in France, The Growth of an Idea* (New Haven: Yale University Press, 1942).

9. A. Elwart, *Histoire de la société des concerts du conservatoire impérial de musique* (Paris: S. Castel, 1860).

10. Schrade, *Beethoven*, 29–38.

11. Ibid., 11.

12. Ibid., 10.

13. Ibid., 16–17.

14. Ibid., 32–34.

15. Ibid., 52.

16. Ibid., 55–57.

17. Ralph DeSola, *Beethoven by Berlioz: A Critical Appreciation of Beethoven's Nine Symphonies and His Only Opera, Fidelio – with Its Four Overtures* (Boston: Crescendo Publishing Co., 1975), 34.

18. Charles Baudelaire, *The Painter of Modern Life and Other Essays*, trans. Jonathan Mayne (London: Phaidon, 1965), 114–17.

19. Ibid.

20. Ibid.

21. Ibid.

22. Ibid., 138.

23. Ibid., 118.

24. Perhaps the more appropriate term "bilangual" should be introduced here to name something functionally quite different from that which would be denoted by the term "bilingual." The latter is evocative of the fairly precise parallel operation of two written (verbal) languages with comparably fixed grammar and syntax. "Bilangual" would imply a looser parallel operation between grammatically and syntactically different language-types, or what are usually termed *different media,* which may or may not be "written" in character.

25. Ibid., 116.

26. Andrew Kagan, "Ut Pictura Musica, I: to 1860," *Arts Magazine* 60 (May 1986): 86–91.

27. For the largest body of documentation in print see: Alfred Robaut et Etienne Moreau-Nélaton, *Histoire de Corot et de ses oeuvres* in 4 vols. (Paris: H. Floury, 1905), and Alfred Sensier, *Souvenirs sur Théodore Rousseau* (Paris: Léon Techener, 1872). For an interesting quasi-musical interpretation of Corot by a twentieth-century critic see: Germain Bazin, *Corot* (Paris: Tisné, 1942 [with simultaneous Berlin edition]), particularly 51–55. See also Gustave Geffroy and Arsène Alexandre, *Corot and Millet* (Paris-London-New York, "The Studio," 1902) XXI, for characteristic turn-of-the-century hearsay regarding Corot's listening and reading habits.

28. See *Methodological Notes.*

29. Robaut, *Corot*, and Sensier, *Rousseau.*

30. Robaut, *Corot*, 196.

31. Ibid.

32. Ibid., 260.

33. Ibid., 329.

34. Ibid.

35. Sensier, *Rousseau*, 6.

36. Ibid., 155.

37. Ibid., 200.

38. Ibid., 362.

39. Ibid., 66.

40. The notion of "pace" in this instance introduces one of the most problematic features of mid-century

imaging practice. Whether speaking of Corot, Rousseau, or Courbet from the perspective of musical modeling, there is no avoiding a description (however provisional) of the strategies aimed at extending spectating time. What this means is that all three artists must be seen to be inhibiting a "fast" reading of their work by delivering pictorial information in steps or, better, by degree. It could certainly be hypothesized that by doing so each artist was courting a music-type extension of spectating attention time, although in Courbet the extension can be seen as reading-type as well as music-type. Painting's traditional bondage to the fixed moment is clearly under attack here.

In Corot both the pace of touch and the left-right, front-back oscillations of the increments composing the landscape force the spectator to process the image rather slowly and from various directions, and the processing is rarely conclusive enough to deposit a clear "picture" of the "painting" in the spectator's memory. Corot thematizes this in his well-known late (post-1860) paintings of women models in his studio, shown either studying a landscape displayed on the easel or turning away to muse on that experience (perhaps before turning back to undergo it again). Usually the model is posed holding a mandolin, suggesting that her spectatorship proceeds from music to painting and back to music.

I should note here that a Ph.D. candidate at Brown University, David Ogawa, is undertaking a dissertation study of musical pacing in Corot. Also his colleague David Brenneman is pursuing the related but prior efforts at musical imaging (as well as other issues of "technique") in the late landscapes of Thomas Gainsborough. The Brenneman study works from the notion that in the 1780s in England, Gainsborough yielded at least in part to his own melomania; to a nearly seventy-year-old tradition of theoretical discourse involving the comparative functioning of music and painting; and to his enthusiasm for the actual musical practice (including improvisation) of his friends J.-C. Bach and Friedrich Abel.

However, to return to the notion of "pace" in France in the 1850s, Rousseau's strategies of slowing perception are perhaps even more remarkable than Corot's, since they are in a certain sense less pictorially formulaic and more basic to the generative process of formal composition. Either through motific spareness or congestion, Rousseau demands extended spectating time to deliver his images as comprehensible pictorial wholes. Clarity in the informing sensation develops slowly and deliberately (in an arguably Weber-like way).

For Courbet, impedance works at visual maximums. In Professor Michael Fried's terms, it develops through the persistent erosion of physical-psychological distinctness between artist/spectator and depicted image. He has discussed this in a series of articles which have recently appeared in book form, *Courbet's Realism* (Chicago and London: University of Chicago Press, 1990). In Professor Linda Nochlin's terms, it develops (without her fully recognizing it) in a reading of the "unfinish" of Courbet's *Studio*, where something like cinematographic fade-in or fade-out develops. For her discussion of this, see: Sarah Faunce and Linda Nochlin, *Courbet Reconsidered* (Brooklyn: Brooklyn Museum, 1988), 24. Whether one works with Professor Fried's terms or Professor Nochlin's, the proposition that Courbet is generating a time-occupying "swim" for himself and his spectators seems viable, but as mentioned above (and as is discussed below in note 59), the musical or reading character of the spectating event is left, probably intentionally, unsorted.

Professor Anne Wagner's notion that a contracted reading time characterizes Courbet's landscape imaging represents a contrary interpretation to that offered here. Her argument is well developed, but arguably directed against the wrong painter. Manet, who foregrounds perceptual speed and apparent imagistic simplicity, flagging music performatively as of a moment in actual time, might be a better target for Professor Wagner's form of argument. See Anne M. Wagner, "Courbet's Landscapes and Their Market," *Art History* 4 (Dec. 1981): 410–31.

41. Robaut, *Corot*, 165–66, 199–200, 208–19.

42. Alfred Sensier, *La vie et l'oeuvre de J.-F. Millet* (Paris, 1881), 6.

43. Ibid., 190.

44. Sensier, *Rousseau*, 272.

45. See also Petra Ten-Doesschate Chu, "It Took Millions of Years to Compose That Picture," Faunce and Nochlin, *Courbet Reconsidered*, 55–65.

46. See also Faunce, "Reconsidering Courbet," Faunce and Nochlin, *Courbet Reconsidered*, 4. See also Aaron Scharf, *Art and Photography* (Harmondsworth, England: Penguin Books, 1974).

47. Wagner, "Courbet's Landscapes," 21.

48. See Susan Strauber, "The Religious Paintings of Eugène Delacroix," Ph.D. diss., Brown University, 1980, and Heather Pattison, "Delacroix and the Venetian Tradition," Ph.D. diss., Brown University, 1987.

49. Professor Robert Herbert has rightly suggested in a letter critiquing this essay that Courbet's love of music should not be underrated. He is absolutely correct in insisting on this. However, with the

exceptions of the Berlioz portrait and *Self-Portrait: The Violincellist* (included in this exhibition), Courbet seems to have tried to identify himself ideologically and imagistically with folk or popular music – rather than with urban bourgeois concert music.

50. No single nineteenth-century painting has had more critical/documentary attention over the past three decades than *The Studio*. The most compelling discussions, prior to the *Courbet Reconsidered* catalogue, have been those of Werner Hofmann, *The Earthly Paradise* (New York: G. Braziller, 1961); Alan Bowness, *Courbet's "Atelier du Peintre"* (Newcastle upon Tyne: University of Newcastle upon Tyne, 1972); Hélène Toussaint, "Le Réalisme de Courbet au service de la satire politique et de la propagande gouvernementale," *Les Amis de Courbet Bulletin* 67 (1982): 5–27; and Klaus Herding, "Das *Atelier des Malers* – Treffpunkt der Welt und Ort der Versohnung," in Klaus Herding, ed., *Realismus als Widerspruch: Die Wirklichkeit in Courbets Malerei* (Frankfurt am Main, 1978). These are collectively summarized by Nochlin in Faunce and Nochlin, *Courbet Reconsidered*, "Courbet's Real Allegory: Rereading 'The Painter's Studio,'" 17–21. Additionally, Nochlin provides in the remainder of her text, 21–41, a "feminist" interpretation of the iconographical dynamics of the painting. This is followed in *Courbet Reconsidered* by Michael Fried's "Courbet's Femininity," which includes a phenomenological reading of a quite radical and personal sort, and one which generates, within the text of the catalogue itself, a heated exchange between Fried and Nochlin.

The interpretation of *The Studio* in the present text relates only peripherally to the above without necessarily contradicting any prior or contemporary readings. It accepts the "democratic" or "it can be read from any direction" notion which has prevailed after Herding's work, but it obviously stresses the "calculated performance" notion in aesthetic rather than political terms. Also, gender issues are downplayed because nothing about the painting gives any incontrovertibly clear gendering signals, even though there are plenty of ambiguous ones. For example, there is the curious appearance of a little girl kneeling on the floor, drawing in the midst of the right-hand group in *The Studio*. What does her drawing have to do with Courbet's painting, and, in terms of the present essay, how does it relate to his "conducting/composing"? How does her obvious drawing relate to Baudelaire's equally obvious absorption in reading at the far right of the image? Is Courbet opposing (and therefore asserting to contain in his own art) readability, visibility (in progressively more sophisticated forms depending on the age of the practitioner), and musical audibility? Like most questions posed in *The Studio*, this one cannot be answered definitively, for the obvious reason that Courbet wanted no answers to appear. He left the painting, at least in large part, as an allegory of allegory, something which has been recognized in one way or another by several critics. And an allegory of allegory is in "real" terms an enigma – as infinitely closed to interpretation as it is open to a whole range of interpretations. Everything in the picture is only semi-encoded, so it can only be semi-decoded. This is why the picture is so lifelike in a quite literal sense. It absorbs interpretations, but yields itself to none. I am *not* using the concept of "allegory of allegory" in any way at all related to Professor Nochlin's discussion of the discipline of art history in *Courbet Reconsidered*, 21.

My colleague Professor Michael Driskel has generously responded via letter to this essay suggesting that my "performance" model for *The Studio* is unsatisfactory in its stress on an exclusively high-culture model, like concert music. Working from the notion that Courbet's Pavilion was in fact a glorified tent, Driskel would prefer to have it seen in relation to popular theater or circus, or perhaps as a setting for a parade. He cites the incontrovertible taste for such things in the Realist circle generally. I have no difficulty accepting as plausible Professor Driskel's suggestions. They provide precisely the kind of ambiguous complementary/ contradictory discontinuities of reading that I find endemic to, and exciting about, Courbet's strategy in the whole of *The Studio*.

51. Assuming the female child on the floor mentioned in note 50 is drawing with a crayon, almost no sound is "readable."

52. See note 50.

53. The small boy seems an equally compelling image of the spectator/artist as a pre- or a-political creature. In the instance of Courbet, for at least *one* contemporary critic, the anonymous American Paris correspondent who published an obituary in *The New York Times*, the artist was not seen in firsthand conversations to give off the "idea that he thought of politics." In Faunce and Nochlin, *Courbet Reconsidered*, see Douglas E. Edelson, "Courbet's Reception in America before 1900," 70.

54. Rewald, *History of Impressionism* remains the published focus (through successive editions) of this view.

55. The term "pre-Impressionism" may have developed prior to 1911, but it becomes endemic after Roger Fry's invention of the term "post-Impressionism."

56. Champa, *Studies in Early Impressionism*.

57. See Rewald, *History of Impressionism*, for a straightforward critical/documentary survey of the response.

58. See Fried, "Courbet's Femininity" in Faunce and Nochlin, *Courbet Reconsidered*, 49, for related discussion.

59. Ibid. Fried's distinction between Manet's "presentational" as opposed to Courbet's "actional" mode of theatricality is, in the context of that author's view of mid-century pictorial dynamics, generally, a brilliant and compelling one – uniquely so. However, there is from the perspective of the present essay both more (and less) to be made of Fried's distinction.

If one thinks of Courbet and Manet together forming a radical counter-axis to the imaging practices of Corot and Rousseau (and late Delacroix as well), it is possible to propose that there is a concomitant thematization of sound (musical or just noise) that connects the work of Courbet and Manet, rather than separating the former from the latter. Sound in the paintings of both artists tends to be portrayed as originating from within the picture space – staying inside (but available to be read as heard) in Courbet's work, refusing to stay inside in Manet's (and requiring the hearing to complete itself in the spectator's space).

Courbet thematized sound (musical, hammering, and speaking) in his three breakthrough works of 1848–50: the *After Dinner at Ornans* (Lille, Musée des Beaux-Arts), *The Stonebreakers* (Dresden before destruction), and *A Burial at Ornans* (Paris, Musée d'Orsay). This thematization of sound, which Fried has examined in relation to the *After Dinner at Ornans* (see note 40) serves as powerfully as any strictly pictorial device to connect bodily (read "sensorily") the artist/beholder to the depicted image. It is oppositionally convenient as well for Courbet's counter-thematization of silence or near silence in subsequent work, *The Studio* in particular.

Manet's thematized sound, issuing as it does from little, if any, depicted space, is persistent in type through much of his work from the late 1850s into the early 1870s. It begins in a rather Courbet-like mode in *The Absinthe Drinker* (Copenhagen, Ny Carlsberg Glyptotek) where the bottle has just dropped and (fictively) rolls on the pavement. In the *Guitar Player* (New York, Metropolitan Museum of Art), both the vocal and instrumental sound aim straight out at the spectator, combining with the strident value contrast of Manet's color structure to bowl the spectator over sensorily. In the *Music in the Garden of the Tuileries* (London, National Gallery), the spectator is fictively surrounded by the sound of the military band, because he/she views Manet's image from the forwardmost ranks of the band. *The Fifer* (Paris, Musée d'Orsay) repeats the strategy of the *Guitar Player*, while the *Luncheon in the Studio* (Munich, Bayerische Staatsgemäldesammlungen) and *The Balcony* (Paris, Musée d'Orsay) refine the *Music in the Tuileries* precedent. The fictive sonic presence of the artist's voice conversing with his models (more or less at random) provides in the former the only component of imagistic legibility available to the spectator. *The Balcony* suggests the passage of a noisy parade on the fictive narrow street across which the spectator looks. The space of that parade is shared by the spectator *and* the depicted spectators. An ingenious variant develops in *The Railroad* (Washington, D.C., National Gallery of Art) where the confusing noises of the rail yard come from behind the depicted figures, either entertaining them or distracting them (from reading!) and presumably doing the same to the spectator. Courbet's offer to "listen in" has been incrementally replaced by Manet's insistent devising of ever more complex strategies for depicting auditory complicitousness developing inside *and* outside the painting simultaneously.

The most overt stagings of Manet's thematized sound reside in the several versions of the *Execution of Maximilian* (Boston, Mannheim, and elsewhere). For full treatment of these see: Kermit S. Champa, ed., *Edouard Manet and the Execution of Maximilian* (Providence, 1981).

60. See A. de Gasperini, *La nouvelle allemagne musicale – Richard Wagner* (Paris, 1866) for usage of terms relating nervousness to the modern condition as perceived and exemplified in Wagner's music. For Bazille letters describing concert-going activities, see: Gaston Poulain, *Bazille et ses amis* (Paris: La Renaissance du Livre, 1932) and François Daulte, *Frédéric Bazille et son temps* (Geneva: Pierre Cailler, 1952); also Galerie Wildenstein, *Bazille* (Paris: Wildenstein, 1950).

METHODOLOGICAL NOTES
(Explication de Texte)

Contexts, Subtexts, and Pretexts
(En Forme Symphonique Dégradé)

Premier Mouvement (demi-sérieux)

The preceding essay is destined, I fear, to appear somewhat eccentric to a substantial number of its potential readers. This "eccentricity" was not intentional, but that is different from saying that it was not purposeful. In order to explain the difference between intentional and purposeful in this instance, I am attempting to describe (insofar as it is ever possible to do so with any reliability) what happened to me from a scholarly or critical perspective during the preparation of my essay. While my account may explain nothing (or everything), I will feel better having offered it. As a staunch believer in the notion that serious criticism (and scholarly writing) is always aimed at the production of an "interpretation," and that any interpretation, if it is an interesting one, contains as clear an exposition of its author as it does of its subject, I regard criticism/history as more or less hermeneutically responsible narcissism.

In providing an "explication" after my text in place of the time-honored "introduction" – writing it and (I admit) conceiving it after that text was complete – I am, of course, responding rhetorically, even ideologically, to the best pedigreed of recent French critical precedents, those issuing from Paris and now, I gather, increasingly from Lille. Having tried in my essay to confront a magnificent grouping of paintings as so many visual texts, I am now turning to my text *as text* in order to explain it by classifying certain features of it, to defend it (to whatever degree it is defensible), and to elaborate on several of its contentions.

I have avoided writing in the first person and/or using "she" as a pronoun to refer to male artists or male spectators (or random mixes) in my essay, but I confess that I have felt rather old-fashioned for doing so. Although I have been writing letters in the first person all my life (and

using the form fairly freely in conversation as well), I have never used it in scholarly writing. As regards the "she" form for "he(s)," I have no intention of absorbing the guilt burden of generations of gender-empowered authoritarian misuse of pronouns (as the feminists see it). I plead for understanding and concomitant permission for certain dinosaurisms of language.

To conclude this section of my notes (which I now realize as I write it is a "letter" by my own definition in the previous paragraph), I want to assure the reader that the absence of "Left-Bank" aphorisms and italicized buzzwords in the preceding essay should not be taken as signaling a sub-text of ideological *abhorrence.* Many of these (both the fecund and the fru-fru) rattle happily in my head but roll uneasily from my pen or from my tongue. Similarly, let me comfort the reader by admitting my own deep-seated uncertainty as to whether I have worked, ideologically speaking, within a pre- or post-Marxist, a pre- or post-feminist, a pre- or post-structuralist, or a pre- or post-(Franco) Freudian space of discourse. I know I have worked in some sort of space, but not being sure whose it was, I have tried not to use up very much of it. My apologies to the owner.

Deuxième Mouvement (plus sérieux)

In late February 1987, at the College Art Association's annual meeting in Boston, Marilyn Hoffman, the newly appointed director of The Currier Gallery of Art in Manchester, New Hampshire (and a former graduate student of mine at Brown University), asked me to think about a "major" nineteenth-century exhibition to celebrate the museum's sixtieth anniversary. Together we decided on a restaging in expanded form of the most successful and best-known of the Currier's post-war loan shows – one known fairly widely because of its excellent catalogue.[1] I suggested focusing the show on the Barbizon School; Hoffman liked the idea, and a few months later, when I was in England, I heard by mail that she wanted to proceed with this idea, and that she hoped I would agree to be the coor-

dinating curator for it. I agreed, even though my own research at that time was centering on developments in French and British criticism in the 1890s.

On several occasions over the next few months, Hoffman and I exchanged proposal materials – more or less elaborate in nature – with the intention of applying for development grants. In the late fall of 1987, working in Belgium, I began to review the last decade's scholarly literature on early- and mid-nineteenth-century French landscape painting (and related topics) with the intention of assisting with more detailed grant applications and with the development of loan lists for the exhibition – lists which Hoffman could also begin to use in order to negotiate for other museum venues for her exhibition.

Back in my academic home in Providence in early 1988, I spent the spring continuing an exhibition project at Brown on an American topic, *Over Here: Modernism, The First Exile, 1914–1919*. I wrote the first draft of "The Rise of Landscape Painting in France" in the summer of 1988. Then in the fall, my attention was back on producing and editing text for the *Over Here* catalogue; the exhibition was shown at the David Winton Bell Gallery at Brown in the spring of 1989.[2] In November 1988, the first draft of the "Rise" essay was circulated to a broad cross-section of the scholarly community in nineteenth-century studies. I received a large number of responses, some encouraging, others productively critical, and used the responses in the summer of 1989 to edit and revise the manuscript into its current form.

My reason for having circulated the manuscript so widely had to do with my recognition of the basic facts: first, that I had been out of early- and mid-nineteenth-century studies as a publishing scholar (but not as a graduate advisor) for fifteen years; and second, that I was returning to these studies with perspectives obviously influenced by interim research in late-nineteenth-century and early-twentieth-century topics. I needed to get some detailed sense of how my development of a "musical

model" would resound, since it proceeded differently from any other currently operative critical models. It even ran against Professor T. J. Clark's contention, expressed in his *Painting of Modern Life* of 1985, of the impossibility of dealing with the "music" issue.[3]

To summarize the situation in another way, I knew that my essay was running into intellectual territory that was *very* highly sensitized from both a political (partisan or neutral) and gender perspective. My own reputation as a die-hard formalist, combined with the politically and sociologically disinterested character of my culturally elitist "music" model, threatened, it seemed, to congeal into a "nobody is going to risk reading it" package in the essay as it was drafted. To my surprise, the draft as circulated actually met with a high degree of positive interest, something I took not as a tribute to myself, but rather to the genuine curiosity and open-mindedness of many of my most distinguished colleagues, collectively representing several academic generations.

In the months just after the drafting of the "Rise" essay, I had the privilege of seeing the Brooklyn Museum's superb *Courbet Reconsidered*. Before actually seeing the exhibition, I had been given a fair notion of the character of Professor Linda Nochlin's contribution to the catalogue[4] when she gave a kind of preview lecture at Brown the previous spring. I had also read galleys of Professor Michael Fried's contribution to the catalogue prior to its publication. With these and the catalogue's other essays available in print, I was made aware even more clearly than before of where mid-nineteenth-century studies stood, and by comparison how whimsical my own interpretive perspective would likely appear to readers *outside* the field in particular. At the same time, I could see that the *Courbet* catalogue had exhausted, if only by temporary overstatement, several reigning methodological/ideological options in much the same manner as Professor Clark had seemingly exhausted others four years earlier. This being the case, it seemed that my model might serve with others devised along semiotic lines, either

by Professor Norman Bryson (or someone following in his wake) or from neo-positivist perspectives representing the "social history of art" in its current politically unaligned form by Professors Albert Boime, Michael Driskel, and Patricia Mainardi, to keep mid-century studies open for business during a period of method-ological re-sorting.

In regard to the more practical public-education mission of the essay, because of Hoffman's excellent planning, I was not required to write an essay providing an account of *all* aspects and perspectives which in various ways informed French landscape developments. Her planning included contracting supplementary essays from two other scholars who could be relied upon to emphasize what I, for reasons either of disinterest or incompetence, would not. The highly informative results of her foresight are, I think, obvious in the catalogue as it appears.

Troisième Mouvement (très sérieux)

As suggested earlier, my research and writing of the "Rise" essay first interrupted and then was continued in conjunction with other scholarly projects. The situation requires some explanation in order that my singular insistence on a "music" model be understood.

In the two summers following the publication of my *Mondrian Studies* (1984), I used the excellent resources of the Royal Library in Brussels to begin tracing (for consistency or metamorphosis) the critical use of the term "modern" in French discourse after the death of Baudelaire. At a very early point I discovered both explicit and implicit crossover usage between the terms "modern," "musical," and "Wagnerian." The crossovers became a virtual blur in the 1880s — about the same time the artist Renoir began to undertake various forms of specifically Wagnerian or more loosely "musical" imaging. Intrigued by this discovery I looked at slightly earlier Impressionist work, Monet's in particular, to see how or whether "music" modeling signals might be seen as immanent, or might

have been seen as immanent. I concentrated on his work rather than Renoir's, because I noted in much c. 1890 discussion of Monet that his series paintings evoked musical responses almost routinely. In the writing of so-called symbolist critics, particularly that of Camille Mauclair, the loose musical parallels that had been drawn a decade before by Jules Laforgue, linking Monet and Wagner, eventually gave way to more confident and comprehensive descriptions of Monet's symphonization of color. As synesthetic phenomena were the evident sub-texts of much c. 1890s discourse, my next research steps were in the direction of following specific (aesthetic and scientific) discussions of "color-hearing."

In the fall of 1985, I offered some preliminary thoughts on the first stages of my research at a symposium sponsored by the Boston Museum of Fine Arts in conjunction with its Renoir retrospective. The following spring at a College Art Association colloquium called by Professors David and Ellen Rosand, I shifted my emphasis to early 1870s Monet in a paper entitled "What Does This Painting Sound Like?" Revised versions of that paper were given later in 1986 at the National Gallery of Art in Washington, D.C., and at Bates College.

When my sabbatical year began in January 1987, I left for London intending to do an in-depth study of what had come to seem a potentially useful and responsible focus for research which had up to that point developed in an undisciplined, random manner. The focus was to be on the 1896 color-music concerts produced by the British watercolor painter Alexander Wallace Rimington using a carbon-arc lighted and electrically motorized color-organ machine of his own devising. I knew that Rimington's concerts had received enormous press coverage in journals and newspapers of every sort. The majority of that coverage was in the English press, but there was a substantial echo in American and Continental reporting. And there was, on the basis of a few published hints from the 1930s, the tantalizing prospect that Rimington's machine might still exist.[5]

What I wanted to determine about the

Rimington concerts was how they were perceived – what they were thought to be and what their influence was, if any, on subsequent discussions of color-music. To summarize briefly, I found that the Rimington concerts coincided with the most sophisticated *and* the most "popular" moment in painting-music discourse in the post-Pater period in England, with R. A. M. Stevenson's *Velasquez* monograph (1895)[6] marking a crest that ebbed only slightly in the writings on more modern subjects over the next few decades by Roger Fry, J. E. Phythian, D. S. MacColl, and Clive Bell.[7] English translations of the modern "histories," those of Muther, Meier-Graefe, and Mauclair, I found to affect the ongoing fascination in various ways but not to modify it to any substantial degree.[8]

In American criticism of the same period, I found a related pattern of discourse, but one which "peaked" much later in the work of W. H. Wright.[9] The American elaboration of the painting-music (more specifically, color-music) paradigms was, however, unique in several respects. In the spring of 1988 in a graduate seminar at Brown on the topic *Early English Language Historians of Modern Art,* and in the fall 1988 exhibition seminar for *Over Here,* my graduate students and I explored the parallel as well as the eccentric functioning of all forms of the musical analogy between 1895 and 1920. The essays – my own in particular – in the *Over Here* catalogue represent the published results of one branch of the Rimington project, which had, as a project per se, to be abandoned temporarily.[10]

The American development of the musical analogy was, as I came increasingly to realize, the forwardmost point historically in a tradition of discourse that had partnered the development of "modern" art routinely and for a considerable period of time – not just in one way but in many ways. This realization (or as others may prefer that I call it, "this deep-seated belief") *authored* the musical model for the "Rise" essay, which was drafted in the summer of 1988. I had the opportunity (and the challenge) in this essay to test the functioning of the analogy as a comprehensively informative master model operating under *specific and systemic early conditions.*

For those who will continue to grant me license to treat canonically "important" painting as part of the larger operations of something I insist existed and still exists (if precariously), namely high culture, there will be a few hermeneutical innovations worth considering in the "Rise" essay. For those who will not or who ideologically cannot, there will be perhaps at least some cause for intelligent amusement.

Quatrième Mouvement
(le plus sérieux, le plus spéculatif!)

Over the last decade or so I have followed with much genuine interest the studies of Professors Michael Baxandall and Svetlana Alpers examining the high degree of reciprocity potentially operative between the production of certain types of painting in a given historical period and what they refer to as the "period eye."[11] The "period eye" is defined in their studies as a sociologically processed receptor (and, by extension, enforcer) of pictorialized information. While I may or may not agree in detail with all of what has been written about "period eyes," I do think the theory bears some exploration on my part in order to derive a few additional hypotheses and generalizations from my "Rise" essay.

Obviously we have a good deal more sociological data on the nineteenth century to explore for purposes of determining the character of a "period eye" than is true for earlier periods. In fact we have arguably too much data, and the major problem has to do with identifying the relevant facts. Scholars working in nineteenth-century studies know so much about political attitudes, options of sexual alignment, as well as sociological behavior generally, that the sheer weight of information seems almost to mandate the construction of psycho-sociological models of causation. The result of all this is that aesthetic models tend to be seen as, at best, unfashionable and, at worst, irresponsible from a documentary point of view.

The definition of a nineteenth-century

"period eye" has been hindered, in my judgment, by a prevailing unwillingness on the part of scholars (or critics) to examine what the "period eye" actually had to look at and to deduce from that certain obvious parameters of strictly visual idiosyncrasy distinguishing nineteenth-century pictorialization from pre-nineteenth-century precedents.[12] Only Professor Michael Fried and (to a somewhat lesser degree) Professor Richard Shiff have absorbed themselves in looking and continuing to look, but neither has attended to the "period eye" theory in a direct fashion.[13] There are some explanations for this. Fried's eye is consumingly and brilliantly personal. There has never been an "eye" quite like it in the nineteenth century or in any other period. Like Pater's, it is *sui generis* – an "eye" in itself; it is more interesting (and in many respects more open-endedly informative) than any "period eye" ever was or could be. Shiff's eye, on the other hand, is clinical and directed by a desire to uncover visual strategies which can be indexed and cross-indexed. It is the eye of a partly disguised semiotician, born from art history (and criticism) but nurtured by the search for what I will call, for want of a better classifying concept, pictorial signal systems.

Why do I think that I am in a better position, at this moment at least, to talk about the nineteenth-century "period eye" (from the perspective of looking more than reading) than Professors Fried and Shiff? The answer is, I think, that I have a better sense of the "period ear," and I believe that the "period ear" was for the first time in the late eighteenth and nineteenth centuries highly affective of the "period eye." I am intellectually comfortable and confident watching the two "period organs" converse. However, I am not, I admit, comfortable judging the perhaps equally important pictorial print-out of political sentiments or private sexual practices, even when I know something about them. I cannot see much ideological (and thereby affective) consistency in my own erratic political or sexual inclinations, so I feel totally irresponsible in attributing consistency or causation to those of anyone else – particularly if that (poor,

confused, and ego-fragile) someone else is an artist of undeniably high, original achievement.

Returning to the specifics of the Baxandall-Alpers "period eye" notion, I would argue that beginning auspiciously in J.-J. Rousseau and in particular in the posthumously published *Confessions* (1782 and 1788), there is the imminent signal of a new kind of spectator: a proto-nineteenth-century spectator. I would call that spectator (and that writer/spectator in Rousseau) a "listening spectator" as opposed to a "reading spectator." Even more than Diderot, J.-J. Rousseau had his most powerful aesthetic experiences in music – in particular, in Italian opera and in Venetian instrumental and choral music of various sorts. For J.-J. Rousseau, the Italian opera represented the most comfortable medium of expressive self-reference as it would for transitional "reading-listening" spectators for over a century. Wagner's music dramas were the penultimate food for this transitional form of spectatorship.

I would hypothesize that through the nineteenth century in France and elsewhere, spectatorship was a problematic condition for an artist in any medium to define or to identify with. Yet some of the most intriguing definitional and identificational maneuvers are evidently operative in the first half of the century and, as I argue in the "Rise" essay, in the production of landscape imaging by musically hyper-sensitized painters like Corot and Théodore Rousseau. Their "period eye" – as well as that of their anticipated spectators – was primed to hear as it saw, rather than to read. Rather like the contemporary German philosopher Schopenhauer, these artists risked listening-dominant structures of discourse and often featured (discursively and imagistically) pure instrumental music as a model of what they attempted to communicate. Without denying the existence of the "reading spectator," many if not most of the creative talents of the first half of the century were, I would suggest, more comfortable with and more attentive to the new, modern "listening" one.

How and why was this "listening" spectator new? The answer resides, I think, in the simple

fact that music – particularly concert music – had gone increasingly public at the same moment it gained, largely via Beethoven, dramatic-expressive maturity. After 1828, particularly but not exclusively in Paris, an artist, whether a painter or a writer, could assume (conveniently *or* inconveniently) that his/her audience *heard* as it read or as it looked. What I mean by "heard" in this instance is that spectators brought to what they read or saw prior experiences not only of reading or seeing but of hearing, and that the latter were the newest and expressively most potent experiences. When one turns to the early histories of modern art, what one seems to see is a kind of distilled summation of a century of listening-sensitized seeing – the only kind of seeing that could at the time (c. 1900) have been imagined or understood.[14]

Twentieth-century scholarly and critical discourse on the arts has increasingly lost touch with what is, from my perspective, the unique "period eye" of the nineteenth century – the listening-sensitized eye. There are several obvious reasons for this. To begin with, one could contend that concert music's ability to be expressively novel in an even small-public accessible way began to weaken in the years surrounding World War I. In the high cultural arena, broadly conceived, concert music lost its force to revitalized writing and even more revitalized painting. The post-war confusion in Stravinsky's work – its self-annihilating vascillation between the antiquarian and the popular in reference – signals the downturn in concert music's preeminent aesthetic confidence and effectiveness. Faced with this situation of concert music's reduced modern aesthetic role, twentieth-century scholars have been understandably suspicious of earlier assertions of concert music's centrality. In the past thirty years of discourse, that suspicion has turned to abject ignorance. Inevitably, being an expert in nineteenth-century artistic matters has meant becoming, as Professor Nochlin proudly admits she is, a reader of paintings.[15] Listening is evidently dead! At least it seems to be so in terms of intelligent twentieth-century spectatorship.

Coda

This is the point at which I must undertake to explain in detail why I consider myself more or less uniquely vested with the obligation and the ability to foreground, or re-foreground, the music model as an interpretive strategy for the most significant pictorial achievements in the nineteenth century – namely, those taking place in landscape imaging. Let me start by confessing that I am, as an intellectual (more or less), a listener rather than a reader. By this I mean that I spend more total elapsed time listening to concert music – live or recorded – than I do reading. Obviously I am not implying that I can't or don't attend to (English, German, or even French) texts of various sorts. I am simply saying that, given free time, I listen.

But what does it mean to say I listen in the last years of the twentieth century? I cannot contend that my listening is at all related (except perhaps in terms of total elapsed time) to nineteenth-century listening. Obviously I have more to avoid in terms of hearing than my nineteenth-century predecessors had. I have to avoid film-listening and television-listening, both of which pre-package in a distinctly twentieth-century form some (arguably fascist) semiotic combination of music, word, and image. At the same time, the fact that I have to avoid this kind of listening means that I know I am avoiding it, and that I know what it is; so my non-listening is ideologically loaded and therefore impure, and it necessarily affects my listening. My listening is informed simultaneously by both the decision to listen and the decision not to. There is a form of non-listening hyperbole in my listening! My twentieth-century act of auditory insulation is in part rhetorical, ideological fakery similar to Baudelaire's refusal to read German or in any event to admit that he could for fear of absorption into music-saturated non-French culture.

Isolating me even further from nineteenth-century listening is the fact that besides being a conventionally intelligent music-lover, I have been for thirty years what is called an "audio-

61

phile," which means that I listen to recording engineers listening as much as I do to the music they are listening to! And every year it gets worse. As many would agree, live concerts nowadays are getting even more interpretively haphazard, poorly rehearsed, and boring than most modern recordings, so I often find myself listening to the eternally fascinating sound of different halls, rather than to what is being played in them. But, I content myself by saying, "Why shouldn't we listeners (however many of us are left) yield to *our* post-modern hang-ups just like everyone else?" By continuing to listen I have, I think, learned to see a few things, particularly nineteenth-century things, more clearly. The best minds of that century – those of Hippolyte Taine and Friedrich Nietzsche – granted music the status of *the* art of the nineteenth century (for better or worse). I intend to keep listening for what they meant for as long as there is concert music – or even the echo of it – around to be heard.

NOTES

1. Currier Gallery of Art, *Monet and the Beginnings of Impressionism* (Manchester, New Hampshire, 1949).

2. Kermit S. Champa, ed., *Over Here: Modernism, The First Exile, 1914–1919* (Providence: Bell Gallery, Brown University, 1989).

3. T. J. Clark, *The Painting of Modern Life* (New York: A. A. Knopf, 1985), 16.

4. Faunce and Nochlin, *Courbet Reconsidered*, 17–42.

5. Adrian Bernard Klein, *Colour-Music, The Art of Coloured Light* (London, 1926). At the time of writing, the author knew of the whereabouts of the Rimington organ and assumed throughout his discussion that it was destined for a museum in London. My research has turned up nothing in this regard except for the fact that a warehouse containing potentially museum-bound machinery of this sort was bombed in 1943. It was located in the area of London near St. Paul's Cathedral. For a description of the Rimington color-organ in its successive guises, see A. Wallace Rimington, *The Art of Mobile Colour* (London and New York, 1912).

6. This is an absolutely landmark book in the development of a strictly visual approach to nineteenth-century French art, even though the approach is "seen through" an analysis of Velasquez. From a nineteenth-century perspective, Stevenson's most important critical notion is that, like music's, painting's true content resides in technique.

7. Roger Fry, *Vision and Design* (New York, 1924); J. E. Phythian, *Fifty Years of Modern Painting* (London, 1908); D. S. MacColl, *Nineteenth Century Art* (Glasgow, 1902); Clive Bell, *Art* (London, 1913). Publication dates here are misleading. The Fry book is an anthology of essays written between 1904 and 1910. For an excellent comparative discussion of these texts, particularly Fry's and Bell's, see Jenny Anger, "Music as Defense in the Aesthetics of Clive Bell and Roger Fry," Master's Thesis, Brown University, 1988. For Phythian, see David C. Ogawa, "The Writings of J. Ernest Phythian: A Study of Early Modernist Methodology," Master's Thesis, Brown University, 1989.

8. Richard Muther, *The History of Modern Painting* (New York: Macmillan, 1896); Julius Meier-Graefe, *Modern Art*, trans. Florence Simmonds and George W. Chrystal (New York: Putnam, 1908); Camille Mauclair, *The French Impressionists* (London: Duckworth, 1903). These three texts are not the only "histories" of the period, but they are, because of their early translation into English (and their discursive joining to those texts listed in

note 7), a critical base for the most sophisticated period debates regarding modern art. The Mauclair text was actually *first* published in English and later incorporated into the author's innumerable French language surveys. See for example: Camille Mauclair, *Un siècle peinture française 1820–1920* (Paris, 1930) for a penultimate version. American critics such as Huneker, Caffin, Eddy, and Wright rely on the English language discourse for their peculiar flotation of the musical analogy. See in Champa, *Over Here,* "Some Observations on American Art, 1914–1919: 'The Wise or Foolish Virgin,'" 11–24, and Jenny Anger and David Brenneman, "Music and the Aesthetic of Masculine Order, As Proposed by A. J. Eddy and W. H. Wright," 78–89. A doctoral dissertation at Brown is currently being written by Lisa Norris treating Mauclair as a prototypical "Wagnerist" critic. Another is being developed by Laura Hendrickson on "Wagnerist" painting and illustration in England.

As an additional note regarding Mauclair, he wrote in c. 1906 (also for a first edition in English) his remarkable study of Watteau. See Camille Mauclair, *Antoine Watteau (1684–1721)* (London, n.d.) in the series produced by Duckworth and Company (London) and E. P. Dutton (New York) – the same firms which commissioned his *French Impressionists*. This is an absolutely *sui generis* text – highly experimental methodologically and highly influential. It is a pre-Freudian attempt at art-historical psychoanalysis, working from the notion that there is something like a pattern to the art of "consumptives" like Watteau, Schubert, Chopin, Beardsley, etc. Had it been written in the last decade, it would have been called *Watteau's Sadness,* but more to the point here is the fact that it suggests that Watteau's "meaning" could not be understood until nineteenth-century music (particularly Wagner's) had exposed expressively the "inner life" of the modern sensibility. At least one major artist, the American Charles Demuth, seems to have been deeply moved by Mauclair's psychoanalytic and physiological description of creative causation and to have modeled his art (and his social being) on it. I thank Professor Joanna Ziegler for providing me with the *Watteau* and the *Un siècle peinture française* as personal gifts.

9. Willard Huntington Wright, *Modern Painting* (New York: John Lane, 1915).

10. Champa, "Some Observations on American Art, 1914–1919," in Champa, *Over Here.*

11. See Michael Baxandall, *Painting and Experience in Fifteenth Century Italy: A Primer in the Social History of Pictorial Style* (Oxford: Oxford University Press, 1972) and Svetlana Alpers, *The Art of Describing: Dutch Art in the Seventeenth Century* (Chicago: University of Chicago Press, 1983).

12. The most perceptive account of this remains Theodor Hetzer, "Francisco Goya and the Crisis in Art around 1800," in *Goya in Perspective*, trans. Vivian Volbach, ed. Fred Licht (Englewood Cliffs, New Jersey: Prentice-Hall, 1973), 92–113.

13. In addition to prior Fried references, see *Realism, Writing, Disfiguration: On Thomas Eakins and Stephen Crane* (Chicago: University of Chicago Press, 1987). For Richard Shiff, see *Cézanne and the End of Impressionism* (Chicago: University of Chicago Press, 1984).

14. See notes 7 and 8.

15. Faunce and Nochlin, *Courbet Reconsidered,* 21–23.

The Generation Gap

FRONIA E. WISSMAN

THE STORY OF nineteenth-century French landscape painting is usually told as the teleological progression of plein-air painting, culminating in Impressionism. Taking as their cue the example of John Constable's studies of the English countryside, the Men of 1830 – Camille Corot, Théodore Rousseau, Narcisse Virgile Diaz de la Peña, to name but three – took their easels out-of-doors to paint their unassuming scenes in the Forest of Fontainebleau. These views were the intellectual and emotional precursors of the loosely brushed pictures of rivers and beaches and country walks executed, also in the out-of-doors, by Claude Monet, Camille Pissarro, Pierre-Auguste Renoir, and Alfred Sisley. The story of these latter artists is well known.[1]

There is another way to look at this story, however, and that is as a story not of continuity but of disparity and even hostility. Simply put, the careers and fortunes of the Men of 1830, so-called because they forged their professional identities around that year, were to a large extent determined by their exhibition histories. These histories, and much of the art world in nineteenth-century Paris, were influenced by the structure and regulations of the Academy and the Ecole des Beaux-Arts.[2] Years later, the Impressionists, a term to be used in the absence of a better one,[3] following the lead of the older artists, began their careers by trying to fit into the structures established by those same official institutions. Their fit, however, was not as good. A combination of factors including institutional changes and their own personalities forced the Impressionists to find alternatives to the system in which the older generation had flourished. The generation gap between the younger and older artists represented in this exhibition demonstrates not only the natural succession of youth following age but also the shift from a state-sponsored art world to a private market in Paris.[4]

Most artistic activity in nineteenth-century Paris was dominated by the Salon, the huge, annual or biennial, government-sponsored, and juried exhibition of contemporary art. The composition of the Salon in turn was determined by the jury, a body that until 1848 was appointed by the Academy. For an artist to appear in the Salon was the necessary first step in a possible progression of honors, awards, and commissions from the government and members of the public. Each year from 1830 to 1848, the years of the July Monarchy, more than one million people visited the Salon. Those million people would have no reason to dispute the judgments of the jury, whose business it was to choose worthy examples of art to show to the public. If an entry was rejected by the jury, usually for an unknown reason, the public (and members of the government) would assume that both the work and the artist were not worthy of notice.[5] Gustave Courbet, whose name is more usually associated with acts of defiance than compliance to rules, was nevertheless painfully aware of the importance of the Salon to his career. He wrote to his parents in March 1847, "To become known, you have to exhibit, and unfortunately there's only this one exhibition."[6] A year later he wrote: "My picture is progressing rapidly. I hope to finish it for the Salon exhibition, and

if it is accepted it will be most helpful and will secure me a great reputation."[7] The Salon remained a central concern for artists for many more years. As late as 1870, Frédéric Bazille complained to his parents about the high cost of modeling fees, justifying the expense by saying, "None of this would matter if my painting was successful at the Salon."[8]

Until 1848, the members of the Salon juries were chosen exclusively from the ranks of the teachers at the Ecole des Beaux-Arts, the art school administered by the Academy. The curriculum at the Ecole emphasized drawing the human figure for incorporation in history paintings, works that told ennobling stories drawn from the Bible or classical myth and legend. The Academy held rigorous competitions for the Prix de Rome, a four-year scholarship in the Eternal City awarded to the best history painting on a given subject.[9] In addition to the drawing classes, students attended the separate painting studios run by Ecole teachers. Bowing to increasing interest on the part of the public, teachers, and students, the Academy instituted a Prix de Rome for historical landscape painting in 1817, a landscape analogue of history painting that told stories from the same classical or biblical sources. Pure landscape painting was considered a minor genre, despite its popularity with both artists and patrons.[10] Treatises were written to guide young historical landscapists, setting forth prescribed models. At the top of the hierarchy were the austere scenes by Nicolas Poussin, followed by the more pastoral vision of Claude Lorrain; at the bottom of the list were the seemingly humble scenes by the seventeenth-century Dutch masters.[11] This teaching by imitation is exemplified by Jean-Achille Benouville's *View in the Roman Campagna* (Private Collection), whose relatively late date of 1843 demonstrates both the tenacity and surprising vigor of the tradition.

Landscape painters such as Corot, Rousseau, and Charles-François Daubigny are generally called independent artists, presumably because they did not follow the complete official course of study at the Ecole des Beaux-Arts, stayed aloof from the politics of the jury, and were more interested in expressing their feeling for nature than in depicting the human figure in stories taken from classical legend. Yet with the Salon the only viable avenue to public recognition, they were compelled to try to gain admission.

The system was flexible enough to accommodate artists who did not formally enter the Ecole; they had the option of attending the painting studios taught by teachers from the Ecole, where they would not only learn the techniques of oil painting but also become acquainted with other young artists. This mode of study allowed artists like Corot, Rousseau, and Daubigny to focus much of their energies on gaining admission to the Salon without fulfilling all the requirements for advancement within the structure of the Ecole. For example, Corot studied with Achille-Etna Michallon (1796–1822), the winner of the first Prix de Rome for historical landscape, and, after his untimely death, with Michallon's teacher Jean-Victor Bertin (1767–1842), from 1822 to 1825. In later life Corot tended to deny any influence these teachers had had on him; the fact remains that he took instruction for at least three years, and his Salon pictures betray his deep attachment to tradition.[12] For his part, Rousseau spent four years studying, first, from 1827 to 1828, with Jean-Charles-Joseph Rémond (1795–1875), who won the Prix de Rome in historical landscape painting in 1821. During the time he was with Rémond, Rousseau made copies in the Louvre after the works of the seventeenth-century Dutch painters Karel Dujardin and the Van de Veldes and also after Claude. Rousseau even entered the competition for the Prix de Rome for historical landscape painting in 1829, having prepared for it with further training from 1828 through 1831 with Guillaume Guillon-Lethière (1760–1832), another teacher at the Ecole des Beaux-Arts. Lethière was a figure painter, not a landscapist; his training as a history painter included practice in linear perspective. Rousseau found the principles of linear perspective helpful in organizing the vast spaces of nature.[13] Although he apparently failed the first round of

Benouville: Cat. 2

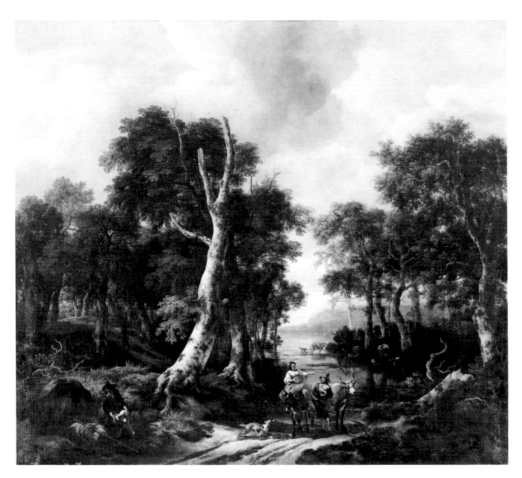

Fig. 1 Jacob van Ruisdael and Nicolaes Berchem, *The Forest*, late 1660s. Oil on canvas, 67⅜ × 76⅜ inches (171 × 194 cm). Musée de la Chartreuse, Douai, Giraudon/Art Resource PEC 8768.

tests, the fact that he entered the competition points to his ambitions and willingness to follow the prescribed path to official recognition. Jean-François Millet, too, began his career unexceptionally. After studying in Cherbourg, he went to Paris in 1837 to enter the studio of Paul Delaroche (1797–1856) at the Ecole. In 1839 he competed unsuccessfully for the Prix de Rome. Likewise, Daubigny, after returning to France from a six-month trip to Italy in 1836, tried for the Prix de Rome in historical landscape painting in 1837, having entered the studio of Pierre-Asthasie-Théodore Sentiès (b. 1801), but failed the second rung of the tests. Although the following year he could boast that two of his pictures hung in the Salon, and two more in 1840, this success did not prevent him from competing for the Prix de Rome again in 1841. For this second attempt he felt he needed more

study and therefore entered Delaroche's studio for six months in 1840. This time he turned in a better performance: he passed the first two tests but seems to have been rejected on a technicality for the third.

Artists tailored their Salon entries to curry favor with the jury. For the 1847 Salon, Millet submitted a history painting, *Oedipus Taken Down from the Tree* (Ottawa, National Gallery of Canada); it was a strategy that worked – the painting was accepted. Constant Troyon and Daubigny both exhibited historical landscapes, Troyon's *Tobias and the Angel* in 1841 (Cologne, Wallraf-Richartz Museum) clearly resembling Daubigny's *Saint Jerome* of the previous year (Amiens, Musée de Picardie). Corot often took pains to develop pictures with literary themes, following academic teaching, touching throughout his career on stories from the Bible,

classical myth, legend, and from writers such as Dante and Shakespeare.[14]

Pictures that recalled past traditions of landscape painting were often accepted by the conservative jury, such as Troyon's *View of Saint-Cloud* (Notre Dame, Snite Museum of Art) and Daubigny's *Crossroads at the Eagle's Nest* (Collection of Ruth and Bruce Dayton). Troyon's work looks to the primarily British genre of topographical views, originally intended as portraits of owners' estates and then functioning more as tourist views. Daubigny's *Crossroads* and Corot's *Forest of Fontainebleau* (Boston, Museum of Fine Arts) follow the example of seventeenth-century Dutch masters, such as Jacob van Ruisdael (fig. 1). Landscapes depicting foreign sites were popular, and Italy's role as the locus classicus offered to landscape painters a subject as venerable as the stories used for history painting. Corot's *View near Naples* of 1841 (Springfield, Mass., Museum of Fine Arts), for example, with Mount Vesuvius in the background, recalls an ancient site replete with history and legend.

As suggested earlier, Courbet approached the works he submitted to the jury with special care. He had made his reputation with the very large, generally dark depictions of rural life that shocked the Parisian art world with their head-on directness—some said ugliness. In later years, wanting to appear more conciliatory, Courbet described his Salon strategy to his friend, the critic Champfleury: "For the next exhibition I want first to finish my big picture of stags fighting, and then the dramatic one of a stag taking to the water. This is neutral ground; everyone can understand it, and it satisfies the general love of landscape and animals."[15]

The various strategies – study at the Ecole or in painting studios, patterning works after accepted models, and making pictures to appeal to specific tastes – were, to a large extent, successful for these older artists. Of all the artists represented here, Corot was the most constant exhibitor at the Salon; paintings by him were included every year a Salon was held from 1827 until the posthumous showing in 1875. Both

Corot and Rousseau were fortunate in having their first submissions accepted; Corot even sent his entries long-distance from Rome. Rousseau submitted regularly from 1831 through 1867. In his lifetime Rousseau was known as *le grand refusé*, an epithet alluding to his absence from the Salon from 1836 through 1848. It is true that Rousseau's pictures were systematically rejected by the jury from 1836 through 1841, yet it was his own decision not to submit any work from 1842 through 1848. He began to show again in 1849 and continued to do so until his death. Indeed, the validation of the Salon jury was so important to Rousseau that in 1850–51 he submitted canvases for judgment, despite the fact that his having won a first-class medal in the previous Salon exempted him from this process. Troyon showed from 1833 through 1859. Daubigny, too, was a constant exhibitor from 1838 through 1878, in both the painting and graphic arts sections. Neither Millet nor Courbet let periodic rejection by the jury deter them from further submissions.

In addition to seeing their pictures hung in the Salon, the Men of 1830 were awarded special medals in recognition of extraordinary achievement for individual works. Prize money was attached to the medals, but the money was not as great as the honor.[16] A medal was more important for its power to exempt the recipient from the jury process. Corot, Rousseau, Daubigny, Troyon, Jules Dupré, Johan Barthold Jongkind, Millet, and Diaz were all awarded medals. However, the jury could be as fickle in awarding honors as it was in accepting pictures: whereas Troyon received a first-class medal in 1846, Millet had to wait until 1864 for his. The older artists also enjoyed the honor of attaining at least the first rank of Knight in the Legion of Honor: Corot (1846), Dupré (1849), Troyon (1849), Diaz (1851), Rousseau (1852), Daubigny (1857), Charles Jacque (1867), and Millet (1868).

Another benefit derived from exhibiting in the Salon was the chance to be chosen for a government commission, which would ensure one's work being seen by a large number of people on a permanent basis. The new Republican govern-

Troyon: Cat. 111

Daubigny: Cat. 47

Corot: Cat. 19

Corot: Cat. 17

ment of 1848 embarked on an active program of art patronage. Despite his long absence from the public forum, Rousseau was known well enough to be asked to contribute a painting to the Luxembourg Museum, the museum in Paris that housed works of living artists (*At the Edge of the Forest of Fontainebleau*, Paris, Musée du Louvre). Another commission came his way in 1851, but the painting was never completed. Millet was given his choice of subject with a commission in 1848; he settled on Hagar and Ishmael but was dissatisfied with the results (unfinished, The Hague, Mesdag Museum) and submitted *Haymakers Resting* (Paris, Musée du Louvre) instead. The city of Paris contracted with Millet to decorate a chapel of the Panthéon with scenes from the life of Saint Geneviève in 1874, but he died before he could complete the work. Corot's penchant for religious works was recognized in a commission from the city of Paris to decorate the baptismal chapel of Saint-Nicolas-du-Chardonnet (1847, *The Baptism of Christ*).

Daubigny's prowess with the etching needle garnered him a succession of commissions, starting in 1848 when he made etchings after drawings from the Louvre collection for a program that was intended to make art available to a wide audience. Allowed to choose his own subjects, he selected works by the seventeenth-century Dutch artist Jan Pynas and Claude. Since Daubigny had rendered his own Salon paintings in etchings for publication, starting with his first entry in 1838, such a request for commercialization was both appropriate and welcome. The government of the Second Empire commissioned him to do prints after famous landscape paintings by Ruisdael, including *The Thicket* (fig. 2) and *The Ray of Sunshine* (etching, Salon of 1861).[17] In 1859 Daubigny executed decorative panels for the Pavillon de Flore in the Ministry of Finance *(The Deer* and *The Herons; The Pavillon de Flore* and *The Palace and Garden of the Tuileries).* In 1862 he was called upon by the fine-arts administration to paint *The Park and the Château of Saint-Cloud* (1865, Musées de Châlons-sur-Marne).

The government bought pictures from the Salons to display in Paris or in provincial

Fig. 2 Charles-François Daubigny, *The Thicket*, after Jacob van Ruisdael, 1855. Etching, 12⅞ × 15½ inches (325 × 393 mm). The Baltimore Museum of Art, Garrett Collection, 46.112.11397.

museums; the latter became increasingly important repositories of the nation's artistic patrimony.[18] Corot's *Little Shepherd* was bought from the Salon of 1840 for the museum in Metz; scenes of Italy from 1842 and 1848 were sent to Avignon and Douai, respectively. Courbet's *After Dinner at Ornans* of 1849 was bought for the provincial museum in Lille. Daubigny's 1853 *Pond of Gylieu near Optevoz* (Cincinnati Art Museum) was bought by the government – specifically by the emperor, a distinction that conferred even greater prestige on the artist. Corot's later works harmonized with the imperial taste; his *Souvenir of Marcoussis* (Paris, Musée du Louvre) of 1855, *Souvenir of Mortefontaine* (Paris, Musée du Louvre) of 1864, and *Solitude* of 1866 (location unknown) were all bought on the emperor's request.

The older generation of landscapists, who worked in the time of the July Monarchy, could look to the nobility for patronage. The duc d'Orléans (the eldest son of Louis-Philippe, the Citizen King) proved to be a supporter of the Men of 1830. In 1833 he bought *Forest of Com-*

Corot: Cat. 29

piègne from Rousseau, which was then exhibited in the Salon of 1834 (*Rousseau*, 1967, cat. 9). It is highly likely that the third-class medal awarded Rousseau that year was primarily a means to flatter the nobleman; it was still good for the artist. Later in that same decade Corot sold two paintings to the duc; one of them was *Italian Landscape*, which was shown in the Salon of 1839 (fig. 3). In 1835 the prince de Joinville, brother to the duc d'Orléans, bought two sketches from Rousseau, which were shown in the Salon of that year. The duc de Broglie commissioned Rousseau to do a view of the Château de Broglie in 1835, which was rejected by the jury for the Salon of 1836, suggesting that a noble name did not necessarily guarantee success.

Dupré enjoyed considerable noble patronage. In 1831 the baron d'Ivry bought four studies by Dupré and offered the artist his support. Later that same year the English Lord Graves subsidized a study trip to England for the artist, which was to have a profound effect on Dupré's art.

The duc d'Orléans commissioned a large *Harvesters Resting* from Dupré (preparatory sketch, Norfolk, The Chrysler Museum) but died in 1842 before the artist finished the work. Artists were asked to work on collaborative as well as individual projects. The duc de Montpensier made plans to assemble an album of landscape drawings in 1845, to which he asked Rousseau, Eugène Delacroix (1798–1863), Antoine-Louis Barye (1795–1875), and Alexandre-Gabriel Decamps (1803–1860) to contribute. Prince Demidoff commissioned Rousseau, Dupré, Corot, and Eugène Fromentin (1820–1876) in 1865 to paint decorative panels for his dining room.[19]

The painters who began their careers in the middle third of the nineteenth century, then, willingly and eagerly pursued careers through official means to accrue the benefits deriving from success in the Salon. They enjoyed the additional outlet of a private art market, separate from the church and state.[20] Private collec-

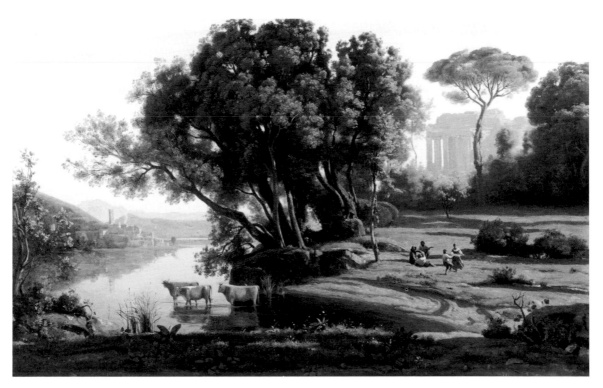

Fig. 3 Jean-Baptiste-Camille Corot, *Italian Landscape*, 1839. Oil on canvas, 25 × 39⅞ inches (63.5 × 101.4 cm). The J. Paul Getty Museum, California, 84.PA.78.

Fig. 4 Constant Troyon, *View Taken from the Heights of Suresnes*, 1859. Oil on canvas, 71⅞ × 104½ inches (182.5 × 265.5 cm). Musée du Louvre, Paris, Giraudon/Art Resource G17928.

tors and art dealers increasingly influenced the kind of pictures artists made, providing a welcome alternative to the circumscribed rules of the Salon. Dealers such as Paul Durand-Ruel, Pierre-Firmin Martin, and Arthur Stevens were especially partial toward landscapes.[21]

The spaces of middle-class apartments could not accommodate the large canvases produced for exhibition at the Salon; collectors wanted domestically scaled pictures. Some were connoisseurs interested in works that showed the artist's hand that was evident in works less highly finished than the typical Salon exhibition pieces. Rousseau's *Morning Frost, Uplands of Valmondois (Effet de givre)* (Baltimore, Walters Art Gallery) exemplifies the freer manner that was popular with people whose taste was more liberal than that of the Salon jury members,

Rousseau: Cat. 104

who were concerned with issues of academic technique.

Collectors would often want a picture similar to one already in existence. It is safe to assume that paintings surviving in several versions were generated by the private market demand. Courbet wrote to his dealer that he had in hand four versions of *The Source of the Loue* (Buffalo, Albright-Knox Art Gallery).[22] Likewise, Corot's many variants on the theme of a boatman on a still lake, such as *The Moored Boatman: Souvenir of an Italian Lake* (Washington, D.C., The Corcoran Gallery of Art) or figures in a sylvan setting, such as *Peasants Stopping at the Edge of a Wooded Road near a Village* (Cincinnati, The Taft Museum), most likely owed their genesis to the marketplace.

However, the dealer system, which was to be

Courbet: Cat. 43

Corot: Cat. 27

Corot: Cat. 26

crucial for the Impressionists, was not so well established by the early 1860s that aspiring artists could afford to ignore the Salon completely. After working with Eugène Boudin in Le Havre, Monet went to Paris in the spring of 1859 to see the contributions of the major landscapists at the Salon. He reported to Boudin after his first visit: "In quality the Troyons are superb, the Daubignys are for me something truly beautiful. In particular, there is one of Honfleur that is sublime. There are some nice Corots, some nasty Diaz, for example."[23] After his second visit two weeks later, Monet wrote again:

> As for the Troyons – there are one or two enormous ones – the *Return to the Farm* is marvelous, with a magnificent sky, a stormy sky. There is much movement in it, there is wind in the clouds; the cows, the dogs are completely beautiful. There is also the *Departure for the Market*; it is a mist effect at dawn. It is superb and particularly luminous. A *View Taken at Suresnes* is of an astonishing scope. You would think you were out in the country; there are animals in a body; the cows in all sorts of positions; but it has movement and disorder. . . .
>
> Théodore Rousseau made some very beautiful landscapes. . . .
>
> Daubigny, now there is a fellow who does well, who understands nature! . . .
>
> The Corots are unadorned marvels.[24]

The works by Troyon and Corot are not those we would expect Monet to find "superb" and "unadorned marvels." Troyon's works were variants on his enormously successful animal pictures. The lofty, cloud-filled skies are not the subject of the paintings; rather, they are the background to the herds of cows and flocks of sheep dominating the foreground (fig. 4). Indeed, Troyon's animals became so popular that he could not meet the demand himself; he hired Boudin in 1861 to fill in the backgrounds of his pictures while he concentrated on the animals. Likewise, Corot's works in the Salon of 1859 were not the pictures that we have come to identify with him, such as *The Moored Boatman* or the *Goat Girl beside a Stream, Lormes* (The Cleveland Museum of Art). Rather, they were

Fig. 5 Jean-Baptiste-Camille Corot, *Dante and Virgil*, 1859. Oil on canvas, 102½ × 67⅛ inches (260.5 × 170.5 cm). Museum of Fine Arts, Boston, Gift of Quincy Adams Shaw.

enormous, dark, brooding pictures, with subjects taken from Dante and Shakespeare (fig. 5). For Monet, these paintings represented the pinnacle of contemporary landscape painting. He was able to appreciate the less anecdotal aspects of Troyon's pictures, and he was much impressed with the different effects of light Troyon captured on canvas. So, too, he discerned the strength of Corot's compositions, his

Corot: Cat. 18

71

method of picture making, apart from the story being told. Monet most likely would have agreed with the assessment of Corot's art made by the poet and critic Charles Baudelaire in his review of the Salon of 1859:

> [H]e is one of the rare ones, the only one left, perhaps, who has retained a deep feeling for construction, who observes the proportional value of each detail within the whole, and (if I may be allowed to compare the composition of a landscape to that of the human frame) the only one who always knows where to place the bones and what dimensions to give them.[25]

If Monet could appreciate the underlying structure in Corot's paintings and Troyon's luminosity, he nonetheless was at the beginning of his career and had to train and study. He and his future colleagues Renoir, Bazille, and Sisley began the same way the Men of 1830 had: they entered the private painting studio of a teacher from the Ecole des Beaux-Arts, in their case, that of Charles Gleyre (1806–1874). Sisley and Renoir also matriculated at the Ecole, Sisley with plans to compete for the Prix de Rome, following the pattern set by Rousseau and Daubigny. For his part, Pissarro spent time in the studios of Heinrich Lehmann (1814–1882), François-Edouard Picot (1786–1868), and Isidore Dagnan (1794–1873).

Throughout the 1860s, this younger generation worked assiduously to gain official recognition in the Salon, with varying success. Pissarro, older and more experienced than the others (also perhaps more cautious, with a family to support), was able to show his paintings regularly throughout the decade. To lend credibility to his work, he gave the names of Corot and Anton Melbye (1818–1875) as his teachers when he exhibited in the Salons of 1864 and 1865. His conservatism extended to the execution of his entry for 1864, *The Towpath* (Glasgow Art Gallery and Museum), for which he prepared by making a full compositional oil sketch (Cambridge, The Syndics of the Fitzwilliam Museum), a procedure advocated by academic practice and one that Daubigny followed quite often with his riverine views. Monet, who is seen as the great rebel, tried to conform to the prevailing taste, albeit on his own terms in matters of touch and scale, in his efforts to insert figures into a landscape setting (*Women in a Garden*, Paris, Musée d'Orsay) or even a pure figure piece in 1866 (*Camille in a Green Dress*, Bremen, Kunsthalle).[26] When making marines, such as *The Pointe de la Hève at Low Tide* (Fort Worth, Kimbell Art Museum), he would enlarge smaller paintings to an appropriately grand Salon scale, as Pissarro did with *The Towpath*.[27]

Monet: Cat. 92

Despite Monet's hope that his large compositions would find favor with the jury, he was the most resistant of the four beginners to any teaching of a traditional nature that Gleyre might have given him. He was not impressed with Gleyre's teaching and early on began to seek his own way, having had a head start with Boudin in Le Havre. Although some of his compositions are reminiscent of those of the Men of 1830 and thus by extension relate to seventeenth-century Dutch precedents (*Forest of Fontainebleau*, Switzerland, Private Collection, Wildenstein 19), Monet himself felt much closer to a nineteenth-century painter, Johan Barthold Jongkind. Monet explained that Jongkind

Jongkind: Cat. 75

> asked to see my sketches, invited me to come and work with him, explained the why and the wherefore of his manner and thereby completed the teaching that I had already received from Boudin. From that time he was my real master; it was to him that I owe the final education of my eye.[28]

A comparison of subject matter and the broken-brushstroke technique of the two artists confirms Monet's assessment.[29] Monet's avowedly anti-academic stance argues against his submission to the kind of tradition embraced by Corot, Rousseau, Daubigny, and their generation.

The story of the young Impressionists and their attempts to enter the official art world is more complicated than that of the older generation. For one thing, much more documentation about their lives, both personal and artistic, is available in the form of letters, memoirs, and account books. Because their personalities are more accessible, it is tempting (and perhaps inevitable) to assign motives to their actions. Their characters become as much an object of

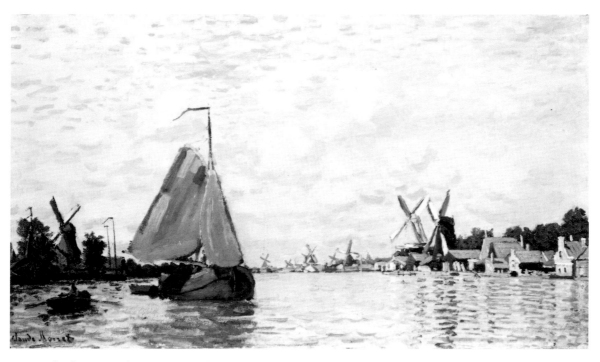

Fig. 6 Claude Monet, *The Zaan at Zaandam*,
1871. Oil on canvas, 16⅝ × 28¾ inches (42.2 × 73 cm).
Private collection.

study as their works. By contrast, very few personal papers of the older generation survive. The books written about them in the nineteenth century are often uninflected eulogies; such is the case with the books on Rousseau and Corot.[30]

If the story of the younger generation of landscapists is given texture by the wealth of personal information available, it is further enriched by the changes in the structure of the art world itself. The Men of 1830 saw little change in the institutional structure. They witnessed a glimmer of liberalization in the jury when, after 1848, artists elected by their peers judged Salon entries along with members appointed by the Academy. Corot and Rousseau, among others, had this honor. Yet in 1857 the composition of the jury reverted to the pre-1848 configuration; only Academy members judged the Salon entries. The backlash against this codified conservatism resulted in the Salon des Refusés and the restructuring of the Academy in 1863. Yet, when the jury was organized afresh, sympathetic voices on the jury were in the main restricted to Daubigny's. When he sat on the

jury in 1866 and 1868, he did what he could to allow works by his younger colleagues to be accepted, and it is largely owing to his efforts in 1868 that Monet, Bazille, Pissarro, Sisley, Berthe Morisot, and Renoir had the success they did. But Daubigny was soon accused of being a rabble-rouser. "If the Salon this year is what it is, a Salon of newcomers; if the doors have been opened to almost all who presented themselves; if it contains 1,378 more items than last year's Salon; if in this abundance of paintings, the official art cuts a rather poor figure, it is Daubigny's fault."[31] Daubigny supported the newer art financially as well as politically, buying a painting by Monet from Durand-Ruel in 1873, *The Zaan at Zaandam* (fig. 6). Interestingly, Daubigny did not buy one of Monet's radical compositions of Dutch canals but one that was more traditionally composed. Although Monet's brushwork is freer and his palette is more highly keyed than Daubigny's, *The Zaan at Zaandam* can be interpreted as homage to the older artist's riverine views.

The notion of continuity of plein-air land-

Daubigny: Cat. 57

scapists breaks down when instances of personal contact are examined. Corot was not as open-minded as Daubigny about the younger artists. Indeed, Corot disliked Daubigny's own *Fields in the Month of June* of 1874 (Ithaca, N.Y., Cornell, Herbert F. Johnson Museum of Art). He complained of Daubigny's freely brushed, loosely composed image: "His field of poppies is blinding. There are too many."[32] Although Bazille could write to his parents in 1869 that several established artists, including Courbet, Corot, Diaz, and Daubigny, supported the plan concocted by him and his friends to hold an alternative exhibition,[33] several years later Corot would have nothing to do with the group. When plans were underway to organize the first independent exhibition in 1874, Corot advised Antoine Guillemet (1842–1918) to submit pictures to the Salon instead of exhibiting with Monet and his friends. When Guillemet was admitted to the Salon and achieved some success there, Corot exclaimed, "Well, this little Antonin, saved at last! When he was with that dirty gang, I thought he was lost forever."[34] Monet's (long) memory is somewhat harsher.

> The *good* Corot. I don't know about that, but what I do know is that he was very bad for us. The swine! He barred the door of the Salon to us. Oh, how he slashed at us, pursued us like criminals. And how all of us without exception admired him! I didn't know him. I knew none of the 1830 masters; they didn't want to know us....[O]nly Diaz and Daubigny defended us, the latter energetically. He was on the jury, and he resigned [in 1870] because we were turned down.[35]

Félix Fénéon, a noted art critic of the late nineteenth and early twentieth century, recorded Monet's disappointment with Corot's attitude. After recounting an anecdote in which Diaz gave encouragement to Monet, Fénéon added, "But how much more Monet would have preferred to receive the endorsements of Daumier or of Corot instead of these! Corot, however, who was passionately admired by these new painters, did not at all understand the importance of their innovations."[36] Corot's pictures, the objects so admired by Monet and his colleagues, would have been only those that could be seen at the Salons or at dealers. Many of Corot's plein-air pictures, those which seem to form the conceptual basis for the tradition Monet continued and developed, were unavailable to most of the younger artists. Most of the pictures remained in Corot's studio until his death, to be seen there by friends and students; of the younger landscapists, Pissarro was the only one who knew Corot personally.

Part of Corot's lack of interest in the newer art can be ascribed to his age. He was very conscious of having been born in 1796, in the relative calm of the Directoire following the Terror.

> [B]y 1795 the bad days were in the past, it was the time of the Directoire, spirits were much more calm, confidence was renewed with the interior repose, and I was born in 1796, a little after the victory festival on the Champ de Mars, that is to say, well prepared with a robust constitution.[37]

If a man considered himself imprinted with the peace of 1795 when he was *in utero*, it is not surprising that he did not become involved in the revolutions of 1830 and 1848, much less the artistic changes of later in the century, when he was older and in increasingly poor health. Relative ages are important in this context; Corot was forty-four years old when Monet was born, sixty-three when Monet first saw the older man's paintings at the Salon. Corot was so much of an older school of thought that he had long found Delacroix's pictures too difficult to appreciate – and Delacroix was two years younger than Corot. Of Millet, whose mostly placid scenes of rural labor to us seem more pastoral than revolutionary, Corot said as early as the late 1850s:

> For me it is a new world; I no longer recognize myself there; I am too attached to the old ways. I see there a great knowledge of atmosphere, of depth; but it frightens me. I am slow in getting used to this new art. It has been only recently, and after having been for a long time distanced from it, that I have finally understood Eugène Delacroix, whom I now regard as a great man.[38]

If Corot had trouble appreciating the work of

Delacroix and Millet, it is understandable that he did not welcome the art of Monet, with his innovative technique and contemporary subject matter.

Corot's scorn for Monet and Monet's apparent resentment toward Corot and the disregard he felt for the tradition that Corot represented created an unbridgeable gap between the older and younger generations of landscape artists. While the Salon remained paramount for Corot and the Men of 1830, they were also able to enjoy the rewards of the emerging dealer economy. The benefits offered by the two systems in tandem, however, were unavailable to the young Impressionists. Although Monet had enjoyed comparative success at the Salons in the mid-1860s, by the late 1860s, harsh juries blocked access to the Salon when continued support would have been most welcome. Undaunted, Monet, a keen businessman, took advantage of new alternatives. In 1869, Boudin was able to describe Monet's solution to appearing before the public:

> Finally, his two paintings have been refused [by the Salon] this year, but he is taking his revenge by exhibiting at one of our [paint] merchants [in Paris], Letouche, a study of Ste.-Adresse, which has horrified his fellow artists. There is a crowd outside the window all the time, and for the young people, the generalization of this picture has produced fanatical responses. It is this which compensates for his refusal at the Salon.[39]

Monet expanded such exhibition opportunities, spearheading the organization of the independent group exhibitions. Yet when these were not as lucrative as he had hoped, he was willing to return to the broader forum of the Salon in 1880. His success there — and his first submission since 1868 — was not great enough to deflect him from other ventures, however. The year 1880 saw his first solo exhibition at a dealer's, which became his preferred mode of presenting his work to the public. The generation gap — best demonstrated by Corot's incomprehension of Monet's technique and subject matter and Monet's reluctance to submit himself to tradition — in the end rested not so much on matters artistic as economic. Changing institutional structures meant that the strategies of self-promotion that had worked for the Men of 1830 were no longer available for the young Impressionists. If Monet did not find success in the institutional context in which Corot had flourished, he was well endowed with the personality to use the new system of private entrepreneurship to full advantage.

NOTES

1. John Rewald, *The History of Impressionism*, 4th, rev. ed. (New York: The Museum of Modern Art, 1973). As always, thanks go to Marc Simpson for his unstinting advice, patience, and humor.

2. For a concise discussion of the Academy and the Ecole des Beaux-Arts, see Albert Boime, *The Academy and French Painting in the Nineteenth Century* (New Haven and London: Yale University Press, 1986), 1–8. See also the introductions to the Paris Salon reviews in Elizabeth Gilmore Holt, ed., *The Triumph of Art for the Public: The Emerging Role of Exhibitions and Critics* (Garden City, N.Y.: Anchor Books, 1979).

3. The term "impressionist" is a vexed one in the wake of the exhibition and catalogue *The New Painting: Impressionism, 1874–1886*, exh. cat. (San Francisco: The Fine Arts Museums of San Francisco, 1986), which demonstrated the lack of unanimity in style and aims among the exhibitors.

4. The material for this essay has been assembled from many sources. In addition to Rewald, I am particularly indebted to Robert L. Herbert, *Barbizon Revisited*, exh. cat. (Boston: Museum of Fine Arts, 1962). Various exhibition, collection, and oeuvre catalogues have been invaluable. Among them are: *Gustave Courbet, 1819–1877*, exh. cat. (London: Arts Council of Great Britain, 1978); Charles C. Cunningham, with Susan D. Peters and Kathleen Zimmerer, *Jongkind and the Pre-Impressionists: Painters of the Ecole Saint-Siméon*, exh. cat. (Williamstown, Mass.: Sterling and Francine Clark Art Institute, 1976); Sarah Faunce and Linda Nochlin, *Courbet Reconsidered*, exh. cat. (Brooklyn: The Brooklyn Museum, 1988); Madeleine Fidell-Beaufort and Janine Bailly-Herzberg, *Charles-François Daubigny* (Paris: Geoffroy-Dechaume, 1975); Nicholas Green, *Théodore Rousseau, 1812–1867*, exh. cat. (Norwich, Eng.: University of East Anglia, 1982); Robert L. Herbert, *Jean-François Millet*, exh. cat. (London: Arts Council of Great Britain, 1976); *Lighting Up the Landscape: French Impressionism and Its Origins*, exh. cat. (Edinburgh: National Galleries of

Scotland, 1986); Etienne Moreau-Nélaton, *Histoire de Corot et de ses oeuvres* (Paris: H. Floury, 1905); Alexandra R. Murphy, *Jean-François Millet*, exh. cat. (Boston: Museum of Fine Arts, 1984); and *Théodore Rousseau, 1812–1867*, exh. cat. (Paris: Réunion des musées nationaux, 1967).

5. William Hauptman, "Juries, Protests, and Counter-Exhibitions before 1850," *The Art Bulletin* 67, no. 1 (March 1985): 95–96.

6. Courbet to his parents, March 23, 1847, quoted from Georges Riat, *Gustave Courbet, peintre* (Paris, 1906), 45, by Alan Bowness in introductory essay in *Courbet*, 1978, 12.

7. Courbet to his parents, early January 1848, quoted from Gerstle Mack, *Gustave Courbet* (New York, 1951), 45, quoted by Bowness in *Courbet*, 1978, 13.

8. Bazille to his parents, 1870, in J. Patrice Marandel and François Daulte, *Frédéric Bazille and Early Impressionism*, exh. cat. (Chicago: The Art Institute of Chicago, 1978), no. 83, 182.

9. For a discussion and reproductions of the paintings that won the Prix de Rome, see Philippe Grunchec, *Le Grand Prix de peinture: Les concours des Prix de Rome de 1797 à 1863*, exh. cat. (Paris: Ecole nationale supérieure des beaux-arts, 1983).

10. Petra Ten-Doesschate Chu, "At Home and Abroad: Landscape Representation," in *The Art of the July Monarchy: France, 1830 to 1848*, exh. cat. (Columbia and London: University of Missouri Press, 1990), 116–30.

11. See Pierre-Henri de Valenciennes, *Elémens de perspective pratique, à l'usage des artistes, suivis de réflexions et conseils à un élève sur la peinture, et particulièrement sur le genre du paysage* (Paris, 1800). See also Jeremy Strick, "Connaissance, classification, et sympathie: Les cours de paysage et la peinture au XIXᵉ siècle," *Journal littérature*, no. 61 (February 1986): 17–33.

12. For a discussion of the sources for Corot's Salon paintings, see Fronia E. Wissman, "Corot's Salon Paintings: Sources from French Classicism to Contemporary Theater Design," Ph.D. diss., Yale University, 1989.

13. See discussion of Rousseau's training in Green, *Rousseau*.

14. Too many to cite here; a few examples include *Destruction of Sodom* (1843 and 1857, New York, The Metropolitan Museum of Art); *The Flight into Egypt* (1840, Rosny-sur-Seine, church); *Homer and the Shepherds* (1845, Saint-Lô, Musée des Beaux-Arts); *Dante and Virgil* (1859, Boston, Museum of Fine Arts); and *Macbeth* (1859, London, The Wallace Collection).

15. Courbet to Champfleury, c. 1860, quoted from a letter in Paris, Musée du Louvre, Cabinet des dessins, by Marie-Thérèse de Forges, in "Biography," *Courbet*, 1978, 34. See Anne M. Wagner, "Courbet's Landscapes and Their Market," *Art History* 4 (1981): 410–31, for a discussion of the kinds of pictures Courbet's patrons wanted, and the concessions the artist made, or did not make, to secure a following.

16. Harrison C. White and Cynthia A. White, *Canvases and Careers: Institutional Change in the French Painting World* (New York: John Wiley & Sons, 1965), 31; the authors cite the following figures for 1853: 250 francs for a third-class medal; 500 for a second-class medal; and 1,500 for a first-class medal.

17. Michel Melot, *Graphic Art of the Pre-Impressionists*, trans. Robert Erich Wolf (New York: Harry N. Abrams, 1981), see esp. nos. D5, 11, 50, 62, 64, 87, 89, 92, 93, and 98.

18. Daniel J. Sherman, *Worthy Monuments: Art Museums and the Politics of Culture in Nineteenth-Century France* (Cambridge, Mass.: Harvard University Press, 1990), explains the rise of the provincial museum in France.

19. For a partial discussion of this commission, see Fronia E. Wissman, "Corot's *Hymn to the Sun*," *Elvehjem Museum of Art Bulletin* (1983–84): 9–17. Rousseau's panels were of a *Setting Sun* and a *Spring Day*.

20. See Patricia Mainardi, *Art and Politics of the Second Empire: The Universal Expositions of 1855 and 1867* (New Haven and London: Yale University Press, 1987), for a wonderful discussion of this shift.

21. For the most useful discussions of the burgeoning art market in Paris, see Nicholas Green, "Circuits of Production, Circuits of Consumption: The Case of Mid-Nineteenth-Century French Art Dealing," *Art Journal* 48, no. 1 (Spring 1989): 29–34; his discussion of Théodore Rousseau's response to the market in his *Rousseau*; and the still helpful book by White and White, *Canvases and Careers*. From 1873 through 1875, Durand-Ruel, who became one of the main supporters of Monet, published six large volumes of prints reproducing stock on hand. Almost all of the three hundred prints were of landscapes, twenty-eight of which were of paintings by Corot, and another twenty-eight were of paintings by Georges Michel. Other artists represented were Rousseau, Daubigny, Millet, Troyon, Dupré, Monet, and Pissarro, but in far fewer numbers; Galerie Durand-Ruel, *Recueil d'estampes gravés à l'eau-forte*, preface by Armand Silvestre, 6 vols. (Paris: Maisons Durand-Ruel, 1878).

22. Faunce and Nochlin, *Courbet Reconsidered*, cat. no. 47.

23. Monet to Boudin, May 19, 1859, in Daniel Wildenstein, *Claude Monet: Biographie et catalogue raisonné*, 3 vols. (Lausanne-Paris: La Bibliothèque des arts, 1974), 1:419. All translations are the author's.

24. Monet to Boudin, June 3, 1859, in Wildenstein, *Monet*, 1:419. Curiously, Monet did not mention Boudin's own entry, his first to the Salon, *Pardon of Sainte-Anne-la-Palud, Gulf of Douarnenez (Finistère)* (1858, Le Havre, Musée des Beaux-Arts "Andre Malraux").

25. Charles Baudelaire, "The Salon of 1859," *Art in Paris, 1845–1862: Salons and Other Exhibitions*, trans. and ed. Jonathan Mayne (Ithaca, N.Y.: Cornell University Press, 1965), 197.

26. For a discussion of Monet's Salon career from the point of view of technique and style, see Kermit Champa, *Studies in Early Impressionism* (New Haven and London: Yale University Press, 1973), 1–32. For a close reading of the dissolution of genres in the 1860s, see Leila W. Kinney, "Genre: A Social Contract?" *Art Journal* 46, no. 4 (Winter 1987): 267–77. I would like to thank Paul Tucker for his helpful comments after reading a draft of this essay.

27. For a brilliant discussion of Monet's method, see John House, *Monet: Nature into Art* (New Haven and London: Yale University Press, 1986), in general and page 135 for this observation; see fig. 180 for the smaller sketch for *The Pointe de la Hève*.

28. Monet, in François Thiébault-Sisson, "Claude Monet: An Interview," *Le Temps*, November 27, 1900, quoted in Rewald, *Impressionism*, 69–70.

29. For an appreciation of Jongkind's contribution to mid-century plein-air painting, see Cunningham, *Jongkind and the Pre-Impressionists*.

30. Alfred Sensier, *Souvenirs sur Th. Rousseau* (Paris: Léon Techener, 1872) and Moreau-Nélaton, *Histoire de Corot*.

31. Castagnary, writing in the newspaper *Le Siècle*, speaking of the reaction to Daubigny of the comte de Nieuwerkerke, the superintendent of fine arts, quoted in Rewald, *Impressionism*, 185–86. It is difficult to determine how powerful a single voice on the jury could be; the comte could have been using Daubigny's name as representative of more than one juror's opinion, but Daubigny certainly was sympathetic to the younger landscapists' artistic goals.

32. Fidell-Beaufort and Herzberg, *Daubigny*, 71; see also Moreau-Nélaton, *Histoire de Corot*, 336.

33. For a history of alternative exhibitions, see Hauptman, "Juries, Protests, and Counter-Exhibitions," 95–109. For an account of Bazille's efforts to organize an independent exhibition, see his letter to his family in Marandel and Daulte, *Bazille and Early Impressionism*, no. 76, 180.

34. Félix Fénéon, "Bulletin de la vie artistique" (March 28, 1914), quoted in Charles F. Stuckey, ed., *Monet: A Retrospective* (New York: Park Lane, 1986), 36.

35. Quoted from René Gimpel, *Diary of an Art Dealer, 1918–1923*, from an interview with Monet on October 11, 1920, in Stuckey, *Monet*, 309. Another indication of Corot's attitude is the following: "He spoke severely about Pissarro; it was he himself who told us this. He gave Daubigny the honor of extolling Monet. As for Manet, his original temperament frightened him"; Moreau-Nélaton, *Histoire de Corot*, 247.

36. Fénéon, "Bulletin de la vie artistique," in Stuckey, *Monet*, 36.

37. Alfred Robaut's notes from conversations with Corot, Paris, Bibliothèque Nationale, Cabinet des estampes, Yb3 949 II.

38. *Corot raconté par lui-même et par ses amis*, Pierre Courthion and Pierre Cailler, eds., 2 vols. (Geneva: Pierre Cailler, 1946), 1:111.

39. Quoted in Champa, *Studies in Early Impressionism*, 32.

Confluence and Influence: Photography and the Japanese Print in 1850

DEBORAH JOHNSON

Of THE THREADS THAT TIE the nineteenth century into a coherent whole, none, perhaps, is more compelling than that century's obsession with issues of "objective" reality and perception. In the area of painting, particularly in France, landscape became the primary testing ground for this obsession. Landscape painting was less bound than other types by academic rules and regulations and could easily be checked against reality; and the land itself, in the face of nineteenth-century urbanization, had taken on the additional romantic appeal of a place of escape and the potential victim of extinction. While the artist might choose to work from nature or not, a certain level of verisimilitude was a growing expectation in nineteenth-century France, and artists began to search for ways to unite "objective" reality with artful perception. Many "new" arts were uncovered as part of this search, including British watercolors and seventeenth-century Dutch painting. None, however, was more significant than the tandem discoveries of photography and East Asian art, especially the Japanese print. Together, they provided artists with both the motivation and the structure to generate the profoundly new aesthetic premises of the modern age.

The reasons for their powerful influence are many and complex. Clearly a factor was the apparent "coincidence" of their near-simultaneous appearance. The announcement of the invention of photography was made in London and Paris in 1839, and China and Japan were both forced open to trade with the West during the period 1839 to 1854. More important, both the early photograph and the Japanese print deviated in many of the same ways from traditional western aesthetic conventions, and thereby reinforced each other's visual statements. Perhaps most important, however, they focused and gave direction to nineteenth-century concerns with reality and perception. The photograph was immediately accepted as the ultimate statement of visual truth in science and art. The "truthfulness" of the Japanese print was also lauded, however – a surprising position given the premises of decorativeness and non-illusionism fundamental to the print. Through the elements shared in common by the print and the photograph, the photograph gave impeccable credibility to the print. This, in turn, allowed access to and understanding of the print's essential abstraction. Without the precedent of photography, it is unlikely that the Japanese print (and East Asian art in general) would have captured western artistic imagination as significantly as it did.

It was particularly the landscape painters working in and around Paris in the 1850s who first betrayed the crises, experimentation, and modifications brought on by the appearance of photography and the Japanese print. The primary purpose of this essay is to establish a sound foundation for further study of this phenomenon: to show that specific opportunities existed for meaningful contact between these painters, photography (especially landscape photography), and East Asian art in a period earlier than has been considered to this point; and to investigate the ways in which the potential impact of the Japanese print distinguished itself

Fig. 1 William Henry Fox Talbot, *The Open Door*, 1843.
Salted paper print from a calotype negative.

from that of the photograph, thus providing some correction of the confusion that has accompanied discussions of this issue. Secondarily, Corot and Millet have been focused on in order to determine how key developments in art at mid-century might have been inspired by both photography and the Japanese print. Tangentially, it is fascinating to consider the bulk of evidence that suggests that the Japanese print was "uncoverable" some time before it was, in fact, uncovered. This gives a certain amount of weight to the notion that it addressed the needs and obsessions of the specific time in which it appeared, and that it is necessary that its impact be considered together with that of photography.

Although it has rarely been acknowledged, the diversity that characterized photography in France at mid-century is impressive. Despite the simultaneity of its invention, two very different kinds of photography had been developed in France and England by 1839. The Englishman William Henry Fox Talbot produced photographic prints on paper from a negative base, closely resembling modern photographic pro-

cesses. Characteristic of these prints was a grainy surface texture that subsumed detail in a warm, atmospheric veil (fig. 1). Aesthetically, this result was well suited to an age which had embraced similar effects in the paintings of Turner. Combined with the fact that Talbot jealously guarded his patent through the 1840s, it is not surprising that relatively little experiment evolved around the process in England before the 1850s.

In contrast, the French inventor of photography, Louis-Jacques-Mandé Daguerre, had produced works that differed from Talbot's on two critical points: since they were direct positives – that is, not printed from negatives – they were unique and not easily reproduced; and rather than paper, they were printed on small, shiny metal plates that would reveal their images only when held in specific relation to the light. Daguerre's invention was immediately bought by the State and made public to all. As a result, an enormous amount of activity by a wide variety of operators was generated which not only assured France's general leadership, but laid the groundwork for a near total reorientation of

French photography in the 1850s. France was not without its early and important paper practitioners, such as Hippolyte Bayard; but the 1850s saw a turn to paper that was so enthusiastic and informed as to produce major technological options and the earliest appearance of a variety of photographic styles.

The technique of the daguerreotype simply did not hold the commercial potential of the paper negative process with its promise of multiple prints. But the early French adherence to daguerreotypy was much more a stylistic than an economic issue. The cool, tightly focused, and rigorously planar daguerreotype (fig. 2) would easily appeal to the champions of the neoclassical mode still dominant among "important" painters in the Paris Salons. The shift to paper in the 1850s, with its very different aesthetic, reflected the stylistic "crisis" in French painting as it moved toward an increasingly painterly and idiosyncratic surface. As if announcing its bias, landscape photography, at its height as a genre in France in the 1850s and 1860s, almost invariably appeared on paper. To be sure, paper processes were easier to manipulate in the field *en plein air*. More important, the immediate source to which a mid-nineteenth-century landscape artist might turn for precedent consisted of the painters of the Romantic school and the painters of 1830. These two rich and painterly models automatically suggested to photographers the warm-toned, fuzzy-edged, sketch-like quality of the paper print.

From the beginning, examples of photography could be seen easily and frequently throughout Paris. The distinction of the first photographic exhibition belongs to Bayard, who in 1839 (the same year as the announcement of the invention of photography!) showed thirty of his paper prints in Paris. In 1844, nearly a thousand daguerreotypes by various photographers, including the Bissons, Claudet, Derussy, Plumier, Sabatier, and Blot, were shown in the important Exposition des Produits de l'Industrie Française.[1] Their exhibition as "industrial products" illustrated the controversial issue of whether photography most properly belonged to the domain of art or science. Photography did not move firmly into position for artistic consideration until the Great Exhibition of London in 1851. Over seven hundred photographs from six countries were exhibited, all under the category of "Science and Art."[2] Nonetheless, medal winners were most frequently lauded not for the achievements of their "science," but for the beauties of their "art." The Scottish photographers Adamson and Hill, for example, were cited as deficient in technique, but won honorable mentions nonetheless, and their portraits were compared to the best paintings of the day.

The all-encompassing category of "Science and Art" was retained in the 1855 Universal Exposition in Paris, where nearly five hundred photographs were exhibited, most notably including Crimean War images by Roger Fenton and landscapes by Gustave Le Gray.[3] In this same year, the newly formed Société Française de Photographie began to hold its own annual Salons outside the structure of any official art organization, and the third exhibition of the Société in 1859 attracted an unprecedented 30,000 visitors to view 1,295 pieces by 145 photographers.[4] Pure landscape images were well represented at the exhibition, where, interest-

Fig. 2 L. J. M. Daguerre, *Arrangement of Fossil Shells*, 1837–39. Daguerreotype. Musée National des Techniques, Paris.

ingly, they were placed in a separate category from travel, topographic, and archaeological views. The list of landscape entries is impressive and included views of the Bois de Boulogne by Jean Renaud, tree studies by Comte Aguado, flower studies by Adolphe Braun, interior courtyard scenes by Bisson Frères, views of Fontainebleau by Gustave Le Gray, and Compiègne forest scenes by Margantin (compared by at least one reviewer to landscape paintings by Théodore Rousseau).[5]

However, the 1859 exhibition of the Société was hardly more significant in its ramifications than the opening of official Salon doors to photographers in the same year, an event which crystallized the controversy regarding photography's status. As with Hill and Adamson in 1851, the photographer Nadar was compared to the best painters of the day, one reviewer going so far as to call him a Titian.[6] The leading spokesman for the opposition was none other than Charles Baudelaire, who published a now-famous denunciation of the technique. "Photography's real task," he wrote, " . . . is in being the servant of science and art, but a very humble servant like typography and stenography which have neither created nor improved literature."[7]

On a fundamental level, Baudelaire's position is a typically Romantic one of the time in its skepticism of the power of technology to create art. The kind of photography against which he spoke, however, was that patterned after paintings he disliked equally. For the most part, these works were sentimental, moralist, and maudlin, and heavily reliant on the realistic credibility of form for impact. More profoundly, it was this Realist "cult of nature" with which he was disturbed, its confusion with the beautiful, and the absence of dream and fantasy. To Baudelaire, an artist of this type no longer created life, but merely reproduced it. This led to questions of intentionality throughout the essay that became central to the debates around photography: like the Realist painter, how much control might the photographer exercise over the medium and predict and *intend* the results he or she achieved? Even critics sympathetic to photography, such

as Philippe Burty, could not allay this concern and, declaring photography the perfect instrument by which to record the age, underscored its "objectivity" and subsumed its potential for aesthetic creativity.

At this same time, travel books illustrated with photographs (or prints after photographs) proliferated and were significant on several levels: they appealed to the wanderlust of the age, widely popularized photography as a preeminent reproductive technique, and continued to identify it with notions of absolute reality. At least three great early programs of French photographic documentation found their way into print: Lerebours's *Excursions daguerriennes: vues et monuments les plus remarquables du globe [Daguerreotype excursions: the world's most notable views and monuments]* of 1841 and 1843, illustrated with prints after daguerreotypes; Girault de Prangey's photographs of Italy, Greece, and Egypt published in 1846; and the twenty-four portfolios published from 1851 to 1854 by the Imprimerie Photographique of Blanquart-Evrard, the most important publisher and proselytizer of paper photography in the 1850s. To varying degrees, all three ranged themselves within the tradition of Romantic travel lithography found in earlier publications such as the *Voyages pittoresques*, begun in 1819. It is the confrontation between aesthetic convention and empiricism, however, that makes these photographs so commanding and new. This is particularly true of a fourth project, the Missions Héliographiques, begun in 1851 to document systematically the great historic monuments of France. Although never published, its negatives formed an archive of public record and helped to keep photography in the French consciousness.

It is difficult to believe that the landscape painters of the 1850s could ignore the activity outlined above, particularly after photography's entry into the Salon; in fact, Barbizon forest scenes dominated the photography sections of the Salons of 1859, 1860, and 1861, and their photographers were regarded as international leaders of the genre.[8] It is inconceivable as well that the painters could have missed the photog-

raphers setting up tripods in "their" forests. Charles Marville, Edouard-Denis Baldus, Gustave Le Gray, Adolphe Grandguillaume, Charles Desavery, Paul Gaillard, Paul Delondre, Constant and Pierre Dutilleux, and Eugène and Adalbert Cuvelier all worked in and around the Forest of Fontainebleau from the late 1840s through the 1850s. Beyond this group, several other photographers at mid-century specialized in landscape, including Blanquart-Evrard with studies of rocky seascapes and trees from 1851–54; Henri Le Secq with landscapes and marines from the first half of the 1850s; Charles Nègre with views of the French provinces from 1851; and Louis-Alphonse Davanne and Ildefonse Rousset, whose landscapes and marines routinely won the highest praise in the press, beginning in the late 1850s.[9]

The relationship of photographers and their work with the Barbizon landscape painters can be drawn even more precisely. The experiments of Constant Dutilleux, Grandguillaume, and Adalbert Cuvelier with the photographic print process of cliché-verre while at Barbizon certainly inspired a number of neighboring landscape painters to experiment likewise. With this process, the artist "draws" a design with a sharp tool directly onto a glass plate coated with photographic collodion, and then exposes the plate against a sheet of sensitized paper to sunlight. Charles Daubigny, Théodore Rousseau, Jean-François Millet, and Camille Corot each produced a body of important clichés-verre, creating a significant pocket of artistic activity and absorbing photographic principles firsthand. Corot, more taken with the process than the other painters, also experimented with a less common technique: he painted the glass plate with varying degrees of opaque ink before exposing it to sunlight.

Earlier, in 1843, Daubigny had etched a landscape from a daguerreotype for Lerebours's *Excursions daguerriennes*.[10] Eugène Isabey owned several unusual daguerreotypes by Hippolyte Macaire of Le Havre whose marines were among the first to reflect an interest in (and capture) the phenomenology of waves, clouds,

and smoke in motion.[11] Virtually all of these individuals were themselves photographed. But no artists were more involved in photography – or at least documented as such – than Millet and Corot.

Millet counted among his acquaintances the photographers Nadar, Etienne Carjat, Félix Feuardent, and the Cuveliers, all of whom photographed him. On at least one occasion, in a letter of 1861 to Rousseau, he characterized Eugène Cuvelier's photographs as "very fine," and supposed that Rousseau had seen Cuvelier recently.[12] He frequently wrote friends, Feuardent among them, to request photographs that "would be useful" to him.[13] No doubt this relates to the observation of American painter Edward Wheelwright, studying with Millet in 1855–56, that the latter was positively enthusiastic about using photographs as an aid in landscape painting.[14] Millet is said to have explained that "photographs are like casts from nature, which never can be as good as a good statue. . . . But photography, used as we use casts, may be of great service."[15] While this pronouncement is conspicuously Baudelairean in tone, it is disappointing in revealing so little of how Millet actually used photographs.

Corot was especially friendly with the Dutilleux, Grandguillaume, and Cuvelier families. It was Grandguillaume and Adalbert Cuvelier who taught him the cliché-verre process with which he ultimately made more than seventy prints over the period 1853 to 1874. He served as best man at Eugène Cuvelier's wedding in Barbizon and went on to hire Pierre Dutilleux and Charles Desavery to photograph several of his paintings. Many photographers made his portrait – most notably, a stunning studio shot by Victor Laisné from c. 1852, less formal characterizations by Adalbert Cuvelier and Grandguillaume from 1852–53, and a charged and telling image, apparently by Charles Marville in 1854, of Corot and Narcisse Diaz posed on boulders in the Forest of Fontainebleau (fig. 3). At his death, more than three hundred photographs were found in his studio, two hundred of which were described by his biographer Alfred Robaut as "après nature" and which can

Fig. 3 Charles Marville, *Forest of Fontainebleau with the Painters Corot and Diaz Seated on Boulders*, 1854. Albumen print from a calotype negative. Bibliothèque Nationale, Paris.

be connected to Desavery, Grandguillaume, and the Cuveliers.[16]

Knowledge of photography on the part of French landscape painters can be readily established by mid-century; it is more difficult to determine the precise point at which accessible East Asian art – particularly the Japanese print – began to attract artists. Nonetheless, there is no question that East Asian art and photography were entering public consciousness at the same moment.[17] Japanese art was, in fact, available long before the traditionally accepted date of 1856, when Japanese prints were said to have been discovered by French printmaker Félix Bracquemond, or even 1854, the date of the first opening of Japanese ports to trade. As will be discussed further on, the awareness of alternative pictorial structures and the apparent turning point in the work of many of the landscape painters in this decade indicate the influence or at least the knowledge of Japanese art.

A certain amount of controversy has surrounded the question of exactly how accessible East Asian art was in western Europe prior to 1860, or even if it was available at all. Both

China and Japan were officially closed to free trade with the West from 1621 and 1639 to 1842 and 1854, respectively; this stricture was rigorously enforced by Japan, which expelled all foreigners except for the Chinese, Koreans, and Dutch. Even in Japan, however, official policy toward the West was not an even-pressured stranglehold on free enterprise, but responded to the ethos of particular eras and rulers, tightening and loosening in turn. In addition, there were regular and predictable opportunities for contact with, trade in, and purchase of indigenous objects on the part of foreigners and nationals alike. This resulted in the establishment of legitimate public collections of Japanese and Chinese art and craft in the West decades before this art was said to have been "discovered" in France.

China, which had prohibited trade, travel, and immigration before Japan, experienced particular difficulty enforcing this policy.[18] Foreign ships were allowed to sail into China "with tribute," and although they were forbidden by Chinese law, Chinese merchants maintained an active import/export station in Japan. After Ming emperors (from 1684 to 1717) failed to enforce the ban on foreign trade, it was abolished; thus, at a productive moment in its own artistic history, China became the veritable center of trade in the East – a position that no future edict was able to assail. What had been in the early sixteenth century a trickle of classic Chinese goods westward swelled in the next century into a flood of diverse objects. By 1692, in Paris alone, there were no less than twenty dealers specializing in Oriental items, and many of the great historic collections of Oriental porcelain and lacquer date from this period. Significantly, this would include the French royal collection nationalized at the end of the eighteenth century, and public collections originally established by aristocratic houses shortly thereafter.

Japan was far more effective in the observation of its own regulations. Nonetheless, Japan was also represented in the marketplace with diverse products by the middle of the seventeenth century. Foreign trade with China was

interrupted in the 1650s, and the Japanese profited by the hiatus not only with the marketing of their own goods, but with imitations of Chinese objects. In 1686, two years after China abandoned commerce restrictions, the so-called Siamese ambassadors (who were, in fact, a trade delegation) arrived at the court of Versailles with a wide range of Japanese and Chinese works of art to present to the king. The most reliable sources of Japanese products in the West, however, were the Dutch merchants allowed to remain in Japan. The Dutch were initially engaged in the shipping of vast quantities of gold, silver, copper, and camphor mined in Japan. After 1668 and the prohibition of these exports, invoices of official trade activities reveal that attention was turned specifically to porcelain and lacquerwork, and secondarily, to decorative papers, folding screens, furniture, and textiles.

However, it becomes clear from examining the activities of the United East Indies Company – the umbrella organization for Dutch presence in Japan – that documented trade in the following century represented only a part of the picture. Despite dissolution in 1796 under pressure of increased Japanese restrictions, the company did not alter the number or tasks of its employees in Japan. Although legitimate trade was now precluded, private smuggling became the raison d'être for continued Dutch presence. It is undoubtedly through these means that forbidden export items, such as maps, prints, and books (which the government believed to contain information about Japan it did not wish to share with the West), entered western collections.

Throughout this period, the Dutch remained the source not only of Japanese goods in the West, but also of information and publications about their host nation. While much of this activity was necessarily centered in northern Europe, it was in the early 1780s that the first privately owned, indigenous Japanese works entered France with the chief of the Dutch delegation in Japan, Isaac Titsingh. When Titsingh died in Paris in 1812, France was the center of scholarly interest in the East, largely as a result of the presence of three leading Orientalists in Paris: Abel Rémusat, Julius Klaproth, and

A. Nepveu. All three collaborated on the editing of Titsingh's memoirs and the cataloging of his collection, published posthumously as *Illustrations of Japan* (London, 1822). An extremely popular publication, it is remarkable not so much for its information on Japan (most of which had already appeared elsewhere), but for its authenticity: the presentation of Japanese literature in translation and illustrations that suffered only a minimum of change at the hands of western printers.

As potential source material, Titsingh's art collection was as important as his book, and most of it can be reconstructed at least in type.[19] Nepveu wrote that upon Titsingh's death, certain of his effects were put up for sale, primarily "ordinary furniture" and a few articles of "Chinese locksmith's work." Indeterminate items were disposed of by Titsingh's son in 1814, and in 1820, Nepveu claimed to have purchased all of Titsingh's Japanese drawings, paintings, curios, and very likely, the notes that became *Illustrations of Japan*. However, in 1827, one painting, 59 *objets*, and 126 drawings from the Titsingh collection, among other collections, were put up for sale in Paris. More items turned up at auction the following year among a group of Chinese and Persian paintings and 200 Chinese porcelains, and again in 1832, at an auction presided over by Nepveu. Several other pieces, primarily books, manuscripts, and letters, were sold at auction by Klaproth in 1840. These were significant enough to have been purchased, in part, by the British Museum, while others eventually made their way into the Victoria and Albert Museum. It is important to emphasize here that these items were on the open market in Paris at least by 1827 and perhaps as early as 1812.

The two-dimensional works can best be divided into two parts: books and manuscripts about Japan; and Japanese prints, drawings, and paintings, bound and unbound. The former category included a complete set of the *Dai-Nihon-Shi*, an important and monumental history of Japan published in 243 volumes between 1697 and 1715 that Titsingh donated at the end of the eighteenth century to the Bibliothèque du Roi; the set was consulted by the painter

Jean-Honoré Fragonard. The latter category included *Nagasaki-e* (literally, pictures from Nagasaki which reflected the influence of western presence in subject, style, or technique), Nagasaki scroll painting (highly traditional, somewhat unskilled, and strongly Chinese in feeling), and single-figure color prints of women in oban size (15×10 inches). This last type of work was done exclusively during the Edo period (1615–1867) and, more specifically, can be dated between the years c. 1740, when color-print technology was introduced, and 1784, the year Titsingh left Japan. This particular era represents the height of the Japanese print phenomenon *(ukiyo-e)* and had an enormous impact on European artists of the second half of the nineteenth century.

Not long after its publication, *Illustrations of Japan* was superseded by the work of another former Dutch resident in Japan, Dr. Philip Franz von Siebold.[20] Of Siebold's many scholarly publications, none was more significant than *Reisen in Nippon [Trips to Japan]*, published in France in 1838 as *Voyage au Japon*, which became the definitive source on Japan until the end of the century. Of five volumes, two are wholly devoted to illustrations, primarily by or after Japanese artists such as Nagasaki painters Buntsui, Takesaki, and Kawahara Keiga (Toioski), and the leading *ukiyo-e* printmakers of the landscape genre, Hiroshige and Hokusai. Hokusai is, in fact, the best represented of any artist, and most of these images can be traced to the first ten volumes of his fifteen-volume *Manga* (fig. 4), perhaps the most influential piece of Japanese art to enter the West. Significantly, Siebold's *Voyage au Japon* is the first European publication to refer to the *Manga* by name. Equally significant, many of the illustrations were reprinted in popular French periodicals soon after its publication, most notably in the well-circulated *Le magasin pittoresque*.

Siebold's *ukiyo-e* collection is still regarded as among the finest in the world. Not only did it include huge numbers of Hokusai and Hiroshige prints (somewhat predictable given the growing landscape bias in Japan during Siebold's stay from 1823 to 1829) but also rare

Fig. 4 Hokusai, "Harvesting Rice," *Manga [Sketchbook]*, vol. 3, 1815. Woodblock print.

works of the eighteenth century by Masanobu and Harunobu – and even a number of prints considered by historians unavailable in the West until late in the century, such as the ornate two-volume masterpiece *Jehon musi no erabi* by Utamaro and highly desirable metal-ground actor portraits by Sharaku. Precisely how accessible these works were before 1837 is unclear. In that year, however, Siebold constructed a museum in Leiden to house his collection and mounted the first recorded exhibition of his prints. This was augmented by *ukiyo-e* donated to the Royal Cabinet of Rarities at The Hague by two other Dutch colonists in Japan, J. Cock

Fig. 5 Hokusai, "Peasants Climbing in the Fog," *100 Views of Mount Fuji*, vol. 1, 1834. Woodblock print.

Blomhoff and J. F. Van Overmeer Fischer; these prints may have been on view as early as 1824.

Over the next fifty years, all three collections would be absorbed into major archives. In 1845 Siebold founded the Japanese Library at the University of Leiden, an institution which had already received works owned by Blomhoff and Fischer. This became the State von Siebold Museum in 1859 and finally a Rijksmuseum in 1864. Siebold's collection was well known enough to have attracted a variety of French visitors, including the preeminent porcelain specialist Albert Jacquemart in 1852 and author-critics Jules and Edmond de Goncourt in 1861. In 1883 the collection was merged into the National Museum of Ethnology in Leiden, where most of it still remains.

From the 1830s, French interest in Japan quickened decisively. Between 1826 and 1854, a variety of Oriental societies, journals, and reviews appeared, as well as translations by Klaproth and Hoffman of Japanese texts complete with reproductions of original Japanese prints. In terms of illustrative material, the most notable publication of this type may have been the *Forms of the Passing World, in Six Folding Screens*. Translated by the Austrian linguist August Pfizmaier, it was characterized as "a Japanese romance in the original text containing facsimiles of fifty-seven Japanese woodcuts."[21]

The *Didot-Bottin annuaire*, the annual Parisian business gazette, recorded increasing numbers of boutiques specializing in Japanese objects, forming an enclave along the rue Vivienne. Most, like *Giroux et Cie.*, dealt primarily in porcelain and were seasoned, respected merchants. Perhaps the most diverse in stock was the shop of the Houssayes which opened in 1826 as a tea-importing firm selling Japanese objects as a sideline. By 1842 it could advertise that it "held and directly received from China and Japan . . . rare and curious objects in porcelain, lacquer, ivory, paper, fans, material, and furniture."[22] Within the next decade, J. G. Houssaye had moved the firm to a new location on the rue Vivienne and christened it *A la porte chinoise*. This was the same boutique where artists like Edouard Manet, Edgar Degas, and James McNeill Whistler would later compete for choice robes and *ukiyo-e*. The street itself, as the art and auction district of Paris, would traditionally have attracted artists.

In 1842, in order to bring the bloody Opium Wars to a halt, China surrendered Hong Kong to Britain, opened four harbors to free trade, and granted foreigners the right to live in port and to journey inland. At this moment, Chinese objects were exported in unprecedented quantities, but the type and kind seem to have changed little. The same could be said for the impact of the opening of Japanese ports in 1854. Still another shop, *L'empire chinois*, appeared on the rue Vivienne by 1856, and at least one major auction per year was recorded in Paris: for example, in 1856 nearly two hundred Japanese objects were sold by the former commissioner of commerce of Japan; in 1857 three lots totaling nearly a thousand pieces of Chinese and Japanese art were sold by the duchesse de Montebello; in 1859 an anonymous collection of 114 Chinese and Japanese objects was sold; and in 1860 a collection of 323 items.[23]

Both China and Japan were well represented at the Great Exhibition of 1851 in London, although neither government participated officially.[24] Dominating the display were artistic items such as furniture, porcelain, screens, lacquer, prints, drawings, and paintings; and the British Museum took advantage of the exhibition to acquire *ukiyo-e* by the printmakers Shuntei and Masayoshi. Four years later in Paris at the Universal Exposition, Japan and China were apparently not represented at all. Although one might expect that collectors and merchants would have displayed Oriental wares as they had in 1851, the political climate may have precluded this: Sino-European relations were shrouded in the aftermath of rekindled hostilities, and Japan was in the throes of invasion by a number of western powers. In 1857 a relatively small international exhibition in Manchester, England, although lacking official British support, was nonetheless able to construct an "Oriental Museum." According to French critic Théophile Thoré, porcelain and pottery were represented by those nations' "most brilliant examples," and in a general discussion of prints, he cited the presence of *ukiyo-e* and the "old woods [used] for the illustration of Japanese books."[25]

Several more books on Japan, important for their faithful reproductions of *ukiyo-e*, increased the quantity of source material on that art. Adalbert de Beaumont and Eugène V. Collinot produced a large and lavish portfolio in 1859 entitled *Recueil de dessins pour l'art et l'industrie [Collection of drawings for art and industry]* based for the most part on prints from Hokusai's *Manga* (fig. 4), *Ringa*, and *100 Views of Mt. Fuji* (fig. 5); Laurence Oliphant's two-volume *Narrative of the Earl of Elgin's Mission to China and Japan*, published in Paris in 1860, was illustrated by over fifty prints, primarily from the *Manga*, from the *100 Views of Famous Places in Edo* by Hiroshige I or II (fig. 6), and from the

Fig. 6 Hiroshige, "Moon Pine at Ueno," *100 Views of Famous Places in Edo*, 1857. Color woodblock print.

Fig. 7 Charles Nègre, *Oil Presses at Grasse, France,*
1852. Gelatin-silver print from a calotype negative.

54th Chapter of the Tale of Genji by Kunisada II;
and the baron de Chassiron's 1861 publication,
Notes sur le Japon, la Chine et l'Inde, included
fifteen facsimile colored woodcuts, most after
the *Manga*, but several from other Hokusai
publications such as the *100 Views of Mt. Fuji,*
the *Hokusai Gafu*, and the *Hokusai Gashiki.*

Most of this heightened activity in the 1850s
involved a sophisticated respect for and under-
standing of the art of East Asia that, as the dis-
cussion above suggests, developed over a long
period of time. For this reason, it is difficult to
accept the common notion that Japan was
"rediscovered" by the West only after 1854, and
impossible to accept the artistic apocrypha that
is the corollary to this: that the first piece of
ukiyo-e uncovered in France was found in 1856
as packing in a crate of porcelain.[26] The sup-
posed work in question, yet another volume of
Hokusai's *Manga*, was already in the collection
of the Bibliothèque Nationale in 1843, and by
1856, it was on the verge of near-cult status.

There is little question that the landscape
painters of the 1850s would have had ample
enough opportunity to examine the "alterna-
tive realities" represented by the photograph
and the Japanese print, and that they would have
been attracted to the options they presented.
Already characterized as renegades by the Salon
system and established hierarchy of the arts,
these artists were free to explore the new, the
experimental, even the controversial. More
important, both the photograph and the Japa-
nese print presented themselves most impres-
sively – in terms of quantity and quality – in
the area of landscape. Although some of these
painters had begun to question the French land-
scape tradition prior to 1840, it is unlikely that
they had as yet perceived viable means toward a
redefinition of that tradition; however, the
appearance and experience of photography and
the Japanese print over the period 1840 to 1860
provided those means, especially as both the
photograph and the print held certain powerful
pictorial idiosyncrasies in common.

It may have been Edmond de Goncourt in his
book on Utamaro of 1891 who first noted that
photography and the Japanese print offered cer-
tain mutually supportive pictorial systems.[27]
On the most fundamental level, both the photo-
graph and the print presented a destabilized
definition of reality, at least in terms of tradi-
tional structure. Paintings in the dominant
western Renaissance tradition were typically
contained and finite, the proverbial "window
onto the world" in which a box of space, clearly
defined by non-intrusive framing edges, pre-
sented that world as calculable and whole. In
contrast, the photograph and the print pre-
sented a fragmentary view of the world based
upon discontinuous forms and unexpected jux-
tapositions. The factors generating this frag-
mentary view differed.

The early photographer, only moderately in
charge of the edges of the image, unavoidably
truncated incidental objects while focusing on
the real point of interest (figs. 7 and 8); it is part
of the genius of photography that as its aesthetic
matured, "haphazard" cropping was exploited as
a positive characteristic, evolving into the genres

Fig. 8 Gustave Le Gray, *Forest of Fontainebleau,*
1851. Albumen print from a waxed paper negative.

Corot: Cat. 26

of the *instantanée* and the snapshot, and even-
tually influencing painting attitudes. Similarly,
the absence of finite framing edges in Japanese
art was inherent from its beginnings in the
scroll form. Within this format, space literally
unrolled as narrative continuity without defini-
tive beginning, middle, or end. As *ukiyo-e*
developed, printmakers saw no need to restrict
themselves to the small and regularized sizes of
the woodblock – although the block itself might
end, the image frequently spilled over onto sev-
eral other blocks, resulting in similarly truncated
forms. One need only compare a typically stable
and timeless landscape in the Renaissance tradi-
tion from early in the century with a more ran-
dom, destabilized image after mid-century to
appreciate the radical shift in reality-definition
this represents.

These types of framing edges encouraged
other formats that the photograph and the print
shared. Suggestions of arrested motion were
most common: a spirit of temporality, momen-
tariness, or movement continuing beyond the

frame into "real" space that dramatically con-
tradicted the whole, contained, and timeless
quality of pre-modern painting. Most notably,
the intrusive framing edge encouraged signifi-
cant perspectival miscues. This primarily took
the form of aggressive abutments of near and
distant zones. *Ukiyo-e* artists, particularly in
the nineteenth century, cultivated this dramatic
impact and, in fact, heightened it, by allowing
the entire image to pull to the surface (fig. 6).
Photographers, on the other hand, soon learned
to work against this: a broad empty foreground
is among the most typical characteristics of
early photography, assuring that the main motif
is pushed back at least to middle distance. This,
in itself, tended to introduce a perspectival rush
into space that threatened to exaggerate or dis-
tort the relationship between zones. Either way,
the representation of three-dimensional space
within a rational, centralized one-point perspec-
tive system – the Renaissance box of space –
was potentially subverted. The dynamic tension
resulting from perspectival miscue became

Courbet, Millet,
Monet: Cat. 41,
89, 95

increasingly systematized in landscape painting at mid-century.

Where, then, did the photograph and the print part company in what they could offer the landscape painters at mid-century? It is obvious that the apparently "objective" reality offered by the camera image would be a compelling factor, one with which artists would have to come to terms. Art critics began to demand increasingly "correct" views and painted images and by mid-century, in a kind of self-fulfilling prophecy, noted a shift toward more "objective" painting. In fact, with a few notable exceptions, such as Narcisse Diaz, nearly all the progressive landscape painters began to distance themselves markedly from Romantic pictorial conventions around 1850. These artists were first lauded, then faulted for their relationship to camera vision. Rousseau was criticized by Baudelaire for a mechanical response to nature, and Emile Zola charged more directly that "a highly colored photograph must be his [Rousseau's] ideal."[28] Charles Blanc accused Daubigny of idealizing the camera image, while the artist was at pains to dissociate himself from the "banality" of the photograph.[29] Meanwhile, in a series of satirical cartoons, Nadar offered Daubigny the backhanded praise of suggesting that one could swim in his marines, and Corot's drawings were favorably compared with photographs by Le Secq.[30]

Finally, with Baudelaire as leader of the charge, photography became the polemic with which to attack the Realist painters. What had begun as unreserved praise for the "truth" of the camera was initially followed by the insistence that artists represent their subjects more accurately, but then the critical tide unequivocally reversed itself. Even Burty, usually a supporter of photography, characterized photographer Comte Aguado as a match for the Realists in creating works that "live but do not think."[31] Photography was perceived as "unfeeling," to be used by painters not as model but as aide-mémoire.

The linking of Realist painting with photography at mid-century was, of course, based on more than the observation that both pursued a passion for simple truths or a representation of the quotidian and mundane. Realism as expressed in the work of its leader, Gustave Courbet, and in photography, represented an intense "search for archetype"[32] that invariably resulted in an insistent, iconic quality of subject. This effect was to some degree unavoidable in the early photograph. Long exposure times, mechanical patterns of light, and the relative absence of middle tone gave to the photograph a blunt and hyper-literal quality. This was heightened to a compelling degree not only in the work of Courbet, but also in that of Manet and much of the painting that followed.

It was the treatment of light, however, as a significant and unique factor in the photograph that was perceived as its single strongest aesthetic contribution. Many critics noted its magnificent effects, especially the unparalleled depth and richness of tone common to both the daguerreotype and the paper print. In addition, the symbolic importance of light as the maker of the camera image should not be underestimated in an era which nurtured major advances in the optical sciences, venerated the seventeenth-century Dutch painters, and finally spawned the celebration of light that is called Impressionism. More than an interest in the phenomenology of changing patterns of light which both shared, photography and landscape painting at mid-century saw sun and light as virtual generating forces. Le Gray wrote that it was the manipulation of light that allowed the photographer to control the image and that image's final outcome:

> The artistic beauty of a photographic print consists nearly always in the sacrifice of certain details; by varying the focus, the exposure time, the artist can make the most of one part or sacrifice another to produce powerful effects of light and shadow, or he can work for extreme softness or suavity copying the same model or site depending on how he feels.[33]

This transformation of a world in full color into "powerful effects of light and shadow" must have been compelling to a generation of

painters traditionally more attentive to chiaroscuro than to hue. Burty noted that the broad massing of light and shade was something of a speciality of French photographers, as opposed to the greater concern with detail manifest in the work of the English.[34] The context for this speciality was clearly derived from French painting tradition and its concern with broad, sweeping *effet*. For photographers, *effet*, as abstracted patterns of light and shade, came to be closely linked to modern notions of the "real" and "natural" in landscape. For the landscape painters, this must have represented the resolution of traditional goals with non-traditional vision.

More than any other painter of his circle, Rousseau was routinely linked by contemporary critics, pro and con, to photographic naturalism. No painter, however, was more substantively influenced by the principles of photographic light and *effet* than Corot. It has frequently been noted that around 1848, Corot's style and apparent interests shifted dramatically. From an early style heavily dependent on architectural structure, hard-edged linearity, and geometrically based formal relationships, Corot broke through to an overwhelming concern with light effects, particularly with light as it dematerialized the earlier solidity of his forms. The result was a new and sweeping atmospheric veil that would be impossible to explain without the precedent of the paper photograph (fig. 7). His "sacrifice of detail" for a "feeling of extreme softness" is a virtual illustration of Le Gray's pronouncements; but more specifically, the blurring of leaves against the sky and halo of light around these forms – the latter an unavoidable chemical phenomenon known as "halation" – specifically point to the paper print with a coated glass negative popular after 1850 as source.[35] Significantly, this technique also de-emphasized dramatic tonal contrasts in favor of a more even gray cast, a kind of "tonalism" that is predominant throughout Corot's middle period.

Corot: Cat. 23, 24, 37

The interest in photographic light is no doubt key to understanding Corot's intense involvement with cliché-verre during this same period (fig. 9); the process provided a means to test and check light and relative values as a natural phenomenon literally created by the sun. This experimentation with value and tone is the primary link among most of his clichés-verre, as well as an insistent graphic quality also apparent in his paintings at this time. In the latter, silhouettes of trees rendered stark against the sky are full of the charged and nervous mark-making exploited in the clichés-verre. Not coincidentally, these qualities were also commonly found in early paper prints in which the middle tones had been dropped out, emphasizing silhouette, edge, and linearity (fig. 8). In all three – Corot's paintings of the period, his clichés-verre, and early paper photographs – this encouraged a wealth of illusionistic surface

Fig. 9 Jean-Baptiste-Camille Corot, *The Gardens of Horace*, 1854. Cliché-verre. Museum of Art, Rhode Island School of Design, Gift of an Anonymous Friend.

incident, touch, and a kind of painterly quality that grew increasingly autonomous. In fact, it must be considered that the phenomenon of autonomous brushstroke as it evolved into Impressionism had among its immediate precedents not only Corot, as is traditionally asserted, but the mid-century landscape photograph with its rich and abstract surface activity.

It is unlikely that at any point after 1840 a painter could approach the landscape without photographic principles of naturalism in mind, specifically, its conventions of fidelity, *effet*, and graphic surface. Certainly by 1850, these conventions had become synonymous with the "real" and the "natural" in landscape, and works which eschewed these conventions were often characterized as artificial. There is no question that photography provided Corot with a specific vocabulary by which to break out of architectural formalism into his now-famous naturalism. As with several of the Barbizon painters, the question of what exactly encouraged this shift remains open. It is probable that each had forged a new and more direct dialogue with visual phenomena by mid-century, but equally probable that this dialogue itself was inspired by the example of photography.

It was this emphasis on naturalism that may have been an early factor in the popularity of East Asian art and, specifically, the nineteenth-century Japanese landscape print that came to dominate interest in France. Its arrival in the West fit right into nineteenth-century archaeologizing impulses or, more commonly felt, nineteenth-century wanderlust. Publications catering to this wanderlust, such as the *Voyages pittoresques* (1819–78) helped to cultivate taste throughout the century for humble images of humanity in the context of a simplified nature.[36] While this was in marked contrast to British notions of nature as the experience of the dramatic and the sublime, this taste is uniquely paralleled in prints by Hiroshige and Hokusai, especially in the latter's *Manga*, and might account for the considerable popularity of this work in France at mid-century.

No one could have felt the humble symbiosis

of humanity and nature as expressed in the *Manga* more profoundly than Millet, who at least by the early 1860s owned a volume from the series and had begun to collect Japanese prints in earnest. He shared this interest with Rousseau, said to be his closest artist friend. Millet's biographer, Alfred Sensier, recorded a tiff among the three in 1864 over the acquisition of certain prints. Millet wrote the latter: "What plaguey wind is this that blows on us from Japan? I, too, came near having a very disagreeable affair with Rousseau in regard to some pictures which I brought back from Paris. While I wait to hear what happened between you and Rousseau, I want you to believe that no sort of meanness has been done by me toward you. . . . "[37]

Millet's own *Manga*-like images of men and women at work on and struggling with the land first appeared around 1846. It is not impossible for him to have examined the *Manga* by this date, and if he had not, the mutuality of spirit and language between the two must be acknowledged as remarkable. However, it is more significant that through the 1850s, Millet's figures grew increasingly idiosyncratic in pose, gesture, and activity – in much the same way that Hokusai was intensely involved in the quirkiness of body posture as it pushed and pulled at the earth. This is, of course, the same quality that would later attract Degas to both Millet and the *Manga*. It is particularly apparent in Millet's drawings – the area in which the artist typically tested out new ideas and produced works more daring and experimental than in any other medium. His highly contrasted black-and-white drawings are especially sympathetic to Hokusai's similarly monochromatic scheme in the *Manga*; in addition, both stressed a charged, dynamic, and information-laden line.

Millet's response to the monochromatic works of Hokusai and to their rich and varied line continued through the 1860s, and came to a climax after 1866 in a group of startling pen and ink drawings, such as *Plain at Sunset* of 1869 (fig. 10). This work, based wholly upon the shifting rhythms of reed pen, provides a variety

Millet: Cat. 80

Fig. 10 Jean-François Millet, *Plain at Sunset*, c. 1869.
Pen and brown ink, 8⅛ × 7¹/₁₆ inches (20.8 × 18 cm).
Musée du Louvre, Département des Arts Graphiques,
Paris.

throughout this decade we can also perceive a general trend toward more daring approaches to color. At its simplest, this might take the form of higher-keyed color or the adoption of dramatic contrast for which there is little precedent in the West.

Once again, it was in drawing that Millet seemed to test this new approach to color. By the middle of the 1850s, he began to reintroduce color slowly and tentatively into his drawings, injecting passages of pure local color into schemes that still revolved around the establishment of mid-tone. By 1865, however, when he took up drawing in earnest in a series of pastels commissioned by Emile Gavet, he presented a fully mature and jewel-like palette based on color contrast and intensity not easily matched by any other artist in this decade. This is equally reflected in paintings of this period. Works like *Starry Night* (New Haven, Yale University Art Gallery) from 1855–67 and *Spring* (Paris, Musée du Louvre) from 1868–73 would be virtually inexplicable without taking into account the example of the Japanese print and its emphasis upon color; more importantly, the function of color as shape and form and the concomitant devices of silhouette and value reversal are dramatically non-western in origin, and prove Millet to be at the forefront of Japanese color impact.

This sophisticated understanding of the function of color in the color print becomes clear in comparing Millet's work with Rousseau's. Rousseau, too, began to collect Japanese prints at least by the early 1860s, and a similar shift to consistently higher intensity color in his work became apparent at the same time. While this was a significant development, demonstrating the artist's ability to move in a radical direction even in old age, Rousseau nonetheless retained respect for color as atmosphere and for the establishment of a strong middle tone. In fact, Zola's charge that Rousseau's ideal "was a highly colored photograph" was incisive. As the decade progressed, Rousseau's painting revealed the dual impulses of photographic naturalism and a growing intensity of color. Nowhere, how-

of marks whose nearly autonomous function later influenced van Gogh in drawings which were in turn ascribed to the study of Japanese art. At this same time, however, Millet initiated a new phase of dialogue with the Japanese print. His interest no longer remained focused upon the monochromatic figure studies of Hokusai, but began to shift decisively to the highly colored landscape prints of Hokusai and Hiroshige (figs. 5 and 6), reflecting, no doubt, the greater general interest in these works. It is probably not coincidental that Millet's first concentrated interest in pure landscape can be dated to this point in the mid-1860s; in concert with this, color became not only prominent but dominant in his work.

With the important exception of the *Manga*, the nineteenth-century Japanese print positively commanded attention in its strength of color: bright primary hues without interceding half-tones not only contradicted traditional western emphasis on color transition through chiaroscuro, but also ignored subtle tonal traditions in Japanese art as well. Just as c. 1850 we can trace a shift to a kind of photographic naturalism in the work of several landscape painters,

ever, does color achieve the abstract autonomy of form as it is found in Millet's coloristic works of the same decade.

The importance of Japanese color was not restricted to highly keyed contrasts and general intensity. In its most sophisticated use, bright, local color without half-tone produced an aspatial, surface-oriented image by precluding modeling in depth. In the Japanese print, this tendency to flatness was purposefully cultivated by many of the devices described earlier: the intrusion of the framing edge which visually pulled objects to the surface plane of the work, and raw abutments of foreground and background zones which eliminated any rational suggestion of spatial illusion. Historians have asserted that the early photograph was similarly prone to flattening effects, especially when contrasting tones of black and white subsumed middle grays or, in contrast, when middle gray was overwhelmingly predominant. However, we have seen that photographers soon learned to compensate for this by, for example, introducing open foregrounds which assured some degree of recession into space. That flattening effects were not prominent in the early photograph is confirmed by the pronouncement of a critic in 1855, who wrote that photography was an excellent source of study for exercises in perspective;[38] flattening effects could be found consistently and purposefully only in the Japanese print.

Similarly, decentralization as a conscious compositional feature in the Japanese print has no real parallel in any western media. Even where the edges of a characteristic early photograph and a Japanese print may appear similar in the apparent randomness of their framing, the photographer invariably revealed his or her western heritage in placing the subject matter squarely in the center of the picture. In contrast, the Japanese artist, exposed from the very start to works without stationary focus at all, learned to see and compose in a manner that can only be called cinematic. The subject unfolds in a continuum that almost prohibits the centralization of one's point of interest. Each of the devices discussed above – intercepting framing edges, surface flatness, dramatic contrasts of color and shape – is in the service of this continuum, this cinematic vision, in a way that distinguishes its use from that of simple convention as in the photograph.

The profound understanding of this vision in the Japanese print, particularly as it relates to flatness and decentralization – its most unique and perhaps important pictorial components – was left to the next generation of French artists to explore. However, it was Millet, once again, who seemed to be among the first of the "older generation" in the 1860s to modify his compositions in a specifically Japanese way. The cinematic unfolding of subject finds its most obvious parallel in the series work of the Japanese print artists, not only the fifteen volumes of the *Manga* or the multipartite single subject prints, but the many works conceived as the *100 Views of Famous Places in Edo* or the *100 Views of Mt. Fuji*. Millet, too, became interested in the notion of series in works like *The Four Times of Day, The Twelve Labors of the Field,* and *The Four Seasons*. While there are surely precedents in western art for works in series, particularly in medieval art, the renewed interest in the

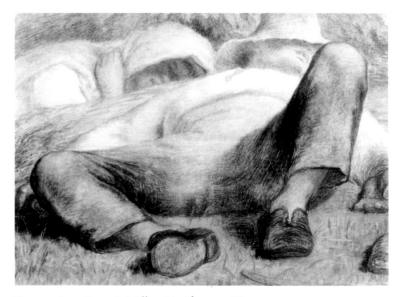

Fig. 11 Jean-François Millet, *Meridian,* c. 1865. Pastel, 23⅜ × 38¼ inches (59.1 × 97 cm). Philadelphia Museum of Art, The William L. Elkins Collection.

series is very much a nineteenth-century phenomenon which develops under the influence of Japanese art. Millet, as the first nineteenth-century French artist to re-explore the series concept, was in the vanguard of this activity.

Millet also seemed consciously to manipulate perspective in works which, after c. 1865, grew increasingly strange and dramatic. Once again, this was most apparent in his drawings. While the looming anatomic components of *Meridian* of 1865 (fig. 11) have been compared to photographic idiosyncrasies, this type of frontal plane distortion would have been actively eliminated in the early photograph, especially in figure compositions. Instead, the unusual worm's-eye vantage point and resultant inversion of spatial recession better suggest the witty effects in certain plates of Hiroshige's *100 Views of Famous Places in Edo,* well known by this date. Moreover, the figure in Millet's work has a decisive object quality – as if it could as easily be a haystack as a figure – underscoring a possible source in study of Hiroshige's landscape prints.

Millet: Cat. 89 At least one landscape painting of this period, *In the Auvergne* of 1867–69, seems to have derived its dramatic spatial construction from works like *Meridian:* although less aggressive in feeling, the painting is equally dependent on looming frontal-plane distortion for its powerful Japanese-like effect.

Similarly, works like *Entrance to the Forest of Barbizon in Winter* (fig. 12) of 1866–67 and *The Windstorm* of 1871–73 (Cardiff, National Museum of Wales) rely for much of their effect on Millet's urge to flatten space. The former drawing, although a reworking of earlier ideas, is also suggestive of the spirit and aesthetic of Hiroshige's popular landscapes of the 1840s and 1850s: it is resolutely vertical in its push to the surface plane, especially via chalky wisps of snow which spot the surface and in the projection of highest light from the scene's apparent background; it is redolent with atmospheric space – identified as western influence when it appears in Hiroshige – which subtly pulls against the flattening impulse; and it is evocative of the quiet, spirit-laden presence identified

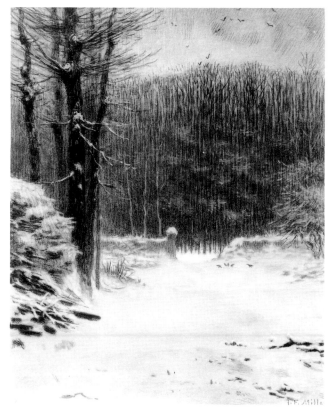

Fig. 12 Jean-François Millet, *Entrance to the Forest of Barbizon in Winter,* c. 1866–67. Conté crayon and pastel, 20½ × 16 inches (51.5 × 40.6 cm). Museum of Fine Arts, Boston, Gift of Quincy Adams Shaw through Quincy A. Shaw, Jr., and Mrs. Marian Shaw Haughton.

in Japan as the reflection of Zen Buddhism.

From the 1850s through the 1860s, Millet's involvement with the Japanese print moves from one distinctive phase to another: specifically, from the initial influence of Hokusai's *Manga* to other works by Hokusai, to color prints by Hokusai and Hiroshige, and finally, to the late print series of Hiroshige. In this shift to Hiroshige, Millet might have taken his cue from his friend Rousseau. Unlike Millet, Rousseau was exclusively a landscape artist, and may have been attracted to Hiroshige on the same level of sympathetic interests that linked Millet and Hokusai. More importantly, Rousseau revealed in his work of the 1860s a consistent and intuitive understanding of the Zen spirit underlying Hiroshige's landscapes, and a specific awareness of his aesthetic devices. Thus, while Rousseau

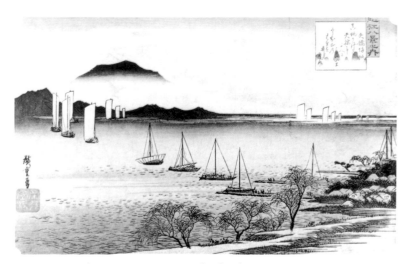

Fig. 13 Hiroshige, "Return at Eventide of Sailing Boats to Yabase," *Eight Famous Views of Omi*, c. 1834. Color woodblock print.

Rousseau:
Cat. 104, 107

generally intensified his palette in this period and tentatively explored flattening effects, the slow and symphonic recession of elements on a diagonal plane – a Hiroshige hallmark (fig. 13) – also began to appear in Rousseau's work. Another Hiroshige motif – the gently lit scene in which the highest light appears along the top edge of the image – similarly appears.

Initially, the appearance of photography was the hottest fuel to fire the fundamental Realist debate of the century. Together with the Japanese print, it also offered options toward its resolution. It is not surprising that photography as the theoretical expression of Renaissance ideals – a world of visible facts – would need to be discarded by nineteenth-century painters slowly but surely rejecting the core of Renaissance tradition. When it was discarded, what came to replace it as model was the Japanese print. Many critics at mid-century considered the greatness of the Japanese print to be its marriage of the imaginative and the real, the creation of artifice from the raw material of nature, at a time when French painting seemed hopelessly polarized in its dedication to one or the other. Thus, we find that Baudelaire was a collector of *ukiyo-e*, and had he lived long enough to write about it, he may have seen the Japanese print as a reasonable resolution of the

dilemma he posed regarding photography.

Where the photograph provided asymmetrical compositions and movement arrested in mid-action as evidence of visual realism, these same elements in the hands of the Japanese artist were included as aspects of decorative and effective pattern-making. Rather than aspects of slice-of-life realism, these were actually subtle and purposeful devices of non-illusionism consciously used to maintain surface flatness. It is this stylization of the Japanese print, corroborated by the implicit realism of the photographic image, that helped move nineteenth-century painting definitively into the modern era. In terms of its impact in the West, the relationship between photography and the Japanese print was symbiotic, perhaps best recalling Roger Fry's defense of Matisse in 1912 with the words, "to arouse the conviction of a new and definite reality . . . not seek[ing] to imitate form, but to create form, not to imitate life, but to find an equivalent for life."[39]

NOTES

1. See Helmut Gernsheim, *The History of Photography: From the Camera Obscura to the Beginning of the Modern Era* (London: Oxford University Press, 1969), 119.

2. Yvonne Ffrench, *The Great Exhibition: 1851* (London: Harville Press, 1950).

3. *The Exhibition of Art-industry in Paris* (London, 1855).

4. Philippe Burty, "Exposition de la société française de photographie," *Gazette des beaux-arts* II (1859).

5. Ibid.

6. Nigel Gosling, *Nadar* (New York: A. Knopf, 1976), 21.

7. Charles Baudelaire, "The Modern Public and Photography," *Salon of 1859* in *Baudelaire, oeuvres complètes* (Paris: Editions du Seuil, 1968), 398.

8. Philippe Burty, "La photographie en 1861," *Gazette des beaux-arts* XI (1861).

9. Rousset felt so close to – or competitive with – the Barbizon painters that following the example of Daubigny, he outfitted a boat as a studio and pro-

duced *Le tour de Marne* in 1865 in response to Daubigny's *Le voyage en bateau.*

10. Lerebours, *Excursions daguerriennes: vues et monuments les plus remarquables du globe,* vol. 2, 1843.

11. Van Deren Coke, *The Painter and the Photograph: From Delacroix to Warhol* (Albuquerque: University of New Mexico Press, 1972), 197.

12. Aaron Scharf, *Art and Photography* (London: Allen Lane, 1968), 92.

13. Ibid., 93.

14. Aaron Sheon, "French Art and Science in the Mid-Nineteenth Century: Some Points of Contact," *Art Quarterly* (Winter 1971): 442.

15. Julia Cartwright, *Jean-François Millet* (London: S. Sonnenschein and Co., Ltd., 1902), 161.

16. Alfred Robaut, *Les oeuvres de Jean-Baptiste-Camille Corot* (Paris: H. Floury, 1905).

17. For a complete discussion of the history of Japanese contact with the West from the seventeenth through the nineteenth centuries, and the art collections which resulted, see Deborah Johnson, "The Impact of East Asian Art on the Parisian Avant-Garde, 1856–68," Ph.D. diss., Brown University, 1984, chapters one and two.

18. For more information, see ibid.

19. For full information on Titsingh and his collection, see ibid.

20. For full information on Siebold and his collection, see ibid.

21. Klaproth translated the *Sankoku tsuran zusetsu* of Hayashi (Rin) Shihei in 1832, and Hoffman translated the *Yo-san-fi-rok* of Kano Tamboku in 1848 and produced the *Histoire et fabrication de la porcelaine chinoise...et du Japon* in 1856. Unfortunately, the details of Pfizmaier's publication are obscure.

22. Listing under "Houssaye" in the *Didot-Bottin annuaire,* Paris, 1842.

23. Fritz Lugt, *Répertoire des catalogues de ventes publiques,* 3 vols. (The Hague: M. Nijhoff, 1938).

24. *Art Journal Illustrated Catalogue of the Great Exhibition* (London, 1851) and Sir Matthew Digby Wyatt, *The Industrial Arts of the 19th Century Produced by Every Nation at the Great Exhibition,* 2 vols. (London, 1851–53).

25. Théophile Thoré, *Trésors d'art en Angleterre* (Paris, 1857), 447–48.

26. First asserted in Léonce Bénédite, "Félix Bracquemond, l'animalier," *Art et décoration* 17 (February 1905).

27. Edmond de Goncourt, *Outamaro* [sic] (Paris, 1891), 55.

28. Scharf, *Art and Photography,* 94.

29. Ibid., 95.

30. Ernest Lacan, *Esquisses photographiques* (Paris, 1856).

31. Burty, "La photographie en 1861," in *Gazette des beaux-arts:* 248.

32. André Jammes and Eugenia Parry Janis, *The Art of French Calotype* (Princeton: Princeton University Press, 1983), 99.

33. Quoted in ibid., 98.

34. Burty, "La photographie en 1861," in *Gazette des beaux-arts:* 239.

35. Halation occurred when light acting upon the emulsion also struck the uncoated side of the glass and was refracted back through the emulsion, causing a redevelopment or erosion of dark areas.

36. For a good discussion of the extended impact of the *Voyages pittoresques,* see Bonnie L. Grad and Timothy A. Riggs, *Visions of City and Country* (Worcester: Worcester Art Museum, 1982).

37. Alfred Sensier, *Jean-François Millet, Peasant and Painter,* trans. Helena de Kay (Boston, 1881), 170.

38. A. Bonnardot, "La photographie et l'art," *Revue universelle des arts* II (1855).

39. Roger Fry, "The French Post-Impressionists," reprinted in *Vision and Design* (New York: Brentano's, 1924), 102.

Catalogue Entries

The entries are arranged alphabetically by artist. Brief biographical sketches preceding each entry include only material chronologically relevant to the scope of the current exhibition.

FRÉDÉRIC BAZILLE
1841, Montpellier – 1870, Beaune-la-Rolande

1860–62: Studies medicine in Montpellier. 1862: Leaves for Paris to study medicine and enters studio of Charles Gleyre. 1863: Meets Delacroix; travels to Fontainebleau with Monet and Renoir and with them in 1864 to Normandy; quits medicine. 1865: Shares studio with Monet; meets Cézanne, Courbet, Pissarro, and Edmond Maître; returns to Fontainebleau. 1866: Salon debut; shares studio with Renoir. 1867–68: Shares studio with Renoir and Monet; meets Manet. 1868–70: Accepted in annual Salons. 1869: Visits Corot.

BAZILLE NEVER LIVED to see his name enshrined along with those of his friends, Monet and Renoir, as a premier Impressionist. He died in action at the age of twenty-nine as a member of the French army helplessly attempting to ward off the Prussian offensive. Coming from a Protestant family of substantial means in the south of France, Bazille was never totally at home either with Paris or the dense light of the north. However, he came under Monet's confident tutelage almost as soon as he arrived in the French capital, and his entire commitment to landscape (or seascape) painting can be traced to Monet's example. Even though driven to prove himself by established Salon routes, Bazille remained throughout his short life under the spell of Monet's taste and the example of Monet's painting; he bought one early masterpiece, *Women in a Garden,* 1866 (Paris, Musée d'Orsay), soon after it was painted.

Monet literally conscripted Bazille into land-scape painting, taking him to Fontainebleau and to his native Norman coast. One of the few really accomplished of Bazille's landscape works, *The Beach at Sainte-Adresse,* was executed in Normandy under Monet's guidance (and possible retouching) in 1865. This painting is substantially larger in scale than the norm for Monet's contemporary works and was obviously intended from the first as a Salon entry. It shows in its large areas of comparatively unmixed color and in the apparent energy of its brushing a great deal of familiarity with Monet's example and with Monet's current enthusiasms for Manet's seascapes which had just appeared in a private gallery exhibition in Paris in 1864.

In a way totally unlike the treatments of light and movement developed by landscape painters of earlier generations, Bazille strives in *The Beach at Sainte-Adresse* for a quick and forceful communication of his effect. Even though he composes with boats and figures, he concentrates his effort on a clear yellow-orange/blue-green color chord (initiated from red-ochre) which is delivered powerfully and without much distracting detail.

The term "chord" in the instance of this picture seems particularly appropriate. Bazille, along with Cézanne and Renoir, was an avid fan of Wagner's music during the 1860s, hearing it at every opportunity. He even had a piano in his studio, where it was played routinely, one suspects, by his closest friend (and equally fervent Wagnerist) Edmond Maître. Exactly what might have developed from Bazille's contemporarily informed melomania and his practice of landscape imaging can only be conjectured. However, on the basis of *The Beach at Sainte-Adresse,* it is obvious that new aural/visual forms of effect were being entertained from a very early point.

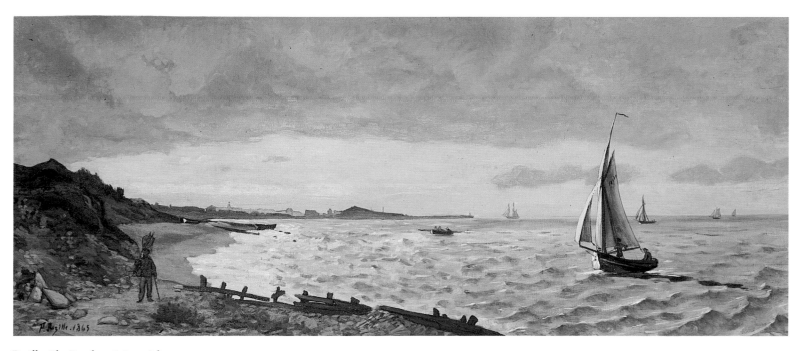

Bazille, *The Beach at Sainte-Adresse*, cat. 1

JEAN-ACHILLE BENOUVILLE
1815, Paris – 1891, Paris

1834: Begins exhibiting regularly at the Salon, submitting views of the park around Versailles and Ville d'Avray (1834), the forests at Saint-Cloud (1835), Compiègne (1837), and Fontainebleau (1839). 1837: At least by this date, studying painting under François Picot, a celebrated history painter; accepted into the Ecole des Beaux-Arts; and awarded second place in quadrennial competition for historical landscape painting. 1843: Living in Rome, where he welcomes the visiting Corot to his apartment/studio. 1844: Receives third-class Salon medal for *Homer Abandoned on the Isle of Syros* and *Souvenir of the Valley of Narni*. 1845: Wins the Prix de Rome for historical landscape painting, to general acclaim. With his brother Léon, who wins the Grand Prix de Rome for historical painting, he returns to Rome for four years of study at the French Academy. Jean-Achille remains in Rome until 1870, regularly sending paintings back to Paris for Salon exhibition. 1863: Receives first-class Salon medal for *St. Peter's, Rome* and *View of the Villa Borghese*. 1870–80: Travels widely through France and the Netherlands, greatly expanding the subject matter of his subsequent landscape paintings.

Benouville made his first appearances at the Salon during the decade of the 1830s – as did Rousseau, Dupré, Troyon, and Daubigny – regularly submitting naturalistic landscapes of the same forests, parks, and picturesque river towns frequented by those more familiar masters. Little is known of Benouville's training before his enrollment at the Ecole des Beaux-Arts in 1837, but his skills at landscape painting were already sufficiently well-honed to gain him second place in the historical landscape painting competition that same year. At the Ecole, Benouville studied painting under one of the more conservative history painters of the day, and for several years the young artist carefully paired each of the freer landscape paintings he submitted to the Salon with a major landscape composed according to academic standards and graced with figures from biblical or mythological history – a practice followed by Corot as well in the late 1830s and 1840s. Staying the course until 1845, when he finally won the prestigious award entitling him to four years of state-funded study in Italy, Benouville almost immediately abandoned historical landscape painting for a more personalized approach to the Italian countryside.

View in the Roman Campagna acknowledges the still well-rooted French admiration for the clear skies and timeless subject matter offered by the hilltowns surrounding Rome, an affection that had dominated French landscape painting for two centuries. But in emphasizing the arching tree that shadows a band of resting fieldworkers as well as much of the foreground, rather than a prominent monument or an identifiable city profile, Benouville wrested a margin of freedom from the conventions that made so much Italianate landscape painting static and studio-bound. The irregular alternation of light and shadow that organizes the space and offsets carefully studied details and textures is inherited from the English landscape tradition so much admired by Dupré and Troyon, while Benouville's grand tree echoes Rousseau's work of the 1830s. The cow herd and resting harvesters take their roles from the terrain they inhabit. The landscape does not rely upon the figures for its own significance.

Throughout the 1850s and 1860s, Benouville brought an earthy naturalism to the content of his Italian landscapes, but unlike his colleagues working in French forests and pastures, he remained simultaneously committed to a degree of precision and detailed craftsmanship that they chose to forego in favor of greater immediacy.

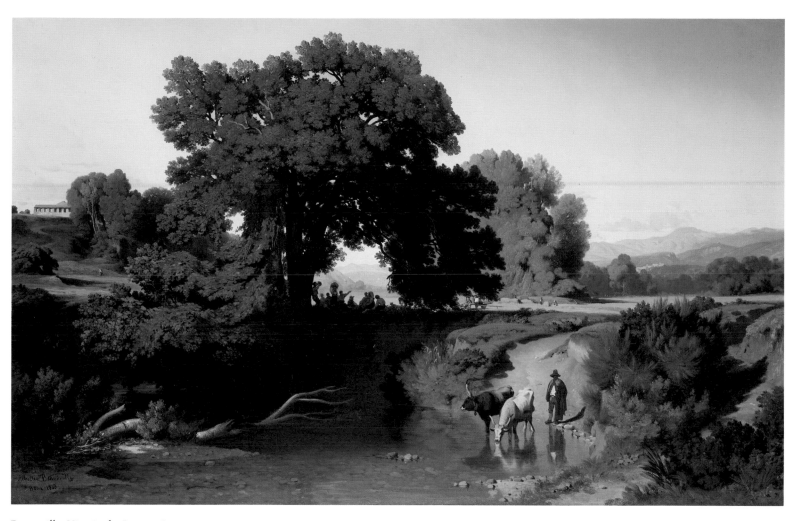

Benouville, *View in the Roman Campagna*, cat. 2

EUGÈNE BOUDIN
1824, Honfleur – 1898, Deauville

1844: Encouraged to paint by Millet and Troyon who exhibit in his Le Havre artist-supply store. 1847–48: Begins to paint; studies Flemish masters in Belgium. 1851: To Paris via a grant from Le Havre government; makes regular trips to Honfleur, Rouen, and Le Havre. 1855: To Brittany. 1858: Shows at Society of Friends of the Arts in Le Havre (eleven paintings). 1859: Salon debut (regular acceptances through 1897). 1862: Meets Jongkind; draws in Deauville; on recommendation of Isabey, paints beach scenes in Trouville. 1860s: Settles in Paris studio with routine summer painting trips. 1870–75: Summers in Belgium. 1876–79: Summers in Bordeaux. 1873: Begins frequent trips to Holland (through 1890). 1885: Regular trips begin to South of France. Early 1890s: Several trips to Venice.

BOUDIN'S ACCOMPLISHMENT as an artist in his own right has often been overshadowed by his role as the discoverer and nurturer of the young Claude Monet. And it is in fact very doubtful whether Monet would ever have considered undertaking a career in painting had it not been for Boudin's recognition of the enormous talent shown in Monet's caricatures of assorted citizens from the Le Havre – Ste.-Adresse area. By the same token, Boudin must himself have been an inspiring spokesman for the practice of his profession. The adolescent Monet appears not to have been easily impressed by anything and was certainly not career-oriented when Boudin discovered him; in addition to the encouragement given to young Monet to pursue the not-unpleasant pastime of sketching out-of-doors, Boudin's work itself obviously kindled interests which prior to the time of their first meeting, Monet had never entertained at all.

In the period between 1858 and 1860 when Monet and Boudin were closest, the latter was just beginning to consider how to translate works begun out-of-doors into finished paintings. He sketched the beaches around the Seine estuary routinely in an effort, probably inspired by the work of both Corot and Daubigny, to break free from his early painting style which had produced rather conventional neo-eighteenth-century landscape *rustiques*. The examples of innovative imaging and the radically new emphasis placed on techniques for generating a painted lightness approaching that of nature, which Boudin saw happening around him increasingly after 1855, seem to have encouraged him to stake out an imaging domain particularly his own – one based in the beaches of the Normandy coast that he knew so well. Boudin was not a young painter in 1855, but he was embarking on a new naturalist path soon far removed from the conventional, quasi-academic one of Isabey and his followers in the picturesque mode. Rather like Jongkind in the same period, Boudin was remaking his art, without knowing at first what the new product might look like.

Judging from work produced, exhibited, and sold in the early 1860s, it appears that Boudin made some important imaging decisions and held to them. He rejected the conventional picturesque in all forms, and he committed his art of painting out-of-doors to motifs that were both unconventional and, most important, of the moment. Boudin became the first painter of the modern life of the "beach as middle-class resort site." With the rapid expansion of the passenger rail network in France in the 1850s, the Normandy beaches became yearly more popular with and easily accessible to the urban bourgeoisie of Rouen and of Paris. Soon the hotels and casinos would be built; but the most exciting of Boudin's works (done between 1862 and 1865) image a still slightly unsettled bourgeois beach life – bustling, but not absurdly commodious.

It is a beach life still sufficiently unsorted socially to have remained a comfortable ambience for serious painters, including (besides Boudin) Courbet, Jongkind, Monet, and Whistler. Advanced artists and the touristically adventurous urban bourgeoisie stood together for a moment on the tidal beaches of Trouville, Deauville, and elsewhere – their feet planted semifirmly in the sand and their eyes trained either on each other or on the continuous horizon of the open sea. It is this horizon line, with a sandy floor and a cloud-filled ceiling, that seems most consistently to initiate Boudin's particular means of imaging. He hangs (in the most characteristic of his early beach works) his figures, their tent-cabins, their horses and wagons, on the horizon line. Everything seems more attached to it than to the softly changeable sand. In an almost Japanese way, the shapes of figures and of things seem to stand or move without weight or substance of any sort. They are small colored patterns, alone or in groups, stretched from one side of the picture to another. Boudin seems extremely fascinated by the often caustic interaction between nature and the man-made, chemically dyed fabrics of Second Empire beach dress. Here he indicates a taste for the chromatically unpredictable that is quite likely informed by the art of the schematically colored Japanese woodblock print. This is a taste he will pass on directly to Monet. But what is ultimately most remarkable about the Boudin beach scenes is the manner in which they overturn anticipated conventions of landscape imaging – conventions still respected by Corot, Daubigny, and Courbet. No longer is the "ground" (where things stand) dark and the sky light; *both* are light in tone, and this lightness above and underneath increases the tempo of the seeming dance of variously tinted shapes across the horizon. Boudin's palette is uniquely fresh in the landscape practice of the early 1860s, and its freshness resides not just (as Daubigny's does) in high values, but in the combination of those high values with a wide range of intense, pure hues. It is the palette from which Monet will begin.

Around 1865 Jongkind's influence seems to make itself felt in Boudin's work. As it does, Boudin gradually substitutes a nervous sketchiness of touch for the flatter and more optically focused animation of earlier work. A more old-master form of painterly touch appears in works like this exhibition's *Fishmarket, Honfleur,* to make the excitement of Boudin's way of seeing somewhat easier for the spectator to comprehend and accept.

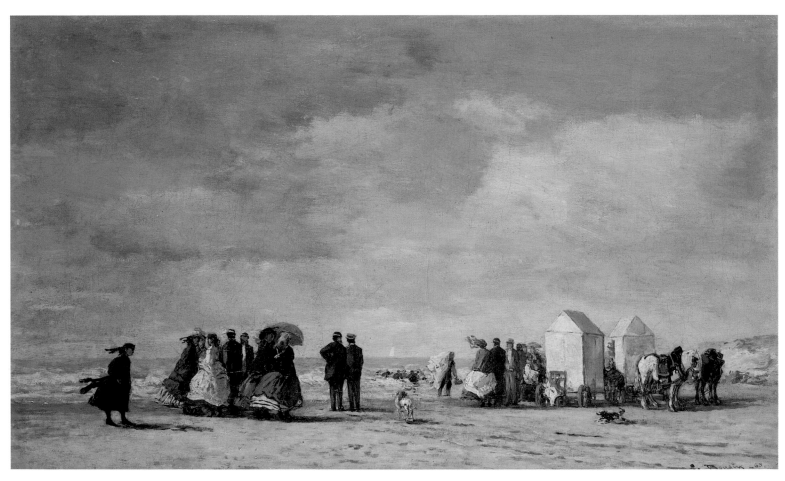

Boudin, *The Beach at Trouville*, cat. 3

Boudin, *Fishmarket, Honfleur*, cat. 4

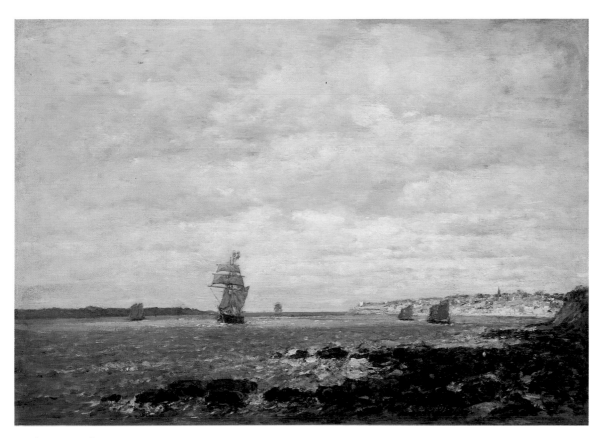

Boudin, *Coast of Brittany*, cat. 5

JOHN CONSTABLE
1776, East Bergholt, Suffolk – 1837, London

Childhood on Stour River at father's Flatford Mill. 1799: Studies in London's Royal Academy with Joseph Farrington. 1801: Travels to Derbyshire. 1802: Royal Academy debut. 1806: To Lake District; shows at Royal Academy. 1810: Meets Maria Bicknell (marries in 1816). 1816: General Rebow commissions *Wivenhoe Park.* 1819: *The White Horse* praised at Academy; named Royal Academy Associate. 1819–29: Summers in Hampstead to nurse wife's health. 1820–36: Successful submissions to Royal Academy. 1823: Bishop of Salisbury commissions *Salisbury Cathedral from the Bishop's Gardens.* 1824: Two Salon paintings, *The Hay Wain* and *View on the Stour,* earn gold medal from Charles X; trip to Brighton with wife. 1829: Named Full Academician at Royal Academy. 1830: Trip to East Anglia.

CONSTABLE'S REPUTATION in his native England was secure if not spectacular by the time his works first appeared in France in the Salon of 1824. From an English perspective, the concentrated study of landscape motifs on site was a common practice of Constable's generation, but he did it more persistently, with greater conviction, and ultimately to greater effect than any of his contemporaries. Faced as all of them were by the question of how to make landscape as a "real" experience inform painted imaging, the great negative model was Thomas Gainsborough, who had in the 1780s developed a monumentally personalized form of landscape painting that was almost totally improvisatory in character. It evoked landscape sensation without attending very closely to any actual topographical particulars. Gainsborough's landscapes were highly processed memory images, leaving nature, as a sum of specific sensations, virtually out of the picture. Constable undertook to bring nature back in, and to bring it in with an emphatic form of descriptive clarity. This did not mean that he was ever to be a painter of details, but rather that he would manage in a wholly unprecedented way to construct paintings that seemed to match painted color with natural light. In order to do this, he sketched (in oil) out-of-doors as a matter of routine, and his sketches served to guide the order and number of color steps that appeared in "finished" large-scale works intended for Royal Academy showing.

When two of Constable's "finished" large landscapes appeared in the Salon of 1824, they caused a considerable stir, largely because their rendering of light was so convincingly complex. Recognizably natural landscape coloration was set forth by painted greens, reds, blues, and yellows that were clear in hue and often highly saturated in value. No colors were simply a single value, but a series of carefully adjusted values leading to the most forceful statement of the hue. More about the appearance of landscape emerged than had ever been seen in painting before. This was viewed as an exciting accomplishment by the entire group of French landscape painters who would come to the fore in the 1830s and 1840s. Yet their excitement was mitigated by the suspicion that too much of "feeling" had been left out of Constable's imaging practice and that too much of "science" had been allowed to replace it. The somewhat ad hoc character of Constable's highly innovative paint construction showed no obvious style, and for eyes still sensitive to and appreciative of the poetry of style in French classical landscape – particularly Claude Lorrain's, or in later seventeenth-century Dutch examples – the shock of Constable was ultimately too great to produce a continuously positive effect in France. Yet the example of Constable as a landscape painter of radical ambitiousness guided French

confidence for many generations, even though the actual paintings might have been considered slightly raw items.

Looking at Constable's work today, it is difficult to reconstruct the sense of shock his paintings initially produced. Images like *Dedham Lock and Mill* or *Branch Hill Pond* remain crisp in the coloristic and topographical effect they deliver, but they seem to have a strongly picturesque side as well. Although he adjusts his motifs relatively little in terms of spectator-directing schemes of alternating light and dark, Constable nevertheless uses just enough contrast to guide the viewer comfortably into the picture and through the variety of landscape attractions. Perhaps more of the original sensation which Constable's work produced remains visible in oil sketches like *Hampstead Fields Looking West* or in a pre-1820 oil like *Weymouth Bay*. In images like these, the poetically less-processed side of Constable still stands distinct. The color harmonies are unexpected, emphatic, yet ultimately natural in feeling. Even though they have never appeared before in painting, they begin after a time to look right and to feel almost inevitable. The effort is somewhat analogous to the roughest and most excitingly unexpected of Beethoven's progressions of musical harmony.

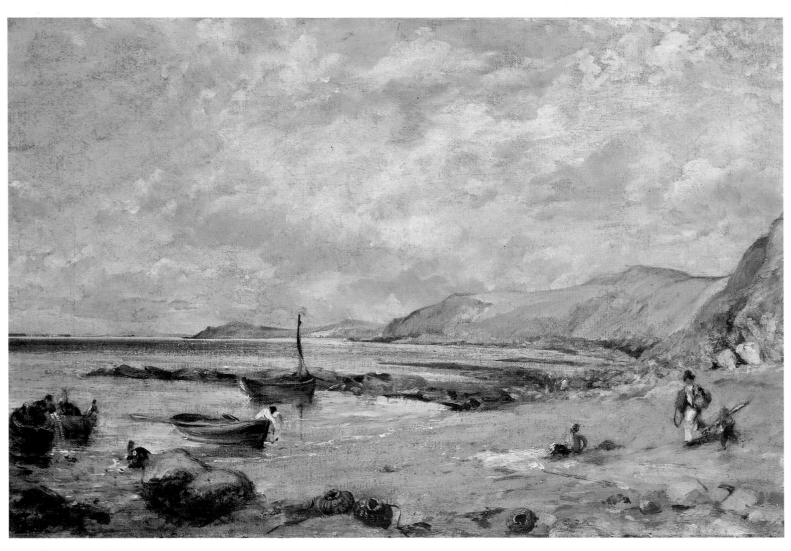

Constable, *Weymouth Bay*, cat. 6

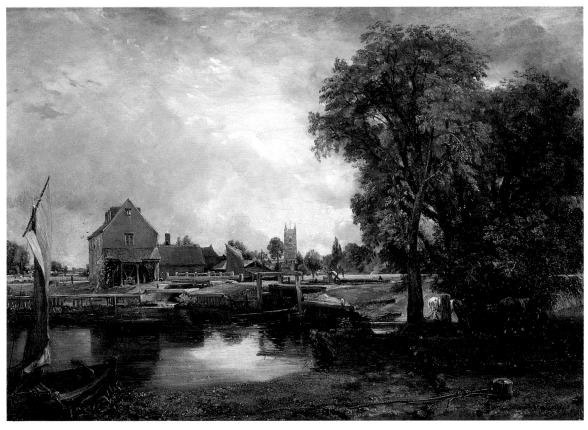

Constable, *Dedham Lock and Mill*, cat. 7

Constable, *Hampstead Fields Looking West: Afternoon*, cat. 8

Constable, *Branch Hill Pond, Hampstead Heath*, cat. 9

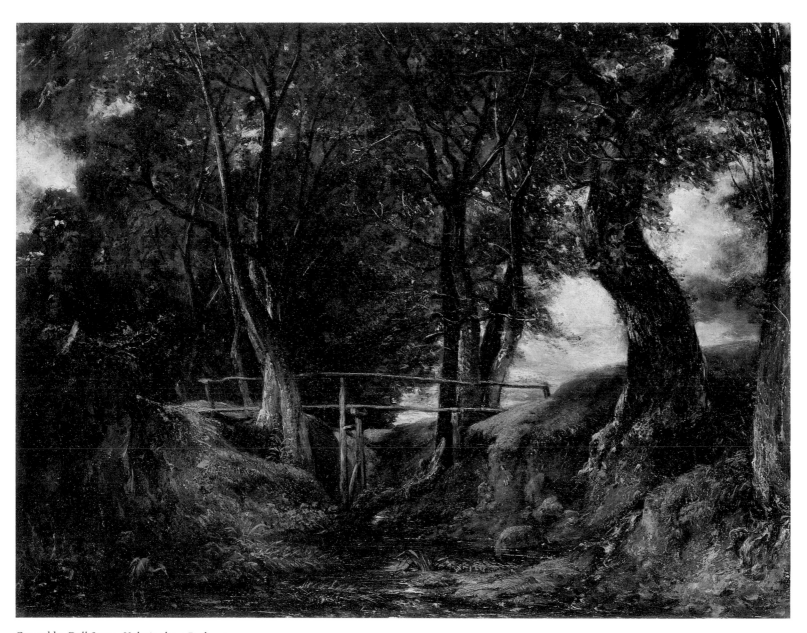

Constable, *Dell Scene, Helmingham Park,* cat. 10

JEAN-BAPTISTE-CAMILLE COROT
1796, Paris – 1875, Paris

Son of a cloth merchant. 1807–11: Early schooling in Rouen. 1812–14: School in Passy with night classes in drawing at the Académie Suisse, Paris. 1822: Full-time art student under Achille-Etna Michallon and then with Jean-Victor Bertin; first studies in Fontainebleau. 1825–28: First trip to Italy (Rome and central Italy). 1827: Salon debut; submits paintings regularly until his death. 1828–34: Based in Ville d'Avray and Paris studio, travels between Normandy, Burgundy, and Fontainebleau, and joins Barbizon painters. 1831: Shows *Forest of Fontainebleau* at Salon. 1833: Wins second-class medal at Salon for *Mercantile Piers at Rouen*. 1834: Makes second trip to Italy. 1842: To Switzerland. 1843: Makes third trip to Italy (Rome). 1846: Receives Legion of Honor. 1848: Obtains second Salon medal. 1854: Short trip to Holland. 1855: Wins first place at Universal Exposition (six entries); Napoléon III purchases *The Cart, Souvenir of Marcoussis*. 1862: Meets Courbet in La Charente (French countryside); travels to London. 1864: Becomes Salon jury member. 1867: Named Officer in Legion of Honor; wins second place in Universal Exposition (seven entries). 1869: Trip to Mantes.

COROT IS BOTH intentionally and appropriately the "star" of the present exhibition. As a landscape painter, he stands alone in this period in the breadth of his achievement. Yet, to modern eyes, Corot's range can seem narrow. His work has in the consistency of its general approach perhaps too few of those surprises which might merit the highest forms of modernist compliment. There are no "breakthroughs"; Corot appears always to have known (more or less) what he wanted to image and to have possessed the means to manage it. The nervousness, the theatrical personalisms, the frontal ego that we so admire and seek in the most honored of nineteenth- and twentieth-century work is hard to find in Corot. In this sense, he seems not of his time or, by extension, of ours. More than any other modern artist of note, Corot managed, or at least seems to have managed, what the great German philosopher Friedrich Nietzsche so prized among philosophers: the ability to stand apart from and above contemporary life, so as not to be dominated or limited by its prevailing habits of feeling (and of knowing). The landscape world that Corot imaged is only partly "real" in terms of actual time and place. But that is not to say that its "non-real" aspects are precisely modeled on nostalgia for a lost Arcadia any more than they are simplistically longing for an impossibly innocent future. At base, "nature" for Corot is what he wants it to be; he makes it behave according to his wishes. His is a radical art only in its peculiar aesthetic refinement and in its refusal to let that refinement be guided by anything but private feeling of a highly confident and consistent sort. The making public of this privateness through exhibited works and the refusal to develop any but carefully cultivated personal sensations are Corot's radical act. He makes himself public without *becoming* public. Political feelings exist in his art only by virtue of their absence.

Corot's relation to nature, time, and the spectator is a collectively complex phenomenon. He requires that the spectator approach his work without demanding anything specific of it besides "beauty" (that word so unacceptable to modern ears) in a virtually limitless yet always related series of manifestations. In his offering up of beauty in what is, in essence, a value-free fashion – no ethics, no politics, no religion – Corot demonstrates in the very roots of his aesthetic behavior the preeminent characteristics of a romantic melomane. He is a sublime entertainer of the sensations and he never questions

the worthiness of his entertainment, since it is in its essence identical to that most valued of civilized treasures – namely, live culture. Corot's spectator can be anyone who treasures culture. His audience is, therefore, at once elite *and* democratic.

As with the music he loved most, Beethoven's and Mozart's, the sense of time and place in Corot's painting is intensely familiar and intensely special at the same time. His landscapes suggest actual experience, but no more or less than they signal memories and dreams. At their best, the synthesis of experience with memories and dreams is perfect, and the perfection resides in the alternation of the accented and the unaccented stresses of pictorial technique – in tone and in touch, and in the softly elaborate, precisely choreographed dance of topographical and figural specifics within a given picture to the particularly rhythmical character of the stresses. Corot requires, as few other painters before him, extended spectating time. Viewers have to find their way into and through the veils of the stated and the suggested in order to grasp the sensible character of the imaged whole. The required spectating time gives nothing in terms of the quantity of what is pictured, but everything in terms of the quality, character, and feeling of the picturing. The demand for extended spectating time is perhaps the most quintessentially musical characteristic of Corot's paintings. One must look at them for a considerable time, just as one must listen through the entirety of an inspired piece of concert music. Otherwise one sees (or hears) very little of real substance.

Quite remarkably, Corot's art displays its distinctive (and musical) character from an early point in his career. In a sense his art cannot really be said to develop (in a conventional way) substantially from 1830 to his death in 1875. True, there is much sorting, adjusting, and refining to be noted, but there is little alteration of basic aesthetic premises. Technique just becomes more flexible and secure as the years pass. From the time of the small, carefully constructed, Constable-inspired oil sketches of French (and Italian) sites in the years around 1830, Corot asserts his preference for working with close

values and close hues (and without much contrast). Depending on his location (Jumièges, Dunkerque, or the Forest of Fontainebleau, for example), Corot would decide to work rather high or low on the scale of light values, but his combinations of high and low are cautious in order to avoid having the spectator's eye led too coarsely (or abruptly) from the painted surface into pictorial relations of space. Even in larger, more studio-finished Salon-type pictures derived from oil studies made out-of-doors and from rather schematic drawings, there is a substantially limited availability of spectator access to pictorial space evident in Corot's work – limited by comparison to prior landscape practice, including Constable's. Corot seems always to want the spectator's eye to read all relationships of tone, substance, and position with reference to the singularly forward presence of the picture surface. While motifs can often seem to convey softness in substance or atmospheric ambience, the sensations that originate in that ambience, as well as more clearly defined accents, always begin from the picture surface and the differentials of paint deposit left visible there.

The refinements that Corot's work undergoes, in the decade of the 1850s in particular, appear tied to his productive decision to focus his motific reference in more geographically limited terms. Increasingly he restricted himself to studying "northern" (north or west of Paris), atmospherically rather heavy motifs in semi-river, semi-forest settings similar to those he lived with on a day-to-day basis at Ville d'Avray. In the process of developing a deep familiarity with predominantly veiled conditions of light – rarely full sunlight – Corot managed to sensitize his eye and his touch to increasingly subtle coloristic variations. Alternating between horizontal and vertical medium-sized picture formats, portraying a variety of landscape prospects, he created a series of masterpieces that combine aspects of intense looking and intense feelings experienced by looking that are both brilliant in themselves and basic to the often more improvised compositions of the 1860s. In this exhibition there is an excellent representative sampling of Corot's mid-1850s achievement in the paintings from

Manchester, Omaha, Des Moines, Dallas, and Richmond.

Even more impressive perhaps is the grouping of works from the 1860s, featuring the justly famous *Souvenir of Mortefontaine* of 1864 from Paris, the related *Moored Boatman* from the Corcoran Gallery of Art (Washington, D.C.), *The Island of Happiness (L'île heureuse)* from Montreal, and *An Idyllic Spot at Ville d'Avray* from Worcester. These paintings, along with residually more motif-specific works such as the *Canal in Picardy* from Toledo or the *Old Bridge at Limay, on the Seine* from Los Angeles, mark out the range of late Corot's symphonic magnificence from every vantage point imaginable. In Corot's pictures, soft, semi-transparent veils of tone mingle in his painted trees, water surfaces, and reflections. There is almost nothing of substance besides differently brushed passages of close-valued tones. Only the spectator's eyes are given material with which to exercise pleasurably. Comprehension of all touch and substance in the paint layers, and all access to whatever seen or remembered space is represented, can only be achieved by the spectator's willing and durable complicity in retracing the processes of Corot's complex optical interweavings. Not until the very late works of Claude Monet, his *Waterlily* canvases in particular, will anything like the purely optical denseness of Corot's most refined imagings reappear. When it does, the pictorial feeling will again be ultimately musical in its direction, its character, its cadence, and its undisguised address to the most grandly edifying pleasures of sensation.

Within his lifetime, Corot had a few first-rate admirers, including Daubigny, Monet, and Pissarro, as well as countless second-rate imitators; this proves not only how *admirable* he was but how *inimitable*. He set the standards for landscape practice for half a century without intentionally dictating how other artists should work.

Corot, *The Inn at Montigny-les-Cormeilles*, cat. 11

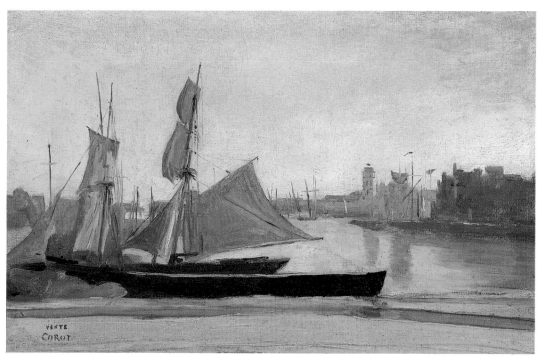

Corot, *Dunkerque: Fishing Boats Tied to the Wharf*, cat. 12

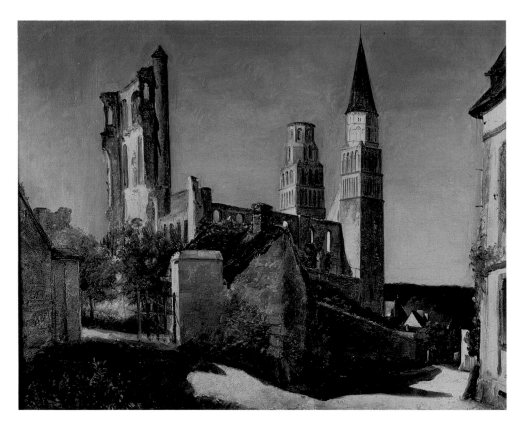

Corot, *Jumièges*, cat. 13

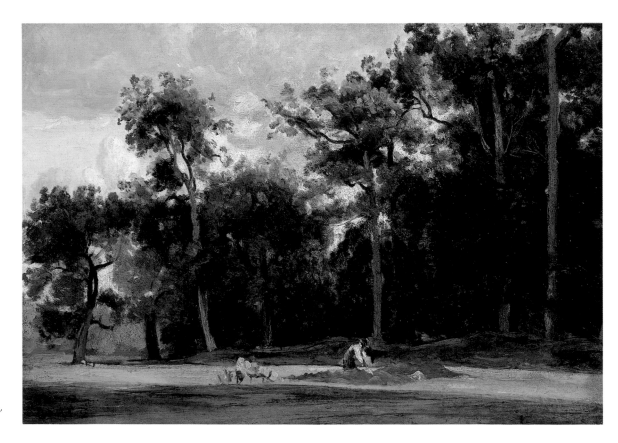

Corot, *The Paver of the Chailly Road,*
cat. 14

118

Corot, *Landscape with Lake and Boatman, Evening,* cat. 15

Corot, *View near Naples*, cat. 17

Corot, *Ravine in the Morvan, near Lormes*, cat. 16

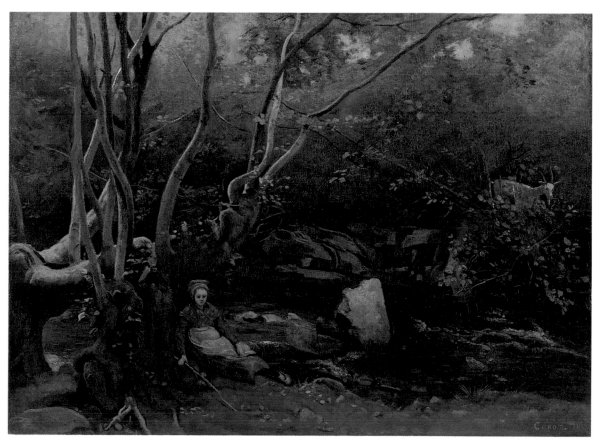

Corot, *Goat Girl beside a Stream, Lormes*, cat. 18

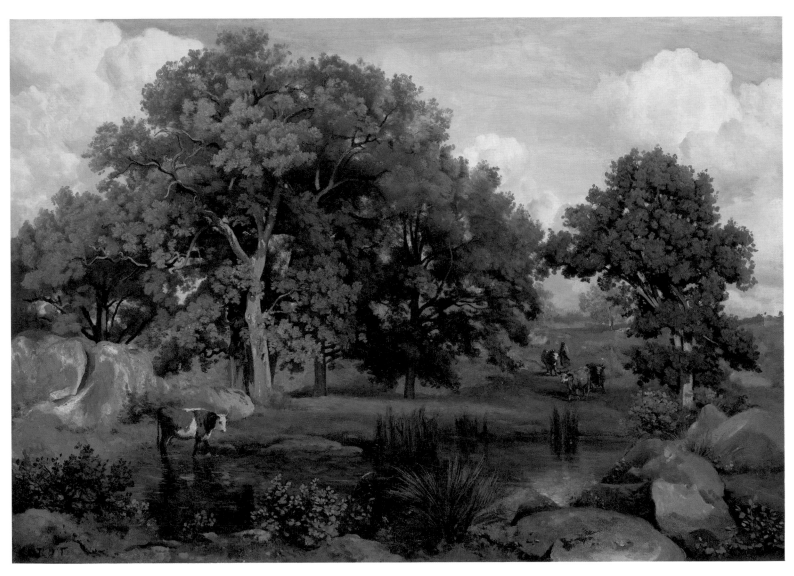

Corot, *Forest of Fontainebleau,* cat. 19

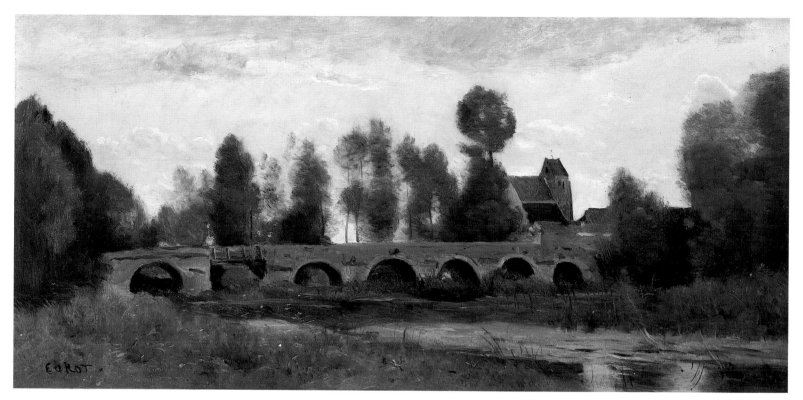

Corot, *The Bridge at Grez-sur-Loing,* cat. 20

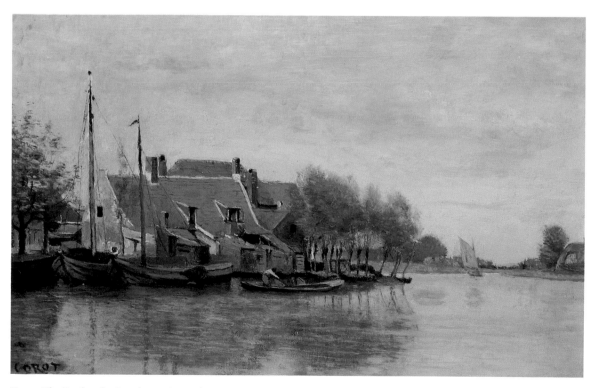

Corot, *The Banks of a Canal near Rotterdam,* cat. 21

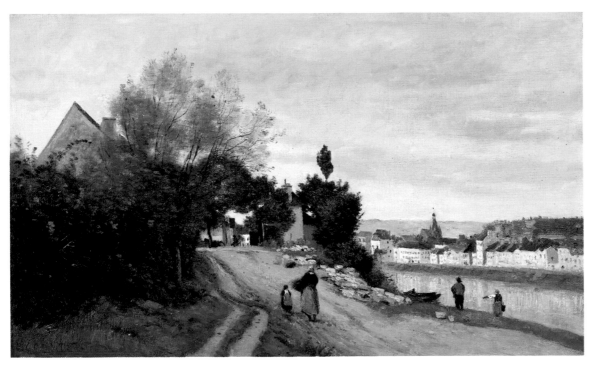

Corot, *Château Thierry*, cat. 22

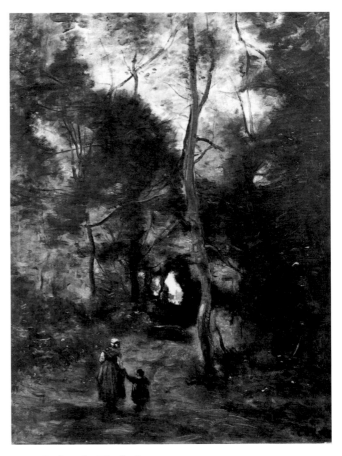

Corot, *Path in the Woods, Semur*, cat. 23

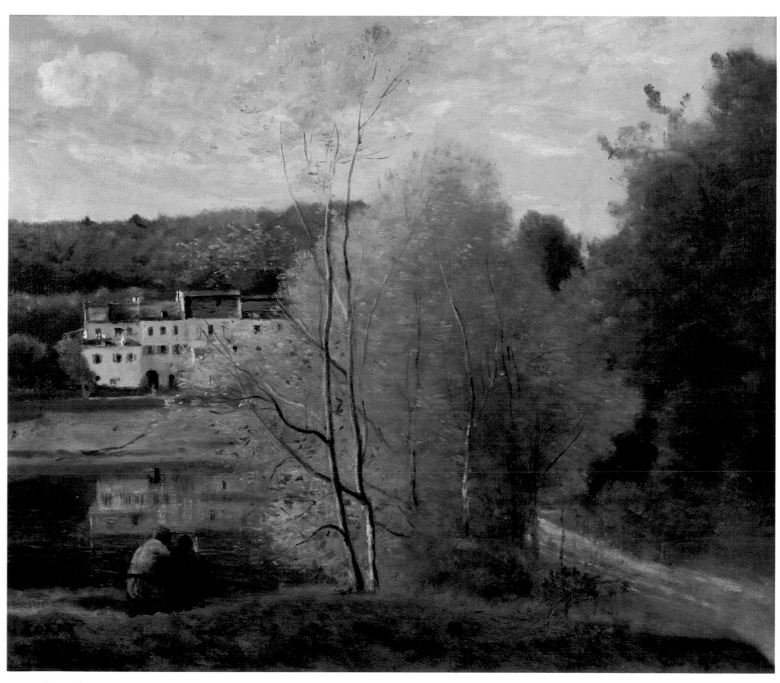

Corot, *The Pond and the Cabassud House at Ville d'Avray,* cat. 24

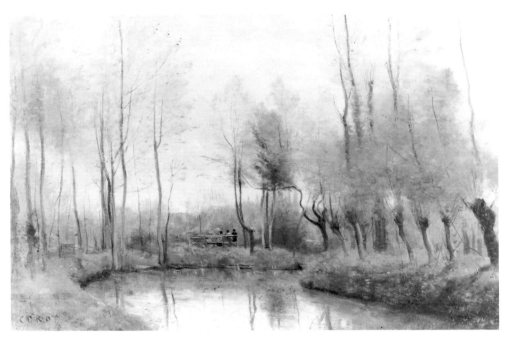

Corot, *In Monsieur Wollet's Park, Voisinlien,* cat. 25

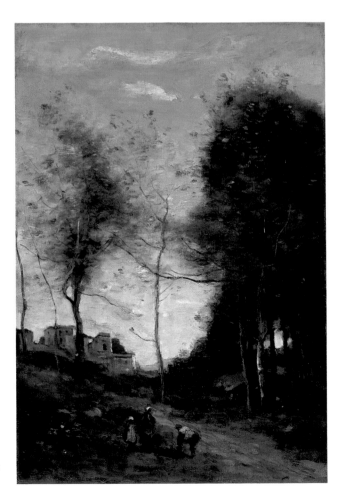

Corot, *Peasants Stopping at the Edge of a
Wooded Road near a Village,* cat. 26

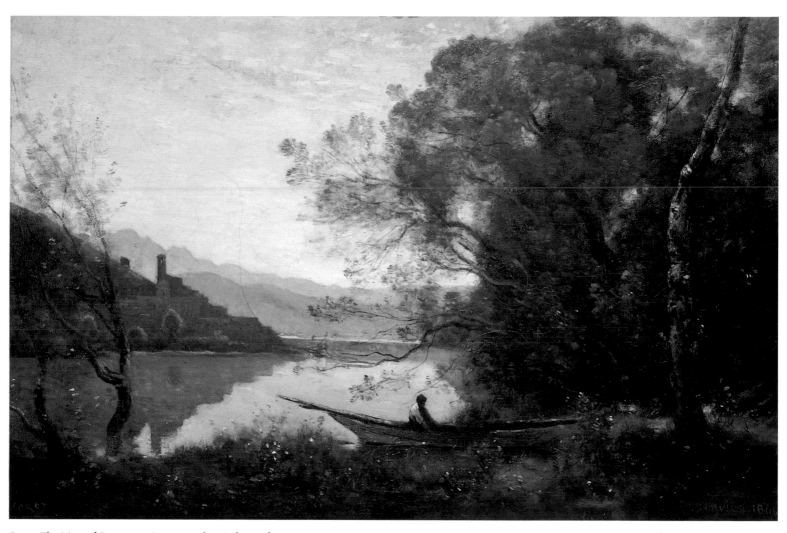

Corot, *The Moored Boatman: Souvenir of an Italian Lake*, cat. 27

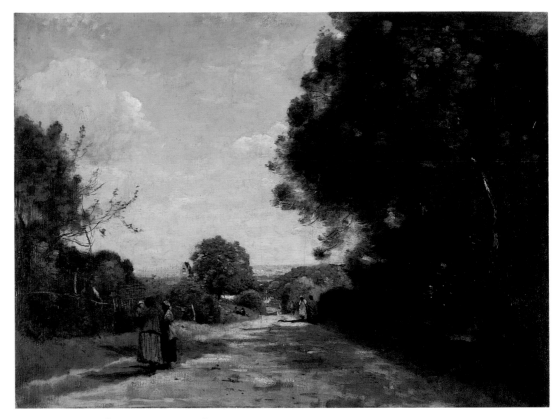

Corot, *Sèvres-Brimborion – View toward Paris*, cat. 28

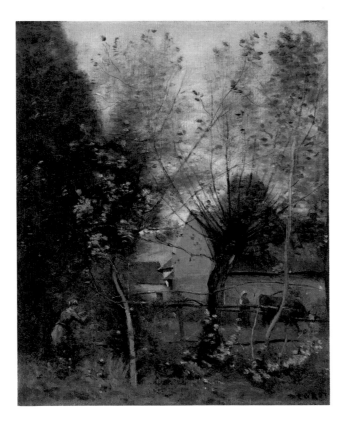

Corot, *Farm Scene*, cat. 30

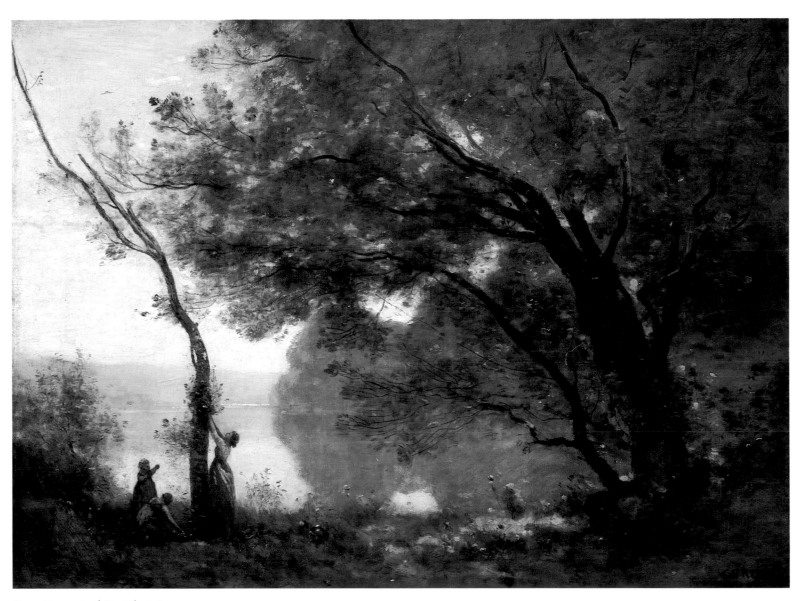

Corot, *Souvenir of Mortefontaine*, cat. 29

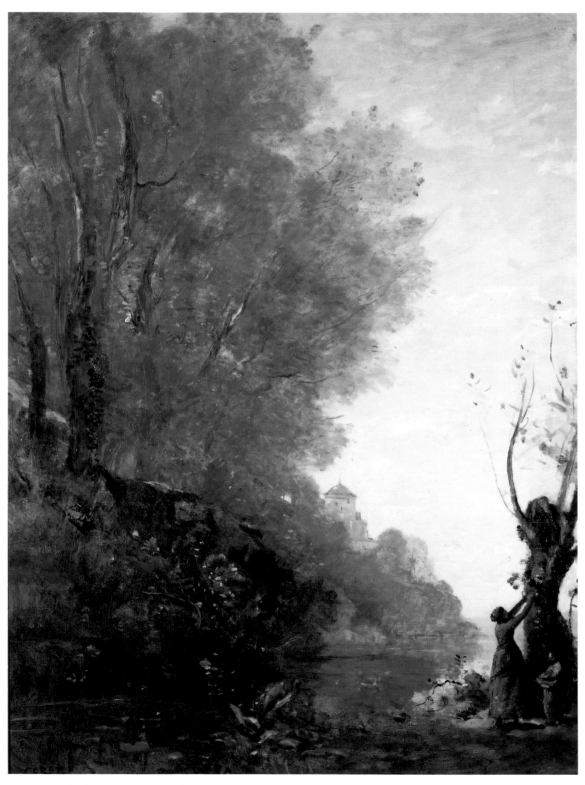

Corot, *The Island of Happiness (L'île heureuse)*, cat. 31

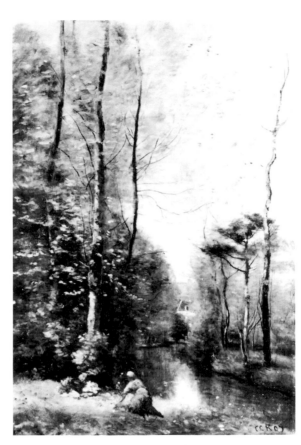

Corot, *A Brook beneath the Trees with a House in the Distance*, cat. 32

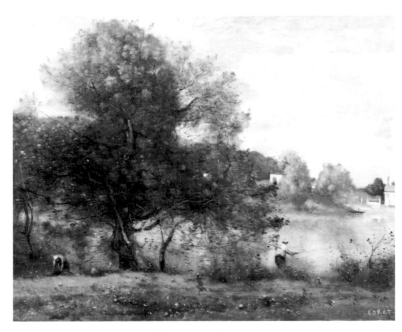

Corot, *An Idyllic Spot at Ville d'Avray: A Fisherman on the Banks of the Pond*, cat. 33

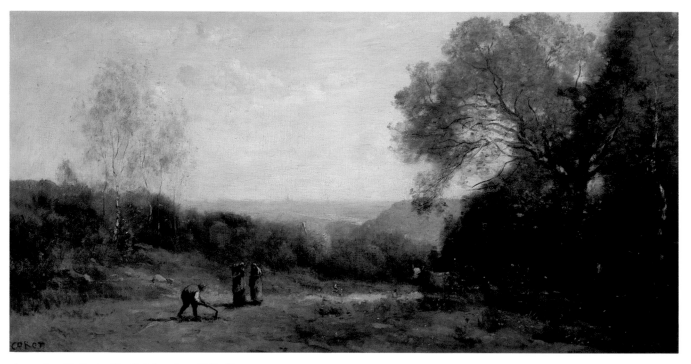

Corot, *Outside Paris: The Heights above Ville d'Avray,* cat. 34

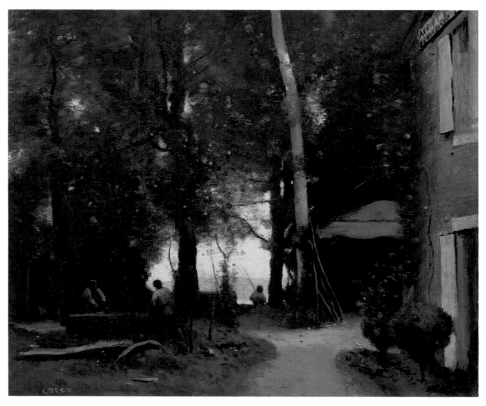

Corot, *Wheelwright's Yard on the Seine,* cat. 35

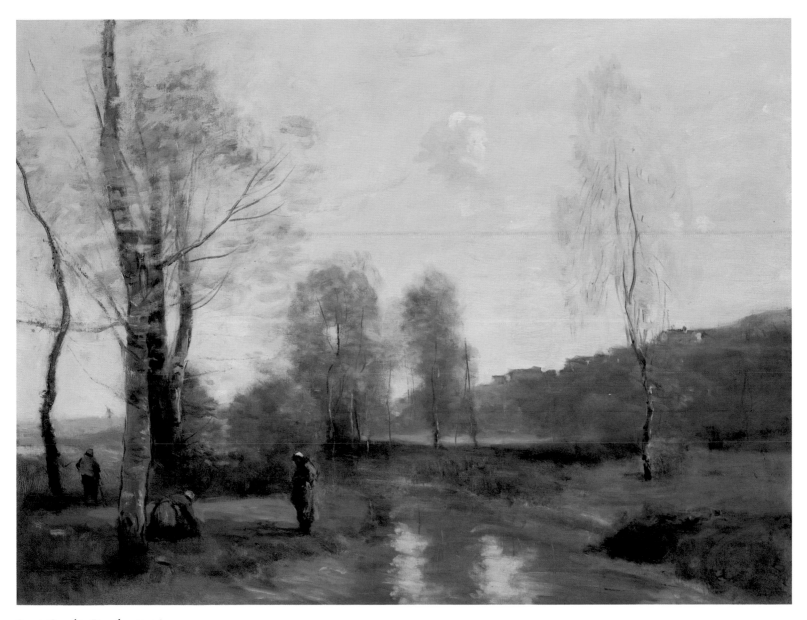

Corot, *Canal in Picardy*, cat. 36

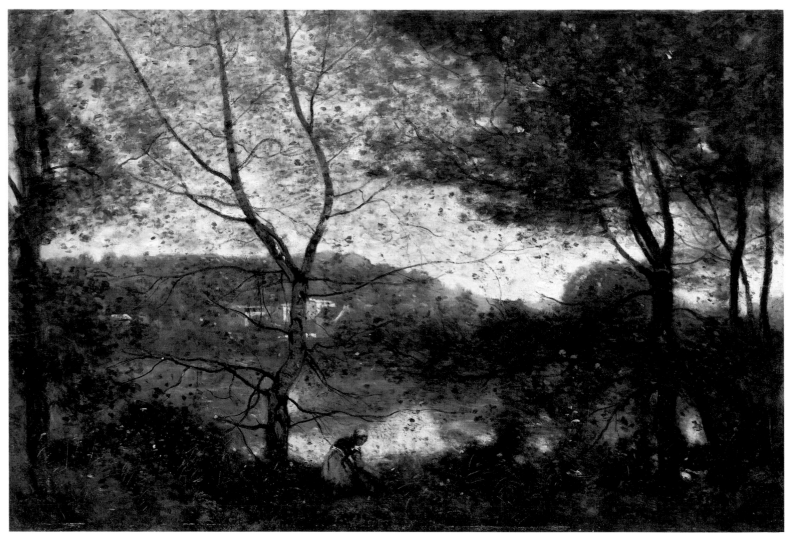

Corot, *Ville d'Avray,* cat. 37

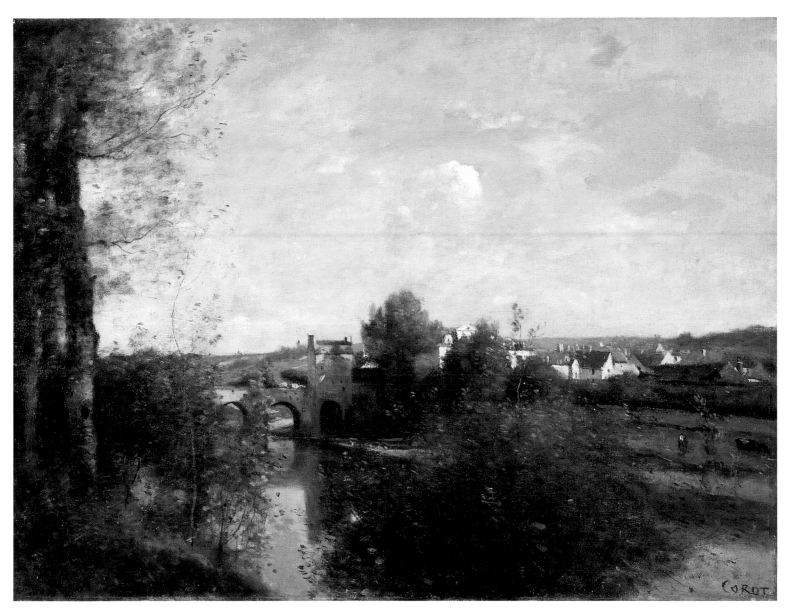

Corot, *Old Bridge at Limay, on the Seine*, cat. 38

GUSTAVE COURBET
1819, Ornans – 1877, La Tour-de-Peilz (Switzerland)

1833: First art instruction with *Père* Baud (or Beau), Ornans. 1837–38: Polytechnical school in Besançon; studies at studio of Charles-Antoine Flajoulot. 1839: To Paris to attend law school; frequents studio of Steuben; meets François Bonvin. 1841–43: Rejected by Salon. 1840s: Drops law, enters Académie Suisse; meets leading artists and critics at Brasserie Andler, a popular café; makes copies at Louvre. 1844: Salon debut with *Portrait of the Artist (Courbet with a Black Dog).* 1846–47: Refused at Salon; first foreign group exhibition (Amsterdam). 1847: To Holland; to Belgium (with friend and critic Champfleury). 1848: Draws for *Le Salut Public*; shows at Salon (ten works). 1849: Wins second-class medal for *After Dinner at Ornans* which is purchased by the State and sent to the Musée des Beaux-Arts de Lille (ten works shown in Salon). Alfred Bruyas (Montpellier collector) becomes a patron. 1850–51: Shows nine works at Salon including *The Stonebreakers, A Burial at Ornans,* and *Peasants of Flagey Returning from a Fair*; trip to Berry; to Ornans via Brussels and Munich. 1852: Salon painting *The Young Ladies of the Village* purchased by the comte de Morny in advance of Salon; visits the journalist Pierre-Joseph Proudhon. 1853: Accepted by Salon. 1854: Visits Bruyas in Montpellier to plan for 1855 Universal Exposition. 1855: Holds independent forty-painting exhibition, including *The Studio – A Real Allegory . . .* in his Pavillon du réalisme; eleven paintings also included in official Exposition. 1856: No Salon held this year; returns to Ornans,

travels in northern Europe. 1857: Shows in Salon. 1858–59: Successful sales and foreign exhibitions; meets Whistler in Paris and Boudin in Le Havre. 1860: Meets Jules-Antoine Castagnary, influential critic; shows in Salon and many French exhibitions. 1862–63: Productive painting campaign in Saintonge; Isabey advises on Salon submissions; *Return from the Conference* is excluded both from Salon and Salon des Refusés; collaborates with Proudhon on *On Art and Its Social Significance.* 1865: Shows in Salon; to Fontainebleau (meets Monet and Renoir); to Trouville. 1866: Given Room of Honor at Salon; to Deauville (sees Boudin and Monet); travels again from Paris to Ornans. 1867: Special pavilion at Universal Exposition, also included in main international section. 1868–70: Annual Salons. 1869: To Etretat. 1870: Publicly refuses Legion of Honor. 1871: Elected Commune member; made President of the Federation of Artists. 1873–77: Accused of toppling Vendôme column; after imprisonment flees to Switzerland to paint in exile.

D
URING THE Universal Exposition of 1855 in Paris, Courbet managed what no other painter before him had – namely, to bring landscape to center stage, presenting it in his huge painting called *The Studio – A Real Allegory Representing Seven Years of My Artistic Life* (Paris, Musée d'Orsay) as the focus for the entire enterprise of pictorial imaging. This painting was itself a monumental centerpiece for Courbet's private exhibition (in his own Realist Pavilion) where it was surrounded by a large group of paintings, both landscape and figural, representing his artistic accomplishment to date. The landscape which Courbet pictures himself painting in *The Studio* is therefore the centerpiece of a centerpiece in a complex spectacle devised to portray the seamless bond between the Realist artist, his life, and his work. For purposes of the present exhibition, what is most important about Courbet's portrayal of this bond is the fact that landscape painting is made to serve as the simultaneously real and allegorical point of reference. In addition, Courbet's staging of the reference develops around a pic-

tured analogy that brings together the performative activity of the landscape painting and the performative activity of the composer/conductor of symphonic music. This strategy and its implication are discussed in detail elsewhere in this catalogue.

Courbet's role in generating an accelerated momentum in the overall practice of landscape painting in the years between 1847 and 1860 has often been blurred by the more publicly affective character of his accomplishments as a figure painter. By 1855 Courbet had already produced most of the large-scale figure paintings for which he is best known – the *After Dinner at Ornans* (Lille, Musée des Beaux-Arts), *The Stonebreakers* (destroyed, formerly Dresden), and *The Burial at Ornans* (Paris, Musée d'Orsay) – as well as a considerable number of variously programmed self-portraits. It is these figural paintings with their unexpected featuring of common people, natives of Courbet's hometown, Ornans (in east central France near the Swiss border), that generated the notion that Courbet's was a new kind of art, describable as Realist rather than just naturalist in the prevailing "based on nature mode" of other figure or landscape painters. Courbet's art was real in its specificity of choice of subjects – ordinary subjects familiar and important to him – and in its highly original modes of representing them. Traditionally eloquent arrangements of figures were rejected for ordinary arrangements. The ways in which Courbet chose to evoke them pictorially involved equally novel technical procedures. His paint surfaces were built up with virtually any implement he could get his hands on – brushes of all sizes, the palette knife, and all manner of things that could deposit or scrape pigmented oil. The constructive activity of Courbet's painted surfaces is as demonstrably real in its emphatic handmade quality as are his subjects.

Not since Constable's work had anything like the variegated paint construction of Courbet appeared in France. And even while reminding the spectator of Constable, if of anyone, the actual message of Courbet's surfaces – how they function, what they mean – is ultimately unique. Both Constable and Courbet improvise their paint construction variously in different pictures, but what guides the improvisatory activity is not the same. Constable's hands respond to seeing; Courbet's, to seeing and touching simultaneously. Because this is so, Courbet's surfaces are sensuously more complex. Feelings of seeing and touching combine in them to produce virtually limitless combinations of passive representation and active abstract crafting. So open are the processes of Courbet's paint construction that those processes themselves become a kind of second subject in his pictures, and the remarkable effect of this is the highly radical and influential demonstration that content may be made in painting to reside (as it does in pure music) in technique alone.

Nowhere does the demonstration of technique functioning as content in Courbet's art emerge more clearly than in his landscapes, but the production of landscape was part of a larger art-political agenda which requires some discussion. For the works produced between 1847 and 1857, Courbet concentrated on the area near his hometown, painting typically interesting hill, valley, and river views common to the area. Remaining close to his rural heritage was an important polemical maneuver (related to that followed in his figure paintings) undertaken to establish both aesthetic and socio-political distinctness in his artistic practice. Although comparatively wealthy rural bourgeoisie in terms of his family background, it was important for Courbet in terms of his evolving Realist program to emphasize the rural and suppress the bourgeois about himself. In the years around the revolution of 1848, radical politics required an anti-bourgeois posturing in Paris and other major urban centers all over Europe. Courbet's provincial manners needed only a bit of exaggeration to make him move more easily into what were eventually professionally useful activities of a politically radical sort. Wagner, who tried the same political game in Dresden during the same period, was less fortunate, ending up a fugitive from the law and a fifteen-year refugee from German territory. Courbet, on the other hand, successfully manipulated his radical politics to become an aesthetic hero in France. He used his political

posturing literally to become "Realism" — a sort of one-man emblem of advanced artistic practice in a period obsessed with notions of revolutionary change in every aspect of human activity.

Once Courbet's art-political position was secure, his imaging practices became freer. In landscape this meant painting whatever he saw wherever he happened to be, as well as continuing to return frequently to local sites from the area near Ornans. Highly marketable, Courbet's landscapes constituted an increasingly large portion of his artistic production. By the late 1860s he could hardly keep up with market demand and employed assistants. From the beginning though, landscape had been important to Courbet. He was being honest in giving landscape practice aesthetic pride of place in *The Studio*. Courbet seems to have discovered more about his craft and his own feelings when painting landscapes. Landscape and its imaging, a psychologically more neutral zone of experience than the painting of the human figure, left Courbet comparatively free to explore the intricate expressive relationship manageable via pure and highly original modes of paint construction and coloring.

Of the paintings included in the present exhibition, the 1858 *Valley of Ornans* is a superb summary example of Courbet's first, locally focused, landscape imaging mode. It displays an enormous range of constructive paint markings and a highly unconventional division of color zones between the dark foreground and the complex topographical and architectural motif of the middleground and background. Both areas are more flatly and intensely dark or light than anything imaged by members of the Corot-Rousseau-Daubigny circle. There is no imposed atmospheric unification of tone or color value. Instead, Courbet's paint deposit is allowed to exert very openly both its descriptive and its abstractly tactile intensity.

By mid-career, Courbet seems to have needed frequent changes of location for his landscape work in order to continue to discover new challenges for his increasingly self-expressive technique. Beginning in the late 1850s, seascapes provide such challenges. Courbet was not natively familiar with the sea, and whether viewing it in Normandy or in the South of France, he always managed to find textures and colors of productively unanticipated varieties. At times, as in *The Angry Sea* of c. 1869, the sheer weight of raging surf combined with the almost palpably heavy sky and the spray of salt water produce overtly dramatic contrasts within the paint and color structure. At other times, as in *Seacoast (Souvenir of Les Cabanes)* from a decade earlier, the natural coloristic and textural variety of coastal topography and vegetation combine to encourage a highly flexible, exploratory, Constable-like form of technical devisings. *The Valley of the Loue* from the mid-1860s and *A Bay with Cliffs* from c. 1869 are painted by a more "relaxed" Courbet, content to let his hands build ingratiatingly toned and touched surfaces in response to his obviously enjoying eye.

The most powerful of Courbet's landscapes from this period, and the most idiosyncratic in terms of motif, are the four versions of *The Source of the Loue* from c. 1864. The version from Buffalo, which is included in the present exhibition, is perhaps the most barren and confrontational of all. Represented is the rough, rocky "hole in the earth" from which the river proceeds. The contrast of rock and water is, in terms of depicted substance, virtually absolute, and only the magical responsiveness of Courbet's paint marks and palette manages to weld the content into a continuously live organism of picturing. Spectators are forced to follow with their eyes (and fictively with the hands as well), the uniformly rugged working of Courbet's painted surface as it creates a feeling of unity, when in the motif there is only opposition.

One figure painting by Courbet is included in the present exhibition, sitting in, so to speak, for *The Studio*, which is too large to travel. Produced in 1847 as one of two versions of the same subject, *Self-Portrait: The Violoncellist* proclaims the relationship, as Courbet saw it, between the making of music and the making of paintings.[1] The image is developed in the rather conservative Rembrandt-like mode of many of Courbet's early figural works, so it is in no sense remarkable from the point of view of style. What

is remarkable is the subject embedded in the style. Given his anti-bourgeois posings in his earliest Realist years, why would Courbet portray himself playing a type of stringed instrument identified only with upper-middle-class concert music? Other self-portraits include mandolins or guitars – appropriate proletarian instruments and easily explainable as radical, bohemian attributes – but the cello is not so easily explained, nor is it particularly easy to comprehend visually in Courbet's rendering. As represented, the cello is held as though it were a lap instrument, like a guitar or mandolin. The position of the instrument is ultimately absurd and was clearly known to be so by the artist and is visible as such to intelligent spectators. Additionally, the instrument seems in its proportions and positioning to be made of rubber. It is, in other words, a fantasy instrument rather than a real one. Since it is a fantasy (perhaps a "real" fantasy of Courbet's), its sheet music is behind the player and the player's hands are implausibly placed on the bow and the fingerboard virtually straight across from one another and close in to the body of the instrument. The hands are as much a fantasy as is the cello. They might as easily be seen fictively masturbating (either male or female options available) as involved in making music. Assuming that Courbet intended this as a real portrait of his artist-self, he is representing his activity as an amalgam of imagining, of making music, and of the display of intensely private touch. A more comprehensively real portrait of the artist could not be imagined.

1. Sarah Faunce and Linda Nochlin, *Courbet Reconsidered* (Brooklyn: Brooklyn Museum, 1988), 95.

Courbet, *Self-Portrait: The Violoncellist*, cat. 39

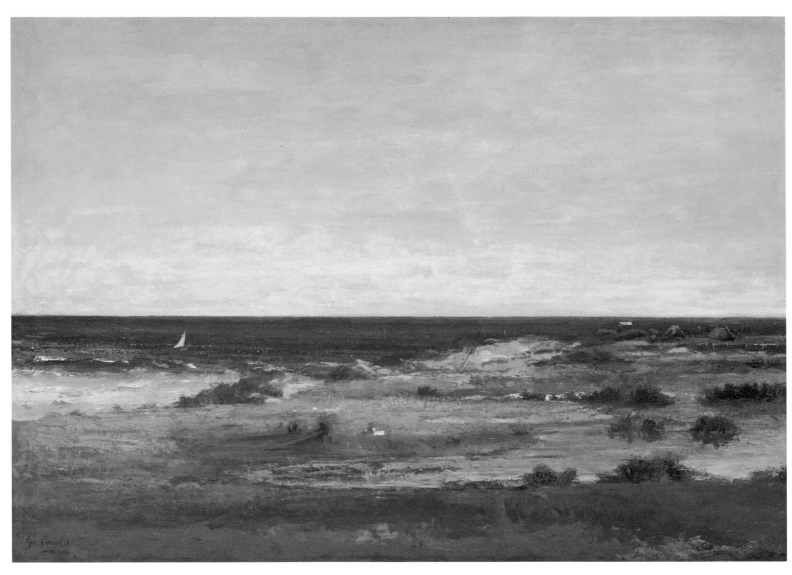

Courbet, *Seacoast (Souvenir of Les Cabanes)*, cat. 40

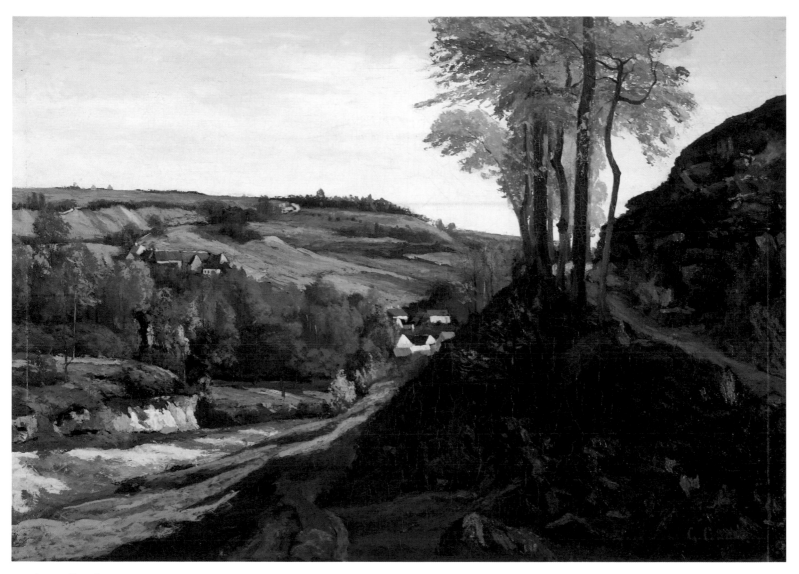

Courbet, *Valley of Ornans*, cat. 41

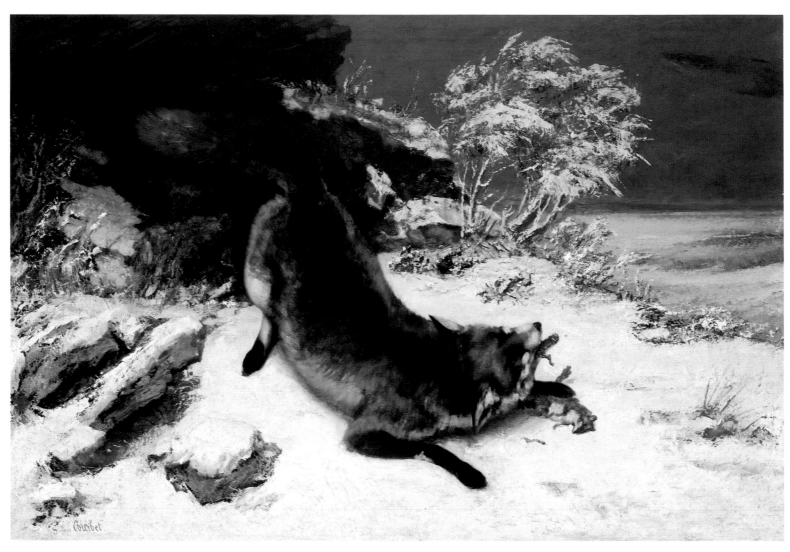

Courbet, *Fox in the Snow,* cat. 42

Courbet, *The Source of the Loue*, cat. 43

Courbet, *The Valley of the Loue*, cat. 44

Courbet, *A Bay with Cliffs*, cat. 45

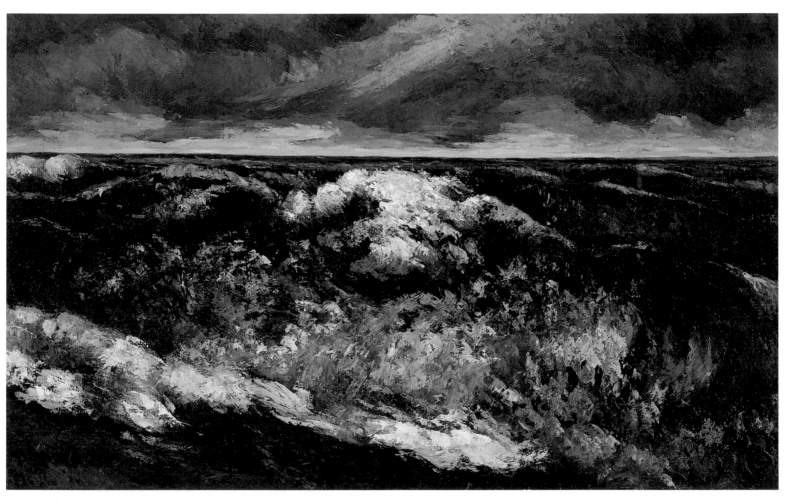

Courbet, *The Angry Sea*, cat. 46

CHARLES-FRANÇOIS DAUBIGNY
1817, Paris – 1878, Paris

1830s: Studies with father, Edme-François Daubigny, a landscape painter. 1836: Trip to Italy; serves as restorer of paintings, Louvre. 1837: Studies in François-Marius Granet's Paris studio. 1838: Practices etching at Paul Delaroche's studio; Salon debut; submits regularly until 1868 (wins medals 1848, 1853, 1868, 1874). 1843: Begins to visit Barbizon; marries. 1844: First trip to Forest of Fontainebleau. 1852: Meets and travels together with Corot; French government purchases *View of the Seine.* 1854: To Normandy. 1857: Builds riverboat, known as *le botin,* to serve as a studio; made Chevalier of the Legion of Honor. 1859: Commission to paint Minister of State's chambers. 1860: Settles in Auvers-sur-Oise; emperor commissions *View of Saint-Cloud.* 1866: To England with Monet (returns during the Franco-Prussian War); serves on Salon jury; *Moonlight* poorly received by London's Royal Academy. 1867: Wins first-class medal at Universal Exposition. 1868: Serves on Salon jury for second time. 1870: Made Officer of the Legion of Honor. 1872: Travels to Holland.

Daubigny is the preeminent figure from the middle generation of artists represented in this exhibition. Like the Dutchman Jongkind, he takes up the modern practice of landscape imaging at a point when the groundwork in terms of models and of marketing has been established. Corot, Rousseau, and, to a degree, Courbet had collectively opened the Salon doors to ambitious naturalist and Realist landscape, and from an early point in his career, Daubigny reaped the benefits of a willing audience, both public and private. Yet there is much more to Daubigny's art than simply good timing. He was immensely talented and perhaps uniquely sensitive to the wide range of achievement represented in the art both of the painters of the generation of 1830 and its alternatives (in Courbet). By the mid-1850s Daubigny produced strong and original work. Several masterpieces were produced from the area around Optevoz — some that are strictly landscapes and others that portray complex "peasant" architectural motifs. The former paintings, such as *The Water's Edge, Optevoz,* demonstrate a clear debt to Courbet in the physical force of their paint construction and in the confident (and largely instinctive) deployment of complex intervals of color. The latter have a material weightiness of both motif and paint structure that gives them a kind of physical hyper-presence analogous to that felt in Courbet's figure paintings. But overall it is — even at this point in his career — Corot who seems to inspire Daubigny most significantly, particularly in matters of painted tonality. There is always an organizing tone – a particular value of a particular hue of gray or green (at times blue) that serves as a reference for all the colors in a given picture. Hues tend to be close (gray, blue, green) with minimums of yellow or rose additions. Depending on the motif (and the depicted time of day), light and dark oppositions may or may not intrude as relatively simple vistas of space are opened.

More than any other major artist in the century (including Constable), Daubigny relied on working in nature and from nature for the development of his effects. He quite likely brought his paintings nearer to finished condition in the out-of-doors than did many other artists (Monet, for example) who made more public clatter about the practice. Daubigny used a studio boat for the development of his innumerable views of moments and places on his beloved Oise River in the 1860s. These paintings, of which there are several superb examples in the present exhibition, seem to represent wholeheartedly nature-based imaging in a

uniquely comprehensive fashion. To modern eyes, trained to believe that nature "looks" like later Impressionist images, Daubigny's paintings seem rather passive and soft. They ultimately rely for their effect on familiarity with pre-Impressionist work (Corot's in particular) for their down-to-earth natural charm and for the subtle changes in feeling – sometimes accomplished by the motif, sometimes by the tonality, and sometimes by the variability of the brush-stroke construction – that distinguish one work from a superficially similar relative. Individual paintings take time to be looked at and into. They need to be compared, either actually or in memory, to others in order that their distinctiveness be made to emerge. There is nothing theatrical in Daubigny and the best of his work is a kind of seamless achievement of the sort Monet would rephrase (no doubt remembering Daubigny) later on in his series paintings of the 1890s. In fact, Monet's series work has its most singular precedent in Daubigny and in the works of Daubigny from the 1860s which he "grew up on." Both in paintings and in suites of etchings, Daubigny moved softly from image to related image, making the most of small changes of position or of natural movement.

The tendency for Daubigny's work to disclose its character slowly and sequentially and within rather narrow motific limits is indicative of his melomania, as is a somewhat similar phenomenon in Corot's works in the late 1850s and 1860s. For both artists, musical-spectating time frames as well as theme and variation practices became almost a procedural rule. Like Schumann's piano suites, which became increasingly popular in France in this period, Daubigny's successive images change their mood (sometimes softly, sometimes abruptly) while holding to fairly constant motific materials. Mastery of technique is everything. That is where variety and richness of effect finally reside. One can hardly imagine an engrossing subject in Daubigny's mature work, but one easily finds exceptionally refined effects – arguably quite musical ones.

Daubigny would on occasion stretch his mate-

rial in the direction of the work of the younger Impressionist artists. His *Fields in the Month of June* comes from the same year as the first Impressionist group exhibition. Its sprinkling of red poppies and the comparatively strong color passages in the sky are a gesture toward the more hue-contrast dominant tastes of the brash, "noisy" Impressionists, but the gesture, in spite of the substantial physical scale of the painting, remains in the end a polite rather than enthusiastic one.

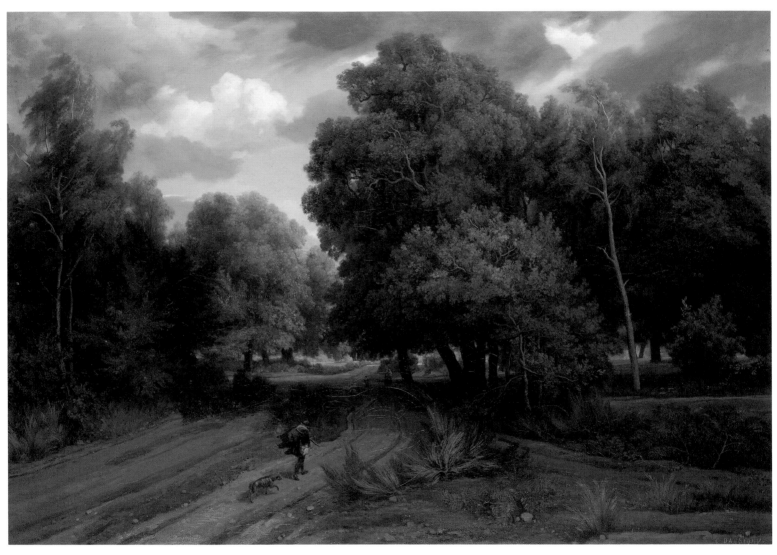

Daubigny, *The Crossroads at the Eagle's Nest, Forest of Fontainebleau*, cat. 47

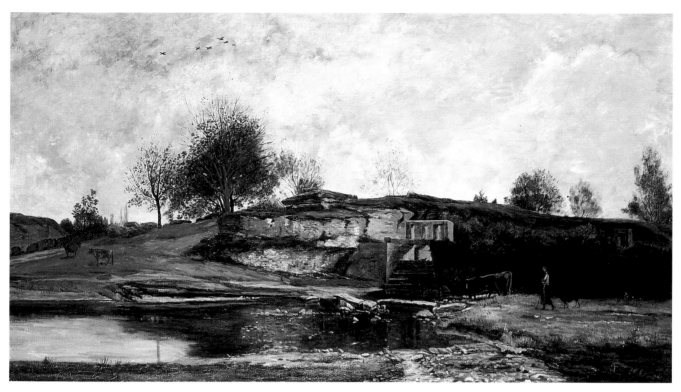

Daubigny, *Sluice in the Optevoz Valley*, cat. 48

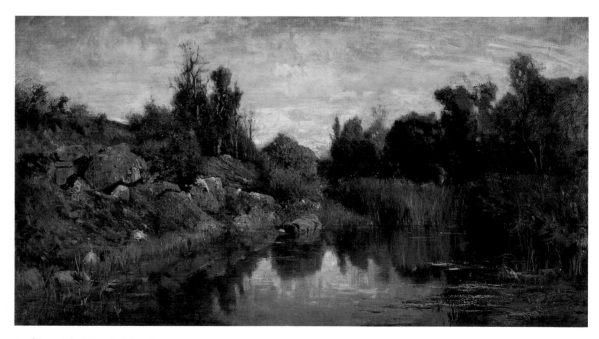

Daubigny, *The Water's Edge, Optevoz*, cat. 49

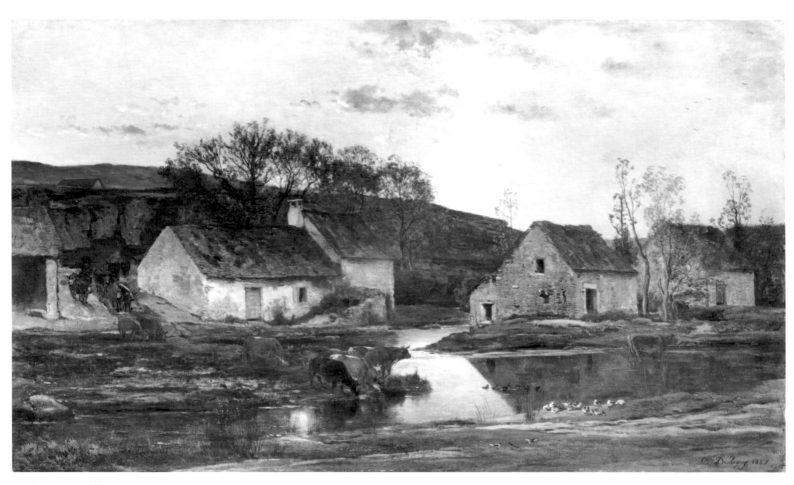

Daubigny, *The Mill at Optevoz*, cat. 50

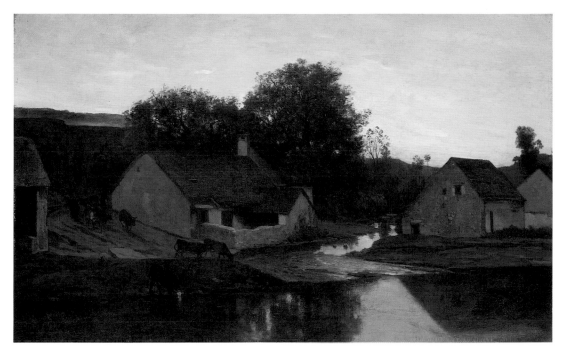

Daubigny, *Gobelle's Mill at Optevoz*, cat. 51

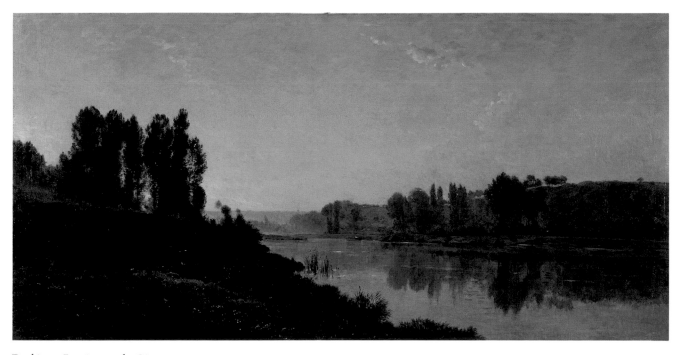

Daubigny, *Evening on the Oise*, cat. 52

Daubigny, *Morning*, cat. 53

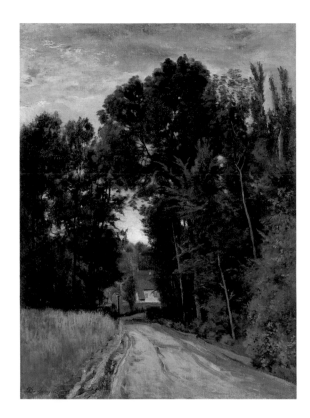

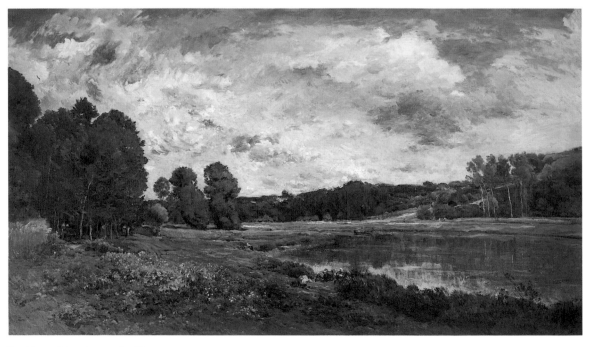

Daubigny, *Morning on the Oise*, cat. 54

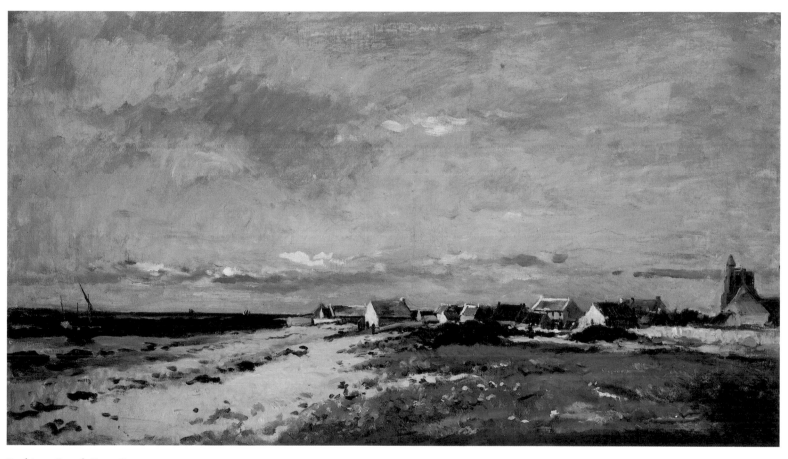

Daubigny, *French Coast Scene*, cat. 55

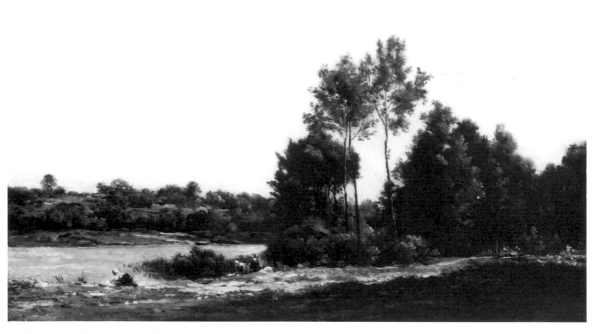

Daubigny, *The Washerwomen of Auvers*, cat. 56

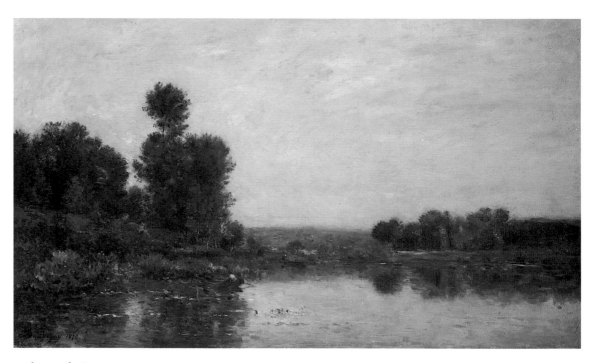

Daubigny, *The River Oise at Auvers*, cat. 58

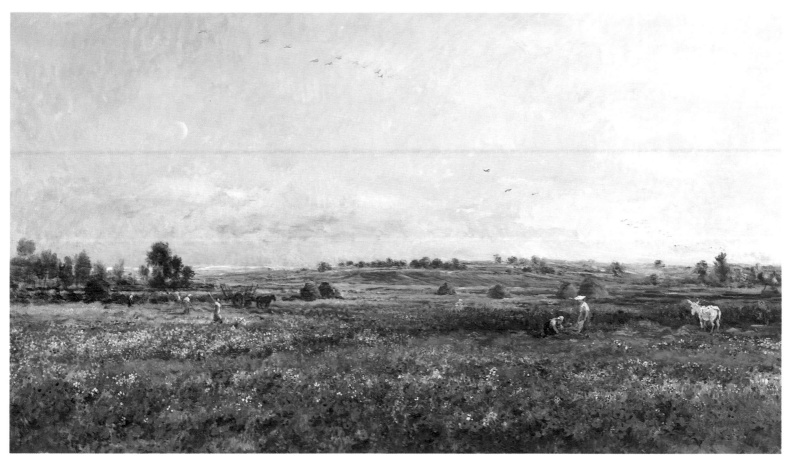

Daubigny, *Fields in the Month of June,* cat. 57

NARCISSE VIRGILE DIAZ DE LA PEÑA
1808, Bordeaux – 1876, Menton

Son of Spanish political refugees. 1818: Orphaned and raised by clergyman; leg is amputated due to snake bite; apprenticed to a porcelain painter; meets artists Dupré, Nicholas-Louis Cabat, Auguste Raffet. 1820s: Studies briefly with François Souchon at Lille Art School; makes copies at Louvre. 1831–59: Consistently accepted at Salon. 1836: Meets Rousseau in Fontainebleau. 1844: Receives third-class medal for *The Bohemians*. 1846: Receives second-class medal. 1847: Meets Corot, Jacque, Millet, and Troyon in Fontainebleau. 1848: Receives first-class medal. 1851: Legion of Honor. 1855: Seven entries at Universal Exposition. 1857: In Paris. 1864: Napoléon III commissions conservation of Tuileries ceilings. 1870: To Brussels. 1870s: Nurses poor health in Etretat and Menton after living for years in Barbizon.

UNLIKE ROUSSEAU, Diaz experienced routine success from an early point, both at the Salon and in the private gallery market with landscape paintings of subjects more or less specifically derived from the Forest of Fontainebleau. In retrospect it is comparatively simple to see why Diaz achieved such broad popularity while Rousseau was considered "difficult." The latter was a totally uncompromising painter. His images make no obvious concessions, either in terms of subject matter or in technique, to established public taste. From the mid-1830s onward, Rousseau pursued the most tragic and psychologically ambiguous of landscape sensations, rarely giving his viewers anything reassuring to hold onto. Rousseau felt loneliness and vastness in the forest. Nature for him was a live complex of monumental geological and botanical forces which were never gentle and often alienating to the helpless human presence witnessing those forces. Everything in Rousseau is in some fashion larger than life, sublime, and ultimately incomprehensible in everyday terms or in everyday fantasy.

Although Diaz was Rousseau's lifelong artistic associate, he was never as personally close to him as Millet was. And despite their association, which began as early as 1837, Diaz seems never to have been inclined to see landscape, even the same landscape, in Rousseau's way. He felt nothing of Rousseau's awe. Instead, the Fontainebleau landscape, as he depicts it, is interesting and inviting. Correspondingly, it is painted as it is seen – gently, often with a luscious softness of touch, and with an ingratiating movement of tone from lights to darks. Often the landscape space opens hospitably to specific human action, becoming the context for the pleasures of the hunt or the wanderings of bands of brightly clad gypsies. There are at times surprises of both landscape or figural sorts in Diaz's works, but the surprises are never threatening. The spectator can approach a Diaz without fear and with the knowledge that there will be much that is conventionally pleasant to be seen and to be felt.

But there is more to Diaz than just a "soft" Rousseau, and it is probably wrong to suggest that he shamelessly catered in a conscious fashion to his bourgeois audience. It is more accurate to see Diaz as himself, naturally bourgeois in his taste and feelings. There is too much imaging conviction, too much flexibility of technique operative in his work, to see it driven by any but authentic feelings. That those feelings may not have been of the elevated variety of Rousseau's (or Beethoven's) is not to prove them ungenuine. Like any artist of integrity, Diaz painted from himself and for himself. It was his contemporary good fortune that his feelings regarding nature were in every important respect identical to those of the audience which would see and buy his works. Diaz's loss

of stature in the present century results from the fact that the viewing audience and many of its feelings have changed considerably.

The range of Diaz's painting at its best can be seen in two of the works included in the present exhibition: *The Stag Hunt* of 1846 and *Early Autumn: Forest of Fontainebleau* from 1870. Except for the greater technical finesse of the later work, the two paintings are not so different as to suggest major modifications of aesthetic premises. *The Stag Hunt* fills a Rousseau-like open foreground with the complex actions of the hunt, while secondary figures are stationed at various positions in the equally Rousseau-like forest background. Everything in the image space is comfortably measured by the presence of figures. The trees and the forest floor seem to contain the figures in a generously accommodating way. The later work, *Early Autumn,* which is not so dependent on the human figure per se, nevertheless positions its topographical details and handles its light and surface construction so as to appear enterable rather than mysterious. The forest, inhabited or uninhabited, remains a pleasant place and a nominally beautiful one.

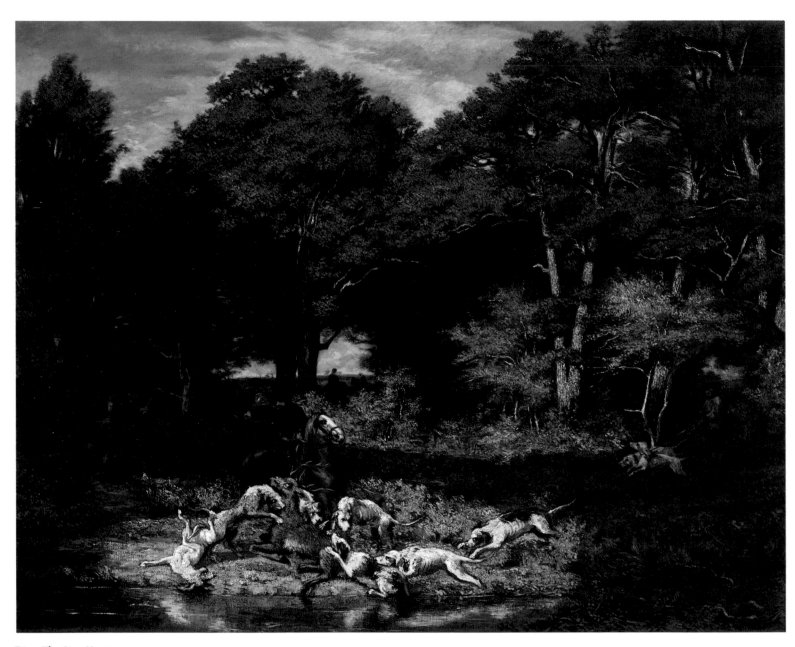

Diaz, *The Stag Hunt*, cat. 59

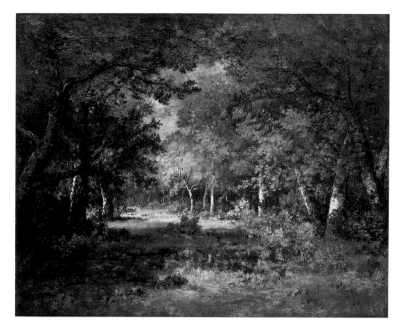

Diaz, *Forest Scene*, cat. 60

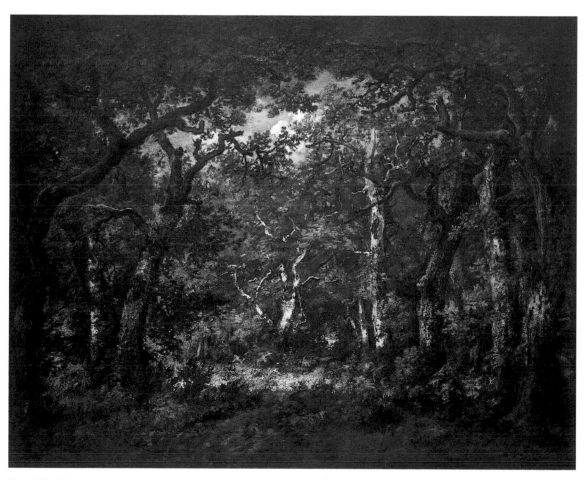

Diaz, *Wood Interior*, cat. 61

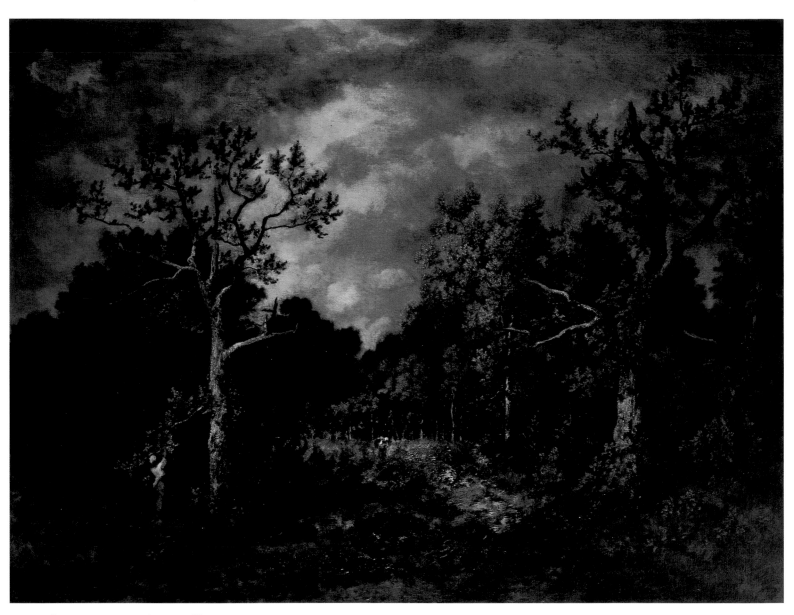

Diaz, *Early Autumn: Forest of Fontainebleau*, cat. 62

Diaz, *Autumn*, cat. 63

Diaz, *Landscape*, cat. 64

JULES DUPRÉ
1811, Nantes – 1889, L'Isle-Adam

Apprenticed to father (porcelain manufacturer); meets Diaz, Cabat, Raffet. 1820s: Brief art instruction under Austrian painter Jean-Michel Diébolt. 1829: To Paris. 1831: Salon debut. 1833: Receives second-class medal. 1834: Meets and befriends Rousseau. 1834–36: Submits to Salon (subsequently 1839, 1844, 1852, 1867, 1873). 1834: To England; admires Constable's landscapes. 1844: To Landes, Bay of Biscay, L'Isle-Adam (north of Paris), and Pyrenees with Rousseau. 1849: Receives first-class medal and Legion of Honor; ends friendship with Rousseau; works alone in L'Isle-Adam with summers on the Channel coast. 1867–73: Included in Universal Exposition (again in year of death); resides in L'Isle-Adam with trips to Picardy, Cayeaux, Oise. Late 1870s: Returns to Paris for a period.

SEEN IN THE CONTEXT of his most formidable contemporaries, Corot, Rousseau, and Courbet, Dupré's work appears anachronistic. His painting seems to resist – almost in principle – being a part of the nineteenth century. Much of his work honors seventeenth-century Dutch examples or the residue of such in the work of Georges Michel. This is not to say that Dupré was unaffected by his contemporaries. Such was not possible. Rather it is to suggest that Dupré, for whatever reasons, undertook to stress continuities between historical and modern landscape painting, rather than differences. For this he was rewarded with considerable contemporary market success but ultimately was rejected as a serious artist-friend by the wayward Théodore Rousseau.

Trained like many other artists of his generation as a porcelain painter, Dupré was comprehensively aware of a wide range of historical imaging practices. In landscape this meant seventeenth-century Holland in particular. Even though his work would respond in various ways to Rousseau's, Constable's, and Troyon's at different points in his career, Dupré would remain an eclectic artist with very particular, and ultimately very limited, taste. He would never stretch the sensibility of his audience with imaging difficulties. Instead he would reassure that audience that everything (with regard to landscape practice) was comparatively normal. Needless to say, Dupré needed a high degree of learned technical sophistication to carry out his arch-conservative role among the artists of his generation. He possessed this from an early point, and because he possessed it, he was able to feign a kind of naive freshness almost as a matter of routine. Unlike any other artist of note in his immediate circle, Dupré conceals his technical prowess. Whether he does so emulating a kind of composite of Diaz and Troyon in the Lehman Collection's *Cows in a Field* or Michel in Cleveland's *Windmill*, it is always clear that Dupré is technically holding back to appear more original. Later in his career, he is more straightforward. His *Pastoral Scene* of 1870 is a splendid seventeenth-century Dutch paraphrase, more than worthy of the equally expert technician Troyon. What is missing in Dupré at virtually every point in his work is original feeling. He is the true academician of mid-century landscape painting.

Dupré, *A Bright Day*, cat. 66

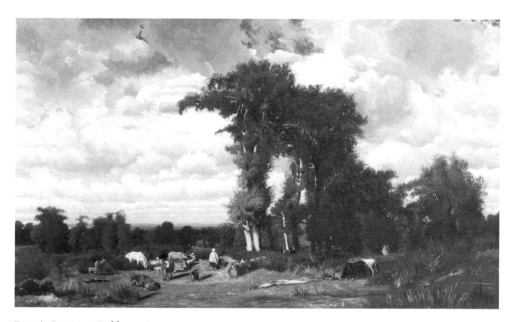

Dupré, *Cows in a Field*, cat. 65

Dupré, *Windmill*, cat. 67

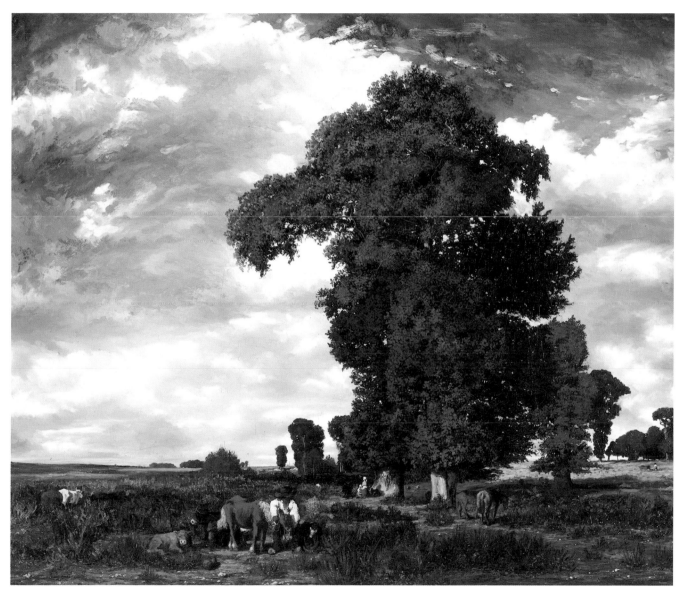

Dupré, *Pastoral Scene*, cat. 68

PAUL HUET

1803, Paris – 1869, Paris

1816: School on L'Ile Séguin. 1818: First trip to Normandy; enters Pierre-Narcisse Guérin's studio. 1819: Enters Baron Antoine-Jean Gros's studio. 1821: Second trip to Normandy (returns frequently 1825–68). 1822: Makes first studies in Forest of Compiègne (returns 1832, 1834, 1837, 1840); meets Eugène Delacroix. 1827: Salon debut; shows at Salon through 1869 (receives medals 1833, 1835). 1833: Travels to the South of France. 1836: Marries. 1838–41: Summers in Sceaux; winters in Nice. 1841–43: Trip to Italy. 1844–45: Returns to Nice; meets Delacroix again. 1848: Wins Salon gold medal; travels in the Dauphiné region. 1849: First trip to Fontainebleau. 1851: To Chailly (returns 1859, 1860, 1863, 1865, 1868). 1855: Success at Universal Exposition. 1862: Trip to London; enters Société des Aquafortistes (Etchers' Society). 1863: Buys chalet in Chaville. 1864–65: Travels in Belgium, Holland, and Brittany.

HUET'S MAGNIFICENT *The Château at Pierrefonds, in Ruins,* the single example of his work in this exhibition, is arguably his masterpiece. Confidently large in its Salon scale, this painting summarizes the character and the extent of Constable's direct legacy in France. And, even more to the point, it does so in the late 1860s when the example was newly interesting. Echoes of Huet's work appear in various forms in the contemporary efforts of both Daubigny and Pissarro.

Despite an academic figural background, Huet was drawn to landscape painting even before 1820. Working routinely in Normandy, he absorbed several waves of influences from a variety of British artists – many of whom were Constable's contemporaries and, working in watercolor, were collectively obsessed with a kind of daylight brightness, often opposed to and emphasized by somewhat strong renderings of shadow. Like his friend Isabey, Huet responded rapidly and enthusiastically to Constable's oil paintings when significant numbers of them appeared in Paris in the 1820s. The intricacy of Constable's palette steps and the seemingly limitless breadth of his technical invention (dedicated to specifying every grade of light-struck tint and texture) left a lasting impression on both artists. At the same time, the equally British taste for the historically picturesque absorbed them; both Huet and Isabey worked productively for many decades with motifs developed in the continuously popular "picturesque voyage" mode found most commonly in widely distributed albums of lithographs and in upscale illustrated magazines in France through the 1860s.

The Château at Pierrefonds represents the brilliant late blossom of the Constable-informed but picturesque mode of French landscape imaging. The subject, presented as though in a moment of impressive contemporary time, in fact represents a fiction since the ruins were already in the process of restoration by the architect Eugène Viollet-le-Duc after the mid-1850s. The Huet view is one of nostalgia for those historical monuments revealing in their ruin the texture of past centuries and their gradual slippage back into nature. Being a romantic in the simplest, yet most profound sense, Huet uses the complex devices of a "scientific" manner of imaging to heighten the affective plausibility of his motif. He makes the remembered (or the desired) come once again to life, with his ruins made to seem pastorally embedded in an excited complex of light and atmosphere. Major contrasts of zones of light and shadow alternate with more minor accents of color to bring the image back to life in the spectator's imagination. True, the science of Constable (at least the Constable of the 1820s) has been neglected in favor of the conjuring potential of his technique, but for his French contemporaries that was the most durable aspect of his legacy.

Huet, *The Château at Pierrefonds, in Ruins*, cat. 69

EUGÈNE ISABEY

1803, Paris – 1886, Montévrain

Studies under father, Jean-Baptiste Isabey, official Empire miniaturist. 1824: Salon debut with marines and landscapes, wins first-class medal. 1825: Meets Eugène Delacroix at Dieppe; travels to England and sees Delacroix again; meets painter Richard Parkes Bonington; paints watercolors. 1827: Trips to Trouville and Honfleur. 1828: Meets Huet; travels in Normandy, Brittany, and in South of France. 1830: Named official painter of royal marines; travels in Algeria. 1839, 1842, 1844, 1859: Salon acceptances of naval combats and ceremonial marine paintings. 1845: Meets Jongkind. 1850: Travels with Jongkind to Normandy and Brittany. 1851: Begins to spend summers at Varengeville. 1878: Submits final Salon entry and shows in Universal Exposition, where he wins first-prize medal.

BY VIRTUE OF having actually visited England in 1825, besides working in the ambience of many British watercolorists in Normandy during the 1820s (and after), Isabey served as the firmest conduit joining advanced landscape practice on both sides of the Channel. It is a function that he carried out (along with Huet) for half a century. By definitions that would link progressive developments exclusively with English sources in this period, Isabey must by necessity be termed the most progressive Frenchman. Indeed, his reputation at the Salon and elsewhere (even among the young painters of the 1850s) was formidable. His market was international, largely, one suspects, because his work displayed so perfectly the essence of the taste for the "picturesque voyage" that was created and sustained by an enormous number of albums of lithographic views of rustic/historical sites in France that were produced from 1825 through the 1860s. Isabey was himself one of the best of the many lithographers engaged in such publishing projects, and certainly *the* best after the death of his English friend and rival, Richard Parkes Bonington. As a painter, Isabey followed Constable's lead carefully, at least for a time. In works like his *Norman Fishing Village* of c. 1831, there is as clear an emulation of the complex crispness of Constable's handling of light via high-keyed color (with many accents of pure white) contrasted with the absence of light in dense romantic passages of shadow, as any French painter would ever produce. Théodore Rousseau, along with many other landscape painters in France in the 1830s, would be keenly impressed by the early interpretations of Constable that Isabey effortlessly provided, while delivering the example in appropriately picturesque French form around distinctly French motifs.

For many decades Isabey was the artist in residence on the Normandy coast where he painted (not necessarily from nature per se) many of the sites and locations later favored by Jongkind, Boudin, and finally Monet. However, as the years passed and as his reputation expanded, Isabey gradually elaborated the theatrical char-

acter of his landscape practice, making it (for want of a better term) somewhat performative, even operatic. His subjects were intended as crowd-pleasers of a fairly predictable sort, ranging from quaint village seascapes with much interesting generic figural activity to exciting, if not unduly sublime or terrifying, sea pieces. His c. 1850 *Boat Dashing against a Jetty* is typical of his mid-career work. It is all activity and spectacle delivered through drawing, paint handling, and coloring that are quite self-conscious in their agitated virtuosity. Before long, Monet would react negatively to works like these – even good ones like the *Jetty* picture – seeing them as "terrible machines," but there was in his hostile reaction a certain undercurrent of envy (one suspects) for the publicly affective force of Isabey's achievement.

Jongkind was sufficiently impressed by Isabey in the early 1850s to have journeyed from Holland to study under his direction; he became Isabey's student as conscientiously as any of those painters who began at about the same time to cluster around Corot. Virtuoso technical practices, long divorced from sources in Constable, combined with locally colorful genre subjects, became basic to Jongkind's early work. The sources in Isabey are as clear as is the forward passage of them from Jongkind into the work of the young Monet.

Isabey, *A Norman Fishing Village*, cat. 70

Isabey, *Boat Dashing against a Jetty*, cat. 71

CHARLES ÉMILE JACQUE
1813, Paris – 1894, Paris

Briefly apprenticed as map engraver. 1830–36: Military service in Antwerp and Burgundy. 1836–38: In London, draws illustrations for new Shakespeare edition. 1843: Gains reputation as watercolorist. 1845: Salon debut (etchings). 1848: Salon debut (paintings). 1849–54: On recommendation of Diaz, settles in Barbizon with Millet and Rousseau until he breaks with Barbizon artists and departs for Paris. 1850–51: Salon third-class medal for graphic arts. 1861: Salon third-class medal for painting. 1863–64: Salon acceptances (wins total of seven third-class medals). 1867: Receives Legion of Honor.

BESIDES BEING AN accomplished painter, Jacque is perhaps even better known as a prolific etcher and illustrator. In fact his early training was devoted to printmaking and cartography. The graphic skill which Jacque possessed served him well as he moved into the practice of landscape in the late 1840s. Millet was his primary model, and Jacque's tendency to feature shepherds and sheep in the half-pasture, half-forest images that carry his reputation owes much to Millet's example. But Rousseau and Diaz seem to have impressed Jacque as well. The former's dry, somewhat impersonal rendering of foliage and the latter's more sensuous painterly finesse combine in various ways to form the characteristic Jacque rendering of landscape. Never an ambitious colorist, Jacque favored tonal effects centering in greens, yellow-greens, and grays. His treatment of light is conservative. He tended to use some pure white in his skies and to sprinkle passages of moderately high values more or less evenly through his landscape sections.

As a landscape painter per se, Jacque has rather little personality to present. But it was not pure landscape that primarily interested him; rather it was animals – particularly sheep. He became an absolute master at populating his landscape openings with large groups of intricately yet naturally positioned sheep. No painter since the seventeenth century had managed to present field animals as so convincingly a part of their painted setting.

In paintings like those grouped in this exhibition, it is the sheep – their positions, movement, and variety in terms of texture, tone, and shape – that establish the feeling of the landscape. That feeling is open in a way that is wholly remarkable considering the constant cast of "characters" Jacque employs. Obviously, Jacque's facility as a draftsman was basic to his accomplishment of so much vitality in his animal groups. He comprehended graphically the expressive anatomy of the sheep almost as completely as Michelangelo comprehended the human body. It is easy to overlook Jacque's expression, since it is vested in the imaging of lower animals, but in a period anthropologically sensitized by Darwin-type notions, lower animals may not have seemed quite so low as they do to us.

Jacque, *Landscape with Sheep*, cat. 72

Jacque, *Sheep (At the Watering Hole)*, cat. 73

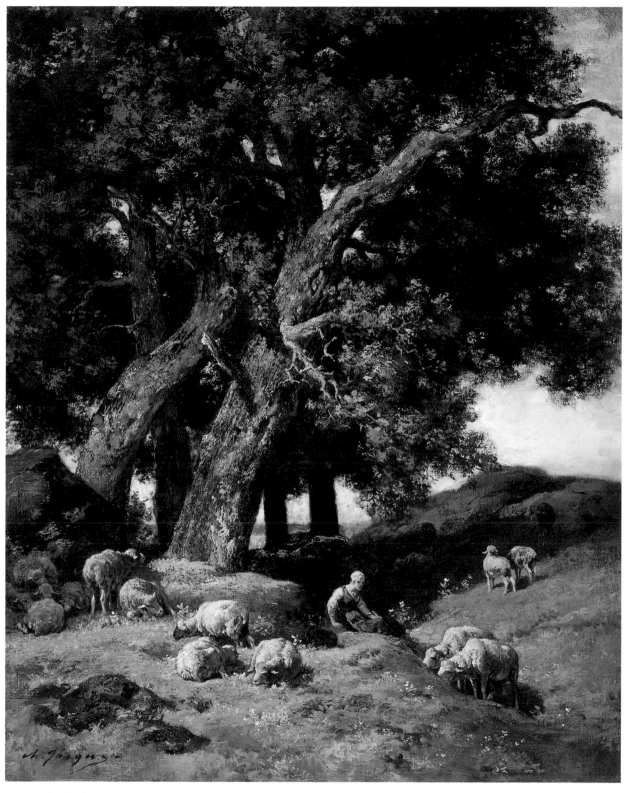

Jacque, *Shepherdess*, cat. 74

JOHAN BARTHOLD JONGKIND
1819, Lattrop (Holland) – 1891, La Côte-Saint-André

1838–39: Studies under landscape painter Andreas Schelfhout at the Hague Drawing Academy; learns watercolor techniques. 1845: Meets Isabey and joins him in Paris, 1846, when he receives Dutch government grant (first Paris stay lasts until 1855). 1848: Salon debut with *Seaport*. 1850–51: Paints with Isabey in Normandy and Brittany; shows *View of the Port of Honfleur* in Salon of 1850; meets dealer *Père* Martin. 1852: Receives third-class Salon medal for *Saint-Valery-en-Caux, Setting Sun* and *Le Tréport, Morning Effect*. 1855: Some official recognition at Universal Exposition (three works) but little success overall. 1855–60: Returns to Holland. 1856: *Père* Martin sells Jongkind paintings and watercolors at Hôtel Drouot to help settle artist's debts. 1857: Meets Courbet. 1858: Wins silver medal at Dijon exhibition. 1860: Returns to Paris where second sale of works organized by friends including Corot, Isabey, Diaz, Harpignies, Rousseau, Ziem, Jacque; marries; paints views of banks of Seine. 1861: *Dutch Sunset* poorly received at Salon. 1862: Paints Normandy coast and Le Havre. 1863: Meets Monet; visits Honfleur; participates in Salon des Refusés (five works). 1865: Meets Boudin at Trouville. 1866–69: Travels to Holland, Belgium, and in France. 1873: Salon jury rejects two Rotterdam landscapes (last submissions to Salon); travels to the South of France. 1870s: Gains sales and recognition among amateurs and collectors; travels to Switzerland. 1878: Settles in La Côte-Saint-André.

ARRIVING IN PARIS in the mid-1840s, Jongkind was perfectly positioned to examine the rich panorama of contemporary landscape imaging for which Corot, Rousseau, and Isabey were largely responsible. Soon after his arrival, he would be confronted by the vigorously physical landscape approach of Courbet as well. Coming from Holland, Jongkind was initially drawn to Isabey (with whom he studied and traveled to Normandy). Isabey's combination of technical bravura in the handling of light and motifs filled with architectural, figural, and topographical interest appealed both to the picturesque taste which Jongkind brought with him to Paris and to his northern (Halsian or Rubensian) love for the virtuoso brush. In his earliest mature works of the mid- and late 1850s, such as the *Boats in the Harbor, Sainte-Adresse* or *La Tournelle Bridge, Paris*, Isabey's influence is strong; however, compared to Isabey's works, Jongkind's treatment of clouds, land, water, buildings, and boats has a freshness that demonstrates a more careful examination of actual motifs in nature (rather than previously pictured ones). The prevailing move in the work of most advanced landscape painters in the 1850s toward continual refinement and expansion of expressive means by reference to particular motifs, studied at length out-of-doors, is specifically apparent in the increased plausibility of the particular moments of light and atmosphere that develop in Jongkind's work. Certainly, his paintings are not yet as dependent on continuous out-of-doors work as those of Daubigny, but the advantages of the practice, pursued selectively, have become evident to Jongkind. In addition, his eye for color relationships has become educated and subtle, probably from studying Corot's example. As a result of this, he manages, even in works (like the two mentioned above) completed in Holland on the basis of studies made in France, to develop a convincing sense of the visually immediate. Isabey's devices of dramatic chiaroscuro (broad contrasts of light and shadow) are increasingly less in evidence, as Jongkind tries to keep his entire landscape prospect open to light of a sort which is (as it is in nature itself) continuous in its effect.

Not since the appearance of Constable's work in the mid-1820s had France seen this open quality of painted outdoor light as convincingly rendered as in Jongkind's and Daubigny's efforts of c. 1860. For Jongkind, the accomplishment of this made it possible for him to respond productively to the sharper, more two-dimensional and *light-generating*, pure color effects which he saw being featured in the paintings of Boudin and the young Monet in Normandy in the early 1860s. Working with them from time to time, Jongkind soon developed the manner of painting for which he is appropriately best known and of which there are several excellent examples in this exhibition. His canal and river pictures, made in all seasons, are enlivened by a Japanese-print-like variableness of silhouette and seemingly random distribution of nearly pure color.

The drawing with paint looks rapid, at times even careless, with a quality of theatricalized spontaneity appearing in the overall distribution of sprinklings of pure white. The paintings can appear almost improvisatory – more calculated than sketches, yet possessed of many of the qualities of the undeliberated decisions characterizing sketches. Compared to the work of younger artists like Monet, there is often a technical showmanship (albeit of an original sort) that undermines the point-to-point clarity of Jongkind's images. They can seem uncertain as to whether they address the spectator as painted surfaces or as conduits into space. But at their best, Jongkind's works feel alive with a spontaneous character that is absolutely distinctive, conveying a nervousness through superheated technical effects that is very much of the 1860s.

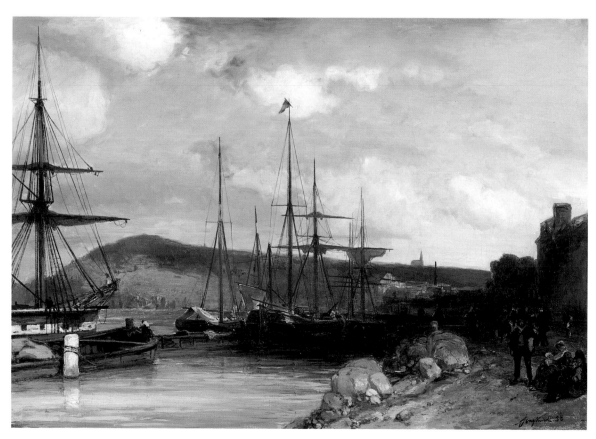

Jongkind, *Boats in the Harbor, Sainte-Adresse (Bateaux en rade, Sainte-Adresse)*, cat. 75

Jongkind, *La Tournelle Bridge, Paris*, cat. 76

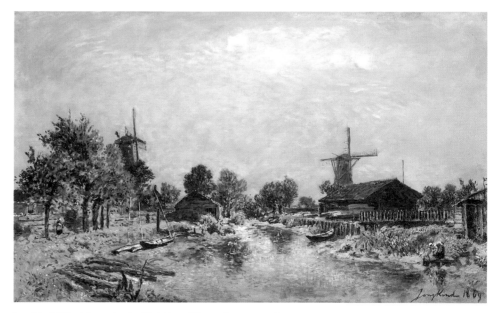

Jongkind, *Canal near Honfleur*, cat. 77

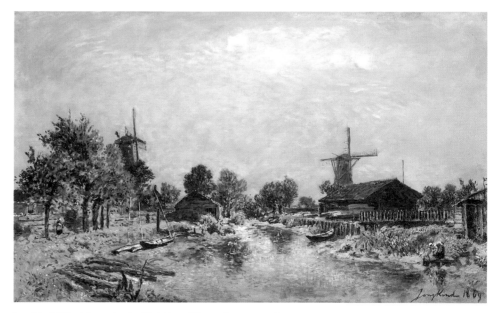

Jongkind, *The Meuse in the Vicinity of Rotterdam*, cat. 78

GEORGES MICHEL
1763, Paris – 1843, Paris

1775: Enters studio of Leduc (history painter). 1779: Marries; becomes protégé of farmer-general of revenues in Chalue. Copies Dutch paintings for LeBrun, a picture-seller and husband of Vigée-LeBrun, with whom he studies. 1790: Collaborates on paintings by Jean-Louis Demarne and Joseph Swebach. 1791: Salon debut (shows through 1814, subsequently refused admission until 1822 when he no longer submits work); the baron d'Ivry becomes patron until falling out after 1830. 1800: Becomes Louvre conservator of Flemish and Dutch paintings; copies seventeenth-century masters. 1808–10: Opens a studio and gives lessons. 1812–30: Becomes picture dealer and continues to paint Parisian suburbs. 1841: Through sale of studio contents, Dupré discovers his work and Jacque acquires his paintings which he modifies by adding figures and animals.

MICHEL WAS THE resident Parisian "expert" on the landscape tradition of the seventeenth-century Low Countries for the first forty years of the nineteenth century. As a conservator and copyist, he knew intimately the general character as well as the technical detail of the best Dutch and Flemish masters from Jan van Goyen to Jacob van Ruisdael. Over several decades Michel produced original works as well. These were, depending on their chronology, more or less dependent on paintings he had repaired or copied. Rediscovered by some of the younger landscape painters, Jacque and Dupré in particular in the years just before his death, Michel had a kind of late celebrity. He was touted as a forerunner of the landscape painting of the generation of 1830 even though his work had scarcely been known by that generation in its formative years.

The erratic market history of Michel's work has made of it a hornet's nest of attribution problems. Michel quite literally *could* have painted virtually any seventeenth-century northern-looking painting in any late-nineteenth-century French dealer's inventory. And obviously he had painted quite a number of them, more than a few of which were retouched or "improved" by his well-meaning mid-century fans. Today, one trusts most the authenticity of medium-sized, low-horizoned images such as this exhibition's example, *Landscape,* from the Worcester Art Museum. In it there is just enough consistency of touch in the sky portions and refinement of values in the lower landscape sections to represent a knowledgeable craftsman at work. Additionally, the depicted spatial recession is convincing in a way that it frequently is not in many so-called "Michels."

Michel's ultimate importance lies in the fact that he was discovered to have existed at all. He served as a living link to seventeenth-century naturalist (as opposed to classical) imaging traditions, particularly for painters like Jacque and Dupré, who were themselves most comfortable following pre-established patterns of taste in landscape imaging rather than inventing new ones in the fashion of Corot or Rousseau. Michel was an ideological godsend – and a Frenchman at that!

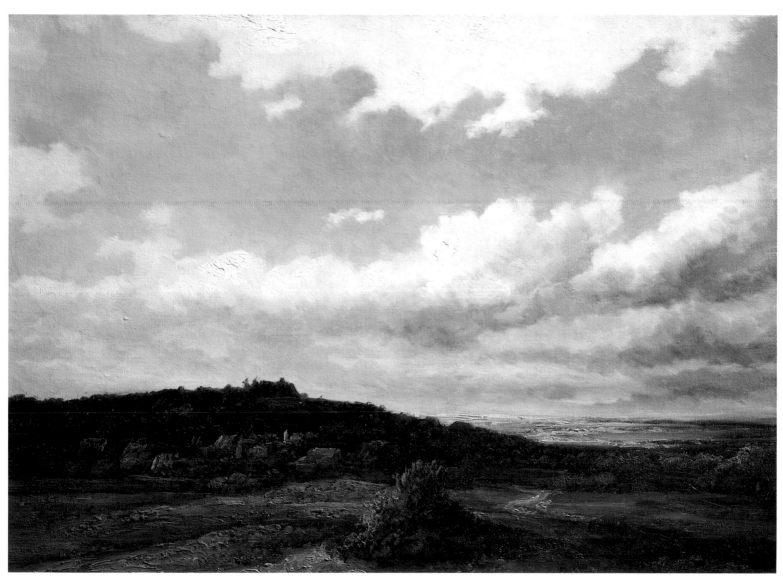

Michel, *Landscape*, cat. 79

JEAN-FRANÇOIS MILLET
1814, Gruchy – 1875, Barbizon

Son of humble Norman landowners. 1833: Enters Cherbourg studio of Mouchel (local painter). 1835: Enters Langlois de Chevreville's studio. 1837: Award permits study with Paul Delaroche at Ecole des Beaux-Arts; frequents Académie Suisse and Louvre. 1840: Salon debut. 1841: Returns to Cherbourg (again in 1853, 1854, 1870–71); marries first wife. 1842: Rejected at Salon. 1845: To Le Havre. 1846: Meets Troyon, Diaz, and art dealer Paul Durand-Ruel; rejected at Salon. 1847: Meets his first potential agent (and Rousseau's future biographer), Alfred Sensier; first Salon success. 1849: Settles in Barbizon with family; meets Jacque; Salon first-class medal. 1850: *The Sower* shown at Salon. 1852: Becomes friends with Rousseau. 1853: Wins Salon second-class medal; remarries (fathers eight children). 1857: *The Gleaners* shown at Salon. 1860: To Franche-Comté with Rousseau. 1862: Periodic monographic exhibitions begin at Galerie Martinet; group exhibitions with Cercle de l'Union Artistique. 1864: Salon first-class medal for *Birth of a Calf*. 1865–68: Shows in foreign exhibitions (Boston, Brussels, London); visits Vichy to nurse wife's health. 1866: Shows *The End of the Village of Gréville* in Salon. 1867: Retrospective exhibition in Universal Exposition. 1868: Receives Legion of Honor. 1870: Durand-Ruel becomes primary agent; to Cherbourg during Franco-Prussian War. 1871: Returns to Barbizon. 1874: French government commissions work for Chapel of the Pantheon (unfinished at time of death).

ILLET'S PARTICIPATION in the "rise" of landscape painting in France after 1830 has traditionally been seen as a supporting role rather than a truly substantive one. Best known for his figure paintings of peasants engaged in a wide assortment of working activities on the land or at home, Millet seems aesthetically and ideologically distant from his fellow artists who dedicated themselves primarily to purely landscape images. Yet the fact of his long association with Rousseau, Jacque, and others suggests that some sensitivity must have existed between his work and theirs. And similar to Rousseau, Millet found it productive to spend long periods in residence in the village of Barbizon, adjacent to the Forest of Fontainebleau, even though he seems to have made little specific motific reference to the forest itself.

It has been argued elsewhere in this catalogue that Millet and Rousseau are viewed most appropriately as two halves of one artist: the former using figures to evoke the land by seeming to be a natural, living extension of it, and the latter using inanimate landscape elements to evoke human presence and human feeling. The two artists, one might argue, start from different points only to end expressively in almost the same place. With a few notable exceptions both artists stayed away from the other's manner of imaging. Only after Rousseau's death does Millet undertake extensive campaigns of landscape painting.

Why, one might reasonably ask, did Millet emphasize the figure so remarkably when his associates systematically minimized its importance in the modern imaging of nature? Obviously something in Millet's temperament inclined him to rely on the figure to fix the expression of his images with greater definitiveness than he felt could be managed with landscape motifs alone. As the "reader" in a group given over more to listening to symphonic music, Millet seems to have experienced a persistent discomfort with the open character of expression that landscape painting, like pure music, encouraged, even mandated. Realizing the richness of expressive range in pure landscape, Millet sought to have that range available,

yet under his firm emotional control. One is reminded of comparable attractions and doubts evident in the writings and, more important, in the contemporary music-dramas of Richard Wagner. Like Wagner, Millet needed some form of roughly interpretable text – in his instance, a figure or a group of figures to initiate and guide expression toward at least partly predetermined emotional goals. Reliance on mythic characters is the specific link between Millet's and Wagner's aesthetic operations. They guide without absolutely closing off ambiguities of meaning, and they prevent the cul-de-sac of absolutely closed and fully "readable" illustration.

Drawing by necessity became a very important component of Millet's art; the figures demanded it. But the kind of drawing Millet had to develop was of a sort which in its breadth and simplicity passed naturally into painting. Academic models were of little use, and by the end of the 1840s, one feels the precedent of the great caricaturist Honoré Daumier guiding Millet as the earliest of his monumental peasant paintings begin to appear. The *Man Turning over the Soil* introduces the supple simplicity of silhouette and internal contours derived from Daumier with a figure which becomes pictorially at one with its landscape ambience. That ambience is schematically Rousseau-like in its overall "tragic" tonality and its bleak generality of aspect.

The present exhibition brings together a highly characteristic grouping of Millet's significant peasant images from the 1850s and early 1860s. Perhaps most remarkable is the small *Summer, The Gleaners*. In this image, figures and the landscape of haystacks form a complex of powerfully rhymed shapes which seem to grow "naturally" from one another in a heavy, almost decorative choreograph. The color too is remarkably elaborated – not so much in hue as in the extended value range of red-oranges and in the enlivening complement of blue. The combination of graphic and coloristic control of rhythm apparent in this painting in particular demonstrates the emergence in Millet's works of an aesthetic individualism that from this point on will move parallel with that of Corot and

Rousseau without in any sense being directly aligned with the works of either in form or in feeling.

Millet's images increasingly move at a tempo which is uniquely theirs; that tempo and the expression it conveys are, somewhat remarkably, most intricately manifested in the artist's post-1865 landscapes, in which the gravity of works from the 1850s gives way to a whole range of surprising, and by traditional standards, off-balance motif constructions that push the spectator's eye back and forth, up and down, in a highly animated, nervous way. As has often been noted, Millet and Rousseau had by the mid-1860s become avid connoisseurs of Japanese woodblock prints, and while the effect of that taste in Rousseau's work remains somewhat elusive, it forms an exceptionally significant part of Millet's late landscape imaging practices. Where but from Japan could Millet have gained the inspiration to use asymmetries, disproportional spacings, and decorative conversations between silhouettes and "open" areas with the abandon he ultimately manages?

If one looks at the comparatively rare attempts Millet made at pure landscape imaging in the 1850s, his *Family Home at Gruchy* for example, one finds a weight of vegetation, topography, and architecture stressed. The sense is of an impacting of adjacent elements. Millet seems to want a kind of figural bas relief to join everything; he wants, in other words, the landscape to behave figurally, even when it is not figural. By contrast, *The End of the Hamlet at Gruchy* and *In the Auvergne* are composed of landscape features (and small figures) that dance freely at the top or toward the side of images where shape and color relationships are equally eccentric – even abrupt. The spectator's eye is moved rapidly across the painting surface toward edges. The vitality of the image expression has passed almost completely into decorative or two-dimensional terms, and the decorative in this instance is much more overtly stated and unequivocal than it ever is in Corot, even in his most schematic and improvised "memory" works of the 1860s.

Millet's move away from the figure to the

decoratively "figural" landscape, influenced by the Japanese print, seems at first inconsistent and discontinuous. Yet it is possible to interpret the operation as one of replacement. The Japanese woodblock print's continuous schematic decorativeness is readable, and was (one might argue) read by Millet as pictorially mythic. Standing in a controlling posture between ornamental convention and incidental representation, the Japanese printmakers had the means to calibrate expression precisely through alternating stress and gloss and through manipulative surprises for the spectator. This kind of control, in degree if not in type, had been an essential attraction of the monumental figure in Millet's works in the 1850s. With the parallel Japanese demonstration seen operative in landscape as well as in figural motifs, landscape takes on a kind of safe attractiveness for Millet which it had never had before. Particularly after Rousseau's death, Millet finds it expressively productive to reconsider landscape imaging as an appropriate domain for developing relatively fixed emotional messages.

The later Millet landscapes would exercise a considerable effect on Monet's work in the aesthetically turbulent years of the early and mid-1880s. Numerous references, of varying degrees of directness, appear from Millet in Monet's many paintings executed (as so many of Millet's were) on the Normandy coast. Millet references combine with equally frequent ones from Japanese prints in Monet's work of this period, restating their recognizable expressive/decorative relationships in no uncertain terms. In the same years, the young Seurat is looking carefully at Millet, too, and not at the Japanese Millet. Rather, in his ambition to produce paintings with the complex structural precision of system characteristic of music, in *A Sunday Afternoon on the Island of the Grande Jatte* (Chicago, Art Institute), for example, Seurat reviews the Millet of paintings like *Summer, The Gleaners* to discover the unity of harmony and counterpoint, rhythmically deployed, graphically and coloristically, that Millet had provided as a prototype of what Seurat felt painting might aspire to be both as structure and as symbol.

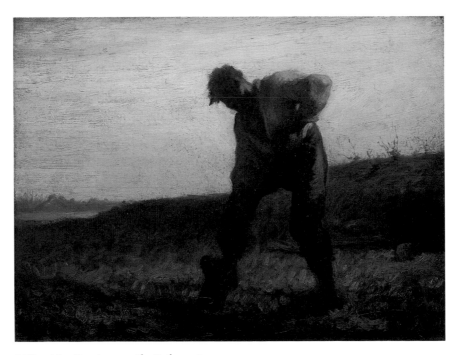

Millet, *Man Turning over the Soil*, cat. 80

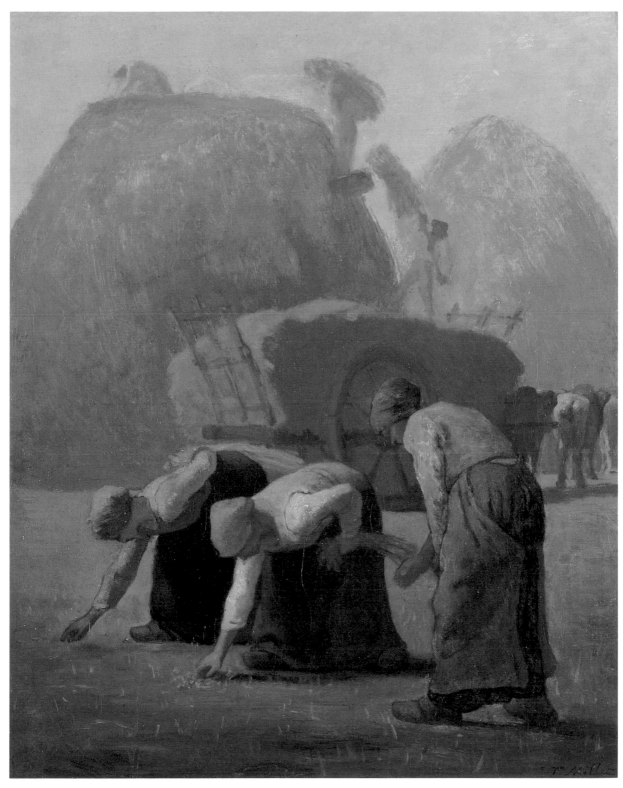

Millet, *Summer, The Gleaners*, cat. 81

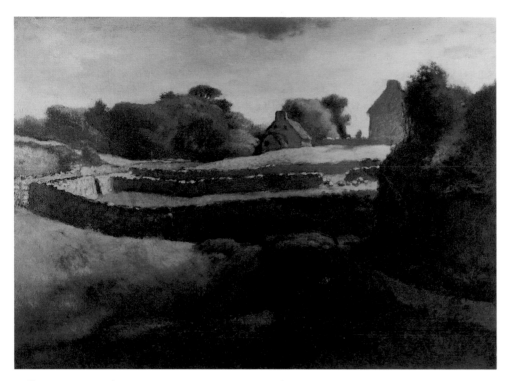

Millet, *Farm at Gruchy,* cat. 82

Millet, *Millet's Family Home at Gruchy,* cat. 83

Millet, *Washerwomen*, cat. 84

Millet, *The Water Carrier,* cat. 85

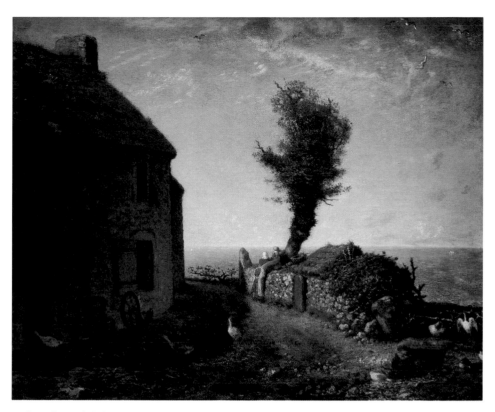

Millet, *The End of the Hamlet at Gruchy (I)*, cat. 86

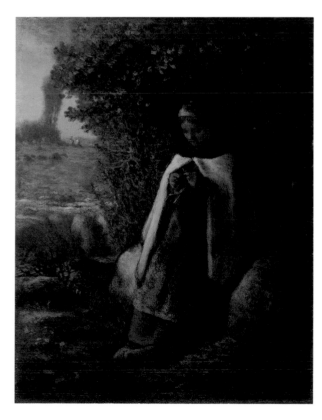

Millet, *The Knitter*, cat. 87

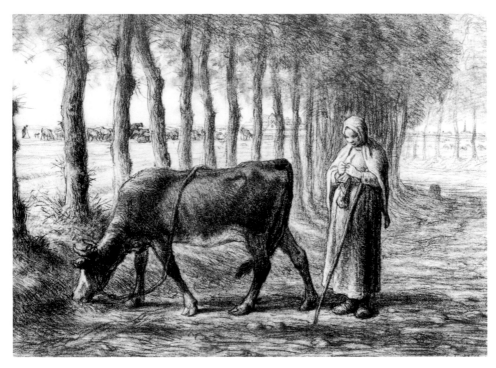

Millet, *Peasant Woman Guarding Her Cow*, cat. 88

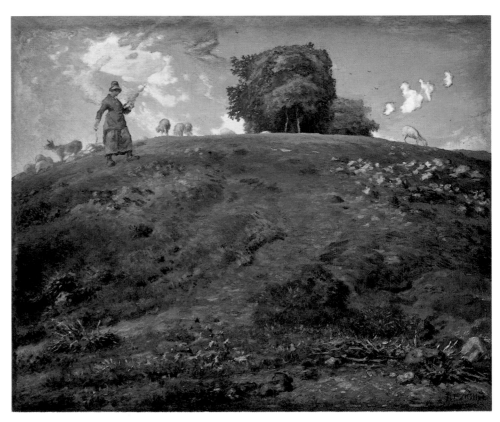

Millet, *In the Auvergne*, cat. 89

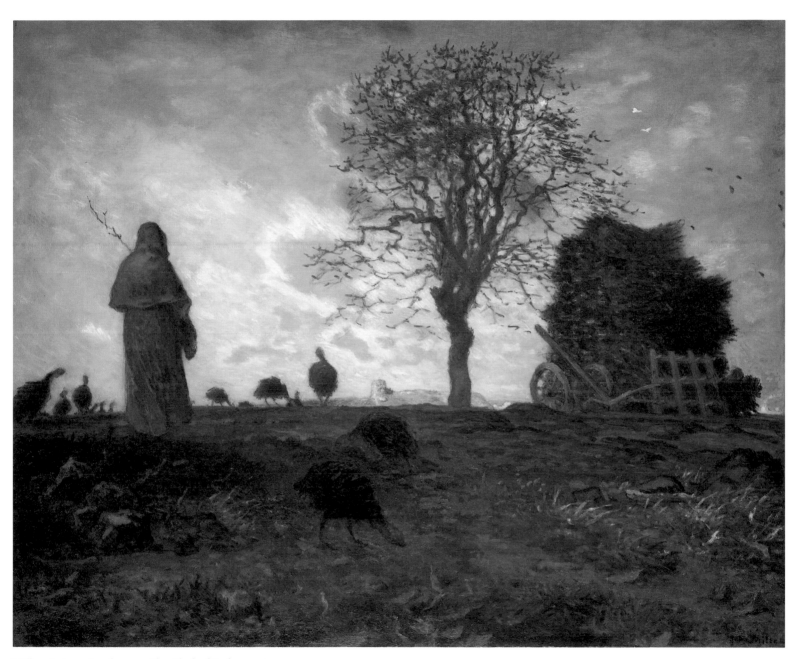

Millet, *Autumn Landscape with a Flock of Turkeys*, cat. 90

CLAUDE-OSCAR MONET
1840, Paris – 1926, Giverny

Childhood in Le Havre. 1856–57: Draws caricatures. 1858: Meets Boudin. 1859: Enters Académie Suisse; meets Pissarro; Troyon advises study with Thomas Couture. 1860–61: Military service in Algiers. 1862: Works in Le Havre with Boudin and Jongkind; enters Gleyre's studio. 1863: To Fontainebleau; observes Delacroix at work; leaves Gleyre and paints with Bazille, Renoir, and Sisley in Chailly. 1864: Meets Courbet; paints with Bazille, Boudin, and Jongkind in Honfleur; tries unsuccessfully to sell to Alfred Bruyas, Courbet's most important patron. 1865: Stays with Bazille in Paris; paints *Déjeuner sur l'herbe (Luncheon on the Grass)* in Fontainebleau; works with Courbet at Trouville; meets Whistler. 1866: *Lady in Green* successful at Salon; meets Manet; lives in Ville d'Avray; travels to Sainte-Adresse and Le Havre. 1867: *Women in the Garden* rejected by Salon but purchased by Bazille; visits family in Sainte-Adresse; son born to Camille Doucieux; sees Sisley in Honfleur; shares Bazille's studio with Renoir. 1868: Accepted at Salon with help of Daubigny; returns to Etretat with Renoir and Bazille; shows in Le Havre and attracts important patron (Gaudibert). 1869: With Renoir at Bougival; again in Etretat and Le Havre; creditors seize paintings; encouraged by Manet to join Café Guerbois circle. 1870–71: Marries mother of his child; during Franco-Prussian War, goes to London with Pissarro and meets Durand-Ruel who eventually becomes his dealer; to Holland and Argenteuil. 1872: With Boudin, visits Courbet (in prison); returns to

Le Havre and Holland; begins to paint with Renoir at Argenteuil. 1873: Like Daubigny, builds a studio boat and uses it for Seine paintings; meets Gustave Caillebotte. 1874: First group exhibition of "Impressionists," term popularized by *Le Charivari* critic who criticizes *Impression – Sunrise*; Manet and Renoir join him in Argenteuil. Included in later Impressionist exhibitions: 1876, 1877, 1879, 1882.

IMPRESSIONIST PAINTING, so-called after 1874, has over the last century been increasingly identified with the work of Claude Monet. And while not everything of accomplishment within the Impressionist orbit was of Monet's making, he certainly provided leadership in matters of landscape imaging for a group of exceptional artists, including Bazille, Pissarro, Renoir, and Sisley. Following a few rapidly assimilated leads from his first mentor, Boudin, in the years around 1860, Monet was well into his early career as a landscape and seascape painter when Bazille, Renoir, and Sisley began to follow his example. Only Pissarro had managed to evolve something like an aesthetic life of his own in the years before he began to consider Monet's directions in the later 1860s, and from the perspective of painting practice, Pissarro had nearly a decade's head start!

Exactly how and why Monet managed the kind of imaging he did during the decade of the 1860s remains a puzzle. He had almost no formal training, a minimum apprenticeship of sorts with Boudin, and he modeled his work on that of others only in highly selective ways. Between 1858 and 1862 he devoured the work of the generation of 1830 as well as that of Daubigny, Jongkind, and Courbet – just by looking at it, one suspects. He made no real copies; he rather chose to develop his eye, assuming his hands would follow as directed. While expressing admiration for the greatest of his predecessors from the beginning and regularly throughout his career, Monet seems from the first to have been determined to produce consistently original work. The standards for the forceful kind of creativity he sought appeared early in the 1860s in the scandal-provoking figure paintings of Edouard

Manet: *Déjeuner sur l'herbe (Luncheon on the Grass)* and *Olympia* (both Paris, Musée d'Orsay). They appeared as well (for Monet probably via second-hand experience) in the music of Richard Wagner which held center stage in the circles of advanced culture in Paris, beginning in 1859 and continuing up to the Franco-Prussian War in 1870. What Manet's painting and Wagner's symphonic writing had in common was a boldness and frankness of effect. Although working in different media, both artists dealt with their audience in new ways — ways that were aggressive, provoking, and loud visually as well as audibly. Both seem to have enjoyed, at least to a point, producing various degrees of scandal with aesthetic surprise, and both, in ways appropriate to his particular medium, used color as the chief device of surprise. (This is elaborated elsewhere in this catalogue.) Coloristic surprise was therefore the common currency of the most ambitious forms of contemporary artistic practice that Monet knew in the early 1860s. Additionally he realized that to be seen or heard as an original artist he would have to deal in that currency as well as absorb and hopefully benefit from the shock waves he might produce. But the prospect of all this excited him, and it is doubtful whether he could ever have become the artist he did, had he not entered the aesthetic scene at such a frenzied moment.

Monet had already developed a strong taste for color in his early stints of work with Boudin, and during his brief period of military service in Algeria (part of 1860 and 1861), he literally fell in love with color of the purest sort, as he found himself surrounded by it in the cloudless world of Arab North Africa. Back in France, the creative questions ultimately became what to make of this love and how to express it, particularly in landscape images. Mid-century landscape examples, even the lightest of Daubigny's paintings of c. 1860, provided relatively few hints regarding a strictly color-based mode of landscape imaging. Corot was probably the nearest thing to a fully color-reliant maker of landscapes that Monet could find, but Corot's color was Corot's color, which is to say tonal and subdued and never given to strong contrasts of hue or value.

Fortunately, Manet had begun to produce seascapes on a more or less routine basis starting in 1864, and while cultivating in them anything but familiar natural effects, he managed through the rhetorically movemented character of his paint structure and the crispness of his value contrasts to evoke strong and immediate sensations. Although his images might look willfully unnatural in many respects, they had enormous optical vitality; that vitality became a talisman for Monet. From 1864 onward, he worked to emulate not so much the appearance of Manet's work, but its energy. Monet derived additional support in matters of appearance from Japanese woodblock prints. What they provided uniquely was an imaging of landscape (among other things) technically restricted to significant shapings of color. With inspirational hints gleaned from Manet's work and Japanese prints, Monet after 1865 would proceed to become his own original.

The primary concern of Monet's landscape imaging would be to make pure color relationships stand for broadly defined nature-based sensations. The process would never be one of simply matching painted color to natural color as it had largely been in Constable and late Daubigny. Instead, color relationships in Monet's works combine in an ultimately endless variety of ways the experience of viewing nature and painting directly from it in the out-of-doors with the differentials of feeling induced by the simultaneous activity of looking and painting. Simplifications of various descriptive sorts and exaggerations of color intensity and color contrast (until they are made to match seeing *and* feeling) — in other words, all manner of schematic artifice — can be considered up to the outer limits of something like representational plausibility. A loose and highly variable paint structure, alternating regular and irregular brushmarks, serves Monet in two ways: first, to theatricalize representational plausibility through technical assertions of spontaneous response to an "actual" moment of nature (here, he invokes the predictable viewer tolerance for the exclusions and inclusions of the traditional sketch); and second, to allow the artist the free-

dom to tighten or loosen color passages at will. A virtually absolute freedom of stress is what Monet wants and what he miraculously manages almost from the first. His stresses come from himself. They come from within the maker and are deposited in the forms of the painting.

Nature, or more concisely, the spectator's understanding of it, would never be the same after Monet had finished imaging it. His willful persistence in making nature behave in accordance with his color feelings caught a science-gullible public unaware. That public came to believe and continues to believe in Monet the researcher, rather than in Monet the magician and aesthetic conjurer. Smartly, Monet never said anything to contradict his public's belief, and he managed by keeping quiet to make the world willingly believe that nature looks like an Impressionist painting. There were a few disbelievers at first, but their complaints soon faded against the collective desire of spectators to be lusciously deceived by works that were truthful only in the radical beauty of their original feeling which was authentic in a creative sense rather than a descriptive one.

It is absolutely remarkable how much of Monet's originality is already functioning by the late 1860s, with strong hints appearing even earlier. In *Haystacks near Chailly at Sunrise* and *The Pointe de la Hève at Low Tide*, one sees the extremes of Monet's early imaging modes — the former broad and schematic in both color and surface construction, the latter composed of an extraordinarily wide range of brushmarks which trace the complex of (distant) coastline, beach, and water both as contrasting zones of color and of color elaborated by natural texture. Two years later in c. 1867, the *Street in Sainte-Adresse* combines the extremes of the schematic and the intricate. A broadly distributed complementary color contrast of various blues and autumnally yellowed greens works along with high value grays in the middle of the image to strike a very bright and resonant chord that seems guided by carefully constructed relationships of shape that proceed differently to the left and right of the central church steeple. Without looking highly contrived, the image

delivers its feeling through a judicious balance of believable natural incident and arbitrary decorative control of color and shape. The paint structure remains comparatively neat and finished in a work which was likely intended for submission to the Salon.

All traces of neatness or any other manner of concession to a conservative viewing public vanish in the aggressive vibrancy of both color and paint structure in the 1869 *Seine at Bougival*. Paint marks and what they represent compete for the viewer's attention. Solid shapes, shadows, water, and foliage blur representationally (in spite of the existence of a "welcoming" road on the right side). Pictorial space is largely siphoned out in order that the tapestry-like intensity and the variety of hue are displayed at every point. Not one but several color chords are struck simultaneously.

Over the next five decades, Monet would learn a great deal technically both about color and supporting painting construction, but he would never lose the taste for aggressively spectator-challenging freshness that he developed even before 1870. His art would never be any more or less original, and the basic character of the originality would remain constant. Once he had accomplished his great forward mutation of landscape imaging, all that was left for him was to cultivate ingeniously what was in essence a post-Realist terrain that he had in fact invented and over which he remained absolute master.

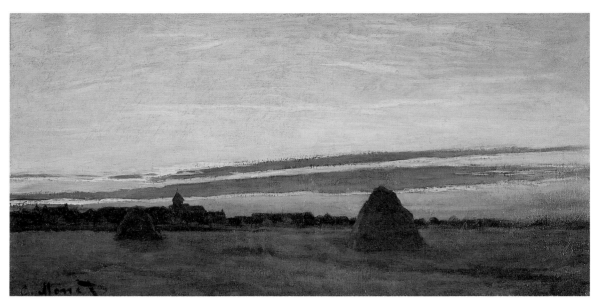

Monet, *Haystacks near Chailly at Sunrise*, cat. 91

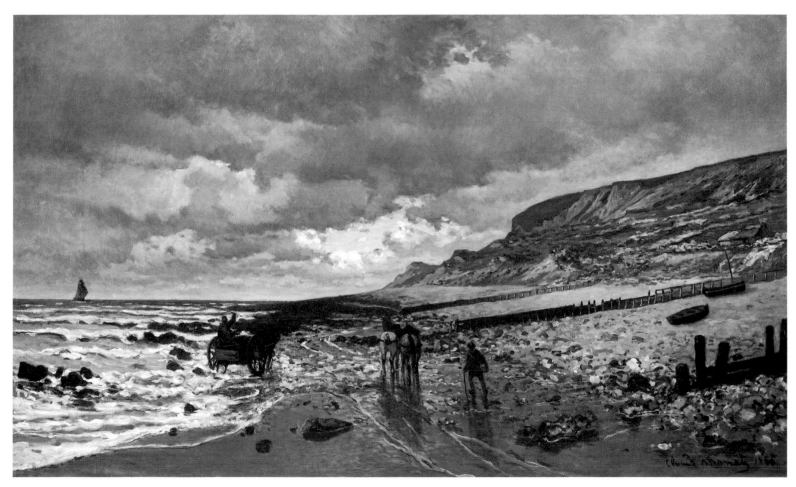

Monet, *The Pointe de la Hève at Low Tide*, cat. 92

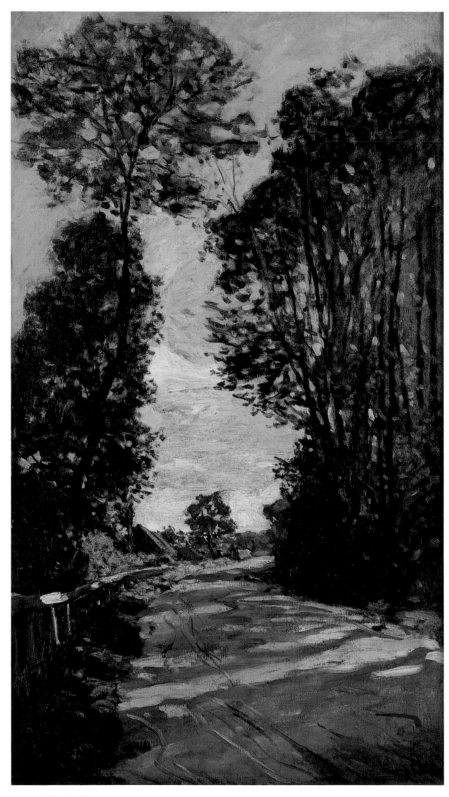

Monet, *The Walk*, cat. 93

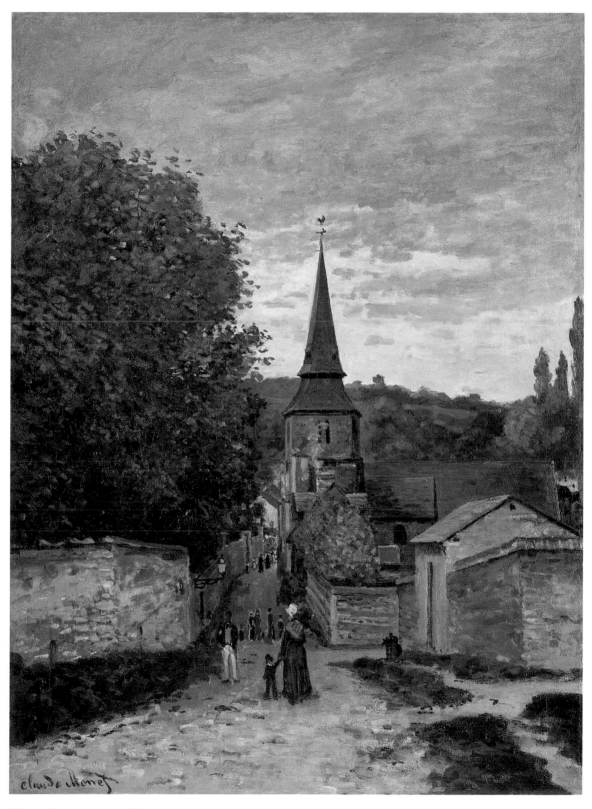

Monet, *Street in Sainte-Adresse*, cat. 94

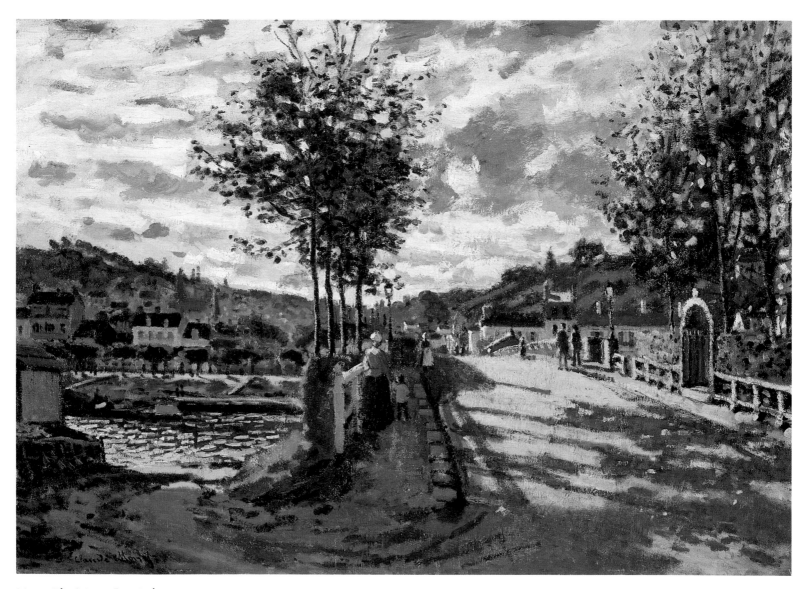

Monet, *The Seine at Bougival*, cat. 95

Monet, *Village Street*, cat. 96

CAMILLE PISSARRO
1830, St. Thomas (Virgin Islands) – 1903, Paris

1842: Boarding school in Passy. 1847: Works as clerk for father in West Indies. 1852–55: To Caracas, Venezuela, with Danish artist Fritz Melbye. 1855–57: Returns to France; uses studio of Fritz Melbye's brother Anton in Paris; summer in Montmorency (1857) to paint from nature following Corot's advice; settles in Paris. 1859: Salon debut with *View of Montmorency*; studies at Académie Suisse where he meets Monet. 1861–63: Rejected by Salon; meets Cézanne and Armand Guillaumin; paints in Montmartre; shows in Salon des Refusés. 1864–65: Advised by Corot; accepted by Salon (two works). 1865: Shows landscape at Salon as "pupil of Corot." 1866: Shows again at Salon; Emile Zola praises his Salon entries; settles at Pontoise. 1867: Rejected by Salon; with Bazille, Renoir, and Sisley, signs petition for new Salon des Refusés. 1868–69: Accepted by Salons; settles in Louveciennes. 1870: At the start of the Franco-Prussian War, flees Louveciennes for Brittany and then to London with Monet; sells two works to Durand-Ruel; marries mother of his children; Prussian soldiers destroy many works left in French studio. 1872: Settles in Pontoise where Cézanne, Guillaumin, and others join him. 1874: Successful sale of work in Ernest Hoschedé auction (Hôtel Drouot); first of eight Impressionist exhibitions.

P ISSARRO WAS THE eldest member of the group of painters who would form the nucleus around which post-Realist painting would emerge in the 1870s. Called "Impressionism," the new painting had among its landscape practitioners only a few characteristics in common, so nothing like a traditional style ever really emerged, except in the works of later imitators who drew at random on the work of Monet, Pissarro, and Sisley. For a number of reasons Pissarro's work is the most distinctive of the three. Sisley tracked Monet quite closely, and neither seems in any obvious way to have responded directly to Pissarro. Conversely, Pissarro followed his own pictorial inclinations for the most part, even while pausing at certain key moments in his career to consider other work, Monet's in particular, which he very much respected. During the period 1865 to 1880, Pissarro was closest to Cézanne, both personally and artistically. The complex give-and-take relationship between these two artists awaits serious study.[1]

The range of Pissarro's work of the 1860s will, unfortunately, never be possible to determine, since a considerable number of his paintings were destroyed during the occupation of his house by Prussian soldiers in 1870, while Pissarro was in exile in London along with Monet. Estimates of the number of paintings destroyed vary, but a conservative guess would be in the neighborhood of seventy. The loss here is a critical one, since Pissarro's work always developed more consistently than did that of his Impressionist friends. A consciously deliberate artist, Pissarro considered and then rejected a wide range of imaging options through the 1860s, and it is this deliberate process which is ultimately impossible to reconstruct. Highly self-critical, and productively so, Pissarro had already demonstrated over a wide range of works the self-critical process of testing and then carefully evaluating his tests that would (along with his considerable articulateness) make him the most effective and sought-after mentor of ambitious younger artists (Gauguin and van Gogh among them) from the mid-1870s until the

time of Pissarro's temporary conversion to Seurat's neo-Impressionism after 1886.

Pissarro's early work, that which is of the most importance to the present exhibition, derives a good deal of its special character from the length of Pissarro's student experience as well as from the somewhat discontinuous nature of that experience. Born in St. Thomas in the then-Danish Virgin Islands, Pissarro had his formal grammar schooling in France between 1841 and 1847, but practiced landscape painting first in St. Thomas and, traveling with a Danish friend, in Venezuela. Only in 1855 did Pissarro commit himself firmly to an artistic career in France. When he did so, he undertook (besides some brief Beaux-Arts-type instruction) to learn by eye the composite landscape achievement of the generation of 1830 supplemented by that of Courbet and Daubigny. While obviously respecting Corot enormously (even listing himself as a Corot student in several Salon catalogues), Pissarro seems from the earliest of his truly professional works, those produced after 1862, to have been unable to accept the personalisms of late Corot – the improvisatory, "musical" effects that had become so predominant. Both aesthetically and politically, Pissarro was committed to remaining closer to nature, and he seems to have considered the persistent practice of working out-of-doors with constant access to the real motif, characteristic of Daubigny, Boudin, and the young Monet, a mandatory one. A lifelong socialist, if not a particularly noisy or radical one, Pissarro would never be ideologically comfortable with anything that smacked of romantic conjuring. Even while permitting his pictorial taste to be stretched by Japanese prints, Monet's art, and later, Cézanne's, Pissarro would never fully abandon his commitment to and his belief in the material reliability of the effects he built into his landscapes.

It is the realist/naturalist side of Pissarro's early work that so distinguishes it from that of Monet. Pissarro's career in the 1860s traces by degrees the metamorphosis from mid-century landscape practice to something much closer to the decoratively emphatic, forcefully colored work of post-1865 Monet. What Pissarro manages is to make the metamorphosis seem inevitably natural rather than willful. In his 1870–71 work, there is always a feeling of discovery through observation to counterbalance the increasingly radical character of effects developed via color and paint structure. Pissarro believed that *his* effects meant something different from Monet's, that they were more true to life rather than just true to his creative self. Whether they were or not is beside the point; Pissarro thought they were and this belief that they were is what made it ideologically possible for him to participate significantly, even enthusiastically, in the freewheeling color-spectacle that was mid-1870s Impressionism.

Already by 1864, in small paintings like *Path by the River*, the essential character of Pissarro's imaging process is evident. There is a composite gesture toward Corot in the setup of the motif and toward Courbet in the physical density of the paint structure and the earthbound quality of the color. What is distinctively Pissarro's about the picture is, first of all, the desire to graft Corot's atmosphere to Courbet's material weight, and, second, the carrying out of the grafting with a studied, craftsmanlike deliberateness that attends simultaneously to the broad structure of the whole image – the major pictorial incidents – and many more minor graphic and coloristic ones as well. The paint construction literally looks serious and, by implication, attentive to carefully studied appearance. Yet the serious look has a strictly aesthetic side as well – a side that theatricalizes the handmade and the original. Pissarro's feeling (his emotion) is expressed with a dignified worker's accent, but also demonstrates a considerable degree of material sophistication about the sensuous attractiveness and expressiveness of painting per se. In its deliberate tempo, *Path by the River* displays Pissarro's temperament (as Emile Zola enthusiastically termed it) as much as it displays nature, and one realizes that there is considerably more to the artist's seeming truth to nature than simple passive description. Works such as this one, while independently complete and pictorially

resolved in their complexly developed two- and three-dimensional signals to the viewer, ultimately served Pissarro in the mid-1860s as models for larger works destined for the Salon. *Path by the River* was one of probably several models used to produce Pissarro's masterpiece of the period, his 1866 *Banks of the Marne, Winter* (Chicago, Art Institute).

By 1870 it is obvious that Monet's representation of nature in terms of hue has begun to affect Pissarro's work strongly. Working first at Louveciennes and then in London, the artist applies Monet's exciting demonstrations of schematic color into what appear to be motifically appropriate places. Pissarro uses complementary color relationships in response to particular motifs and moments of nature, and overall, he adjusts the color scale upward in terms of value. Motifs remain unspectacular, even everyday, in views of roads, fields, and valleys with some vernacular figures included, but the painting structure is anything but everyday. Grids, webs, and geometrically forceful perspective shapes become decoratively active, and in doing so, a nervously animated, purely pictorial rattle against ostensibly simple, natural images is produced. Similarly, Pissarro's touch becomes looser and more variable. It is accountable both to descriptive and decorative emphases almost equally.

The combination of coloristically emphatic decorative stresses and the apparently ordinary moment of vision that develops in Pissarro's work is uniquely confusing, seen in the company of works by Monet and Sisley. The schematic arbitrariness in matters of color that the latter two artists feature leaves the viewer reassured as to the fact that a painting, rather than a rendering of nature, is being offered up for scrutiny. Pissarro never quite permits this degree of reassurance, and the viewer is kept excitingly off-balance, not knowing whether to look at a picture as an artifice or some sort of record of seeing.

Pissarro hangs art and science on the same thread. His durability as an artist of both a generic Impressionist and personal sort rests in his sustaining a high degree of ambiguity regarding what, precisely, his pictures are about. Being the great painter he was, Pissarro probably had no more certainty in this respect than did (or do) his spectators.

1. Christopher Campbell, an advanced graduate student in the History of Art at Brown University, is currently preparing a doctoral dissertation on the question of the Pissarro-Cézanne relationship.

Pissarro, *Path by the River near La-Varenne — Sainte-Hilaire*, cat. 97

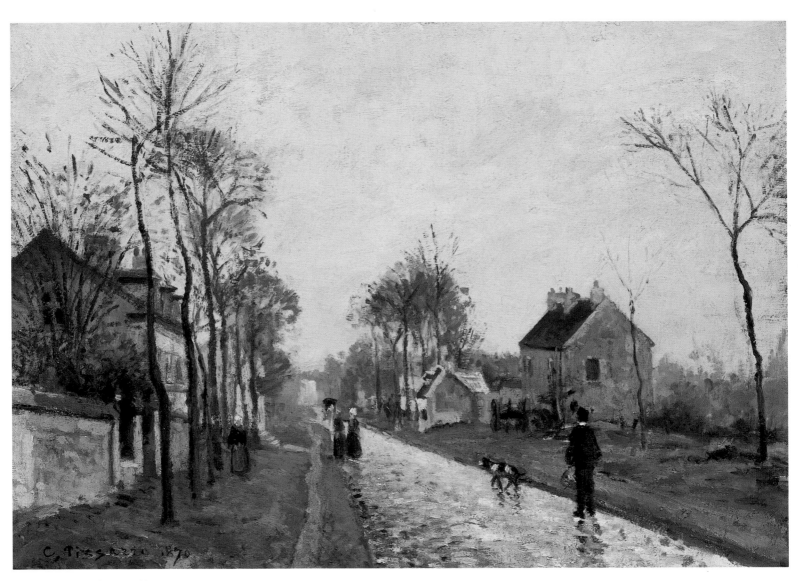

Pissarro, *The Road: Rain Effect*, cat. 98

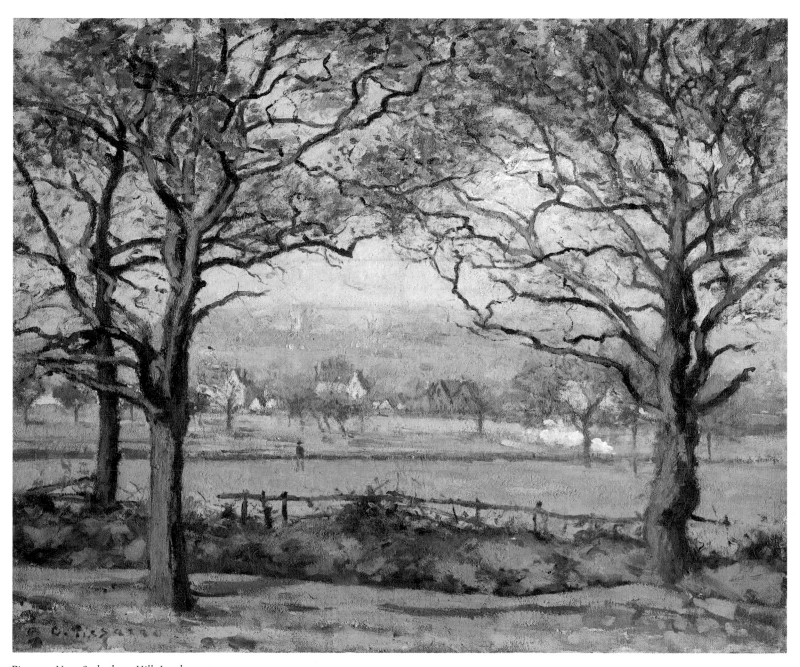

Pissarro, *Near Sydenham Hill, London*, cat. 99

PIERRE-AUGUSTE RENOIR
1841, Limoges – 1919, Cagnes-sur-Mer

Son of tailors; family moves to Paris in 1845. 1856–57: Apprenticed to a porcelain painter; begins night classes in drawing. 1862: Enters Ecole des Beaux-Arts (Charles Gleyre's studio). 1863–64: Meets Fantin-Latour; leaves Gleyre's studio and paints in Chailly with Bazille, Monet, and Sisley; meets Diaz and the painter Jules LeCoeur; Salon debut. 1865: Shows again at Salon; to Rouen and Fontainebleau with Sisley; meets Courbet. 1866: Continues Fontainebleau painting campaign; rejected at Salon despite support by Corot and Daubigny; lives and paints with Bazille in Paris; trip to Channel coast with Bazille. 1869: Accepted by Salon; to Ville d'Avray; to Bougival with Monet. 1870: Shows at Salon; shares studio with Bazille; military service in Tarbes (Pyrenees). 1871: To Paris and Louveciennes; to Bougival with Sisley; returns to Paris. 1872: Meets Théodore Duret; visits Monet in Argenteuil. 1873: Meets Durand-Ruel; shows in new Salon des Refusés. 1874: First of seven Impressionist exhibitions; again visits Monet; befriends Gustave Caillebotte, a painter and collector. 1875: Organizes auction with Monet, Morisot, and Sisley; again rejected at Salon. 1876: To Montmartre. 1878–79: Accepted at Salon. 1879: One-person exhibition at *La Vie Moderne*; meets future wife.

DESPITE HIS IMPORTANCE within the Impressionist group in the 1870s, Renoir was never truly a friend of the forest and the field. He did not seem to enjoy painting landscape subjects as a matter of routine and most likely would have avoided them altogether had he not felt the keen interest of his friends, Bazille, Monet, and Sisley, in landscape imaging. Although certainly not unaware of the mid-century accomplishments of Corot, Courbet, and, in particular, Diaz (for whom Renoir had a special fondness), that awareness alone would likely never have led to practice, since Renoir was from the beginning of his career dedicated to the painting of the human figure. Ultimately it seems to have been Monet's ability in the 1860s to work back and forth between figure paintings and landscapes, and to have each productively informed by the other, that convinced Renoir of the potential utility of working in the uncomfortable out-of-doors, making at least a few pure landscapes. Like Bazille, he would more systematically pursue throughout the 1865–70 period the elusive goal of the convincingly "modern" out-of-doors figure painting, following the path laid out by Monet's *Women in a Garden* of 1866 (Paris, Musée d'Orsay).

Renoir was similar to Bazille in other respects as well. He was a melomane, and something more than just an amateur one. After abandoning an early commercial career painting porcelain and other decorative objects, Renoir studied both drawing and music – the latter in the late 1850s with Charles Gounod. At this time Gounod was one of the inner circle of forward-looking French composers who clustered around Wagner during the latter's residence in Paris in the years before the first performance (1862) of *Tannhäuser* at the Opéra. Even though Renoir abandoned music for painting, entering the Ecole des Beaux-Arts in 1862 and proceeding through the normal curriculum there, Renoir never lost his passion for the art he gave up practicing. With Bazille and their mutual friend, the portrait and still-life painter Fantin-Latour, Renoir counted himself (as from a distance did Cézanne) among the celebrants of the revolution in music effected by Wagner in Paris. Later on, in the

years around 1880, Renoir would produce commissioned paintings (decorative panels) on Wagnerian subjects, tighten up his personal friendship with Fantin-Latour, who was by then producing massive numbers of lithographs of scenes from Wagner's operas, visit Wagner in Palermo in 1882 to paint his portrait, and finally make "the journey" to the Bayreuth Festival in 1896. Renoir was in some manner, yet to be fully explored, a Wagnerist painter throughout his life, and he stands as the clearest and most convincing link between advanced German music and advanced French painting in the culturally politicized years before and after the Franco-Prussian War.

Given his passion for music, it seems likely that Renoir sensed, if only subconsciously, the important role that concert music, acting as an aesthetic model, had played in the art of the great landscape painters of the generation of 1830 and of Delacroix as well. In his own 1865 *Clearing in the Woods,* his taste for the musically ingratiating, rhythmical and lyrical softness of Diaz's work is evoked in a way to mitigate somewhat more forceful aspects of the paint construction, executed with the palette knife and obviously emulative of Courbet. In addition, this picture develops a comparatively extended value range in green particularly and adds small-scale but quite intense accents of a complementary red. The color structure seems vaguely responsive to Monet, while the setup of the motif recalls, in its open foreground and horizontal emphasis, the contemporary work of Sisley as well. Yet the painting has a recognizable personality of its own. Its complex weave of various paint textures and innumerably soft-edged shapes give it a pictorial density, distinct from anything in the works of Monet or Sisley. This density is, in musical terms, polyphonic or multi-voiced in character. The eye is made to follow parallel but different sensuous paths in the color and the paint construction and to proceed at different speeds in comprehending the pictured space of the motif at various points.

The *Portrait of Jules LeCoeur at Fontainebleau* from 1866 is Renoir's first serious attempt to do a modern figure painting out-of-doors (or at least begun out-of-doors). In certain respects it is a more conservative effort than Monet's roughly contemporary *Women in a Garden* or his slightly earlier, unfinished *Déjeuner sur l'herbe* (Paris, Musée d'Orsay). On the other hand, it is a highly compelling demonstration of the maturing of Renoir's manner of pictorial construction. The impacted combination of the figure, the dog, and the heavily overgrown forest setting, enterable only by a path, is developed in an equally impacted, almost impenetrable, fashion by Renoir's color and his application of paint. Without reference to Monet's schematically intense hue changes in comparable images, Renoir deploys a fairly wide range of values in natural greens, blue-greens, and yellow-oranges. The blue-orange complement is softly stated, so that the color stays closely bonded to the elaborate figural and landscape character of the motif *and* to the equally elaborate paint structure. Working with brushes of various sizes and with a palette knife, Renoir constructs a pictured form of continuous low relief (in the sculptural sense), merging elements identifiable as bits of three-dimensional figuration (trees and figures per se), space, and apparently flat or semi-flat surfaces. The whole image moves across the picture plane almost without focus. As it does so, a very abstract condition of unity – a half-tactile, half-visual one – develops. This condition is powerful and as idiosyncratic as Monet's clearly shaped, emphatically two-dimensional chromatic unity, but it is very distinctive in its effect. It is tempting to call it more informed by music in the sense that it features varieties of technical stresses and voicings operating simultaneously and that it requires more spectating time to be penetrated.

Renoir would selectively incorporate characteristics of Monet's more chromatically elaborate manner between 1866 and 1870, but the process was, in a way similar to Pissarro's, a rather deliberate one. Hue complexity was quite literally woven into his work progressively, as Renoir painted both figures and landscapes. Never did he permit this complexity to interrupt the particular structural richness and character already achieved in the *Portrait of Jules*

LeCoeur. Monet's palette was used to extend a form of pictorial unity which Renoir already had firmly in place. Intense colors would amplify and elaborate on an established structural theme.

When Monet and Renoir worked side by side on landscape motifs near Bougival in 1869, they were together as equal but different artists. That equality and that difference, joined after 1870 with Pissarro's, essentially guaranteed the breadth and variety of accomplishment in the new post-Realist painting called Impressionism.

Renoir, *Clearing in the Woods*, cat. 100
(not in exhibition)

Renoir, *Portrait of Jules LeCoeur at Fontainebleau*, cat. 101

THÉODORE ROUSSEAU
1812, Paris – 1867, Barbizon

Parents (drapery-makers) allow Rousseau to leave Auteuil when cousin (landscape painter) Paul de Saint-Martin encourages art career. 1826: Paints in Forest of Compiègne; enters Charles Rémond's studio. 1828: Joins Guillon-Lethière's studio; copies Dutch paintings at Louvre. 1830: To the Auvergne mountains. 1831: Salon debut with *Landscape in the Auvergne*; to Normandy (returns to Honfleur in 1835); meets Paul Huet. 1833: To Chailly; meets Delacroix, Théophile Thoré (Thoré-Bürger), Théophile Gautier; wins Salon third-class medal for *Coast at Granville*. 1834: Visits Swiss Alps with friend Lorenz; wins second Salon third-class medal; meets Dupré. 1836: Duc de Broglie commissions *Descent of the Cattle* (rejected at Salon but exhibited privately in Ary Scheffer's studio); subsequently rejected by Salon through 1841; trip to Fontainebleau. 1837: Rents Fontainebleau studio (returns 1847); travels to Brittany. 1842: Works in isolation in Creuse Valley. 1844: To Landes with Dupré. 1845: To Paris (returns in 1846, 1848) and L'Isle-Adam with Dupré. 1846: Meets his future biographer, Alfred Sensier. 1849: Wins Salon first-class medal; ends friendship with Dupré; meets Millet. 1850: To Barbizon; marries; sale of paintings held (again in 1861); achieves recognition by collectors. 1852: Awarded cross of Legion of Honor. 1854: Made member of Amsterdam Academy of Fine Arts. 1855: Given own exhibition room at Universal Exposition. 1857: To Picardy. 1860: To Switzerland with Millet. 1865: To Boulogne; Prince Demidoff commissions dining-room panels. 1866: To Franche-Comté to nurse wife's health; member of Salon jury; art dealer Durand-Ruel represents his work. 1867: President of Salon jury; Officer of Legion of Honor; medalist at Universal Exposition. 1872: Sensier publishes his *Memories*.

ALTHOUGH ROUSSEAU and Corot, the acknowledged giants of nature-based painting from the generation of 1830, shared a near-absolute commitment to landscape imaging, there is little common expressive ground apparent in their art. When a comparatively large number of works by Rousseau and Corot are seen together as in the present exhibition, it is immediately obvious that the two artists discovered different things when they scrutinized a forest or a village, and even though both seem from an early point to have acknowledged modern concert music (particularly Beethoven's) as a prime model for the powerful deployment of original nature-like feeling, each artist interpreted that model very differently. In simplest terms, in the experience of nature and of the natural in music, Corot felt the lyric/dramatic, while Rousseau felt the tragic/dramatic (even the demonic) most intensely.

Carl Maria von Weber, particularly in his opera *Der Freischütz* (which Rousseau especially loved), combined the rustically simple sounds of peasant choruses and raucous hunting horns with a sophisticated orchestral accompaniment that for many listeners of the period ran in a seamless fashion through the entire range of natural feeling, from the most to the least nameable. Mixing vocal and instrumental voicings of every description, Weber invented dramatic means different from Beethoven's, but just as potent, to thrust concert music (opera, in his instance) into a position of parity with nature, rather than one of reliance on nature, in terms of inducing "natural" experience. Rousseau seems to have wanted to manage the same for landscape painting. He wanted, and in his best works managed, to generate a complex natural experience that originated as much, if not more, in the language of painting as in the strict rep-

resentation of nature itself.

All of this is not to say that Rousseau, any more than Corot, ever totally disregarded natural appearance; rather, it is to suggest that both saw through appearance to feeling or at least believed that they did. The process of having to see through to feeling and then to image that feeling using the same species of topographical stimuli that had produced it – trees, rocks, pools, openings and closings of the forest, changes in seasonal vegetation – involved Rousseau's efforts throughout his life. The order, the sequence – in other words, the arrangement of landscape effects – had to be set out in terms of coordinating or contrasting descriptive/emotional signs that were ultimately spectator legible (or audible). In the final analysis, Rousseau's career was largely spent in invention and deployment of landscape imaging as a self-sufficient non-verbal language – a language like that of dramatic symphonic music and one equally capable of initiating, rather than simply reproducing, "natural" feeling.

Working for much of his career in the Forest of Fontainebleau south of Paris, where he lived in close proximity to his friend and colleague J.-F. Millet, Rousseau saturated himself with landscape prospects of every conceivable sort. The more familiar he became with his imaging material, the better able he was to conceive of landscape elements as infinitely variable units of pictorial voicings operating in isolation or in groups in spaces at times seemingly deep, at other times virtually impenetrable. Elements of landscape become almost human in the sometimes still, sometimes complexly movemented character of their positions, shapings, and apparent gestures. The landscape floor becomes a virtual stage for variable anthropomorphic activity among inanimate elements. The "pathetic fallacy" (the projection of human behavior into the non-human) is clearly in force in Rousseau's work, but his feeling for it is so authentic that it can hardly be faulted in principle. Like the great early-nineteenth-century German landscape painter Caspar David Friedrich (whose work Rousseau could not easily have known), the pathetic fallacy seems an inevitable device.

It is the only mode of expression that feels true if the most monumental of emotions are to be evoked via landscape images. Both Rousseau and Friedrich would ultimately be masters of immeasurable distances (infinity) and the unequal contest between the small things that live or position themselves on the earth and forces of light, winds, and storms that both nourish and erode everything in their path.

Rousseau's taste for the tragic/dramatic seems to have been with him from an early point in his career. The consistency of what he seeks out to feel with and through landscape is as remarkable as Corot's. And similar to Corot's work, Rousseau's does not really develop – rather it is refined. In works such as this exhibition's *The Bridge at Moret* (c. 1828–29) or *The Old Park at Saint-Cloud* (1831–32), Rousseau tested the post-Constable picturesque aspect of both image and technique practiced at the same time by Corot and Isabey, but already his motifs are idiosyncratically grave and emphatic in the manner of their presentation. By the mid-1840s, particularly in works like the *Morning Frost, Uplands of Valmondois (Effet de givre)*, Rousseau's personal accent is absolutely clear in the almost unearthly, barren prospect of the land that seems virtually inflamed by the coloristically complex, yet at the same time almost iconic, sunset. What Rousseau will alter in his works (often very large in scale) of the 1850s and 1860s is what he found increasingly disturbing about the confusion of expressive signals between paint construction (as an expression) and motif and color organization (as a counter-expression). He systematically abandons the former (as did Friedrich in his later work) so that a regular, seemingly envisioned rather than manually executed, deposit of the image parts is made to deliver all feeling, unimpeded by the material traces of manipulated paint. Both *The Dagneau Pond (La mare à Dagneau)* and *Clearing in the Forest of Fontainebleau* demonstrate the technical impersonalism of his mature manner of imaging. What he obtains through de-emphasizing his constructive trace is a sense of definitiveness and finality of expressive effect. All voices are exceptionally clear in an evocation

of nature that seems absolutely certain of its emphases and its content. The spectator is usually held far back from the most imagistically animated parts of the paintings by the device of an uninviting and usually rather deep foreground field. Off and away from this, the many moods of landscape drama, more or less tragic, more or less epic, develop in front of the spectator's eyes, but out of his or her physical reach. There is no materialism permitted to be felt, because there is none permitted to be seen. Dancings and soundings, collected and dispersed by colored light, generate the entire expressive message in a narratively unspecific yet musically pure and intense fashion. In his greatest pictures, Rousseau presents landscape worlds which seem uninhabited, uninhabitable, unapproachable, and unknowable by anything but what the German philosopher Arthur Schopenhauer would likely have defined as the active human "will." Rousseau aims to construct a kind of metaphor for the space of the feeling mind. That mind is engaged both emotionally and metaphysically in images of apparently natural nature that at the same time seem open to totally nonrational signals of the incipiently surreal. This is the Théodore Rousseau that Henri Rousseau would later come to cherish.

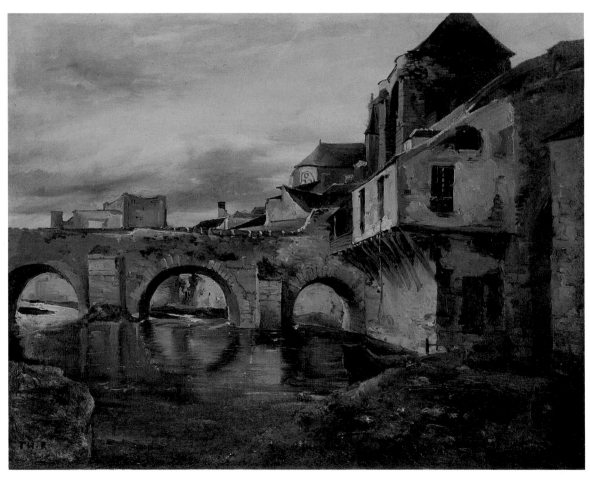

Rousseau, *The Bridge at Moret*, cat. 102

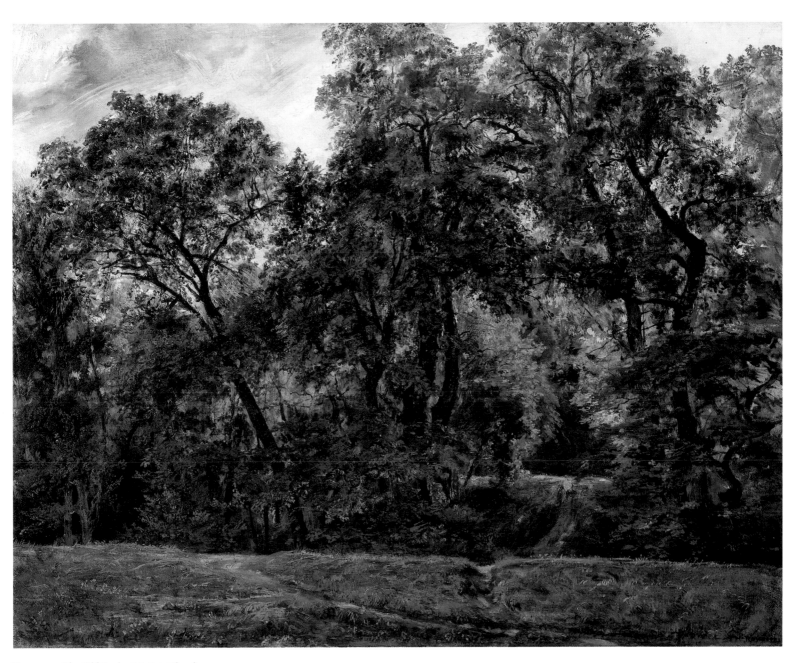

Rousseau, *The Old Park at Saint-Cloud*, cat. 103

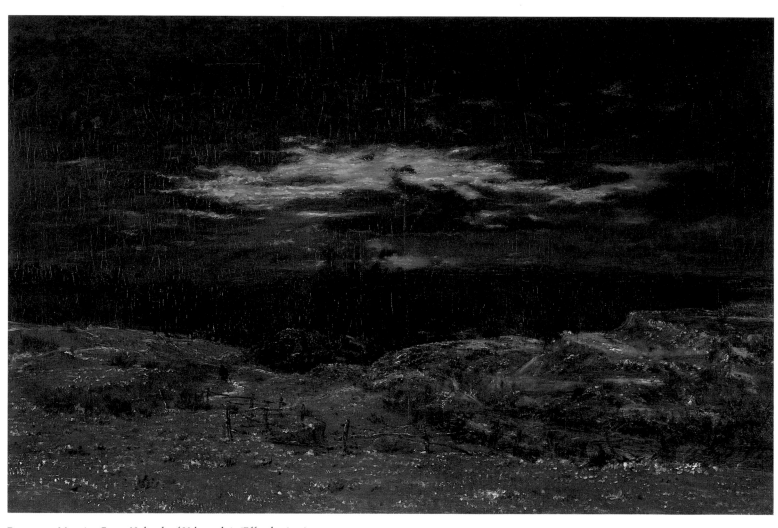

Rousseau, *Morning Frost, Uplands of Valmondois (Effet de givre)*, cat. 104

Rousseau, *The Oaks (Woodland Landscape)*, cat. 105

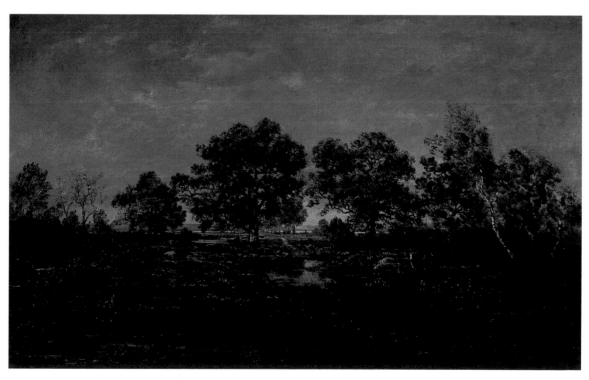

Rousseau, *The Dagneau Pond on the Plateau Belle-Croix, Forest of Fontainebleau (La mare à Dagneau)*, cat. 106

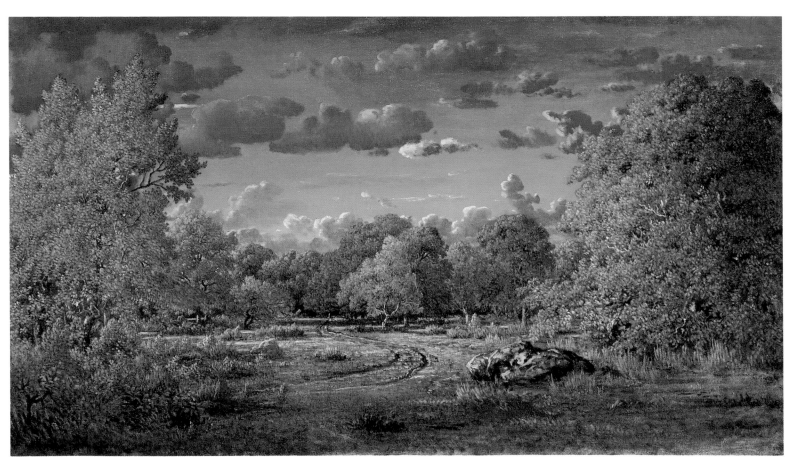

Rousseau, *Clearing in the Forest of Fontainebleau,* cat. 107

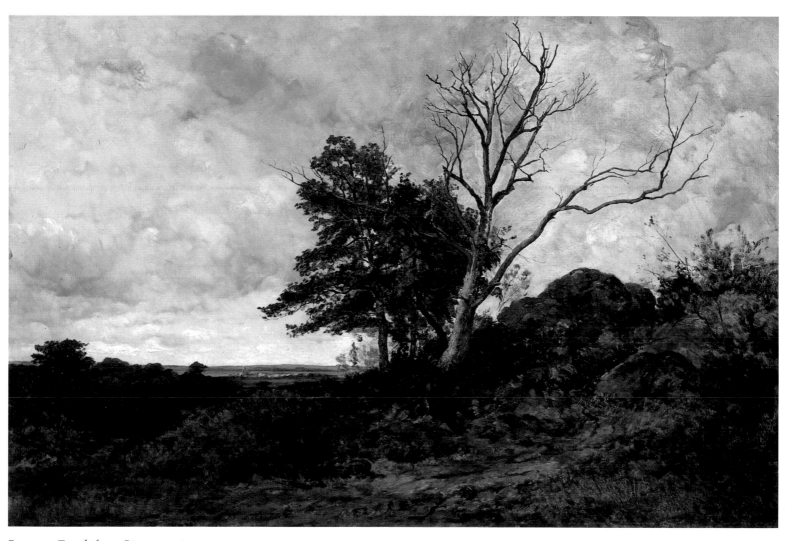

Rousseau, *Trees before a Rise*, cat. 108

ALFRED SISLEY
1839, Paris – 1899, Moret-sur-Loing

Son of a wealthy English merchant. 1856–61: Sent to school in England to prepare for commercial career; visits museums. 1862: Returns to Paris; enters Ecole des Beaux-Arts and Gleyre's studio with Bazille, Monet, and Renoir. 1864: Rents Paris studio in Porte Maillot. 1865: To Fontainebleau and Rouen with Renoir. 1866: Two Salon acceptances; marries; trip to Berck (Channel coast) with Renoir. 1867: Salon rejects *Alley of Chestnut Trees*; signs petition with Bazille, Renoir, Pissarro for a new Salon des Refusés; works in Honfleur; visits Monet. 1868: Only one entry accepted at Salon; at Chailly, poses with wife for Renoir. 1869: Rejected again at Salon. 1870: Moves to Batignolles; two Salon acceptances. 1871: With Renoir at Louveciennes; Durand-Ruel acquires one painting. 1872: Through Monet and Pissarro, meets Durand-Ruel; works in Argenteuil, Bougival, Villeneuve, Port-Marly; Durand-Ruel shows four paintings. 1873: Works in Louveciennes, Marly, Bougival, Pontoise. 1874: Returns to many of same sites; shows in first of four Impressionist exhibitions; trip to England (paints at Hampton Court) with J.-B. Faure, a well-known collector, actor, and singer. 1875: Organizes auction with Monet, Morisot, and Renoir; settles in Marly-sur-Roi; paints in Marly, Bougival, St.-Germain, Louveciennes, and Versailles. 1877: Second group auction sale; moves to Sèvres. 1878: Sells paintings through Duret; decides to show again at Salon. 1879: Rejected at Salon; resettles in Sèvres and then near Moret-sur-Loing (in 1882).

As the son of a British merchant operating in France, Sisley had a comparatively comfortable situation during the 1860s. Without needing to fend off parental complaints regarding his decision to become a painter and without needing to generate sales of his work, Sisley moved at a rather leisurely professional pace at first, studying at the Ecole des Beaux-Arts and then joining the studio of the tolerant academic painter Charles Gleyre, where he worked alongside Monet, Renoir, and Bazille. Like Bazille, Sisley appears to have been progressively overwhelmed by the brash confidence of Monet's work and was easily enticed by the latter to work in landscape. By the mid-1860s Sisley was working in or near the Forest of Fontainebleau during the summers, observing carefully some of Monet's most ambitious early projects (the *Women in a Garden* and the unfinished *Déjeuner sur l'herbe,* both Paris, Musée d'Orsay) as well as savoring his pure landscape work done at the same time.

By 1866 Sisley was gradually accommodating Monet's model and beginning at the same time to mark out certain directions in his own work which suggest a taste and a temperament somewhat different from Monet's. Although Sisley would never throughout his life break totally free from Monet's dominance, he demonstrated already at this early point his ability to thrive aesthetically within what is in fact the pictorial orbit of another artist. In retrospect, one doubts whether Sisley could have functioned as a significant artist without having had Monet's work as a persistent inspiration, but whatever the case, no painter ever made more consistent and effective use of a colleague's inventions over a longer period than Sisley made of Monet's. And even more to the point, despite Sisley's reliance on Monet, he maintained an almost inconceivable degree of creative integrity. He seemed to have been able, without any sense of inner conflict, to honor Monet routinely without ceasing to honor himself. He was never just an imitator of Monet's, as so many painters both from France and elsewhere (particularly America) would be in the 1880s and after. Instead he was a follower in the most dedicated, intelligent, and genuine

sense of the term. Compared to Bazille, Sisley seemed to have felt no impulse to compete with Monet, so his work never shows the signs of aesthetic indecision that had become increasingly characteristic of Bazille in the period just before the latter's tragic death on the battlefield in 1870.

Just how well Sisley used Monet is evident in the two mid-1860s masterpieces included in the present exhibition. Both the *Chestnut Trees at La-Celle – Saint-Cloud* and the *Village Street in Marlotte* emulate Monet's recent work in a composite fashion. The landscape recalls several of Monet's nearly contemporary Fontainebleau works, while the view of Marlotte is reminiscent of Monet's 1864 *Farmyard in Normandy* (Paris, Musée d'Orsay). Where Sisley's two works differ from Monet's is in the greater elaborateness of their motifs. Both are more representationally intricate, more topographically informative, and far less decisively schematic in terms of color and shape. Sisley's viewing aspect seems wider than Monet's. The middle of the paintings are less the focus of attention and the motifs extend generously outward to the edges of the canvas. This tendency to expand, rather than focus, looks like a residue from the mid-century landscape practice of Corot, Daubigny, and Rousseau. Sisley's preference for it is somewhat conservative in the mid-1860s, but certain pictorial emphases are made possible by holding to this tendency and those emphases are clearly of some importance to the artist. Individual decisions relative to color, paint structure, and shapings within a particular image carry less weight than they do in comparable Monets. Sisley is free to deal more gently with the spectator. He allows his images to unfold slowly, even prosaically at certain points. The numerous individual topographical features in the Saint-Cloud painting are comparatively clear. Trees are varied and distinct in type and position. The blue-green, red-orange color chord is struck lightly by Monet's standards, and it moves evenly through the entire image rather than pulling it together decoratively around emphatic shapes.

Many of the same characteristics appear in the Marlotte picture. Even though the motif is predominantly architectural and composed of buildings at different angles to the picture surface (as well as occupying different locations in the pictured space), the effect of Sisley's view is emphatically lateral. The foreground reduces to a horizontally stretched triangular area. The architectural middle ground simply elaborates in scale and number several shape variations on the distended triangle, and the same is repeated in softened form in the foliage background of the painting's left side. The sky shape is then a rambling inversion of the foreground. The intricacy of Sisley's shapings seems to respond again to a desire for variety in the distribution of texture and tone as well as for more informative detail overall. There is a good deal to look at in the picture, and the specific conformations of motif elements are reasonably clear. Again Sisley seems to alter Monet's more abrupt simplifications in favor of a greater diversification of pictorial incident, including a complexly foreshortened (frontally viewed) woodcutter, who, besides being interesting in a sort of picturesque way, also serves via his blue-gray smock to introduce the blue-gray, yellow-orange color complement that threads its way throughout the picture.

Ultimately the sense one has of Sisley as an artist – distinct from Monet, yet dependent upon him for vital direction – emerges in terms of a certain gravity of feeling. Sisley's pictures, at this point in his career at least, do not assault the spectator with their performative brilliance. They charm rather than dazzle. Sisley tends to soften Monet's post-Realist machinations without denying their unique importance for the landscape imaging of the final third of the nineteenth century.

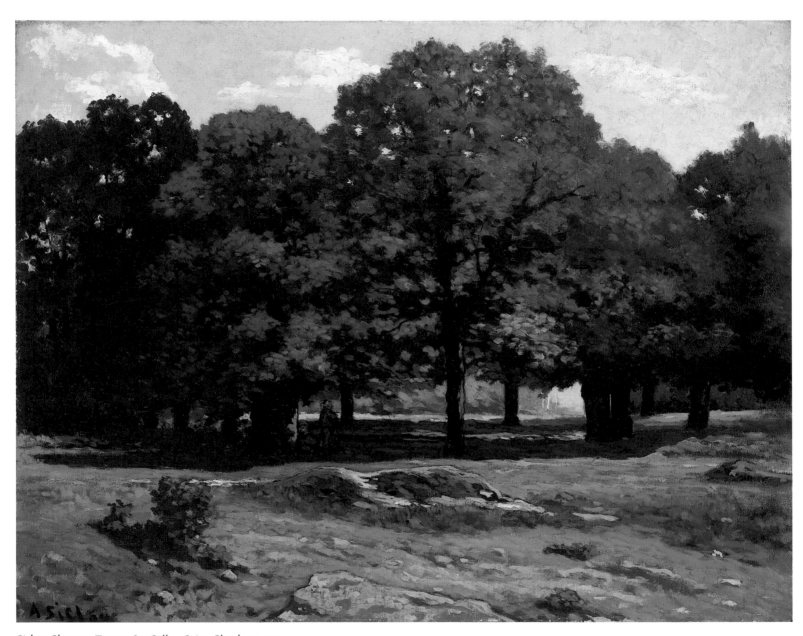

Sisley, *Chestnut Trees at La-Celle – Saint-Cloud*, cat. 109

Sisley, *Village Street in Marlotte*, cat. 110

CONSTANT TROYON

1810, Sèvres – 1865, Paris

Son of porcelain painters; learns trade in Sèvres under Riocreux and Poupart. 1824: Meets Diaz. 1833: Salon debut with several Sèvres scenes and *View of Saint-Cloud.* 1835: *View of Sèvres* receives third-class medal. 1836: To Brittany; to Argentan. 1838: Receives third-class medal. 1839: To Brittany. 1840: Receives second-class medal for Brittany landscapes. 1843: To Landes with Dupré; meets Rousseau and joins Barbizon painters. 1841: Accepted at Salon. 1846: Receives first-class medal. 1847–48: Trip to Holland; admires Albert Cuyp's and Paulus Potter's animal paintings; receives official honors in Belgium and Holland. 1849: Legion of Honor. 1850: To Touques valley with Huet. 1852: To England and Normandy coast with Boudin. 1855: Wins first-class medal for *Cattle Going to Work.*

LIKE RENOIR, Diaz, and Dupré, Troyon was first trained as a porcelain painter. This experience in the instance of each artist seems to have encouraged a taste for historical as well as contemporary pictorial practices. It is, as a result, difficult to describe a typical Troyon painting. There are many different sorts: some recall seventeenth-century Dutch prototypes, and others, eighteenth-century French ones; some are related loosely to the exotic genre works of Delacroix, and others to the landscape imaging of Corot and Rousseau. There is almost equal latitude in Troyon's range of technique. It varies from being neoclassically crisp in drawing and accent to being exceptionally loose and painterly. In the same picture, *The Game Warden* of 1854 from the present exhibition, one can, for example, experience an almost inconceivable combination of seemingly incompatible imaging practices derived in equal measure from Millet, Corot, *and* Courbet. If the generation of 1830 had one composite painter, it was Troyon. But to say this is not to deny Troyon an artistic personality of his own. Rather it is to say that his personality was by nature happily eclectic and genuine in its enthusiasm for many things.

While never as committed to the painting of a particular species of animal as Jacque was to sheep, Troyon made something of a specialty of animals, particularly after 1850. Here, as in his work generally, references abound. This exhibition's *Pasture in the Touraine* of 1853 invokes Albert Cuyp's and Paulus Potter's famous cattle pictures from the 1650s. Troyon even manages to approximate a seventeenth-century Dutch edginess in his treatment of light. *Descent from Montmartre* reflects Delacroix and Jacque, depending on what aspect of the picture one examines. Perhaps the most distinctive Troyon in the present exhibition is the earliest one, the *View of Saint-Cloud* of 1831. Besides being highly informative topographically in terms of landscape and architectural elements, the painting manages to join this informativeness to a broadly dispersed group of variously costumed figures in the foreground in such a way as to evoke a distinctly eighteenth-century *fête galante* ambience. Information is combined with loose, poetic feeling easily, even brilliantly, as Troyon unifies the image with a consistent treatment of rather bright natural light and a comparatively uniform scale of brushmarkings. The latter are sufficiently small and delicate to accept clearly drawn edges when such are necessary, and the painting as a whole shows, as clearly as any Troyon ever will, what broadly informed taste and technique alone make expressively possible.

Troyon, *View of Saint-Cloud*, cat. 111

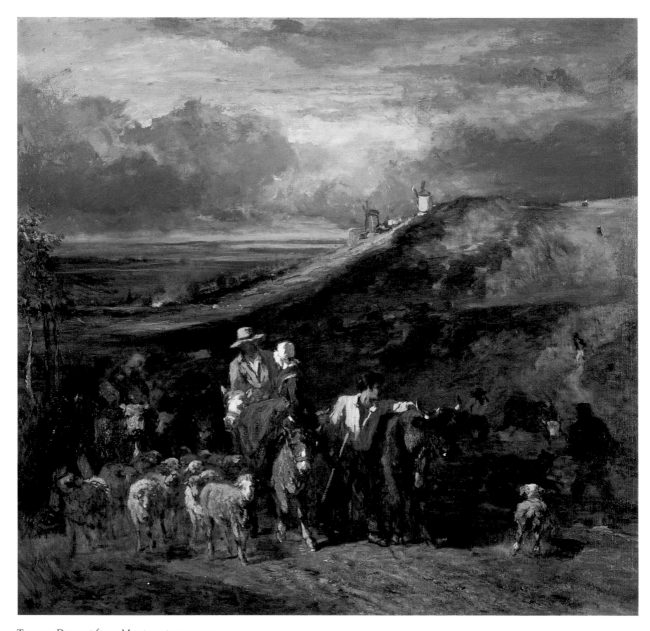

Troyon, *Descent from Montmartre*, cat. 112

Troyon, *Pasture in the Touraine*, cat. 113

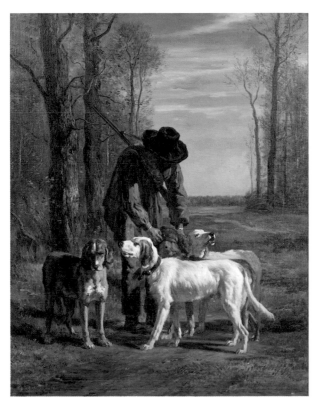

Troyon, *The Game Warden*, cat. 114

Checklist of the Exhibition

BAZILLE

1
The Beach at Sainte-Adresse, 1865
Oil on canvas,
23 × 55⅛ inches (58.4 × 140 cm)
High Museum of Art, Atlanta.
Gift of the Forward Arts Foundation in honor of Frances Floyd
Cocke, 1980.62

BENOUVILLE

2
View in the Roman Campagna,
1843
Oil on canvas,
31½ × 50⅝ inches (80 × 128.7 cm)
Private Collection

BOUDIN

3
The Beach at Trouville, 1865
Oil on canvas,
15 × 24¾ inches (38 × 62.8 cm)
The Art Museum, Princeton
University, New Jersey. Gift of the
Estate of Laurence Hutton, 1913
(Manchester and New York only)

4
Fishmarket, Honfleur, 1865
Oil on panel,
9 × 12¼ inches (22.8 × 31.1 cm)
The University of Michigan
Museum of Art. Bequest of
Margaret Watson Parker,
1955/1.75

5
Coast of Brittany, 1870
Oil on canvas,
18⅝ × 26 inches (47.3 × 66 cm)
National Gallery of Art,
Washington, D.C., Collection of
Mr. and Mrs. Paul Mellon,
1983.1.11

CONSTABLE

6
Weymouth Bay, 1816
Oil on canvas,
13½ × 23⅜ inches (34.3 × 59.37 cm)
Wadsworth Atheneum, Hartford,
Connecticut, The Ella Gallup
Sumner and Mary Catlin Sumner
Collection
(Manchester, New York, and
Dallas only)

7
Dedham Lock and Mill, 1820
Oil on canvas,
21¾ × 30⅝ inches (55.2 × 77.7 cm)
The Currier Gallery of Art,
Manchester, New Hampshire.
Currier Funds
(Manchester, Dallas, and
Atlanta only)

8
*Hampstead Fields Looking West:
Afternoon*, 1821
Oil on panel,
6½ × 8¾ inches (16.5 × 22.2 cm)
Collection of Thomas Marc Futter

9
*Branch Hill Pond, Hampstead
Heath*, 1825
Oil on canvas,
24½ × 30¾ inches (62.2 × 78.1 cm)
Virginia Museum of Fine Arts,
Richmond, The Adolph D. and
Wilkins C. Williams Collection
(Manchester, Dallas, and
Atlanta only)

10
Dell Scene, Helmingham Park,
1826–33
Oil on canvas,
27½ × 35⅝ inches (69.8 × 90.4 cm)
Philadelphia Museum of Art,
John G. Johnson Collection

COROT

11
*The Inn at Montigny-les-
Cormeilles*, c. 1825–30
Oil on paper lined to aluminum,
9¾ × 13 inches (24.7 × 33 cm)
The Wellesley College Museum,
Wellesley, Massachusetts.
Museum Purchase

12
*Dunkerque: Fishing Boats Tied to
the Wharf*, 1829–30
Oil on canvas,
9¼ × 14³/₁₆ inches (23.6 × 36.1 cm)
Sterling and Francine Clark Art
Institute, Williamstown,
Massachusetts

13
Jumièges, 1829–31
Oil on canvas,
12 × 15½ inches (30.5 × 39.4 cm)
Smith College Museum of Art,
Northampton, Massachusetts.
Winthrop Hillyer Fund, 1924

14
The Paver of the Chailly Road,
1830–35
Oil on paper,
12⅜ × 17½ inches (31.47 × 44.5 cm)
The Dixon Gallery and Gardens,
Memphis, Tennessee. Bequest of
Mr. and Mrs. Hugo Dixon

15
*Landscape with Lake and Boatman,
Evening*, 1839
Oil on canvas,
24⅝ × 40¼ inches (62.5 × 102.2 cm)
The J. Paul Getty Museum,
Malibu, California
(New York, Dallas, and
Atlanta only)

16
*Ravine in the Morvan, near
Lormes*, c. 1840–45
Oil on canvas,
18 × 18¾ inches (45.7 × 47.6 cm)
High Museum of Art, Atlanta.
Gift of Forward Arts Foundation,
72.39

17
View near Naples, 1841
Oil on canvas,
27¾ × 43 inches (70.5 × 109.2 cm)
Museum of Fine Arts, Springfield,
Massachusetts, The James Philip
Gray Collection
(Manchester and New York only)

18
*Goat Girl beside a Stream,
Lormes*, 1842
Oil on canvas,
20½ × 27 inches (52 × 68.6 cm)
The Cleveland Museum of Art,
Ohio. Leonard C. Hanna, Jr., Fund

19
Forest of Fontainebleau, c. 1846
Oil on canvas,
35½ × 50¾ inches (90.2 × 128.8 cm)
Museum of Fine Arts, Boston. Gift
of Mrs. Samuel Dennis Warren

20
The Bridge at Grez-sur-Loing,
c. 1850–60
Oil on canvas,
12⅛ × 25⅛ inches (30.8 × 63.8 cm)
The Currier Gallery of Art,
Manchester, New Hampshire.
Currier Funds

21
*The Banks of a Canal near
Rotterdam*, 1854
Oil on canvas,
11¾ × 18⅛ inches (29.8 × 46 cm)
Virginia Museum of Fine Arts,
Richmond. Gift of Count Cecil
Charles Pecci-Blunt

22
Château Thierry, 1855
Oil on canvas,
13¾ × 23 inches (34.9 × 58.4 cm)
Joslyn Art Museum, Omaha,
Nebraska

23
Path in the Woods, Semur,
c. 1855–60
Oil on canvas,
22⅞ × 17½ inches (58.1 × 44.4 cm)
Dallas Museum of Art, lent by
the Hockaday School, 15.1980
(Dallas only)

24
*The Pond and the Cabassud House
at Ville d'Avray*, c. 1855–60
Oil on canvas,
18¼ × 21¾ inches (46.4 × 55.2 cm)
The Des Moines Art Center, Iowa.
Purchased with funds from the
Coffin Fine Arts Trust, Nathan
Emory Coffin Collection, 1962.20

25
*In Monsieur Wollet's Park,
Voisinlien*, c. 1860–65
Oil on canvas,
13⅜ × 20½ inches (34 × 52 cm)
Private Collection
(Manchester only)

26
*Peasants Stopping at the Edge
of a Wooded Road near a Village*,
c. 1860–70
Oil on canvas,
21½ × 14⁹⁄₁₆ inches (54.6 × 37 cm)
The Taft Museum, Cincinnati,
Ohio. Bequest of Mr. and
Mrs. Charles Phelps Taft
(Manchester, New York, and
Dallas only)

27
*The Moored Boatman: Souvenir
of an Italian Lake*, 1861
Oil on canvas,
24⅛ × 35⅜ inches (61.3 × 89.9 cm)
The Corcoran Gallery of Art,
Washington, D.C., William A.
Clark Collection

28
*Sèvres-Brimborion – View toward
Paris*, 1864
Oil on canvas,
18¼ × 24¼ inches (46.4 × 61.6 cm)
The Maryland Institute, College
of Art, The George A. Lucas
Collection, on indefinite loan to
The Baltimore Museum of Art
(New York, Dallas, and
Atlanta only)

29
Souvenir of Mortefontaine, 1864
Oil on canvas,
25⅝ × 35 inches (65 × 89 cm)
Musée du Louvre, Paris
(Manchester, New York, and
Dallas only)

30
Farm Scene, c. 1865–68
Oil on canvas,
18½ × 15⅛ inches (46.9 × 38.4 cm)
High Museum of Art, Atlanta.
Bequest of Albert Edward
Thornton in memory of his
mother, Mrs. Albert Edward
Thornton, Sr., 54.15

31
*The Island of Happiness (L'île
heureuse)*, 1865–68
Oil on canvas,
74 × 56⅛ inches (188 × 142.5 cm)
The Montréal Museum of Fine
Arts. Gift of the family of Sir
Georges Drummond in memory of
Arthur Lennox Drummond and
Captain Guy Melfort Drummond

32
*A Brook beneath the Trees with a
House in the Distance*, 1865–70
Oil on canvas,
22³⁄₁₆ × 15¼ inches (56.4 × 38.7 cm)
The Taft Museum, Cincinnati,
Ohio. Bequest of Mr. and
Mrs. Charles Phelps Taft
(Manchester, New York, and
Dallas only)

33
*An Idyllic Spot at Ville d'Avray:
A Fisherman on the Banks of the
Pond*, 1865–70
Oil on canvas,
22¹⁄₁₆ × 28³⁄₁₆ inches (56 × 71.6 cm)
Worcester Art Museum, Worcester,
Massachusetts. Bequest of
Charlotte E. W. Buffington

34
*Outside Paris: The Heights above
Ville d'Avray*, 1865–70
Oil on canvas,
20¼ × 39½ inches (51.4 × 100.3 cm)
The Taft Museum, Cincinnati,
Ohio. Bequest of Mr. and
Mrs. Charles Phelps Taft
(Manchester, New York, and
Dallas only)

35
Wheelwright's Yard on the Seine,
1865–70
Oil on canvas,
18¼ × 21⅞ inches (46.3 × 55.6 cm)
The Metropolitan Museum of Art.
Bequest of Eloise Lawrence Breese
Norrie, 1921
(New York only)

36
Canal in Picardy, c. 1865–71
Oil on canvas,
18⅜ × 24¼ inches (46.7 × 61.6 cm)
The Toledo Museum of Art, Toledo,
Ohio. Gift of Arthur J. Secor
(Dallas and Atlanta only)

37
Ville d'Avray, 1868–70
Oil on canvas,
21⅝ × 31½ inches (54.9 × 80 cm)
The Metropolitan Museum of Art.
Bequest of Catharine Lorillard
Wolfe, 1887, Catharine Lorillard
Wolfe Collection
(New York only)

38
Old Bridge at Limay, on the Seine,
c. 1870
Oil on canvas,
16 × 26 inches (40.6 × 66 cm)
The Los Angeles County
Museum of Art, Paul Rodman
Mabury Collection
(New York, Dallas, and
Atlanta only)

COURBET

39
Self-Portrait: The Violoncellist,
1847
Oil on canvas,
44¼ × 34⅛ inches (112.4 × 86.7 cm)
Portland Art Museum, Oregon Art
Institute. Gift of C. E. S. Wood

40
*Seacoast (Souvenir of Les
Cabanes)*, 1854–57
Oil on canvas,
37½ × 53½ inches (95.1 × 136.3 cm)
Philadelphia Museum of Art,
John G. Johnson Collection

41
Valley of Ornans, 1858
Oil on canvas,
23¹¹⁄₁₆ × 33⁹⁄₁₆ inches
(60.2 × 85.2 cm)
The Saint Louis Art Museum.
Museum Purchase

42
Fox in the Snow, 1860
Oil on canvas,
33¾ × 50⁵⁄₁₆ inches
(85.7 × 127.8 cm)
Dallas Museum of Art, Foundation
for the Arts Collection.
Mrs. John B. O'Hara Fund

43
The Source of the Loue, c. 1864
Oil on canvas,
42¼ × 54⅛ inches
(107.3 × 137.5 cm)
Albright-Knox Art Gallery,
Buffalo, New York. George B. and
Jenny R. Mathews Fund, 1959
(Manchester and New York only)

44
The Valley of the Loue, 1865
Oil on canvas,
36½ × 58¾ inches (92.7 × 149.2 cm)
The Des Moines Art Center, Iowa.
Purchased with funds from the
Coffin Fine Arts Trust, Nathan
Emory Coffin Collection, 1958.1

45
A Bay with Cliffs, c. 1869
Oil on canvas,
14¹⁵⁄₁₆ × 18¹⁄₁₆ inches
(37.9 × 45.8 cm)
Wadsworth Atheneum, Hartford,
Connecticut, The Ella Gallup
Sumner and Mary Catlin Sumner
Collection
(Manchester, New York, and
Dallas only)

46
The Angry Sea, c. 1869–70
Oil on canvas,
22 × 36 inches (55.8 × 91.4 cm)
Dallas Museum of Art. Gift of
H. J. Rudick in memory of
Arthur L. Kramer

DAUBIGNY

47
*The Crossroads at the Eagle's Nest,
Forest of Fontainebleau*, c. 1844
Oil on canvas,
31 × 45 inches (78.7 × 114.3 cm)
Collection of Ruth and
Bruce Dayton

48
Sluice in the Optevoz Valley, 1854
Oil on canvas,
35½ × 63¼ inches (90.2 × 160.7 cm)
The Museum of Fine Arts,
Houston. Museum purchase with
funds provided by Anaruth and
Aron S. Gordon

49
The Water's Edge, Optevoz, c. 1856
Oil on canvas,
26¾ × 49 inches (68 × 124.5 cm)
Mount Holyoke College Art
Museum, South Hadley, Massachu-
setts. Anonymous gift in memory
of Robert and Mildred Warren, 1981

50
The Mill at Optevoz, 1857
Oil on canvas,
34¼ × 59¼ inches (87 × 150.5 cm)
Philadelphia Museum of Art,
The William L. Elkins Collection

51
Gobelle's Mill at Optevoz, c. 1858
Oil on canvas,
22¾ × 36½ inches (57.8 × 92.7 cm)
The Metropolitan Museum of
Art. Bequest of Robert Graham
Dun, 1911
(New York only)

52
Evening on the Oise, 1863
Oil on canvas,
39¼ × 78¾ inches (99.7 × 200 cm)
The Taft Museum, Cincinnati,
Ohio. Bequest of Mr. and
Mrs. Charles Phelps Taft
(Manchester, New York, and
Dallas only)

53
Morning, 1863
Oil on canvas,
25¾ × 19¼ inches (65.3 × 49 cm)
Indiana University Art Museum,
William Lowe Bryan Memorial
Collection, 59.47

54
Morning on the Oise, 1865
Oil on canvas,
32½ × 56½ inches (82 × 143.5 cm)
The Paine Art Center and
Arboretum, Oshkosh, Wisconsin

55
French Coast Scene, 1868
Oil on canvas,
18½ × 32 inches (47 × 81.3 cm)
Tweed Museum of Art, University
of Minnesota-Duluth

56
The Washerwomen of Auvers, 1870
Oil on panel,
11¾ × 20⅜ inches (29.8 × 51.7 cm)
Memorial Art Gallery, University
of Rochester, New York, George
Eastman Collection

57
Fields in the Month of June, 1874
Oil on canvas,
53 × 88 inches (134.6 × 223.5 cm)
The Herbert F. Johnson Museum
of Art, Cornell University, Ithaca,
New York. Gift of Mr. and
Mrs. Louis V. Keeler, 59.87

58
The River Oise at Auvers, 1874
Oil on panel,
15⁵⁄₁₆ × 26⅜ inches (39 × 67 cm)
The Nelson-Atkins Museum
of Art, Kansas City, Missouri.
Nelson Fund

DIAZ

59
The Stag Hunt, 1846
Oil on canvas,
36⅞ × 47⅜ inches (93.6 × 120.3 cm)
The Snite Museum of Art, Univer-
sity of Notre Dame, Indiana

60
Forest Scene, 1850–60
Oil on cradled panel,
17¼ × 21⅝ inches (44.5 × 55 cm)
The Brooklyn Museum. Gift of
Charlotte R. Stillman, 51.11
(New York only)

61
Wood Interior, c. 1867
Oil on canvas,
22 × 41½ inches (55.8 × 105.4 cm)
Washington University Gallery of
Art, St. Louis. Gift of Charles
Parsons, 1905

62
*Early Autumn: Forest of
Fontainebleau*, 1870
Oil on canvas,
33¹⁄₁₆ × 44 inches (84 × 111.8 cm)
The Taft Museum, Cincinnati,
Ohio. Bequest of Mr. and
Mrs. Charles Phelps Taft
(Manchester, New York, and
Dallas only)

63
Autumn, 1872
Oil on panel,
23¾ × 18¾ inches (60.3 × 47.6 cm)
New Orleans Museum of Art.
Gift of Mr. and Mrs. Chapman H.
Hyams

64
Landscape
Oil on panel,
10⅜ × 11¾ inches (26.3 × 29.8 cm)
The Cleveland Museum of Art,
Ohio. Gift of Mr. and Mrs. J. H.
Wade

DUPRÉ

65
Cows in a Field, 1837
Oil on canvas,
31 × 51½ inches (78.8 × 130.8 cm)
The Metropolitan Museum of Art,
Robert Lehman Collection, 1975,
1975.1.169

66
A Bright Day, c. 1840
Oil on canvas,
11⅛ × 17¾ inches (28.5 × 45 cm)
The Walters Art Gallery,
Baltimore, Maryland

67
Windmill, 1855–60
Oil on canvas,
25 × 36 inches (63.5 × 91.4 cm)
The Cleveland Museum of
Art, Ohio. Gift of Mr. and
Mrs. J. H. Wade

68
Pastoral Scene, 1870
Oil on canvas,
23⅝ × 27¾ inches (60 × 70.5 cm)
Memphis Brooks Museum of Art,
Tennessee. Gift of Mr. and
Mrs. Morrie A. Moss, 59.29

HUET

69
*The Château at Pierrefonds,
in Ruins*, c. 1868
Oil on canvas,
42⅛ × 63 inches (107 × 160 cm)
Musée national du château de
Compiègne, France
(Manchester and New York only)

ISABEY

70
A Norman Fishing Village, c. 1831
Oil on canvas,
15¼ × 20½ inches (38.7 × 52 cm)
The Currier Gallery of Art,
Manchester, New Hampshire.
Bequest of Florence Andrews Todd

71
Boat Dashing against a Jetty,
c. 1850s
Oil on canvas,
36½ × 57⅞ inches (92.7 × 131.8 cm)
Worcester Art Museum, Worcester,
Massachusetts. Charlotte E. W.
Buffington Fund

JACQUE

72
Landscape with Sheep
Oil on canvas,
20 × 32 inches (50.8 × 81.3 cm)
The Montréal Museum of Fine
Arts. Gift of Mr. Colin W. Webster

73
Sheep (At the Watering Hole)
Oil on canvas,
29⅛ × 39¹⁵⁄₁₆ inches (74 × 101.4 cm)
The Nelson-Atkins Museum of
Art, Kansas City, Missouri.
Nelson Fund

74
Shepherdess
Oil on canvas,
32 × 25½ inches (81.2 × 64.8 cm)
Cincinnati Art Museum, Ohio.
Gift of Emilie L. Heine in memory
of Mr. and Mrs. John Hauck

JONGKIND

75
*Boats in the Harbor, Sainte-
Adresse (Bateaux en rade, Sainte-
Adresse),* 1858
Oil on canvas,
17 × 23⅝ inches (43.1 × 60 cm)
Virginia Museum of Fine Arts,
Richmond, The Adolphe D. and
Wilkins C. Williams Collection

76
La Tournelle Bridge, Paris, 1859
Oil on canvas,
17⅞ × 28⅞ inches (45 × 73 cm)
The Fine Arts Museums of
San Francisco. Gift of Count Cecil
Pecci-Blunt

77
Canal near Honfleur, 1865
Oil on canvas,
13⅜ × 18⅝ inches (34 × 47.3 cm)
The Art Museum, Princeton
University, New Jersey. Bequest of
Clinton Wilder

78
*The Meuse in the Vicinity of
Rotterdam,* 1869
Oil on canvas,
15¾ × 25¾ inches (40 × 65.4 cm)
The Currier Gallery of Art,
Manchester, New Hampshire.
Gift of Count Cecil Pecci-Blunt

MICHEL

79
Landscape, c. 1836–37
Oil on canvas,
20¼ × 27¾ inches (51.4 × 70.5 cm)
Worcester Art Museum, Worcester,
Massachusetts. Gift of Mr. and
Mrs. Arthur L. Williston, in
memory of Clarence H. Denny

MILLET

80
Man Turning over the Soil,
c. 1847–50
Oil on canvas,
9⅞ × 12¾ inches (25 × 32.5 cm)
Museum of Fine Arts, Boston.
Gift of Quincy Adams Shaw
through Quincy A. Shaw, Jr., and
Mrs. Marian Shaw Haughton
(Manchester, New York, and
Dallas only)

81
Summer, The Gleaners, 1853
Oil on canvas,
15 × 12 inches (38.1 × 30.5 cm)
Museum of Fine Arts, Springfield,
Massachusetts, The James Philip
Gray Collection

82
Farm at Gruchy, 1854
Oil on canvas,
21¼ × 28⅝ inches (53.9 × 72.7 cm)
Smith College Museum of Art,
Northampton, Massachusetts.
Tryon Fund, 1931

83
Millet's Family Home at Gruchy,
1854
Oil on canvas,
23½ × 29 inches (59.7 × 74 cm)
Museum of Fine Arts, Boston.
Gift of the Reverend and
Mrs. Frederick A. Frothingham

84
Washerwomen, c. 1855
Oil on canvas,
18 × 21³⁄₁₆ inches (45.5 × 53.8 cm)
Museum of Fine Arts, Boston.
Bequest of Mrs. Martin Brimmer
(Manchester, New York, and
Dallas only)

85
The Water Carrier, c. 1855–62
Oil on canvas,
39½ × 31¾ inches (100.3 × 80.6 cm)
Collection IBM Corporation,
Armonk, New York

86
*The End of the Hamlet at
Gruchy (I),* 1856
Oil on canvas,
18¼ × 22 inches (46.5 × 55.9 cm)
Museum of Fine Arts, Boston.
Gift of Quincy Adams Shaw
through Quincy A. Shaw, Jr., and
Mrs. Marian Shaw Haughton
(Manchester and New York only)

87
The Knitter, 1856
Oil on canvas,
14 × 11 inches (35.6 × 28 cm)
Cincinnati Art Museum, Ohio.
Gift of Emilie L. Heine in memory
of Mr. and Mrs. John Hauck

88
*Peasant Woman Guarding
Her Cow,* 1857
Black chalk on paper,
12⅜ × 17⅛ inches (31.4 × 43.5 cm)
The Chrysler Museum,
Norfolk, Virginia. Gift of
Walter P. Chrysler, Jr.
(Atlanta only)

89
In the Auvergne, 1867–69
Oil on canvas,
32¹⁄₁₆ × 39¼ inches (81.5 × 99.9 cm)
The Art Institute of Chicago,
Potter Palmer Collection
(Manchester, New York, and
Dallas only)

90
*Autumn Landscape with a Flock
of Turkeys,* 1870–74
Oil on canvas,
31⅞ × 39 inches (81 × 99.1 cm)
The Metropolitan Museum of Art.
Bequest of Isaac D. Fletcher, 1917,
Mr. and Mrs. Isaac D. Fletcher
Collection
(New York only)

MONET

91
Haystacks near Chailly at Sunrise,
c. 1865
Oil on canvas,
11⅞ × 23¾ inches (30.2 × 60.3 cm)
San Diego Museum of Art,
California

92
The Pointe de la Hève at Low Tide,
1865
Oil on canvas,
35½ × 59¼ inches (90.2 × 150.5 cm)
Kimbell Art Museum, Fort Worth,
Texas
(Dallas only)

93
The Walk, 1865–67
Oil on canvas,
32⅛ × 18⅛ inches (81.6 × 46.4 cm)
The National Museum of Western
Art, Tokyo, Matsukata Collection
(Manchester, New York, and
Dallas only)

94
Street in Sainte-Adresse, c. 1867
Oil on canvas,
31⅜ × 23¼ inches (79.7 × 59 cm)
Sterling and Francine Clark Art
Institute, Williamstown,
Massachusetts

95
The Seine at Bougival, 1869
Oil on canvas,
25¾ × 36⅜ inches (65.4 × 92.4 cm)
The Currier Gallery of Art,
Manchester, New Hampshire.
Currier Funds

96
Village Street, 1869–71
Oil on canvas,
17⅛ × 23¾ inches (43.5 × 60.3 cm)
Private Collection

PISSARRO

97
*Path by the River near
La-Varenne – Sainte-Hilaire*, 1864
Oil on canvas,
22 × 18 inches (55.9 × 45.7 cm)
The Maryland Institute, College
of Art, The George A. Lucas
Collection, on indefinite loan to
The Baltimore Museum of Art
(New York, Dallas, and
Atlanta only)

98
The Road: Rain Effect, 1870
Oil on canvas,
15¹³⁄₁₆ × 22³⁄₁₆ inches
(40.2 × 56.3 cm)
Sterling and Francine Clark
Art Institute, Williamstown,
Massachusetts

99
Near Sydenham Hill, London, 1871
Oil on canvas,
17 × 21 inches (43.5 × 53.5 cm)
Kimbell Art Museum, Fort Worth,
Texas
(Dallas only)

RENOIR

100
Clearing in the Woods, 1865
Oil on canvas,
22½ × 32½ inches
(57.15 × 82.55 cm)
The Detroit Institute of Arts.
Bequest of Ruth Nugent Head, in
memory of her mother, Anna E.
Kresge, and her husband,
Henry W. Nugent Head
(Not in exhibition)

101
*Portrait of Jules LeCoeur at
Fontainebleau*, 1866
Oil on canvas,
41¾ × 31¾ inches (106 × 80 cm)
Museu de Arte de São Paulo, Brazil

ROUSSEAU

102
The Bridge at Moret, c. 1828–29
Oil on canvas,
10½ × 13¼ inches (26.7 × 33.6 cm)
Smith College Museum of Art,
Northampton, Massachusetts.
Purchased 1957

103
The Old Park at Saint-Cloud,
1831–32
Oil on canvas,
26¼ × 32½ inches (66.6 × 82.5 cm)
National Gallery of Canada,
Ottawa / Musée des Beaux-Arts du
Canada, Ottawa
(Atlanta only)

104
*Morning Frost, Uplands of
Valmondois (Effet de givre)*, 1845
Oil on fabric,
25 × 38⅝ inches (63.5 × 98.1 cm)
The Walters Art Gallery,
Baltimore, Maryland

105
The Oaks (Woodland Landscape),
1852
Oil on canvas,
21 × 25¼ inches (53.3 × 64.1 cm)
Indiana University Art Museum,
Evan F. Lilly Memorial

106
*The Dagneau Pond on the
Plateau Belle-Croix, Forest of
Fontainebleau (La mare à
Dagneau)*, c. 1858–60
Oil on canvas,
25 × 40½ inches (63.5 × 102.9 cm)
The Taft Museum, Cincinnati,
Ohio. Bequest of Mr. and
Mrs. Charles Phelps Taft

107
*Clearing in the Forest of
Fontainebleau*, c. 1860–62
Oil on canvas,
32½ × 57¼ inches (82.5 × 145.4 cm)
The Chrysler Museum, Norfolk,
Virginia

108
Trees before a Rise
Oil on canvas,
19½ × 29 inches (49.5 × 73.6 cm)
Tweed Museum of Art, University
of Minnesota-Duluth

SISLEY

109
*Chestnut Trees at La-Celle –
Saint-Cloud*, 1865
Oil on canvas,
19¾ × 25⅝ inches (50.5 × 65.5 cm)
The Ordrupgaard Collection,
Copenhagen
(Manchester and New York only)

110
Village Street in Marlotte, 1866
Oil on canvas,
25½ × 36 inches (64.8 × 91.4 cm)
Albright-Knox Art Gallery,
Buffalo, New York. George Cary,
Charles Clifton, James G. Forsyth,
and Edmund Hayes Funds, 1956

TROYON

111
View of Saint-Cloud, 1831
Oil on canvas,
17½ × 24⅜ inches (44.4 × 61.9 cm)
The Snite Museum of Art, Univer-
sity of Notre Dame, Indiana. Lewis
J. Ruskin Purchase Fund, 72.21

112
Descent from Montmartre, c. 1850
Oil on canvas,
42¹⁄₁₆ × 44¹⁄₁₆ inches
(106.8 × 111.9 cm)
The Corcoran Gallery of Art,
Washington, D.C., William A.
Clark Collection

113
Pasture in the Touraine, 1853
Oil on canvas,
39¼ × 51⅛ inches (99.6 × 130.2 cm)
The Nelson-Atkins Museum of
Art, Kansas City, Missouri.
Nelson Fund

114
The Game Warden, 1854
Oil on canvas,
37 × 29 inches (94 × 73.6 cm)
Malden Public Library, Malden,
Massachusetts

Photographic Credits

Unless otherwise noted below, all photographs were provided by custodians of the works. The following list applies to photographs for which additional acknowledgment is due. (Fig. refers to illustrations to the essays; Cat. refers to objects included in the exhibition.) The publishers have made every effort to contact all holders of copyrighted works; any copyright holders we have been unable to reach are requested to contact The Currier Gallery so that proper acknowledgment may be given in subsequent editions.

Michael Cavanagh/Kevin Montague, Cat. 53, 105; William Finney, Cat. 25; Clem Fiori, Cat. 3, 77; Luiz Hossaka, Cat. 101; R. M. N., Cat. 29; Salander-O'Reilly Galleries, Inc., New York, Cat. 9; Cathy Carver, Johnson Fig. 9; The Frick Collection, New York, Champa Fig. 2; Musée National des Techniques/Photo, Johnson Fig. 2.

The Rise of Landscape Painting in France
COROT TO MONET

was designed by Gilbert Associates and
printed by Meridian Printing on Gleneagle paper.

The type is Aldus, designed for Linotype in
1952–53 by Hermann Zapf. It was named after
the 15th-century Venetian printer Aldus Manutius.

The book was bound by the Riverside Group.

Second edition 5,000 softcover copies for
The Currier Gallery of Art, Manchester, New Hampshire

November 1991